D0583438

COMFORT
&
GLORY

2⁵⁰

WITHDRAWN

Focus on American History Series

THE DOLPH BRISCOE CENTER
FOR AMERICAN HISTORY

University of Texas at Austin

Don Carleton, Editor

COMFORT
&
GLORY

*Two Centuries of American Quilts
from the Briscoe Center*

KATHERINE JEAN ADAMS

UNIVERSITY OF TEXAS PRESS

BRISCOE CENTER FOR AMERICAN HISTORY

AUSTIN

Copyright © 2016 by The Dolph Briscoe Center for American History
All rights reserved
Printed in China
First edition, 2016

Requests for permission to reproduce material from this work should be sent to:
Permissions | University of Texas Press | P.O. Box 7819 | Austin, TX 78713-7819
http://utpress.utexas.edu/index.php/rp-form

∞ The paper used in this book meets the minimum requirements of ANSI/NISO z39.48-1992 (R1997)
(Permanence of Paper).

LIBRARY OF CONGRESS CATALOGING-IN-PUBLICATION DATA
Adams, Katherine Jean, author.
Comfort and glory : two centuries of American quilts from the Briscoe Center /
by Katherine Jean Adams. —
First edition.
pages cm. — (Focus on American history series)
Includes bibliographical references and index.
ISBN 978-1-4773-0918-6 (cloth : alk. paper)
ISBN 978-1-4773-0919-3 (library e-book)
ISBN 978-1-4773-0920-9 (non-library e-book)
1. Quilts—Texas—History. 2. Quilts—Texas—Catalogs. 3. University of Texas at Austin. Center for American History—Catalogs. I. University of Texas at Austin. Center for American History. II. Title. III. Series: Focus on American history series.
NK9112.A33 2016
746.46—dc23 2015033631

doi: 10.7560/309186

Title page illustration: *Sugar Loaf*, circa 1860–1880. Anita Murphy Quilt Collection, 2009-296-11

Page v: *Wild Goose Chase*, circa 1930s. Joyce Gross Quilt Collection, W2h001.027.2008

Page vi: *Oak Leaf and Reel*, circa 1930–1945. Sherry Cook Quilt Collection, 2010-296-13

Page viii: *Stripes Galore, Nine Patch*, circa 1880–1910. Joyce Gross Quilt History Collection, Wzh001.058.2008

Page xi: *Democrat Donkey*, circa 1928–1950. Anita Murphy Quilt Collection, 2009-296-2

Page xii: *Pink Dogwood in Baskets*, detail, circa 1927–1935. Gift of Edie and James Hawley, 2010-134

Page 294: *Penny Tree*, circa 1840–1875, Joyce Gross Quilt History Collection, W2h001.028.2008

Page 306: *Wheel of Chance*, circa 1900, Joyce Gross Quilt History Collection, W2h001.063.2008.

Page 309: *Royal Hawaiian Flag*, circa 1890–1910. Joyce Gross Quilt History Collection, W2h001.042.2008

Page 310: *Engagement Ring*, circa 1950, Joyce Gross Quilt History Collection, W2h001.070.2008

Page 312: *Blazing Star*, circa 1860–1880, John Tongate Quilt Collection, 2009-367-1

Page 321: *Traveling Star with Sunbursts*, dated 2001. Kathleed McCrady Quilt History Collection, W2hl04.06

For

**DAVID,
SARAH,
AND AARON**

&

**MARY JEAN,
SUZANNE JEAN,
ANN JEAN,
AND SARAH JEAN**

CONTENTS

FOREWORD

--

KAROLINE PATTERSON BRESENHAN
AND NANCY O'BRYANT PUENTES

Every quilt tells a story. But many of those stories are lost due to death, the dispersal of family or possessions, or the lack of even rudimentary records or documentation. Not so the quilts in this remarkable book.

To the best of her considerable research abilities, Kate Adams has discovered many of the stories these quilts tell. It will be nothing short of joy for anyone who treasures learning about the history of quilts to find some uninterrupted time to read and study this book. Many quilt research books are handicapped by lack of facts that can be depended upon, but this book, published by the University of Texas Press and the Briscoe Center for American History, has benefitted from the scholarly emphasis of a major university as well as the passion of its author.

From the United States Bicentennial to today, there has been an enormous, widespread interest in quilts as reflective of women's contributions to art, culture, and history. This interest has necessarily been focused on women since the art of quilt-making has been almost exclusively their province.

The spread of ad hoc quilt studies following the state quilt documentation projects, such as the Texas Quilt Search, generated more formal studies, some conducted by members of the American Quilt Study Group and other entities, including the Quilt Alliance (formerly the Alliance for American Quilts). This, in turn, has resulted in the increasing numbers of scholarly works, including theses and dissertations on quilts and quilting in various college and university programs. These range from women's studies to sociology, folklore, anthropology, textiles, and conservation, among others. There is a growing body of serious quilt research into which *Comfort and Glory* fits. It will expand quilt scholarship not only about Texas quilts and Texas-related quilts in the Briscoe Center's collection, but also about quilts in general.

We have been actively involved with quilts and quilting all our lives, as fifth-generation Texas quilters, as descendants who honor a family quiltmaking tradition as well as inheriting family quilts, and as business women involved with the current renaissance in quilting since 1974. We have written or edited a total of twelve books about quilts and quilting, including three that document 175 years of quiltmaking in Texas, and founded five nonprofit quilt organizations, including the Texas Quilt Museum. Yet, even with that background, we were unaware of the breadth of the Briscoe Center's quilt collection until fairly recently.

But, though the collection has received little publicity even among quilt cognoscenti, it has been quietly expanding in size and significance since its founding in the 1960s with a gift of seventeen quilts from Miss Ima Hogg. The collection now includes both quilts and quilt history documentation, and it's past time for this growing treasure of textiles and scholarship to be more widely known.

Our connection with the Briscoe Center for American History and its collection of quilts began when we arranged for the donation of a set of *Quilter's Newsletter*

Magazine to the center. Later, as two of the four founders of the Quilt Alliance, we facilitated the center's involvement in the alliance's efforts to save valuable quilt history archives.

Because we believe that quilt history is, in a very real sense, women's history, that it should be preserved and studied, and that the Briscoe Center is uniquely suited to do both, we worked to introduce the center staff to two major quilt archives: those of Kathleen Holland McCrady and those of Joyce Gross. The center has now acquired both collections. In addition, we've helped the center identify and acquire two rare quilts, the *Troutman Quilt* and the wonderful *Chintz Appliqué Album* quilt featured in this book.

We've been honored to serve on the Briscoe Center's Advisory Council, and to be involved with all of its activities, quilt-related and other. We regard the work the center is doing in preserving American history as incredibly important, and are especially proud to see its Winedale Quilt Collection grow and prosper, as documented in this important book.

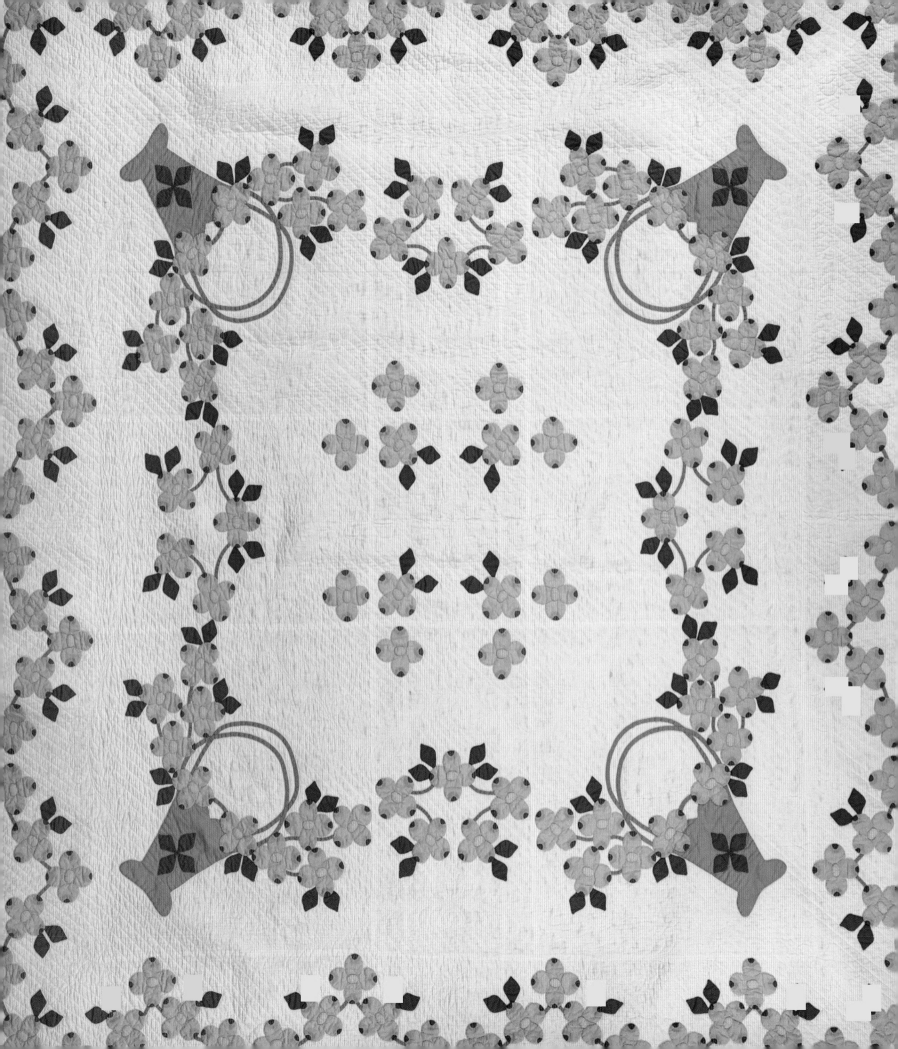

PREFACE

DON CARLETON, PHD

Executive Director, Dolph Briscoe Center for American History
J. R. Parten Chair in the Archives of American History

Comfort and Glory demonstrates the breadth and depth of the Briscoe Center's Winedale Quilt Collection, a premier scholarly resource that supports the preservation and study of quilts and their importance to American culture. In addition to the quilts themselves, the collection preserves extensive documentary resources on American quilt history, including ephemera, patterns, letters, photographs, research files, and countless other types of materials. The collection has quickly evolved to become a focal point for our acquisitions, digitization efforts, and exhibits. And now, due to the passionate and dedicated effort of author and curator Katherine Jean Adams, the collection has a publication worthy of its contents.

What is particularly exciting from my perspective as a historian is the significant research presented in the following pages. As a history research center, the Briscoe Center's mission is to sponsor projects based on our collections to further scholarship and deepen our understanding of the past. We tend to think of primary source material as pieces of paper: documents, newspapers, diaries, letters, maps, and so on. But material culture items, like the quilts featured in this book, can be just as revealing, especially in the hands of a knowledgeable researcher. Kate's work allows us to appreciate these quilts not only for their aesthetic qualities but also for their value as sources of historical information. The book originally was intended to be a published exhibit of sorts, a gallery of images with basic descriptions of the quilts. As Kate developed the book's content, *Comfort and Glory* became so much more. The result is a landmark piece of scholarship, made possible due not only to Kate's understanding of our Winedale Quilt Collection but also her deep knowledge of and experience with all of our archival and material culture collections.

Kate Adams has provided a history of the Briscoe Center's quilt history collection in her introduction, but there is an important piece of the story she has neglected: the critical role she has played in its development. Kate was one of the first people I brought to the Briscoe Center when I took the helm some thirty-five years ago. It was a key moment in the center's development when she joined our professional team. She shared my vision of an active history research center, and her counsel and wisdom helped guide our growth. Her significant capabilities as a writer, editor, and researcher greatly enhanced our program. Kate and I worked closely together to co-author the article "A Work Peculiarly Our Own," a history of the Briscoe Center's early years as a Texas history collection (*Southwestern Historical Quarterly*, 1982). Kate also co-edited, with Lewis Gould, *Inside the Natchez Trace Collection: New Sources for Southern History* (LSU Press, 1999), which brought attention to the center's historical resources for the study of the lower Mississippi River Valley during the antebellum and Civil War years.

Kate deserves all of the credit for establishing the Briscoe Center's historical quilt collection. She persuaded me to build on its foundational holdings to create a collection of national significance. With the support of quilt luminaries Karoline Patterson Bresenhan and Nancy O'Bryant Puentes, as well as her cultivation of a network of quilt scholars and organizations, Kate has spent years building and documenting this collection, and it has been her true labor of love. The fact that the center now plays an important role in the growing scholarly community devoted to quilts and quiltmakers is due largely to her vision and hard work.

As with everything at the Briscoe Center, this book and the collection it documents are the result of countless hours of work and collaboration. Our staff, under the leadership of Brenda Gunn, the center's director for research and collections, has helped care for the quilt collection, catalog its contents, and photograph its treasures. We've also had the enthusiastic support of Dave Hamrick and his talented team at the University of Texas Press as partners in this publication. I'm grateful to everyone who contributed to this project. I'm sure they are as proud as I am to be affiliated with such an outstanding effort.

I hope you enjoy *Comfort and Glory*, a book I consider a culmination of the Briscoe Center's core mission on many levels: a thorough documentation of a key collection, an original research project that blends material culture and archival evidence, a landmark publication that showcases the Winedale Quilt Collection in partnership with our friends at the University of Texas Press, and a truly remarkable piece of research by a dedicated scholar and quilt historian.

COMFORT
&
GLORY

INTRODUCTION

The Winedale Quilt Collection

KATHERINE JEAN ADAMS

Quilts bear witness to the American experience. They illuminate the lives of their makers, record ties among family and friends, communicate belief and ideology, document life's benchmarks, mirror changes in decorative fashions, reflect political aspirations, and commemorate and memorialize events tragic and celebratory. They support the study of such diverse themes in American history as the development of our nation's textile industry, immigration and the migration of settlement, and the growth of mass media and marketing. Quilts are evidence—each one with an intimate story that is integral to America's history.

Nearly 500 traditional American quilts at the Dolph Briscoe Center for American History make up its Winedale Quilt Collection. *Comfort and Glory* is the first book-length publication to focus exclusively on this premier scholarly resource for the study of quilts and their history. Through a gallery of essays and photographs, this book showcases 115 quilts that represent the breadth of the collection. Selections in the book span more than 200 years of American quiltmaking and represent a broad range of traditional quiltmaking styles and functions. Utility quilts, many faded and worn following years of providing comfort, join glorious show quilts, needlework masterpieces, and "best" quilts saved for special occasions. Texas-made quilts and quilts brought to Texas during the nineteenth century make up a significant number of the gallery selections. This reflects an important regional strength of the quilt collection as a whole and emphasizes the Briscoe Center's profound documentary and material culture holdings relating to the history of Texas and the American South.

It has been my pleasure to work with the Winedale Quilt Collection in various capacities since 1995 and exclusively since 2008 as quilt curator. I began thinking about *Comfort and Glory* in 2010 but did not start writing until 2012. At that time I

estimated that researching and writing a good draft would require about one year. This was a wildly optimistic timetable, one that did not take into account several false starts before I settled on a workable scheme for the book's content and organization. As it turns out, I was fortunate not to have had a firm publisher's deadline until I was well into the project. The book benefited from several "late arrivals"—wonderful quilts acquired since mid-2013 that manifestly deserved their place in this book.

My selection of quilts to feature in *Comfort and Glory* was guided by a desire to show the breadth of the Winedale Quilt Collection. Toward that end, however, I also gave preference to quilts whose known date, maker, and/or provenance offered me opportunities for profitable research and, hence, for robust description in essays. This research was very rewarding, adding details that enriched my understanding of each quilt. Not every quilt I included in *Comfort and Glory*, however, has a discoverable past. More than fifty nineteenth-century quilts now in the collection, for example, came to the University of Texas between 1940 and the early 1970s. Typically their acquisition records were incomplete or minimal; sometimes details with respect to provenance were missing altogether. But I was moved to select some of these "orphans" whose histories are so spare—some quilts simply spoke to me, demanding inclusion. Their physical attributes (including improvisational, even quirky, patterns) persuaded me to add them though their histories remain unknown.

A word here about my use of the terms that date each quilt and identify quiltmakers. "Dated 1845," for example, means that the quilt is inscribed with a date directly on it or on a label or piece of paper attached to the quilt. Estimated dates for when a quilt was made are given beginning with "circa" and a date range that reflects my best estimate of the period during which the quilt was made. Naming a quiltmaker when the quilt lacks an inscription or firm documentation as to identity is a bit more complex. When lacking such confirmation, I use three terms, listed here in descending order of certainty based on documentation: "attributed to" indicates that the name given is almost certainly that of the maker based on substantial but inconclusive documentation; "probably by" and "possibly by" indicate strong possibility and some likelihood, respectively. Regrettably, for some quilts the identity of the maker seems forever out of our reach.

I present quilts in the gallery in rough chronological order based on each quilt's known date or the earliest date in its date-range estimate. Typically, each quilt is described in a separate essay. But I like exceptions, so occasionally I grouped and wrote about quilts as pairs, trios, or larger clusters (seven quilts by Chicago quiltmaker Bertha Stenge are grouped together, for example) as a way to enrich our understanding of one maker's quilts and quiltmaking history, to invite comparison between different versions of the same pattern, or to highlight a special relationship between quilts. With only one exception (the last two quilts in the gallery), each pair or group falls in the overall chronology based on the known or estimated date of the oldest quilt.

I also have included photographs of non-quilt items with many of the gallery essays. These items relate in some way to specific quilts. Examples include decorative objects, period clothing, political ephemera, images of quiltmakers, and scrapbooks. All were drawn from Briscoe Center collections, confirming that the center's resources support broad research on the role of quilts and quiltmaking in American culture. I selected some from our library, manuscript, photographic, and material culture collections and others from the vast quilt-related documentary resources that help distinguish the Winedale Quilt Collection. That collection is so much more than quilts—it includes study textiles, subject and biographical files, newspaper clippings, pattern catalogs, commercial kits, photographs, scrapbooks, sewing notions, dolls, clothing, ephemera, exhibit catalogs, books, and periodicals. These documentary resources come largely from quilt collections assembled by Joyce Gross, Kathleen McCrady, Anita Murphy, and Sherry Cook, all quiltmakers and historians whose quilts are part of the Winedale Quilt Collection.

The Briscoe Center's Winedale Quilt Collection contains both discrete quilt collections and individual quilts that have come to the University of Texas since 1940. The collection's history is instructive, as it explains how the early character of the collection was shaped and accounts for its more recent planned growth. It is a story that begins with one woman's vision for educating her fellow Texans about the German heritage of south-central Texas, that includes the serendipity of a major institutional transfer, and that reflects the center's careful building since 2000 on a small core quilt collection. The Briscoe Center's goal, and

mine, has always been to develop a research collection for the study of American quilts and quiltmaking specifically and for the study of American culture, women's history, textiles, and related fields in general.

The foundation of the Winedale Quilt Collection began in the 1960s in Fayette County, Texas, with Miss Ima Hogg (1882–1975). The legendary Miss Hogg reportedly once remarked that she had heard that collecting was a disease and that she thought she must have had it from childhood. Miss Hogg was an energetic and dedicated collector, devoting more than fifty years to acquiring American decorative arts, including furniture, paintings, sculpture, ceramics, glass, and textiles. The only daughter of Texas Governor James Stephen Hogg, she followed her father's example of public service, involving herself in a wide range of philanthropic and historic preservation projects. In the 1960s Miss Hogg combined her passions for collecting, philanthropy, and preservation by developing and then donating to the University of Texas a historic farmstead, a property called Winedale. Her generous gift in 1967 included land, buildings, furniture, decorative objects, and textiles such as bedcovers, sheets and pillowcases, curtains, dresser scarves, rugs, decorative towels, kitchen linens, and homespun cloth.[1]

Miss Hogg's gift also included seventeen quilts. They constitute the foundation of the Winedale Quilt Collection. Most were made in the nineteenth century, including the rare circa 1848 *Mexican War Commemorative Comforter* and the circa 1845 *Le Moyne Stars Crib Quilt*, with its unique Texas-patterned backing fabric. These two quilts, and seven others that Miss Hogg donated, are in this book. Miss Hogg typically acquired quilts at auction and at estate sales in the Northeast, including in New York, Connecticut, and Pennsylvania. She also frequented antiques stores and shows locally, including the annual Theta Charity Antiques Show in Houston. Although the accession records documenting Miss Hogg's quilt acquisitions are sketchy, they occasionally provide fascinating details about her plans for specific quilts. For example, records for August 1972 state that Miss Hogg, then age ninety, brought thirty-one textile objects to Winedale that month, including the *Mexican War Commemorative Comforter*. She intended for these textiles to help furnish the McGregor House, a two-story Greek revival structure built in Washington County, Texas, in 1861 by Dr. Gregor

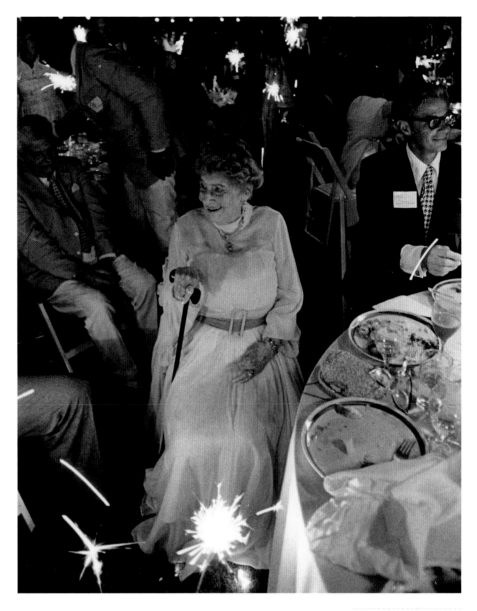

Ima Hogg at her ninetieth birthday celebration, Winedale, 1972. Bill Clough © *Houston Chronicle*. Used with permission. Ima Hogg Photograph Collection.

McGregor, a physician and land speculator. Miss Hogg moved the McGregor House to Winedale from its original location in 1969, restored it at considerable expense, and then furnished it with Texas-made furniture to represent the home of a well-to-do family of the 1860s. It is likely that Miss Hogg planned for the comforter to grace a bed in that home—possibly the famed Umland bed, an impressive walnut four-poster with canopy made in 1861 by Texas furniture maker Johann Umland.[2]

Miss Hogg's vision for Winedale was that it be a museum and conference center devoted to the study of the ethnic heritage and cultural history of the area. Lonn

Taylor, who served as Winedale director from 1970 to 1977, understood that Miss Hogg's attitude toward exhibiting objects was "entirely visual." Her instructions for their use were specific—she was "adamant that all of the objects in the buildings at Winedale remain exactly as she had placed them when the buildings were opened to the public." With respect to quilts, Miss Hogg had no notion of acquiring them in order to establish a research collection. Rather, she assembled quilts so that they could be seen, either on display in a dog-run house known as Hazel's Lone Oak Cottage or covering beds in the historic Wagner or McGregor houses. Miss Hogg, Taylor notes, "really regarded the quilts as accouterments for the beds and, while she appreciated them, I don't think she was particularly interested in them as artifacts in themselves."[3]

Miss Hogg's determination that Winedale's quilts be regularly displayed affected their condition. When Taylor questioned her display technique—hanging quilts for long periods "from rods which were suspended from the ceiling so that the quilts hung flat against the walls"—Miss Hogg countered that this method "was the way that Electra Havermeyer Webb displayed her quilts at [the Shelburne Museum in Vermont] and she certainly knew what she was doing." The historic houses, of course, had no air conditioning or humidity control. Sunlight streamed into the windows and critters snuck under doors. There are notes on one accession data sheet that mud daubers built a nest on one of the quilts. Fortunately Lonn Taylor eventually was able to institute storage practices for the quilts while still accommodating Miss Hogg's wish that Winedale's quilts usually be used and seen. Miss Hogg was supportive of Lonn's changes, "but not happily," he reports, acknowledging that she often referred to his "having 'hidden' her best quilts." Despite her insistence that specific quilts always appear on the beds and not be rotated off, Lonn was able to begin regularly changing quilts in the upstairs bedrooms of the Wagner and McGregor houses once Miss Hogg became too frail to climb the homes' narrow stairs to that level.[4]

The seventeen quilts in the Ima Hogg Quilt Collection laid a firm foundation for the Winedale Quilt Collection. Miss Hogg's gift also inspired other quilt donors, many from the Fayette County area, whose quilts joined a general swell of donations of furniture and material culture objects during her lifetime and for some years after. Several quilts were family heirlooms, including *Evening Star*,

dated 1820, and *Spool Quilt*, circa 1870, both shown in this book.

In 1995 the Briscoe Center assumed administrative responsibility for Winedale and, with it, for all the property's natural resources, historic structures, and material culture objects. By then, quilts identified as belonging to the Ima Hogg Quilt Collection and those received from other donors were defined as the Winedale Quilt Collection. Shortly thereafter the center began to build on this core collection and to share the collection through improved access and public programs. Two major supporters of this effort beginning in 2000 were University of Texas alumni Karoline Patterson Bresenhan and Nancy O'Bryant Puentes, co-founders of the Texas Sesquicentennial Quilt Association, the International Quilt Association, and, in 2009, the Texas Quilt Museum. They are best known, of course, for their International Quilt Festival, which in 2014 celebrated its fortieth anniversary, and for their landmark books on Texas quilts and quiltmakers from 1836 to 2011, the three-volume *Lone Stars: A Legacy of Texas Quilts*. Since then Karey and Nancy have helped the Briscoe Center bring greater visibility to its quilt holdings through exhibitions and public programs, generously giving their time and expertise on occasions too many to count. They also paved the way for the Briscoe Center's association with the Quilt Alliance (formerly called the Alliance for American Quilts), a nonprofit organization they helped found in 1993. Through the Alliance's online Quilt Index (http://www.quiltindex.org/) the Briscoe Center, since 2007, has broadened access to its quilt resources by adding descriptions and photographs to the Quilt Index database of more than fifty thousand quilts held in institutions and private collections in the United States.[5] The center also provides online access to photographs and data for many of its quilts on its own website at http://www.cah.utexas.edu/collections/quilt_history.php. It has been a source of great comfort and pride for me personally to know that Karey and Nancy remain eager for the Winedale Quilt Collection to grow and for the center's quilt programs to succeed. I am endlessly grateful for their friendship and support.

Since 2000 the Briscoe Center has sought to build its quilt holdings and to expand the collection to include documentary materials that support the study of traditional American quilts. The Kathleen H. McCrady Quilt History Collection became the center's first significant acquisition

to contain both quilts and quilt-history documentation. Kathleen Holland McCrady is a native Texan and a third-generation quilter. She began working on quilts at age six, when she embroidered her name on a quilt block for her grandmother's *Friendship Quilt*, which is part of our collection. She has made more than five hundred quilts since then, many of which have received awards and public recognition through exhibitions and publications. Kathleen is nationally recognized for her quiltmaking artistry and has been a significant force in the quilt community as a teacher, conservator, show judge, and appraiser, as well as being a founding member of the Austin Area Quilt Guild and a board member of the Texas Sesquicentennial Quilt Association.

Kathleen founded her Quilt History Study Hall in 1991. Using a studio in her backyard, she held free workshops on quilt dating and history, bolstering her lectures with examples from her extensive collection of quilts and quilt-history documentation. In 2002 Kathleen established her Kathleen H. McCrady Quilt History Collection at the Briscoe Center, an initial gift she has added to over the years. Her extraordinary collection contains most of the documentation she used in her Study Hall as well as more than sixty-eight quilts and quilt tops she made or collected. These include fine examples of redwork, cotton sack quilts, and Amish quilts plus quilts she used as teaching tools, such as the heavily inscribed *Friendship Appliquéd Album* made in Ohio circa 1851 and the Texas-made *Tobacco Sack Puff Quilt* sewn from Bull Durham tobacco sacks. Kathleen's exquisite *Traveling Stars with Sunbursts* (2001), featured on the cover of *Quilter's Newsletter Magazine* in October 2002, is also part of this collection. Kathleen's gift also included a wide array of quilt-related textiles and documentary resources, such as cotton sacks, toiles and cretonnes; pattern booklets and newspaper columns; quilting templates and stencils; textile cigar and cigarette premiums; redwork pillow shams and penny squares; cotton cards and a woodblock; and quilt-related publications. The Kathleen H. McCrady Quilt History Collection is a true legacy collection. It represents Kathleen's lifetime of quiltmaking and her years of studying, collecting, and sharing her knowledge of quilt history.[6]

A fortuitous institutional collections transfer expanded the Winedale Quilt Collection significantly in 2003. Following a redefining of its civic and natural history mission, the university's Texas Memorial Museum, founded in 1936, transferred ownership to the Briscoe Center of more than six thousand material culture objects, including clothing and accessories, household objects, ranching equipment, political memorabilia, and military items. Forty-six quilts were part of that transfer. Among them are several quilts donated to the University of Texas in the 1940s. These, I believe, are the university's earliest quilt acquisitions.

The quilts from the museum include a number of nineteenth-century quilts that came to Texas with newly married couples or migrating families. Distinguished examples are three red and green appliqué trousseau quilts that a Kentucky bride brought with her when she and her husband moved to Sherman, Texas, in 1855, and *Lone Star*, a historically important quilt that a Texas woman carried with her in 1867 when she and her family joined

Kathleen McCrady's *Crossroads to Texas*, which served as the official banner of the Texas Sesquicentennial Quilt Association and its exhibit of Texas quilts at the Texas State Capitol in April 1986. Kathleen H. McCrady Quilt History Collection, W2hc09.6

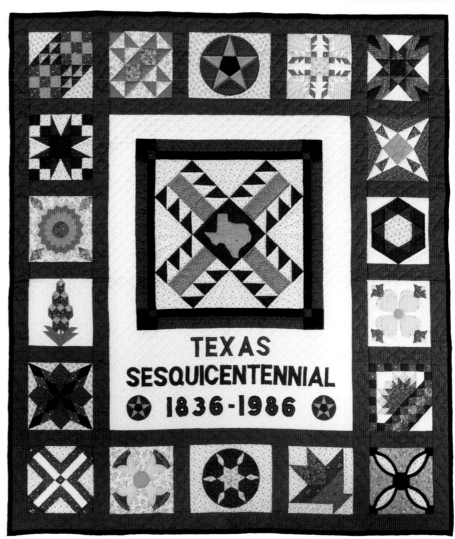

an organized colony to immigrate to Brazil after the Civil War. Her quilt survived thousands of miles of travel and a shipwreck before being returned to Texas in 1946.

The Joyce Gross Quilt History Collection, acquired in 2008, was the Briscoe Center's largest and most visible quilt and quilt-history acquisition. California native Joyce Romeyn Gross (1924–2012) was a quilt collector, historian, teacher, author, publisher, and exhibit curator whose vision and passion helped energize and shape the 1970s revival of interest in and appreciation for quilts and quilt history. Joyce began assembling her quilt collection in 1973 with the purchase of a quilt top at a flea market. Captivated by a love of quilts, always curious to know about their makers ("I wanted to put a human face to the quilts"), and determined to preserve the history of both, Joyce became one of the nation's foremost historians and collectors of twentieth-century quilts and their history. In 1970, along

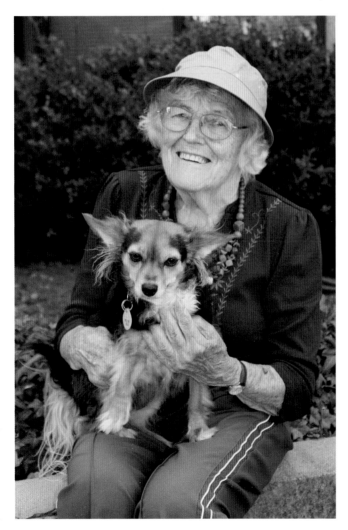

Joyce Gross with her dog Penny, August 2010. Photograph by Vicki Chase, Joyce Gross Quilt History Collection File, WQC.

with colleague Sally Garoutte, Joyce formed the Mill Valley Quilt Authority, which organized quilt exhibitions and, over time, led to the formation of the American Quilt Study Group, now an influential organization that fosters study, research, and publications relating to quilts.[7] Joyce also shared her love of quilts and quilt history with the public by organizing quilting tours throughout the nation; hosting her annual retreat in Point Bonita, California; and founding and publishing *Quilters' Journal*, an important quilt-history research periodical, from 1977 to 1987. Joyce was inducted into the Quilters Hall of Fame in 1996.

The Gross Collection represents Joyce's nearly forty years of collecting on two fronts: the quilts themselves and documentation about quilts, quiltmakers, and quiltmaking. The collection spans quilts dating from circa 1800 through 2004 but is distinguished especially by its twentieth-century quilts. These include quilts made by notable quiltmakers such as Bertha Stenge, Emma Andres, Jean Ray Laury, Dr. Jeannette Throckmorton, Judy Severson, and Maxine Teele. Five quilts by Pine Hawkes Eisfeller, including two judged to be among the "One Hundred Best American Quilts of the Twentieth Century," are in the collection, as are a rare Royal Hawaiian Quilt, a bevy of Victorian-era show quilts, kit quilts, and fifteen nineteenth-century quilts collected by—and one quilt top made by—famed quilt collector and historian Florence Peto.

Joyce's extensive quilt-history archive and library contains quilt-related books, periodicals, and exhibit catalogs, including copies of early quilt-history classics by William R. Dunton, Florence Peto, Rose G. Kretsinger and Carrie A. Hall, Ruth E. Finley, and Marie D. Webster, many of which are inscribed. These publications are bolstered by biographical files for hundreds of members of the quilt community. There are rich subject files as well, ranging from topics such as the 1933 Sears, Roebuck and Company's Century of Progress Quilt Contest to Joyce's unique records documenting her much-loved "BAQs"—every Baltimore Album Quilt she and quilt-history colleague Cuesta Benberry could locate and record. Also included are letters, original and copied, relating to the daily lives and work of many quilt historians and makers, all of which Joyce avidly assembled and/or photocopied over the years. Her files containing letters generated by Florence Peto, for example, number in the hundreds of pages. Magazine and newspaper clippings, commercial kits, pattern catalogs,

scrapbooks, photographs, and ephemera round out this irreplaceable collection for the study of quilters and quilt-making in the United States.

Since 2008, acquisitions of single quilts and collections small and sizeable have enriched the Winedale Quilt Collection. Texas quiltmakers, collectors, and donors such as Dr. Claud Bramblett, Karey Bresenhan, Sherry Cook, Dana Dreinhofer, Marcia Kaylakie, Beth Thomas Kennedy, Anita Murphy, Jane Newberry, Mary Anne Pickens, Nancy O'Bryant Puentes, Shirley Fowlkes Stevenson, and John Tongate have been especially generous. These most recent acquisitions filled gaps in our holdings, offered new examples of patterns already represented in the collection, added rarities, and bolstered our holdings of quilts closely tied to the history of Texas, a major collecting strength for the Briscoe Center. The gift in 2009 of the Reflections on 9/11 Quilt Collection—forty small wall quilts, begun as blocks in Japan immediately after the terrorist attack of September 11, 2001, and then finished by San Antonio–area quilters—brought a new dimension to our holdings. Donations of redwork, cotton sack fabrics, antique sewing machines and notions, a Pennsylvania German decorative hand towel dated 1812, transfer patterns and pattern files, a quilt-related rag doll, scrapbooks, and examples of quilted clothing helped grow our study textile and documentary collections. I am grateful to every donor to the Winedale Quilt Collection. It is a pleasure to include many of these recent acquisitions in this book; I regret that I cannot show them all.

Finally, a few words about this book's title, *Comfort and Glory*. The pairing of these two words is meant to evoke the functional and artistic characteristics that merge so magically in traditional quilts. Typically made to warm loved ones, quilts also express their makers' artistry. Our nation's cultural landscape has been enriched by this powerful combination being repeated for more than 250 years. This title also refers, however, to the ability of *quiltmaking* to bring comfort to the quiltmaker, a solace borne of creating beauty that is visual and tactile. Simply put, quiltmaking has been and is an essential creative activity for many. Perhaps this was best expressed by a daughter's description of her mother, a woman who made hundreds of quilts during her lifetime, some for family and friends and others to cover the beds in a hotel she managed in the 1930s. Her daughter recalled her mother sewing quilts all night after her family and guests were settled for the evening. She recorded that her mother "was never more relaxed than when she was making a quilt." Quiltmaking, she wrote, "satisfied a basic desire in her nature—the creation of Beauty. She worked on them for the need of it."[8]

Gallery of Quilts

"Eighteenth-century crewelwork, especially favored for bedspreads and bed furnishings, is one of the most delightful types of early American embroidery. Though it has become very scarce, resolute seekers may still occasionally acquire a piece." So wrote the distinguished and influential quilt historian and collector Florence Peto in a 1951 issue of *The Magazine Antiques*.[1] As early as the 1940s, Peto collected crewelwork in addition to quilts. She included a brief description of crewelwork bedspreads in her 1949 book *American Quilts and Coverlets*. A photograph of one of her own "finds," a Ridgefield, Connecticut, crewelwork spread made in 1740, accompanied her 1951 magazine article.

Quilted Crewel is another of Peto's crewelwork acquisitions, though when or where Peto acquired it is unknown.[2] This quilt is initialed MH and dated 1804 in a small, tight brown cross-stitch, making it the earliest dated quilt in the Briscoe Center's Winedale Quilt Collection as of this writing. This quilt's top is cotton—both warp and weft fibers. The back is linen. The very thin batting is cotton, with cottonseeds and other chaff visible here and there. Both cotton and linen were hand woven, either in

the home or by a commercial weaver. Three lengths of cotton are joined to create the quilt top; the back is composed of two linen panels. The binding is made from lengths of narrow, straight-grain cotton.[3]

At the time this embroidered quilt was made, crewelwork design sources included pattern books, needlework teachers, engravers, and, of course, the imagination and fancy of the embroiderer. Designs could be drawn on the background fabric in ink or pencil, marked by dusting powder through a perforated pattern, or sketched in freehand. The "crewel" was the wool yarn with which the embroiderer created her designs. The wool yarn used to decorate this quilt most likely was spun at home and then "dyed in a tapestry of colors," also at home.[4] Women of the period could achieve a colorful medley by gathering and preparing vegetable materials and by purchasing other needed ingredients (indigo, madder, and various mordants, for example) from a traveling peddler or local apothecary.[5]

Quilted Crewel features a vining floral medallion wreath with a simple floral sprig at its center. This delicate design is composed of chrysanthemum-like flowers, a shower of smaller, daisy-like blossoms, leaves, and buds—all set on stems in red or light brown. Bows grace the wreath's center top and bottom, small bouquets dance around the medallion, and a gently undulating vine in green forms the border. Flower bouquets in a variety of designs and colors float around the sides, joined only by the single slim vine stitched over the floral designs. Additional bouquets grace the four corners and three of the quilt's four sides.

The hand quilting is a surprise because there is so much of it, and much of it is difficult to see. The crewelwork sits atop the background quilting, indicating that the quilting was completed before the embroidery was added. Diagonal-line quilting, with lines three-eighths inches apart at seven stitches per inch, covers most of the quilt surface. There are also two less obvious quilting designs on this bedcover, one of which is nearly invisible. But the designs are there and well executed. Quilted flowers in vases sit between embroidered bouquets outside the vining border and along the quilt top, and feather quilting meanders around the medallion wreath. Both designs are easily visible from the quilt back.

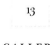

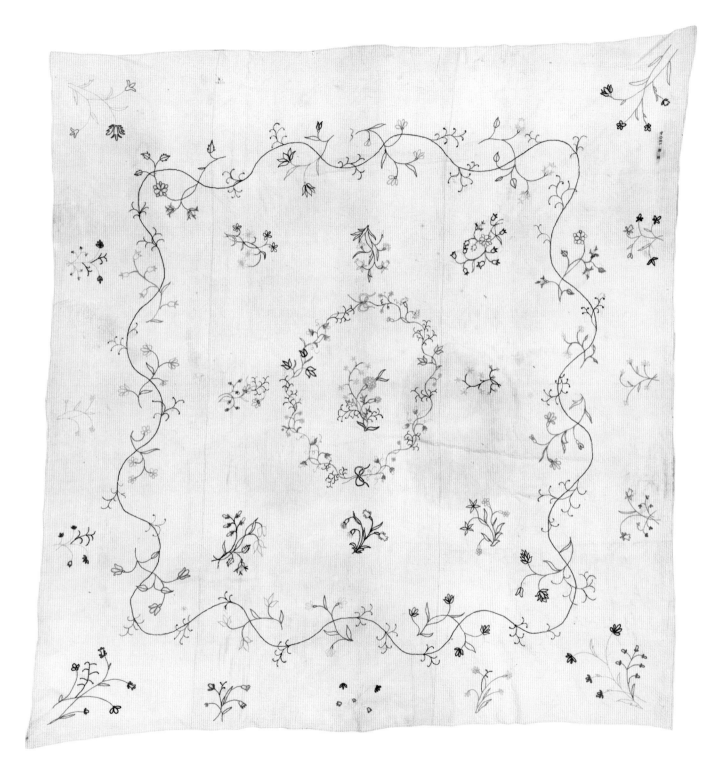

Quilted Crewel

MH, probably New
England, dated 1804

Linen, wool embroidery:
83 x 86 inches

Hand pieced,
hand quilted, hand
embroidered

Joyce Gross Quilt
History Collection,
W2h001.021.2008

The loosely quilted stitches may account for the patterns' near invisibility—the stitches barely leave an impression in the fabric. The quilting thread is cotton and, surely, was homemade, as manufactured cotton thread was not available in the United States until 1810. Perhaps the softness of the homespun thread did not permit either a dense pattern or tight stitches. Still, this hand quilting represents a substantial investment in time and labor—before quilting could begin, quilting thread had to be spun.[6]

Quilted Crewel has a light, open feel, achieved both by the generous space around each of the flower designs and by the delicacy of the embroidery. Only the smallest motifs are filled in with embroidery (the buds, for example, and a few of the smaller leaves), so the eye is never drawn to solid shapes. The quiltmaker, however, frequently embroidered double, even triple outlines to create her many flower petals and leaves, often using interesting color combinations, such as gold inside lavender or pink inside blue. These repeated, multicolored outlines emphasize some floral details and add color and overall interest to the quilt. The quiltmaker's pattern is also eclectic and whimsical. She mixed colors and embroidery stitches throughout her quilt, never repeated a design, and cared little about embroidering botanically accurate florals. Though her overall pattern is symmetrical it is also informal, not rigid, improvisational, not overly planned. Whoever MH was, and whatever her age, in 1804 she finished a delightful crewelwork bedcover that still survives in excellent condition.

SUNBURST

Sunburst is a wedding quilt, inscribed "Sterling & Mary Orgain 1818," with cording at its center. The inscription documents the couple's marriage on March 31, 1818, probably in Tennessee. The quilt, much cherished, moved with Sterling Orgain (1787–1878) and Mary Elizabeth Jones Orgain (1801–1878) and their ten children from Tennessee to Texas in the 1850s. The quilt remained in the family until a grandson donated it to the University of Texas in 1940, making it one of the university's earliest quilt acquisitions.

Sunburst testifies to the skill, patience, and dedication of one quiltmaker, possibly two. Perhaps Mary Elizabeth Jones and her mother made this masterpiece together. The quilt contains thirty-six complete sunbursts, each one pieced into the intersection of four blocks. Each sunburst's center is a circle of large-scale chintz; its petals are successive rows of triangles, diamonds, and triangles in three different fabrics. In all, the complete sunbursts contain 1,764 pieced motifs.

Forty-eight stuffed work and corded floral designs appear between the sunbursts. Each is composed of stems that curve, spiral, or twist to fit snugly between the pieced designs. Some stems sport recognizable flowers such as sunflowers or roses; others support pods, berries, leaves, buds, and grapelike clusters. No two floral designs are identical. To create this elegant dimensional quilting was a delicate, time-consuming process that required great expertise. The quiltmaker first basted a loosely woven fabric patch to the back of the quilt top—the patch is clearly visible when the quilt is held up to the light. She then quilted designs and channels into the back patch and quilt top. Finally, she inserted small bits of cotton through the weave of the patch and into the enclosed floral shapes. To add dimensional stems and tendrils, and to form the inscription, she threaded cording through the stitched channels. The quilting is very fine, at twelve to fourteen stitches per inch. A scallop pattern rims the outer edge of each sunburst, chevron patterns meet in the sunburst centers, and outline quilting defines the diamonds and triangles. The chevron and outline quilting were sewn using blue thread.

Sterling and Mary Orgain died in Texas in 1878—only twenty-four days separated their deaths. They are buried together in the Shiloh Cemetery in Hutto, Williamson County, probably near where they first settled in Texas to farm. A single gravestone memorializes them together in death just as this quilt's inscription joined them in 1818, the year they married. Their stone marker is made of two columns connected at the base and at the top by an arch. Each column bears one of their names.

An important event in Hutto's history is linked to the Orgain family. Legal records indicate that when the family moved from Tennessee to Central Texas in the 1850s, they brought with them Adam Orgain (b. 1837), a slave. According to one source, Sterling and Mary's son John Henry Orgain (1829–1917) owned Adam, whose responsibilities included watching over the ranching interests of his master. Adam Orgain is credited with building the first residence, a primitive cabin, in present-day Hutto. Years later, in 1880, John Orgain sold five acres of land in the Hutto area to Adam Orgain.[7]

Sunburst

Maker unknown,
probably Tennessee,
dated 1818

Cotton:
87½ x 90½ inches

Hand pieced, stuffed
work and cording,
hand quilted

TMM 376.1

Gift of William E. Orgain

Alphabet sampler,
Elizabeth Ann Watson,
circa 1789–1850.
Material Culture
Collection, 2467-9.

ABCDEFGHIJKLMNOPQRSTUVWXYZ

abcdefghi nopqr 234567

REMEMBER now thy Creator in the days of thy youth while the e
s come not nor the years draw nigh when thou shalt say I hav
pleasure in them Receive my instruction and not silve
knowlege rather than choice golde Keep thy heart with all di
for out of it are the issues of life

ELIZABETH ANN WATSON

Sophia Hooker stitched her name and the year 1820 near the center of this quilt, orienting her inscription along the length of the quilt, perhaps so it could be read easily from one side of the bed. Her tiny cross-stitch is one of the many embroidery stitches young girls learned and used to mark domestic textiles and to stitch samplers in the years of colonial America through the 1850s.[8]

Hooker made her quilt using two different chintz fabrics, one in the blocks and the second in the generous borders. Both the prints are probably English imports. The chintz in the quilt's blocks is a two-color, large-scale botanical pattern containing palm trees and game birds, probably pheasants or partridges. The fabric may have been used previously as a furnishing fabric in the Hooker home, perhaps for draperies, bed curtains, or upholstery. Because Hooker cut and pieced chintz as patches not quite five inches square, the fabric's overall pattern cannot be reconstructed nor its repeat measured. The pat-

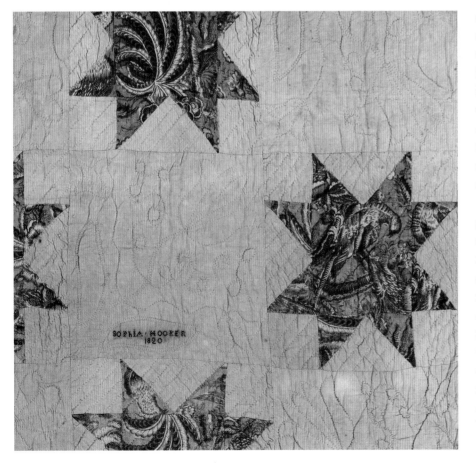

tern may have been block printed with a blotch ground of Prussian blue, which remains bright in many blocks. With this technique, shapes of felt attached to woodblocks selectively dyed the background blue.[9] Additional blue dye was dabbed on here and there to add definition to the pattern. Block or plate printing of madder red created birds, palm trees, and blooms. Overall the fabric pattern registration is uneven. Textile historian Florence Montgomery suggests that such imperfect printing may be a function of attempts in England during the period from 1800 to 1825 to lower printing costs, which resulted in a decline in craftsmanship. Montgomery states, however, that these years also saw the first use of brilliant colored grounds, such as the blue in this quilt's blocks, noting, "What many prints lacked in subtle details they gained in lively color effects."[10]

Sophia Hooker used another, smaller-scaled floral-patterned chintz to make her quilt's generous borders. This is a three-color pattern: robin's egg blue (now faded), madder red, and dark brown. The brown is a madder dye, whose setting agent caused the color to deteriorate and drop out in many areas. Hooker used at least two different cotton fabrics in her quilt's plain blocks, one a visibly coarser weave than the other. The coarser of the two was used again as the quilt's backing fabric. The original color of the fabrics was most likely an unbleached white that now has aged to a soft brown. The thin batting, visible through areas where brown dye has dropped out, is probably wool.

The quiltmaker arranged her pieced blocks in staggered rows, which line up beautifully whether viewed straight on or along the diagonal. Her needlework is very fine, with small, uniform piecing stitches and a tidy (and still stable) running stitch along the edge, where she finished the quilt by turning the front to the back. The hand quilting, at nine and ten stitches per inch, was done in floral patterns, including beautifully articulated tulips, on the plain blocks; diagonal lines in each pieced block; and chevrons in the borders. There is very limited information about this quilt's provenance. The donor believed that the quilt was made by one of her mother's relatives in or near York, Pennsylvania. Her mother's family, she noted, was of German descent.[11]

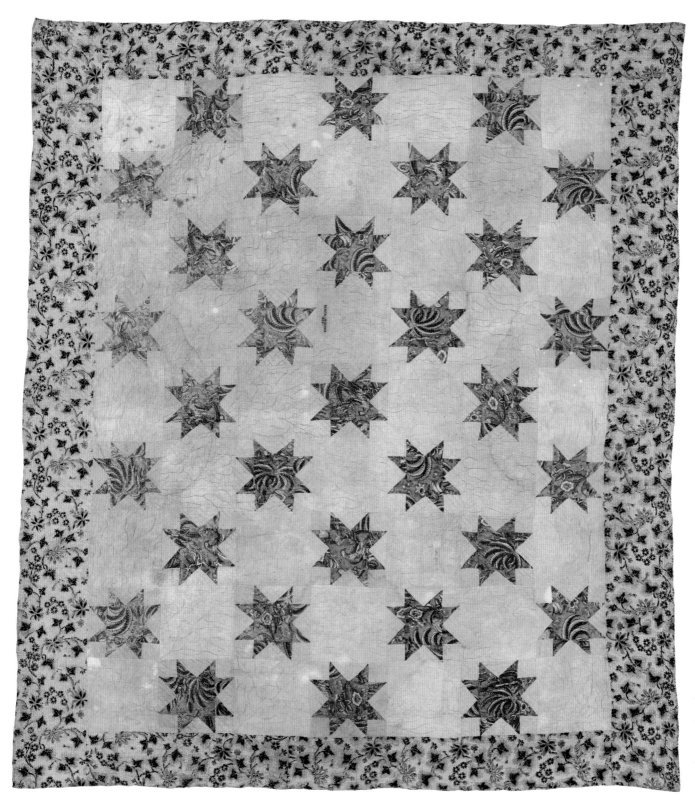

Evening Star

Sophia Hooker, possibly
York, Pennsylvania,
dated 1820

Cotton: 82 x 93 inches

Hand pieced,
hand quilted

W2h12.71

Gift of Mrs. Robert A.
Wyatt

CHINTZ QUILT

COMFORT
AND GLORY

Wood and metal printing
block, late eighteenth
century. The metal design
fitted into the wood
indicates this block printed a
fancy floral border. Kathleen
McCrady Quilt History
Collection, 2.325/0741.

"What was she thinking?" is a question quilt enthusiasts occasionally ask when they see unexpected designs or seemingly odd color combinations in a quilt. One quilt-maker's pairing of an elegant floral chintz with geometric-patterned blocks that joined cottons in solid white and a bold red and black print raises the issue of her aesthetic sensibility. Seen from a distance, when the quilt hangs, for example, the combination is not especially jarring. Close up, as the maker viewed her quilt while she pieced and quilted it, the fabrics and designs collide. Perhaps the solution to the riddle of this apparent mismatch is fabric availability—the quiltmaker, possibly inexperienced, was determined to make a quilt and, so, used the only fabrics available to her in the quantities she needed. Or perhaps this fabric combination appealed to her personal sense of whimsy.

A glorious floral chintz, its glaze intact, makes up the generous border and setting blocks—those single-fabric blocks that create the background for the pieced blocks. The chintz features a brown scrolling pattern that was probably plate printed. The fine ground of brown lines and small curls behind the scrolling are details achievable by plate printing or perhaps by a finely crafted woodblock.

Natural-scale blooms in rosy reds accented by deep blue foliage sit atop the scrolling. These too may have been printed using a woodblock.

The chintz pattern is muted, soft, and flowing and, hence, visibly at odds with the sixteen geometric patterned blocks pieced from a high-contrast red and black fabric and a solid white. Unlike the complex, swirling design of the chintz, the pieced pattern is all stark shapes, sharp points, and imperfect center circles. The red and black print suffers from extensive drop out in the black ovals, where the setting agent has eaten through to the batting.

Aside from the hand piecing, the only needlework in this quilt is the overall clamshell quilting design at six to seven stitches per inch and the stitching around the back edge where the quiltmaker whipstitched the chintz front to back. The excellent condition of the chintz (it appears unwashed) suggests that it was either new or subject to little wear while used as a furnishing fabric, such as in the deep folds of draperies.

Quilts so often surprise and delight. In this circa 1830 quilt, the surprise combinations of colors and patterns are the delight.

Chintz Quilt

Maker unknown,
circa 1830

Cotton and chintz:
96 x 96½ inches

Hand pieced,
hand quilted

Joyce Gross Quilt
History Collection,
W2h001.049.2008

An inked inscription tucked among the appliquéd motifs in this quilt's medallion reads:

Elizabeth Kimbrough Neil Brockinton
Presented by her Mother;
9th April 1833
Darlington District So. Ca.

Although this quilt is faded and stained and has sustained fabric loss, some of its original glory remains. *Chintz Appliqué Medallion* survives as an example of the chintz appliqué quilt tradition in South Carolina and as tangible evidence of family ties, history, and westward migration.

Fashionable in the first half of the nineteenth century, chintz appliqué quilts were especially popular in South Carolina, just as they were in North Carolina, Virginia, Pennsylvania, Maryland, and New Jersey, notably in towns such as Charleston and Trenton, where wealthy women had access to imported fabrics. Because they required both expensive fabrics and considerable time to complete, chintz appliqué quilts often were the work of upper- and upper-middle-class women. The technique, often referred to as *broderie perse*, called for the quiltmaker to cut motifs from chintz fabrics, then rearrange and sew them onto a background. An early format of such quilts was the medallion style, as in this quilt.[12]

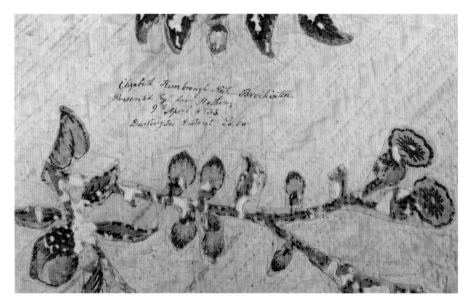

Chintz Appliqué Medallion combines designs made from appliquéd chintz cutouts, preprinted chintz panels, and conventional appliquéd motifs that the quiltmaker created using calicoes and a single indigo blue and white patterned print. She used the chintz appliqué motifs—thirteen in all—in her medallion's center, where four large flower and leaf bouquets cluster around a single smaller bloom. Identical bouquets appear at the corners. The leaves around each bloom have been individually cut and appliquéd to the blooms. Twigs sporting small blossoms, buds, and leaves are appliquéd at medallion top and bottom, and two different birds, one gazing at a separately appliquéd butterfly, are perched between the corner flowers. These cutout motifs are not all from the same chintz fabric.[13]

The inner border framing the medallion is of special interest. Here preprinted chintz panels, cut from a series of such panels printed in a row, were used as corner blocks. These corner panels contain flowers set in and around a ring, all barely visible because of fabric loss. Wigton Printworks, a small company in northwest England, printed the panels circa 1820. The panel, pictured in *Two Centuries of English Chintz, 1750–1950*, originally contained an exuberant and detailed flower cluster at the center, with leaves in dark green—a color now completely gone. The apparent double ring is actually a solid ring featuring regularly spaced, blue bead-like jewels, with smaller white petallike motifs between. Outside the ring, floral clusters fill each corner.[14]

Along the sides of the border, the area between the printed corners contains the maker's original designs in an indigo blue and white resist print and calicoes in light blue and tan. Each repeats the same composition of flowers, stems, leaves, and embracing oak leaves, a design the quiltmaker probably cut from templates of her own making. Two additional borders frame the decorative panels and medallion—a wide white inner border and a wide outer border of large-scale paisley on a red ground. The white bias binding is a replacement.

Helen Penelope Salter Brockinton (1800–?) may be the maker of this quilt. If she was, her quilt demonstrates that she possessed considerable needlework skills, access to imported fabrics, and an awareness of the then-

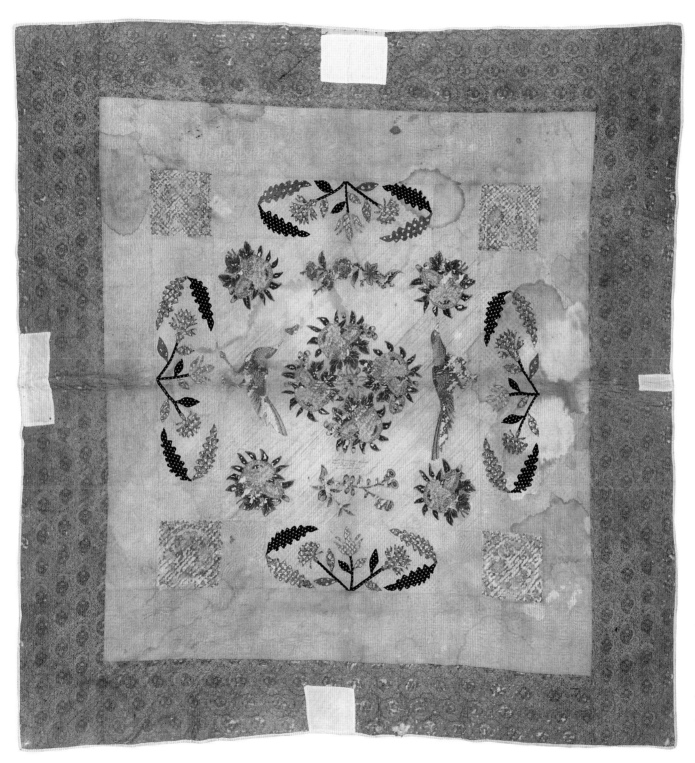

**Chintz Appliqué
Medallion**

Possibly Helen P. Salter
Brockinton, Darlington
District, South Carolina,
dated 1833

Cotton: 81 x 82¾ inches

Hand pieced, hand
appliquéd, hand quilted

2009-038

Gift of Ruth Elizabeth
Thomas

fashionable chintz appliqué style. Her appliquéd design is balanced and inventive, her appliqué stitch is tiny, regular, and precise, and she varied her quilting designs in each section of her quilt. She consistently quilted at seven to eight stitches per inch, using designs that include diagonal parallel lines, grids, and an interlocking loop pattern that produced four-petal flower motifs.

Helen Brockinton was the second wife of Rev. William Brockinton (1795–1867) of Darlington District, South Carolina. In 1833 she presented this quilt to her daughter, five-year-old Elizabeth Kimbrough Neil Brockinton (1828–?). William and Helen's union produced six children in all. Additionally, William Brockinton had six children by his first wife, Rebecca Tommie (1800–1825), who died in July 1825. When Helen married William in December 1825 she took on responsibility for these children, aged ten months to nine years. This is an extravagant and labor-intensive quilt to make for a young child, especially for a woman busy with nine young children in 1833, the year she presented the quilt to Elizabeth.[15] How did Helen Brockinton have time to undertake and complete such a demanding needlework project? Her husband owned slaves, so enslaved women may have helped her, if not by sewing then by freeing her from some household tasks, giving Helen time to devote to quiltmaking.[16]

There are, however, other possible explanations for this quilt's origins. Perhaps Helen made the quilt before she married in 1825. Or perhaps this is a legacy quilt, one Helen's mother made for her, which in 1833 she inscribed and then passed on to her daughter as a cherished keepsake. A letter written by Helen's mother, Elizabeth B. Salter Hearne, in 1820, to daughter Helen Salter (five years before she wed William Brockinton) suggests a tantalizing

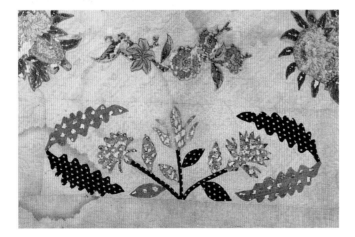

possibility: that Elizabeth Hearne, not Helen Salter, was a quiltmaker and perhaps the maker of this quilt. In the letter Elizabeth instructs Helen, then aged twenty, to gather up and bring some important items to her in preparation for a family wedding.

February 20, 1820
Dear Helen:
I have sent the key of my drawer. I want you to fetch my whit [sic] mourning dress, my dark silk and my striped frock of Calico, Janes band box, the quilt of my bed, the tea kettle and spider, and some dryed apples without fail and some ginger out of my crawer. Your cousin Sarah Salter is to be married tomorrow week. . . .
I am you [sic] loving mother, Elizabeth B. Hearne
I have sent some money for some pins and do fetch me some paper.[17]

Not unexpectedly, there are several family stories connected with this quilt's history. One holds that the quilt wrapped the family silver, "which was buried during the Civil War to hide the booty from the Yankees."[18] Another states that the quilt remained in the family, passed from mother to daughter for 173 years. A third reports that the donor's great-great-grandmother brought the quilt with her when she came to Texas around 1845, settling at Martin's Mill, a small community in Texas's northeastern Van Zandt County.[19]

Federal Census records, however, bolster the quilt donor's known family history to suggest that Elizabeth's *Chintz Appliqué Medallion* quilt passed through her husband's line. The quilt seems to have followed this path: by 1860 Elizabeth Brockinton was married to Frank Abel Thomas (?–1888), a saddler many years her senior. The couple's son Richard S. E. Thomas (1864–?) owned the quilt for a time, as did his son Richard Coker Thomas (1915–1955), who was the quilt donor's father. The quilt's connection to Martin's Mill, Texas, is real, as it turns out, though through marriage rather than through generations of quilt ownership. The donor's maternal great grandfather Thomas E. Marable settled in Martin's Mill some time before 1874. Marable's great granddaughter Alphatique Cole (1915–2010) married Richard Coker Thomas, whose family owned the quilt. Alphatique lived into her mid-nineties—long enough to enjoy the quilt before passing it to her daughter, the quilt's donor.

BALTIMORE STAR

The pattern of this beautifully conceived and executed quilt is usually called Star of Bethlehem. New Jersey quilt collector and historian Florence Peto probably acquired this example between 1939, when she owned twenty quilts, and 1959, when a local newspaper reported that she owned eighty-five, "all of them museum pieces."[20] Peto demonstrated her fondness for Star of Bethlehem quilts by acquiring twelve such quilts at one time or another. When this quilt was pictured in *The American Home* magazine in 1960 the caption named the quilt *Star of Bethlehem* and described it as "characteristic of quilts made in Pennsylvania. Circa 1840." Peto family members, however, recall that the collector referred to this example as *Baltimore Star*.[21]

This quilt contains hundreds of diamonds pieced from seven different printed fabrics in a color palette of dark brown, teal, blue, red, pink, and mustard. Fabrics are small-scale florals, stripes with florals, plaids, and a lovely ombré whose red hues gradate from bright to deep red. The ombré, and perhaps other fabrics in the quilt, may date from the 1830s.

Baltimore Star is an exercise in careful planning and precise execution. The result is masterful a quilt whose large center star (eighty-six inches from tip to tip) seems to pulsate through rows of complementary and contrasting colored diamonds. The arrangement of fabrics in the star's seventeen rows begins with red ombré at the center, an eye-catching fabric that is used again near the star midpoint (Row 7) and again at the tip of each star point. Between these color anchors, two mustard prints are set against teal fabric four times to create a light-dark effect. The boldest fabric in the quilt—a brown-mustard-red plaid fabric—is introduced as the star points separate, bringing added definition to that location. This fabric is used again to great effect in the border. Here, smaller pieced stars also are carefully organized—full stars in op-

posite corners match, each side half star matches the one opposite it, and border half stars march in a specific sequence around the quilt.

Baltimore Star is finished with equal precision and attention to detail. The angular quilting pattern of parallel chevrons covers the entire quilt and perfectly complements the angular star shapes. The quilting stitch is fine and regular, at ten to eleven stitches an inch. The edge treatment, with front and backing fabrics turned in to form a knife edge, leaves the border design uninterrupted and adds to the clean look of this quilt.

It is appealing to identify this masterpiece as an elegant scrap quilt and to imagine it being made by an experienced seamstress who enjoyed access to many leftover dressmaker fabrics. If this is true, fabrics available to her may have been abundant but perhaps small in dimension and, in some instances, limited in quantity. Consider how this combination of abundance and scarcity may have guided the quiltmaker's placement of one fabric in the central star—the small-scale mustard and red floral fabric that appears in the sixth row. It is used nowhere else in the quilt. Although it is slightly darker and more loosely woven than another more frequently used mustard plaid fabric, the mustard floral serves the same purpose—providing a light color to set against a darker teal fabric above it and the red ombré below it. Perhaps the single row of this mustard floral indicates that the quiltmaker had access only to a limited amount of this fabric. It is fascinating to imagine her trying to calculate in which row she could use this specific fabric without running out or leaving a substantial portion unused. The precision of this quilt's execution confirms that she was sufficiently experienced to cut diamonds from this fabric only when she was confident she could complete the full row.

COMFORT
AND GLORY

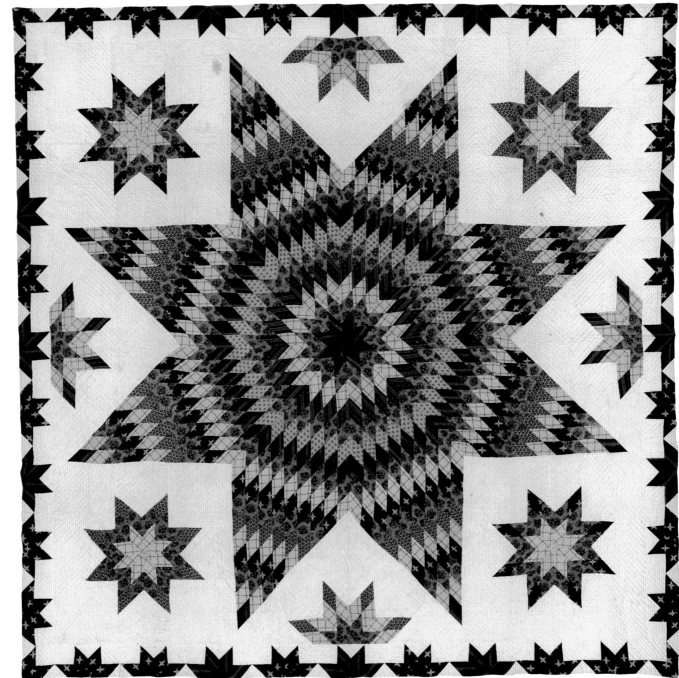

Baltimore Star

Maker unknown, possibly
Pennsylvania, circa
1840–1860

Cotton: 94 x 97 inches

Hand pieced,
hand quilted

Joyce Gross Quilt
History Collection,
W2h001.023.2008

POINSETTIA WITH CURRANTS

The concept of a "best quilt" is one familiar to quilt collectors and curators alike. Best quilts are those nineteenth-century quilt beauties that showcase a quiltmaker's finest needlework in a bedcover and that were made for use only on special occasions. They often are characterized by intricate appliqué and lavish hand quilting, including stuffed work, both perfectly executed on a light background, one subject to soiling with repeated use. Because such textile treasures were used infrequently and cherished in the family through generations, they also are survivors. Still intact and glorious, best quilts now, fortunately, populate institutional and private quilt collections.

Poinsettia with Currants is an example of a best quilt. California quilt historian Joyce Gross (1924–2012) acquired it in 2006 from the quilt collection owned by another eminent quilt historian and collector, Florence Peto. No information yet located documents Peto's acquisition of this mid-nineteenth-century red and green appliqué quilt, nor is the quilt named in the inventory of Peto's antique quilts published in *A Passion for Quilts: The Story of Florence Peto*.[22] The quilt's pattern is an old one. Quilt historian Ruth Finley described and pictured an 1850s quilt in the pattern in her *Old Patchwork Quilts and the Women Who Made Them*, praising it as one that "evidences the generous days of toil lavished on appliquéd patchwork of the period."[23]

The quilt's nine blocks each features a central poinsettia bloom surrounded by a gentle swirl of oak leaves and green stems festooned with red currants—360 berries in all. Wide white inner sashing separates the blocks, and appliquéd swags in the ten-inch border are gathered with another leaf and blossom design. Exquisite hand quilting, at thirteen to fourteen stitches per inch, covers the white background and the appliquéd patterns with a combination of diagonal parallel lines in the blocks, triple diagonal parallel lines in the border, and elegant feather quilting that sweeps along the sashing.

Poinsettia with Currants showcases the work of a highly skilled quiltmaker. Perhaps she created this "best" quilt for her own trousseau or as a gift on the occasion of a daughter's or granddaughter's wedding. The condition of the quilt testifies to its being used infrequently—it may have been passed down as a cherished keepsake through generations in the quiltmaker's family. At some point the family connection was severed, but fortunately the quilt came to the attention of the knowledgeable and discriminating Florence Peto. *Poinsettia with Currants* remains clean, crisp, and bright even after 155 years.

**Poinsettia
with Currants**

Maker unknown,
circa 1840–1860

Cotton: 96 x 98 inches

Hand pieced, hand
appliquéd, hand quilted

Joyce Gross Quilt
History Collection,
W2h001.025.2008

In September 1965 Alvaretta M. Wallace, then living in Thurmon's Convalescent Home in Amarillo, Texas, dispatched two friends to take her family quilt to Austin for donation to the University of Texas. She enclosed a letter describing her hopes for the family treasure. "We are glad indeed," she wrote, "to hand over this beautiful old quilt knowing it will receive the best of care & for unlimited time. . . . I was 97 yrs. old Aug. 29—65 & the last one of my family."[24] The quilt probably was made in Ohio, where Alvaretta, her husband, Lewis Wallace, and their only daughter were born.

Mrs. Wallace's exuberant *Rose of Sharon Variation* is an example of a mid-nineteenth-century floral appliqué quilt in which indigo blue replaces much of the more commonly used green in the appliquéd designs. The quilt combines careful planning with delightful improvisation—whimsy at its best. In this quilt the more you look, the more you see. Design surprises abound. The sequence of layered colors in the roses, for example, varies throughout the quilt but in an identifiable order. Rose centers—some

sewn using conventional appliqué, others with reverse appliqué—have different shapes: some are circles, some have wavy edges, at least one is a square. The quilt's nine-block interior is cleverly arranged. Stem, leaf, and bud combinations radiating from a central rose, for example, are positioned along the seams and at block junctions, making these seams almost invisible. The largest roses—six-layered and more than six inches in diameter—cluster toward the center. Smaller roses span the block and border seams, and still smaller roses are nestled along the border vine's curves. Additional roses float among buds from four flower designs and offer a secondary pattern. Tiny yellow dots mask pieced joints along stems in the corners.

It is interesting to speculate about the quiltmaker's process for appliquéing this quilt. The smallish size of the blocks (about 19½ inches square) made each a candidate for lap quilting. But the placement of the motifs along seam lines and at block junctions dictates that only separate blooms could have been appliquéd before the blocks were joined and, in some cases, before the border panels were added.

The vining border is an original design and a delightful addition. Made of red and indigo blue fabrics, the simple, deeply undulating leafed vine is elevated above the ordinary by the flower cluster tucked in each of its upward curves along the sides. What are those tiny red and blue circles? Berries? Bursting seeds? Their number and arrangement vary markedly. Staggered leaves along the vine and blue circles with red centers at the flower base add to the pattern's complexity. The mismatched corner turns, especially at upper left and lower right, reveal the quiltmaker's willingness to improvise her vining design to meet the requirement of available space as she turned the corner.

The unknown maker of this quilt was both frugal and a fine hand quilter. Pieced scraps appear throughout. The side border panels, for example, were made from irregularly sized pieces. Four different indigo blue patterned prints were incorporated into the quilt, including two in the narrow binding. The hand quilting is very regular, at eight to nine stitches per inch. Diagonal parallel-line quilting in white thread fills the background. Echo quilting, usually in green or brown thread, graces the floral motifs.

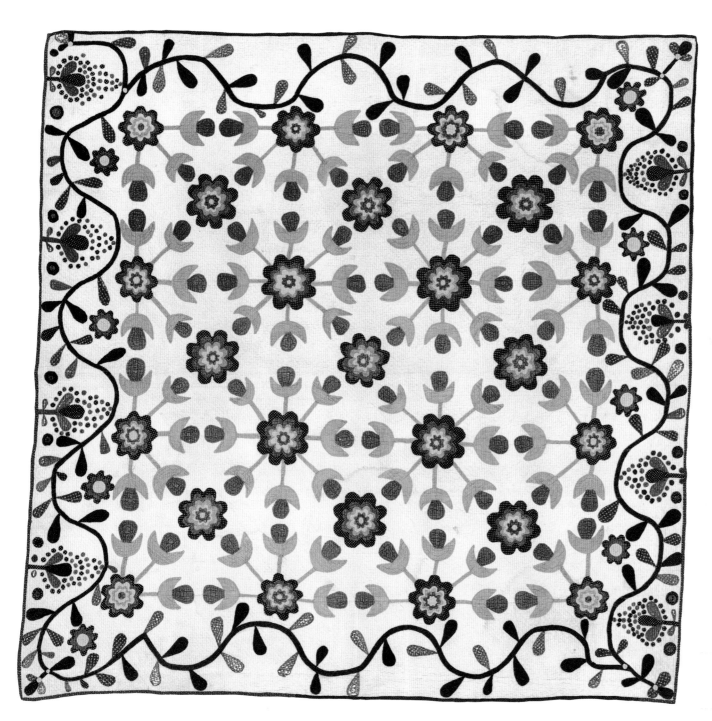

**Rose of Sharon
Variation**

Maker unknown,
probably Ohio,
circa 1840–1860

Cotton:
79½ x 82½ inches

Hand pieced, hand
appliquéd, hand quilted

TMM 2012.1

Gift of Mrs. L. V. Wallace

NINE BLOCK APPLIQUÉ SAMPLER

A Passion for Quilts reviews the life and many contributions of quilt historian and collector Florence Peto. It also contains a helpful appendix that lists the more than two hundred quilts Peto owned at one time or another. Among those listed are two *Nine Block Appliqué Sampler* quilts. This example, recorded as Sampler I, indicates that Peto never knew its maker or place of origin, surely a disappointment, since she put a premium on ferreting out the provenance of each of her quilts.[25] Joyce Gross acquired this quilt from Peto's family in 2006.

An unknown quiltmaker (or perhaps two) set nine blocks on point and appliquéd different floral patterns and four different vining borders to create this delightful sampler, by definition a mix of different patterns. In some blocks, delicate embroidered berries hang from slender branches. In others, abstract bulbous flowers tip hefty stalks. In four blocks, including three along the top row, slender lines of wool embroidery attach buds and berries to larger stems. Bouquets and tree-of-life designs spring from small triangular vases nestled at the corners in four blocks. A burst of holly leaves graces the quilt's center.

Most of the fabrics are solids, including all of the chrome orange accents. Plain Turkey red appears throughout, with two exceptions: small-scale red and white prints create the holly leaf design at the quilt center as well as the center petals in the flowers along the right border. Solid red also forms the delicate dressmaker inset roll along the border. This lovely feature is badly worn through so that,

at a distance, it appears pink. The green fabric is over-dyed and faded, revealing in most instances a tendency toward yellow, but in others, notably in three of the vining borders, toward blue. Most of the green fabric is solid, though along the left border the fabric vine is made from a small-scale, green and brown print and the leaves (most, but not all) from a similar, but not identical, print. The four vining borders are delightfully different—border widths vary, mitered corners are not centered, corner turns are imperfect. Although their considerable variation in style and construction made a consistent border treatment impossible, the result is no less appealing. Fine hand quilting at eight to ten stiches per inch covers most of the quilt, except for a few motifs. Patterns include diagonal line quilting in the borders, grid quilting in the alternate white blocks, and straight-line quilting in the sampler blocks.

The middle block along the right side deserves special attention. Here a hexagon rosette contains a central row of three hexagons in patterned fabrics of brown, blue, off-white, and red. This row is a replacement, one presumably appliquéd over worn fabrics and then hand quilted to complete the parallel-line pattern original to the block. The replacement's fabrics and use of the large quilting stitches contrast markedly with the rest of the quilt. Joyce Gross speculated that Florence Peto may have made this repair and did not wish to disguise it—the repair deliberately was made obvious to anyone studying the quilt.[26]

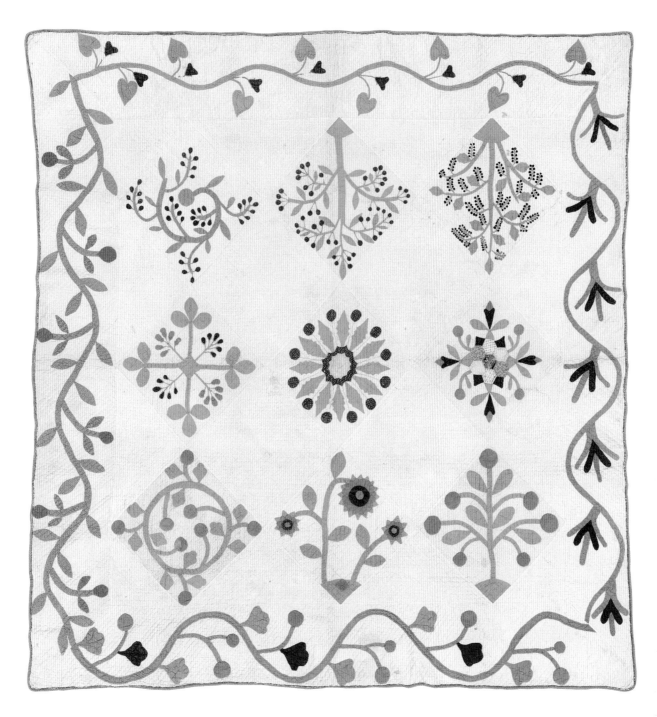

**Nine Block
Appliqué Sampler**

Maker unknown,
circa 1840–1865

Cotton: 77 x 80 inches

Hand pieced, hand
appliquéd, embroidered,
hand quilted

Joyce Gross Quilt
History Collection,
W2h001.031.2008

Nine Block Appliqué Sampler,
detail, containing hexagonal
repair possibly made by
Florence Peto.

COMFORT
AND GLORY

Quilt collector Florence Peto purchased this quilt top around 1934 from Abigail Stevenson, an antiques dealer from Long Island, New York.[27] Peto described and pictured the album top in her *Historic Quilts* (1939) and *American Quilts and Coverlets* (1949). In her first book she simply referred to the quilt as "an unlined quilt top" and labeled its photograph "Quilt Top Made in York." In her second, Peto described the top as a "typical Pennsylvania-Dutch example" and identified its photograph as a "Pennsylvania Dutch Appliqué." Peto named the quiltmaker in *Historic Quilts*, and in both books she located the quilt's origins specifically to York, Pennsylvania, and dated the quilt to the late 1840s.[28]

Several quilt historians are uneasy with Peto's mid-nineteenth-century date for this quilt top, finding it too early. Texas quilt historian Kathleen McCrady, for example, dates the top to 1900 or later. Quilts Inc. founder Karoline Patterson Bresenhan agrees, stating, "I just do not believe that 19th-century date. Not, not, not. That green is sooooo wrong. It's such a mystery . . ."[29] The source of the conundrum is the quilt's green fabric, a solid gray-green used throughout in the sashing, border, stems, and leaves, a green Peto called "vivid" in her *American Quilts and Coverlets*. The green fabric exhibits obvious

signs of fading, especially noticeable where border lengths are joined. All the gray-green sashing fabric has a brown cast to it. Two small irregular areas at the bottom appear bleached and are now tan. Is this fabric a synthetic green, available beginning around 1875? Did Peto misdate this quilt? To repeat Bresenhan's comment, it's such a mystery.

The designs in the quilt top's sixteen blocks are bold and uncomplicated, vividly colored, and seemingly original to the maker. Peto had mixed opinions about these designs, characterizing them as crude and a bit stark, but also as interesting, vigorous, and in colors that "dazzle the eyes." In fact, Peto mused, "when the top is used on a honey-colored maple bedstead and the season is snowy mid-winter [this quilt] lifts the spirit like a cheerful song."[30] The designs are mainly floral, with various plants, including flowers, nuts, and fruits, sitting on thick stems amid leaves presented as bouquets, in pots or as wreaths. Some are realistic enough to be identifiable—note the sumac on the far right, oak leaves with acorns opposite it on the far left, cockscombs in the wreath just below, and, clearly, silver maple leaves along the three borders. The most obscure block is in the top row, second from left, a design Peto described as "oak leaves disposed to form a swastika."[31]

**Album with Dogs
and Birds**

Attributed to Louisa
Kline, York, Pennsylvania,
circa 1840s–1910

Cotton:
83¼ x 80½ inches

Hand pieced, hand
appliquéd, hand
embroidered

Joyce Gross Quilt
History Collection,
W2h001.024.2008

Embroidery enriches these floral designs. Often stitched in a contrasting color, it creates veins in leaves, shades acorns, defines the centers of flowers, adds stamens to blooms, and brings detail to stems. Tossed into the floral mix, apparently randomly, are appliquéd dogs and birds, two pale blue blooms appliquéd over the interior sashing, and embroidered insects. Curiously, the quiltmaker placed four dogs on green platforms, in three blocks, and appliquéd a fifth dog onto a corner patch in another block. Did she add these stands on a whim or to fill in open space? The maker embroidered her birds and dogs lavishly, articulating the birds' wings and giving the dogs distinct coats, eyes, ears, and tails. Peto was especially fond of the dogs, encouraging readers to "not overlook the lovable little dogs which have been embroidered and supplied with flexible ears; the setters, easily distinguished from the terriers, have tails of looped cotton yarn which will wag with a bit of help."[32] A defining characteristic of this album quilt top is the distinctive buttonhole stitch that surrounds and further defines every motif in every floral design. Sewn in a contrasting color—or three or four—this bold stitch adds substance, vividness, and dimension to each block. Paired, the rich embroidery and the colorful buttonhole stitching add even more life to this quilt top.

In *Historic Quilts* Peto offers details about the quilt's maker, Louisa Kline (1824–1907), including the unhappy episode of her being left waiting at the altar by a groom who failed to show and was never heard from again. Peto's description runs for nearly seven pages, jumps back and forth in Kline's life, and is a bit hard to follow. It records that the jilted young woman never married and "as she grew older . . . showed an increasing distaste for society." Peto briefly describes this "hermetical seclusion," writing that Kline "snubbed her relatives, admitted no callers, cleaned her own house, and awed and frightened the boy who delivered milk and vegetables."

After Kline's death at age eighty-three, her nieces found two chests "filled to the covers with hand-embroidered domestic linens, finely tucked pieces of wedding apparel, and many patchwork quilts . . . the traditional equipment of a bride's trousseau!"[33] Peto reports that two of the trousseau quilts were in the President's Wreath pattern. She pictures part of one of them in *Historic Quilts* (Plate 49) and praises it as "a miracle of fine quilting," adding, "This writer has never seen such machine-like precision surpassed on any other quilt."[34]

Peto did not cite her sources for Louisa Kline's history in either of her books, so there is no way to confirm her facts. But she did pose an important question: whether the "solace of needlework" kept the semi-reclusive Miss Kline, so able a quiltmaker by age twenty-one, from going mad. Presumably it did, since Peto also reports that Kline died a happy old lady who never married but nonetheless led a useful life. Perhaps *Album with Dogs and Birds* is an unfinished needlework project of Louisa Kline's later years, and its gray-green fabric a product of synthetic dyes readily available by the end of the nineteenth century.

Florence Peto at home in Tenafly, New Jersey, surrounded by her quilts, circa 1940s. *Album with Dogs and Birds* is to her right. Joyce Gross Quilt History Collection 2008-013/Box 149.

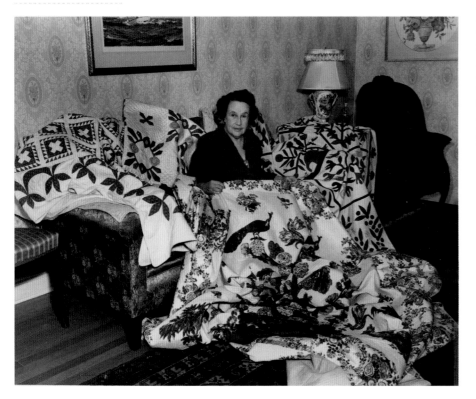

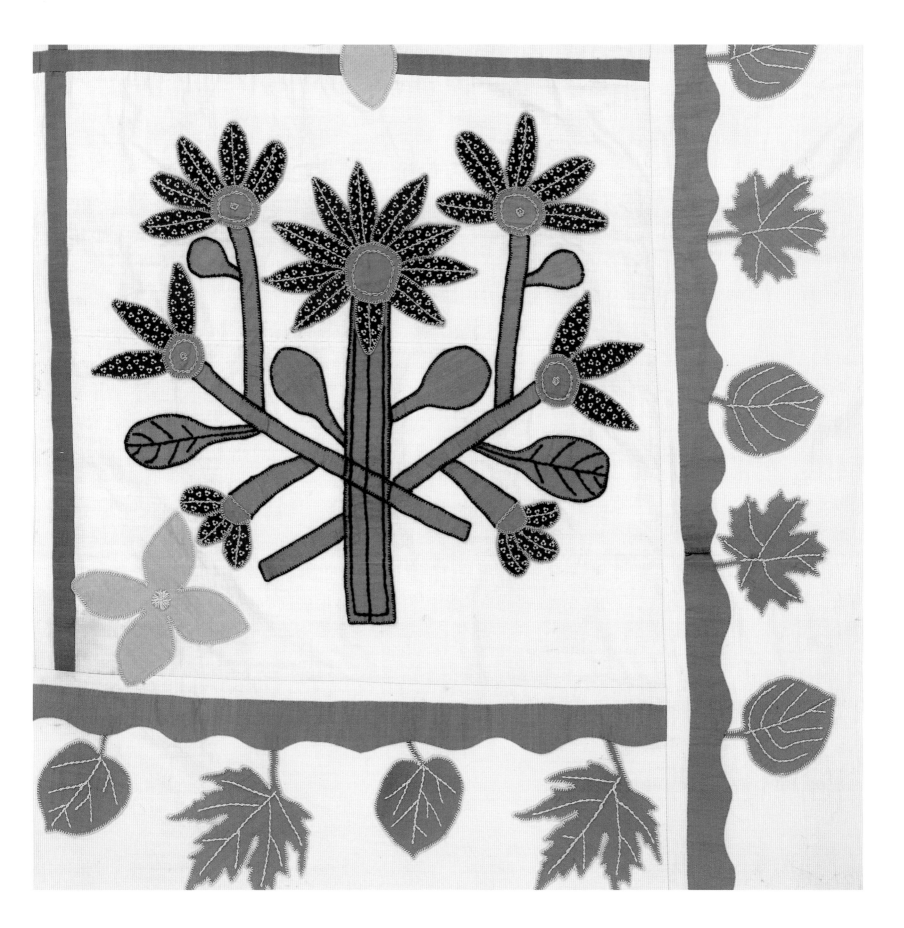

The fashion for cutout chintz appliqué quilts flourished in the United States during the first half of the nineteenth century, especially in eastern and southern states. Such quilts typically were the work of women of means, though middle-class women also embraced this fashion, taking advantage of less expensive English chintzes designed specifically for such projects. The chintz appliqué technique called for a quiltmaker to cut motifs from chintz fabrics and then to reassemble them into a new design, which she appliquéd onto a plain cotton background. Often made for display on high-post beds, chintz appliqué quilts are one example of the high-style quilts made in the United States before 1850. Many, including *Chintz Appliqué Album*, are needlework masterpieces, now prized in institutional and private collections for their magnificent chintz fabrics, their imaginative arrangement of realistic printed motifs, and their expert stitchery.[35]

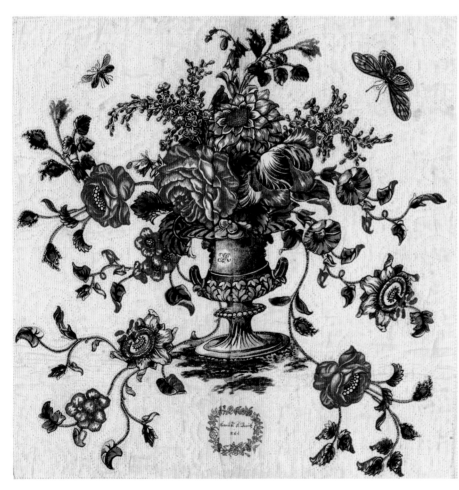

Chintz Appliqué Album contains 106 blocks, each measuring approximately eight inches square, plus a center block equivalent in size to four of these blocks. The quilt's album design reflects the preference of quiltmakers, apparent by the early 1840s, for a pieced block design in quilts. The earlier fashion for medallion-style quilts was, by then, nearly passé—the large center block in this quilt is a nod to that earlier style. All but four of the blocks contain floral designs, some presented as bouquets in urns, others as wreaths, still others as sprays or sprigs of blooms and buds on branches. Birds and butterflies appear in twenty-eight blocks. The non-floral exceptions are in the four corner blocks, where near-identical oriental motifs depict a family about to prepare tea. Such designs reflect the West's ongoing fascination with Chinese culture and design style. As interpreted by Europeans, the use of this style on pottery or textiles, for example, is known as chinoiserie.

In *Chintz Appliqué Album* the quiltmaker heavily manipulated her cutout fabrics. She pieced extra buds from one chintz fabric around large roses from another, for example, and joined smallish flowers to create wreaths. A variety of perky birds were perched on branches and stems, and blossoms were cut out and reorganized to spill over the edge of an urn or basket. Despite this considerable rearrangement, at least fifteen different fabrics are identifiable in this quilt. Together they represent a broad range in terms of design scale and botanical realism. Some flowers and foliage are large, detailed, and boldly colorful; others are small and delicate, set on slim branches and stems. Some blossoms are beautifully articulated and easily identified as roses, petunias, irises, chrysanthemums, and carnations. Others are fanciful and defy naming. As is common in floral patterns of this period, different flower species occasionally appear in the same plant, such as a rose and an iris growing off two stems of a single plant.

Each block design in this quilt is unique, though in some instances the difference between designs is slight, amounting to little more than the presence of an extra vine tendril or blossom. Mapping the location of the quilt's urns, baskets, wreaths, birds, and butterflies on a vertical (numerical) and horizontal (alphabetical) grid provides clues to the quiltmaker's organization of the designs in this quilt. Her arrangement emphasizes, for example, the

**Chintz Appliqué
Album**

Maker unknown,
Somerset County,
New Jersey, dated 1844

Cotton: 87½ x 97¼
inches

Hand pieced, hand
appliquéd, hand quilted

Karoline Patterson
Bresenhan and Nancy
O'Bryant Puentes Quilt
Collection, 2013-267

	A	B	C	D	E	F	G	H	I	J
1	C		S2							C
2				S7			B			
3			U	B S8	B	B	B S14	U	BF	
4				W/BF S9	B BF	B	W/F S15			
5		BK	B, BF S3	B BF	BF	BF	B BF	B, BF S17	W/B S21	
6			S4	B BF	U S11		B BF	S18		
7			S5	W/F S10	B BF	B BF	W/BF S16			
8				B	B S12	B, BF S13	B BF		S22	
9		B	U S6				B	U S19	BK	
10		W/BF S1						S20	W/F S23	
11	C	BF						U		C

B bird	C chinoiserie	W/B wreath with bird
BF butterfly	S signature	W/BF wreath with butterfly
BK basket	U urn	W/F wreath with flower

Names and their locations in *Chintz Appliqué Album*

Signature 1: B10: Jane Quick

Signature 2: C1: illegible

Signature 3: C5: possibly Ralph Van Doren, Ralph Voorhees, or Ralph Van Cleef

Signature 4: C6: Sarah Van Doren or Sarah Van Cleef

Signature 5: C7: probably Margaret Van Cleef

Signature 6: C9: Alleta Quick

Signature 7: D2: Sarah (surname illegible)

Signature 8: D3: John Quick

Signature 9: D4: probably Garetta Quick

Signature 10: D7: illegible

Signature 11: E5–F5 and E6–F6 (center medallion): Sarah V. C. Quick, 1844

Signature 12: E8: probably Abram Quick, Sr.

Signature 13: F8: (given name illegible) Cleef Voorhees

Signature 14: G3: Elizabeth (surname illegible)

Signature 15: G4: probably Margaretta V. C. Quick

Signature 16: G7: probably Abram Quick

Signature 17: H5: Ralph Voorhees, Sr.

Signature 18: H6: E. A. Wickene (signed using cross-stitch, in brown thread)

Signature 19: H9: Mary Quick

Signature 20: H10: John (surname illegible)

Signature 21: I5: Mary Quick

Signature 22: I8: probably Sarah A. (R.?) Van Doren

Signature 23: I10: Sarah (A.?) Voorhees

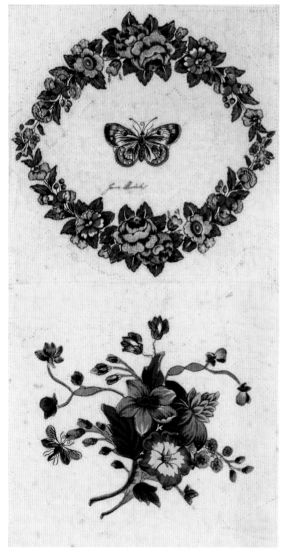

quilt's large center block by massing non-floral objects (urns, birds, etc.) around it. These examples demonstrate the quiltmaker's strategic placement of some designs.

With a single exception, the seven wreaths are placed in blocks just off each of the center block's four corners and at the same block location (B-10 and I-10) on either side near the quilt's lower end. Different sections of the center block's impressive urn are set in only five other blocks in the quilt, all but one (H-11) appearing in blocks just off the corners of the center block. Also, of the twenty-two birds in the blocks, other than the single example of a bird in a wreath, block I-5, all but three are clustered near the center block. The same is true for the placement of the butterflies, whether on branches or in wreaths.

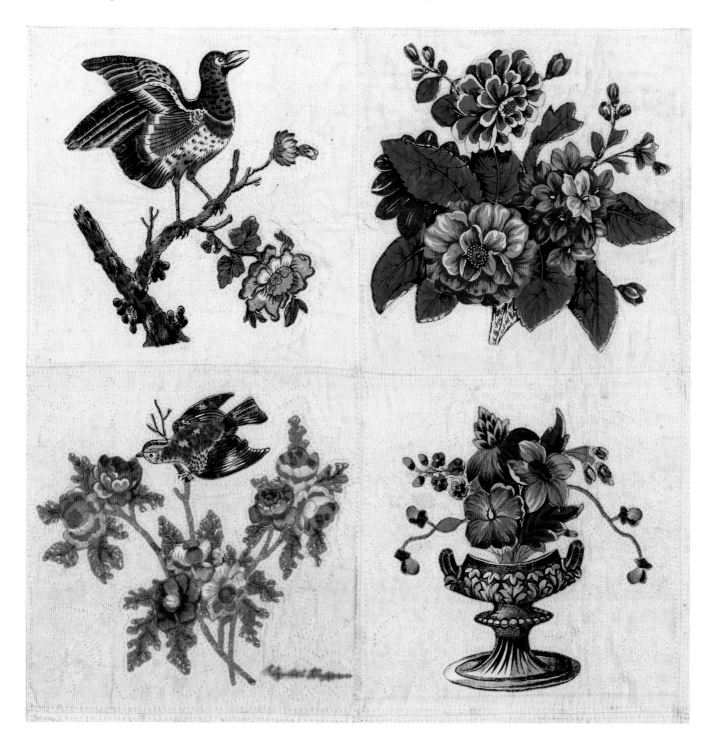

The quiltmaker occasionally extended symmetry to her placement of specific fabrics. The most obvious example is her use of chinoiserie fabric in the quilt's four corners. Note also the quilt's bottom horizontal row. There, beginning at each corner and moving to the middle, the sequence of different fabrics used is in a nearly mirrored order. The same is true along the quilt's top horizontal row.

Chintz Appliqué Album is finished with an extraordinary border of delicate flowers in muted green, tan, and brown with picotage fill. These floral motifs are small, and their use in a continuous thirty-one-foot border perfectly demonstrates the masterful cutting and appliqué the quiltmaker achieved throughout the quilt. She uniformly cut and appliquéd motifs very close to their printed edges, including in tiny interior spaces and along stems and branches one-eighth of an inch wide. Her appliqué stitch is barely visible. The border pattern may actually have originated as a border in a chintz fabric, perhaps even in the fabric whose large blossoms are in block D-1 on this quilt. The colors, the articulation of the flowers and leaves, and the picotage fill in the border and the block fabrics appear to be identical. The quiltmaker's contour quilting, at nine to ten stitches per inch, complements the curved edges of the many blossoms and buds. The binding is narrow (a scant quarter inch) and separately applied.

Chintz Appliqué Album is inscribed with twenty-three names, suggesting that it was made as a quilt of remembrance or celebration. With one exception the names are inscribed in ink; the exception is a single name cross-stitched in brown thread. These names provide the key to some of the quilt's history, one largely of early Dutch settlement and close family ties in Somerset County, New Jersey, located inland along the Raritan River. Regrettably, several of the names are illegible, obscured by blurred

ink. The main inscription, however, is clear. "Sarah V. C. Quick 1844" is embraced by a delicate inked wreath and set in the large center block just below an exuberant bouquet. The quilt very likely was made in Somerset County, though the quiltmaker remains unidentified. Surnames on the quilt include several inscriptions for Quick, Voorhees, VanCleef, and Van Doren, all names of families in the area that were related by marriage. Preliminary genealogical research indicates that some specific names represent Sarah Quick's family, as well as neighbors from nearby farms. Abram Quick may be either Sarah's father or grandfather, for example; Mary Quick is her sister.

Sarah V. C. Quick (1828–ca. 1875) was the daughter of Abraham and Garetta VanCleef Quick. Both parents and Sarah were born and buried in Somerset County. Sarah's middle initials honor those of her mother's maiden name. Quick family ancestors were among the early Dutch settlers in what eventually became New Jersey. By the late eighteenth century, Sarah's great-grandfather Abraham Quick (1732–1805) was a wealthy farmer and landowner who lived on Ten-Mile Run, his homestead in Franklin Township, Somerset County. Quick fought in the American Revolution and became a county judge in 1778. He is buried near Six-Mile Run Church in Franklin Township. His son Abraham (1774–1866) married Maria (often referred to as "Mary" in the US Census) Vanderveer, also of Somerset. Their firstborn son, also named Abraham Quick (1800–1883), married Garetta VanCleef. The couple had four daughters, including Sarah, the eldest. Some of the environment Sarah grew up in still can be seen in Somerset County's Six-Mile Run Historic District, where preserved farmsteads and rural views document the Dutch-settled nineteenth-century built environment and landscape. Sarah's tombstone suggests she never married and that she died relatively young, at age forty-seven.[36]

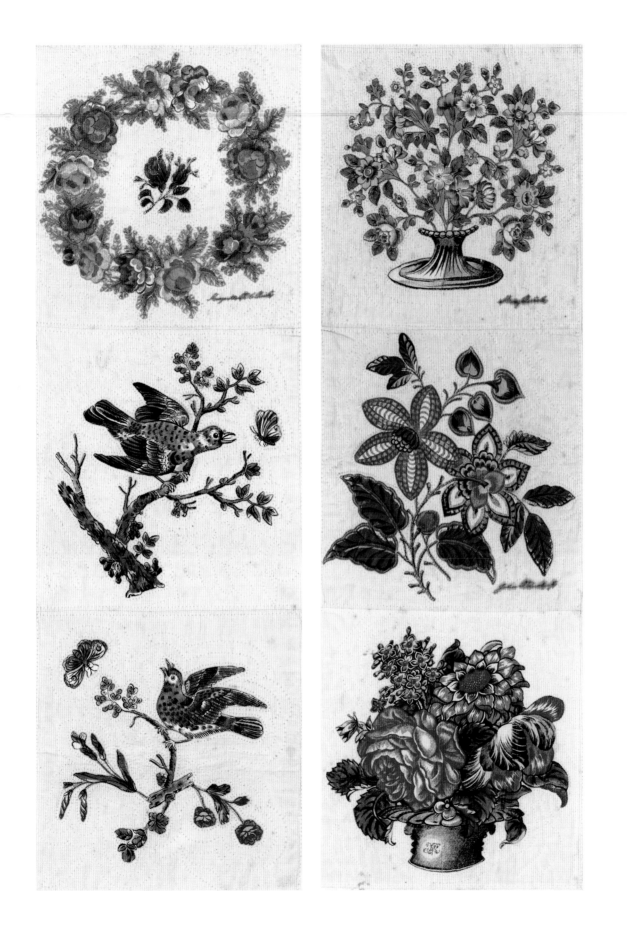

So teach us to number our
days, that we may apply our hearts
unto Wisdom.
Psalms XC. 12.
Margaretta J. Burden
Medford
New Jersey
1844

A Bible passage and an inked inscription grace this New Jersey friendship quilt, which also contains seventy-four other names, all written in India ink in the same hand, most in the quilt's white cornerstones. Two family names dominate: Eachus and Hoopes. Their placement in the quilt's fancy center block also suggests their special status. Written inside that block's wreath of green leaves and between spokes of a red pinwheel they read: Abram Hoopes, Sidney Hoopes, Homer Eachus, and Lydia M. Eachus. Circling the wreath are six more names, all Hoopes. The seventy-five names in *Oak Leaf and Reel* mark it as a record of friendship, remembrance, and commemoration, when families and friends came together, perhaps to celebrate a birth or marriage or to record names of those left behind when an individual or family moved away.

Signature quilts are believed to have originated about 1840 in the area extending from New York to Baltimore, a region that included New Jersey, where this quilt probably was made. A remarkably similar quilt is pictured in *New Jersey Quilts, 1777 to 1950: Contributions to an American Tradition* (Plate 4), which describes the Oak Leaf and Reel pattern "as one of the few familiar appliqué designs seen frequently in New Jersey quilts of the 1840's and 1850's."[37]

The single pattern in the Winedale Quilt Collection example is repeated throughout the quilt, with the single exception of a fancy center block. Calicoes—one a red, blue, and white floral and the other a green overprinted with tiny brown-black dots—are consistent with the popularity of red and green appliqué quilts of that period. These calicoes may have been printed in New Jersey, possibly at Shreveville, an enterprise in

Burlington County that by the 1840s included a calico printworks.[38]

The quilt's construction is somewhat surprising. The top pattern is beautifully cut and finely appliquéd. There is no batting, however, and quilting is found only around the inner edge of the white cornerstones. The back is composed of five hand-sewn panels of solid medium-blue cotton, possibly a Prussian blue. The edges at the bottom and sides are turned in. At the top there is a narrow binding in gold silk hand sewn along the edge, probably to cover and strengthen an original edge frayed from repeated handling or the abrasion of whiskers.

The inscriptions on this quilt record twenty-eight different surnames. These names, plus the specific name, place, and date of Margaretta J. Burden, Medford, New Jersey, 1844, yield the beginnings of productive genealogical research. Preliminary study indicates that the Eachus and Hoopes families were related through location, religion, and intermarriage. Members of both families settled in Delaware and Chester Counties, Pennsylvania, by the 1700s, often as farmers and, later, as merchants. Many were Quakers. The four names in the quilt's center are those of two couples: Homer and Lydia Eachus and Abram and Sidney Hoopes. By the time this quilt was inscribed, Homer and Lydia's daughter Hannah Green Eachus was married to Walker Yarnell Hoopes, the son of Abram and Sidney. Both Hannah and Walker Hoopes are named on this quilt.[39]

As of this writing, the author has been unable to discover specifics about Margaretta J. Burden of Medford, New Jersey, her connection to the other families named on this quilt, or the reason for the special message inscribed next to her name. The biblical passage above it—"So teach us to number our days, that we may apply our hearts unto Wisdom"—invokes thoughts on the brevity of life and cultivation of a wise and understanding heart. Perhaps *Oak Leaf and Reel* is a quilt of remembrance made by Margaretta Burden to remind her of friends now distant. Or perhaps the quilt was made *for* her, possibly even by family and friends associated with Quaker meetinghouses in Delaware and Chester Counties, Pennsylvania.

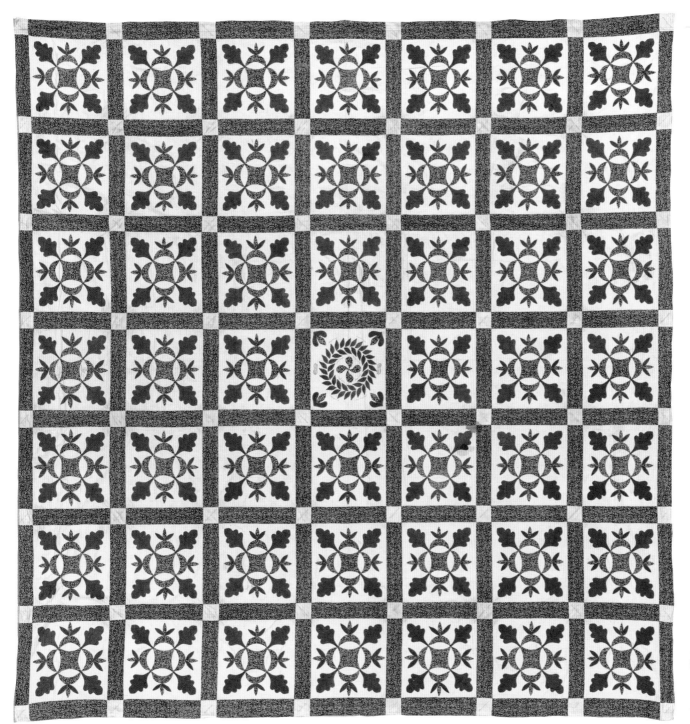

Oak Leaf and Reel

Maker unknown, possibly
Medford, New Jersey,
dated 1844

Cotton: 98 x 97 inches

Hand pieced, hand
appliquéd, hand quilted

Joyce Gross Quilt
History Collection,
W2h001.053.2008

DELECTABLE MOUNTAINS VARIATION

This quilt showcases one of the many variations of the Delectable Mountains pattern, which features scores of tiny triangles arranged in rows that rise and fall as repeating peaks. Traditionally the pattern was made using a single color set against a neutral background. The pattern name is derived from John Bunyan's allegorical masterpiece *The Pilgrim's Progress* (1678) in which pilgrims, after much hardship, come upon the Delectable Mountains and there behold "the Gardens and Orchards, the Vineyards and Fountains of Water . . ." Bunyan's Delectable Mountains were a place of peace, refreshment, and wonder.[40]

Louisa Rice made her quilt using a red and white print so tiny that it appears pink, an effect helped by the quilt's gentle overall fading. The maker organized her repeating peaks as five vertical bars, forming each "mountain" using rows of alternating dark and light triangles that sit atop large triangles. The bars' pattern changes with the view. Looking along the quilt's length, the eye sees bars containing zigzags; from either side across the width, peaks appear. The hand piecing is quite fine—triangles are uni-

form and their points are sharp. Louisa's graceful swag border is an uncommon addition to this typically overall geometric pattern.

The quiltmaker further embellished her *Delectable Mountains* with substantial quilting, adding sinuous feather quilting between each bar and parallel lines along them. At each feather's curve Louisa quilted a double outlined small heart, an indication that *Delectable Mountains* may have been her wedding quilt. More hearts and feathers appear inside the border swags; outside them she added echo quilting. Louisa's elegant quilt patterns are all the more remarkable because of the quilt's thickness. This is a hefty quilt, one made for warmth and, if condition is the measure, used often.

The provenance of *Delectable Mountains* tells of its steady move with family from Tennessee to Texas, a story that spans nearly one hundred years. Louisa (Lou) M. Rice (ca. 1832–?) may have made *Delectable Mountains* as a wedding quilt just prior to her marriage, probably in the mid-1850s, to John D. Borin (ca. 1828–?). The quiltmaker's use of a single printed fabric rather than a miscellany of scraps suggests she had sufficient wealth to purchase the necessary yardage rather than to rely on her scrap bag. Louisa made the quilt in Tennessee—both she and her husband were born there, as were their first three children, all boys. Federal Census records document the Borin family's moves thereafter, confirming that sometime in the late 1850s the family settled in Scottsboro, the new county seat of Jackson County, Alabama. For a time the family lived in a hotel that John Borin helped manage. Residents also included laborers, merchants, and professional men. In 1863 the Borin family welcomed its first daughter—Lula Mae, to whom the quilt would eventually pass. The family remained in Scottsboro at least until 1870, but by 1880 Louisa was widowed, and she, son George, and teenage daughter Lula headed west, first to Arkansas and then, eventually, to Central Texas. Lula Mae Borin (1863–1936) married David Kellar Newsum (1856–1927), also a native of Alabama, sometime before 1905 and the birth of their only child, son Lindsay Borin Newsum (1905–1946). Lindsay Newsum, a longtime Austin resident, inherited the quilt from his mother. He and his wife, Carlotta Jane, donated his grandmother's quilt to the University of Texas in 1941.

**Delectable
Mountains Variation**

Louisa M. Rice,
Tennessee, circa
1845–1855

Cotton: 69½ x 82 inches

Hand pieced, hand
appliquéd, hand quilted

TMM 495.4

Gift of Carlotta Jane and
Lindsay Borin Newsum

COMPASS STAR WITH SAWTOOTH BORDER

Quilt collector Joyce Gross probably named this quilt *Compass Star with Sawtooth Border* after she acquired it in 2006. It is one of several quilts formerly owned by quilt collector Florence Peto, who purchased the quilt from a dealer in Kutztown, Pennsylvania, and called it *Mariner's Compass*, the traditional name for this popular pattern.[41]

This quilt is beautifully composed and constructed, containing more than twenty different fabrics in a variety of red, dark brown, tan, indigo blue, and dark teal patterned prints. The pattern calls for each compass's thirty-two points to be cut in four graduated sizes, each size in a different fabric, all in colors that contrast sharply with the off-white background and compass center. It is this quilt-maker's expert piecing and deft use of color, however, that give each compass a dimensional look—the eye sees the points as four layers stacked around the center. The deep sawtooth pattern along the edge, sometimes called a dog-tooth, echoes the compass points. Its scale, sharp points, and colors perfectly frame the block designs.

The maker's quilting is very regular, at six to eight stitches per inch, and beautifully conceived. Contour quilting flows out from the perimeter of the circle in which each compass is set. A small compass is quilted where contour lines meet, each with a double ring perimeter, each with lines radiating from its center. There are thirty-eight quilted compasses in all, and a hint of marking lines remains visible for most. The echoing effect of the quilting pattern is repeated in the border, where chevrons fill in the white triangles and so repeat the sawtooth shape. The quilt is finished with a binding of plain, woven twill tape with an exposed selvage.

One of the quilted compasses provides a delightful surprise. Perhaps to introduce a whimsical touch to contrast with so much order and precision, the quiltmaker filled one of her small quilted compasses with grid quilting rather than with radiating lines. It's a pleasure to discover this single anomaly.

**Compass Star with
Sawtooth Border**

Maker unknown, possibly
New Jersey, circa 1845

Cotton: 92 x 108 inches

Hand pieced,
hand quilted

Joyce Gross Quilt
History Collection,
W2h001.022.2008

Despite heavy wear, visible and shifting batting, patching and edge repairs, and significant stains and scorching, this pre–Civil War quilt remains bright, cheery, and the essence of a utility quilt—one that invites use and offers comfort. Family history holds that Rachel J. Haynes (1836–1886) made this quilt while living on her parents' cotton farm near Senoia, Coweta County, in west-central Georgia, south of Atlanta.

Three notes written by one of Rachel's granddaughters in the early 1970s accompanied the quilt when it was donated to the Briscoe Center in 2007. One states that the "quilt was brought to Texas from Georgia by Rachel Haynes Addy who is the grandmother of Alta Williams Kaderli and Mrs. Robert B. Shaw of Garwood. We know the quilt is more than 130 years old and that it was made by our grandmother, Rachel Haynes Addy." A second note, describing a bedspread made on the family farm, states, "The cotton in this spread was raised and picked by slaves on this farm. The spread was spun and woven by slaves."[42]

In 1866 Haynes married Jessa (or Jesse) Addy, a laborer at least twenty-eight years her senior. The couple raised four children, two of whom (son Jessa and daughter Cora) were born in Texas after the family moved to Gonzales County in the early 1870s. The quilt remained in the family after Rachel Addy's death in 1886, passing eventually to her daughter Mary Jane and then on to Mary Jane's daughters Clara and Alta. In the 1970s the two daughters gave the quilt to Mary Elizabeth Hopkins of Columbus, Texas. In 2007 Hopkins's two daughters donated the quilt on her behalf to the Briscoe Center.

The 1860 US Census lists Rachel Haynes, then about twenty-four years old, as a seamstress. The stitching in this quilt—its uneven piecing, for example—suggests that Haynes made the quilt years earlier, when she was a young girl still building her sewing skills. Despite her lack of needlework proficiency, Haynes organized her quilt carefully. She selected three different patterned fabrics for the rectangles and squares in each block, arranging and piecing them to match the one opposite. She used scraps as necessary—sometimes piecing together two, three, even four patches to create her pattern. It is appealing to imagine young Rachel carefully organizing sewing scraps into various piles of matching fabrics as she planned her quilt.

It is unlikely that the fabrics Rachel Haynes used for the quilt top were made locally, even though Georgia could boast nineteen cotton mills by 1840 and thirty-two mills by the end of the decade. Some were located relatively close to Coweta County, such as the Troup Factory in adjacent Troup County, which began operation in 1847 with a dye house and a spindle room that could produce six hundred pounds of cotton daily, or the Columbus Cotton Factory, which was spinning cotton as early as 1838. Much of the textile production of these mills, however, was for everyday cotton goods, including coarse fabric for work clothes and ticking for mattresses. The fancier cottons in the quilt's top, most likely leftovers from other sewing projects, probably came from northern mills. By the time Haynes made her quilt, however, they were available to her locally, perhaps at a small mercantile store in nearby Newnan, the county seat of Coweta County, or at a rural outpost, or from a peddler.[43]

The granddaughter's note about the slave-made homespun bedspread raises the issue of whether some part of *Album Patch* was made of homespun fabric, that is, fabric of fiber spun at home and then woven there to create cloth for bedding, clothing, and domestic linens. The likely homespun portion of the quilt, if any, is the quilt's backing fabric—made from three pieces of natural-colored and plain, loosely woven cotton. Is it homespun? Possibly. The quilt was made in cotton country and, if the note is accurate, a ready labor supply was at hand to spin and weave cloth. But so were nearby mills, all producing cotton goods for everyday use. As one textile historian has noted, "Families that could afford to weave could—and did—avail themselves of printed calicos and other store-bought fabric. . . . Homespun was not inexpensive to produce, so it was not a poor person's make-do fate."[44] Examples of documented slave-made homespun are rare. The swatch shown on page 54 was "woven by the negro spinners" from Col. John Winfield Scott Dancy's Texas plantation during the Civil War. According to Dancy's daughter Lena, "All our blankets, towels, and negro clothes were spun & woven by his spinners, and they were willing experts."[45]

Album Patch

Rachel J. Haynes,
Senoia, Georgia,
circa 1845–1860

Cotton:
68¾ x 82¼ inches

Hand pieced,
hand quilted

W2h114.2007

Gift of Mary Elizabeth
Hopkins

A pattern booklet for weaving counterpanes, and a piece of slave-woven homespun fabric from the Dancy Plantation, Fayette County, Texas, 1862–1864. Lena Dancy Ledbetter Papers, 2E353.

1865

J.W.D. J.W. Dancy J.W. Dancy

Col. John Winfield Scott Dancy named for Scott his 1st cousin.
L.D.L.

Patterns for Weavings done on Col. Dancy's plantation near La Grange, Texas.

—— Process ——

Putting threads in the gear of the looms was a most exact & tedious art, and my father often made use of my talent for such work; & I gloried in all kinds of work! Lena D. Ledbetter.

Draw in 1-2.
3 & 4 beginning on back shaft 7

Tread 1 & 4 then 4 & 2
then 2 & 3 then 3 & 1
then 1 & 4 then 4 & 2
then 2 & 3 .. 3 & 1

In Serge
Any other pretty twill is 1 then 1 & 2 then 2 & 3 then 3 & 4
then 4 & 1 then 1 & 2 then 2 & 3 then 3 then 3 & then 4 then 4 & 1 & so

—— Serge & Blanket twill ——

||| ||| ||| ə||| 1 — 1
 ||| ||| ə|| — 2
 || —— || ə||| || — 3
 ||| —— ə ||| ||| — 4
 ||| ——|—|
 4 3 2 1

Begin on back shaft & then on 3rd & draw 5 threads, then on 4th & 3rd & draw 5 1 & 3 & draw 5 threads then 4 & 2 & draw 5 & so on. Tread 4th with left foot & 1st & 2nd with right till you weave 5 threads then 1st treadle with right & 4 & 3 with left till you weave 5 threads. Then 4 with left & 1 & 2 right 5 threads, then 1 with right & 4 & 3 with left 5 threads & so on. This makes

Huckaback —

LE MOYNE STARS CRIB QUILT

This quilt, surely made for a child, is distinguished by its many chintz and indigo blue fabrics and by a rare backing fabric that features a commemorative motif relating to early Texas. Ima Hogg (1882–1975), the eminent Houston philanthropist and decorative arts collector, probably purchased this quilt sometime between 1964 and 1974 while on one of her many collecting trips in the Northeast. She used it and other textiles she collected as period furnishings in the historic homes at her Winedale property located in Fayette County, Texas. Miss Hogg donated Winedale and its furnishings to the University of Texas in 1967. *Le Moyne Stars Crib Quilt* arrived at Winedale in 1976 as part of Miss Hogg's estate following her death the year before. The quilt was part of a large donation that included a child's *Log Cabin* quilt, a candlewick counterpane, damask napkins, linen sheets, and several Pennsylvania German decorative show towels.

On the quilt's front, two borders surround alternating Le Moyne Stars and four-patch blocks. The Le Moyne Stars pattern of eight joined diamonds is named after Pierre and Jean Baptiste Le Moyne, brothers who helped colonize Louisiana for France in the early eighteenth century. By the time Miss Hogg acquired this quilt, the popular pattern was also known as Lemon Star. One tradition holds that a New England quiltmaker, uncomfortable pronouncing Le Moyne, called it Lemon Star.[46]

This is a scrap quilt. It contains more than sixty different fabrics, some dating from the first quarter of the nineteenth century, others from mid century. The quilt front is a medley of pieced patterned fabrics, including large-scale florals, plaids, calicoes, brown grounds with floral prints, and still others that combine light tan, blue, and pink florals. Eight different indigo blue prints are used in the star blocks. Several patterns have vermiculate and picotage fill, suggesting block or copperplate printing. Multiple sites in both borders and blocks are pieced with small patches of different fabrics. One twenty-nine-inch outer border, for example, is made from six pieced scraps, one of which is a triangle whose sides measure less than an inch. At first glance the placement of the fabrics appears random, but in fact the quiltmaker brought a specific order to her pieced arrangement. The border fabrics, for example, match one another on the two sides and top to bottom, though the bottom outer border is scrap pieced at the right. In addition, with but one exception, the indigo blue print fabrics are confined to the three Le Moyne Stars blocks set on point along the horizontal midline, bringing focus to the quilt's center. The quiltmaker also emphasized the quilt's two block patterns by pairing fabrics in light-dark combinations.

Le Moyne Stars Crib Quilt has very thin cotton batting. The backing fabric is turned to the front to create the binding at top and bottom, and two floral fabrics, including one that appears nowhere else on the quilt, make up the separate binding at the quilt's sides. The hand quilting is simple parallel lines and chevrons, sewn at seven to eight stitches per inch.

The quilt's backing fabric is a true rarity. Its off-white background is printed with strips in brown that feature a repeating two-inch-long banner draped across an upright standard. "Texas," printed in all capitals, arches over a five-pointed star at the banner's center. A lance, rifle, and laurel wreath cross below the banner, and an anchor and chain sit at the standard's base. The symbolism of star, weaponry, wreath, and anchor evoke victory, military power, and the Republic and/or the State of Texas—the five-pointed star being included as part of the Texas national flag design, which the Texas Congress adopted in 1839. As yet the author has seen no other example of this fabric either firsthand or published. The fabric possibly was made to commemorate and celebrate Texas independence in 1836 or, perhaps, the annexation in 1845 of the Republic of Texas to the United States as the twenty-eighth state.

**Le Moyne Stars
Crib Quilt**

Maker unknown,
probably northeast
United States, circa
1845–1860

Cotton: 41 x 40½ inches

Hand pieced,
hand quilted

Ima Hogg Quilt
Collection, W2h30.76

BURGOYNE SURROUNDED

This quilt's pattern name refers to an important event in the American Revolution. In October 1777, New England militiamen under the command of General Horatio Gates surrounded General John Burgoyne's retreating British troops. The resulting British surrender at Saratoga, New York, was a major turning point in the war—it helped convince France to lend formal support to the fledgling United States.

The geometric pattern is an old one, reportedly known as Wheel of Fortune before 1850 and, by 1860, sometimes called Road to California.[47] The pattern is constructed using only two colors and features hundreds of small pieced squares and rectangles. Precise piecing is essential if it is to succeed. This early example is especially large, containing thirty-two pieced blocks alternating with an equal number of plain blocks. The red fabric is the same throughout, suggesting that it was purchased for this specific needlework project. The plain blocks were quilted in a curiously random mix of four different designs that contrasts with the geometry and precision of the pieced blocks. There are twenty-one wreaths with pinwheel centers, for example, but also ten blocks with tulips on stems, sometimes set straight up and down, sometimes set on the diagonal. A gathering of swirling tulips graces one block only. This quilt's handwork is quite fine. The hand-piecing stitch, for example, is so regular and tight that it almost appears machine sewn. The quilting is done at nine to twelve stitches per inch. In addition to the wreaths and

flowers in the plain blocks, quilting patterns include chevrons along the border and a diagonal line through each piece in the geometric blocks.

Oral tradition, the indication of family wealth based on the apparent use of project-specific fabric, and the absence of other likely quiltmaker candidates suggest the intriguing possibility that one or more enslaved women on a Louisiana plantation made this red and white quilt. A persistent family legend holds that slaves made the quilt and that Lorahamah Currie Alexander (1807–1891) owned the quilt and probably ordered and supervised its construction. Lorahamah was married to planter William T. Alexander (ca. 1780–ca. 1849). The couple had only one child, daughter Mary Catherine Rebecca Alexander (1836–1864). The Alexander family is believed to have lived near Omega Landing, Louisiana, on the Mississippi River just across from Vicksburg, Mississippi, where William Alexander occasionally conducted business. A rich cache of letters, journals, and business and housekeeping records documenting the family history, including the plantation years near Omega Landing, once existed and might have confirmed the quilt's slave-made origins or at least documented the Alexander family's history. The quilt's donor recalls "avidly reading" them in the attic at her maternal grandmother's house when she was in high school. Regrettably, these crucial documents were lost when another relative made them into an art collage and light exposure further rendered them unusable.[48]

Lorahamah Alexander's circumstances likely changed after her husband died, sometime before 1850. In 1863, assuming the quilt existed by then, it came to Texas when Lorahamah, daughter Mary Catherine and her husband, three grandchildren, and a personal slave fled Louisiana for East Texas in the face of the chaos and danger of war, including the siege of Vicksburg. The family settled in Red River County by early 1864, but Mary Catherine, "so broken by the 'flight' to Texas and all [the family] lost in the war," died not long after their arrival. It is possible, of course, that Lorahamah herself made the quilt in Texas. No family information or legend, however, describes her as a quiltmaker or seamstress. Fortunately, and despite the trials of resettlement, ownership of the *Burgoyne Surrounded* quilt remained within the family, always passing through the female line.

Bird's Eye View of the Mississippi River near Vicksburg, 1863. Omega Landing is located one mile north of Milliken's Bend, the elbow of land shown in the top left third of the map. Robert H. Voight Family Papers, 3K123.

**Burgoyne
Surrounded**

Maker unknown,
probably Madison
Parish, Louisiana,
circa 1845–1870s

Cotton: 100 x 100 inches

Hand pieced,
hand quilted

2010-038

Gift of Rebecca R. Phelps

The specialty quilt known as the "Baltimore Album quilt" originally flourished during the period from 1846 to 1852, springing from the fondness for albums containing autographs and endearments. Specific to the city for which they are named, these quilts, though made by many, may have had a strong guiding force from two women, Achsah Goodwin Wilkins (1775–1854) and Mary Evans (1829–1914). It is possible that Wilkins designed and commissioned Baltimore Album quilts and that Evans accepted and filled orders for complete Baltimore Album quilts and for individual blocks.

The high style of the Baltimore Album quilt begins with similarly sized blocks set on a grid. The quilts' distinguishing feature is their block designs, which combine masterful needlework with fabric abundance to achieve complex designs that favor fruits, flowers, and birds but also include buildings, monuments, railroad cars, ships, and any other objects that captured the maker's fancy. In addition to demonstrating how fabric cleverly arranged can achieve special effects, Baltimore Album blocks showcase sophisticated needlework techniques such as cut-out chintz appliqué, ruching, multilayered appliqué, and stuffed work. These techniques produce surface dimen-

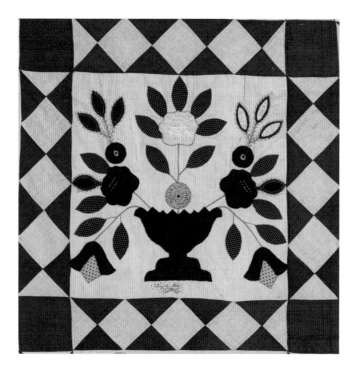

sion; various types of stitching, which define and articulate motifs; and reverse appliqué, which adds detail to objects such as urns and vases. Some, but not all, Baltimore Album quilts include sashing that separates the blocks; some are graced with elaborate borders, others have none. Many are inscribed with initials, names, or sentiments—or some combination thereof. Such inscriptions may serve as important design elements as well as reinforcing the quilt's testimonial message of love, friendship, remembrance, or patriotism.[49]

Typically, blocks in a BAQ (a term Joyce Gross often used to describe a Baltimore Album quilt) are identified using a grid letter/number designation. In *Pentz Baltimore Album* the grid is five blocks across and four down, hence the horizontal rows are lettered A through E and the vertical rows 1 through 4. Block B-2, for example, is located in the second row, second from the left. It features a red urn with a serrated rim that holds flowers in red, white, and yellow. *Pentz Baltimore Album* is a top only and, therefore, is not quilted. At some point in its history the top was stabilized with a muslin back, which was reinforced with wide vertical and horizontal strips. These supports probably were in place by 1981, when Mildred Locke (1919–2008), a quiltmaker and quilt-store owner in Bell Buckle, Tennessee, displayed the quilt on the wall in her home. She received the quilt as a gift from her husband, who reportedly acquired it "from an old Tennessee home." Joyce Gross purchased the quilt from Mildred Locke in 1992. No information yet discovered explains how this Maryland-made quilt found its way to Tennessee.[50]

The twenty blocks in this quilt showcase varying levels of the workmanship and complexity of design, indicating that several pairs of hands contributed to its making. Mildred Locke, in fact, thought the quilt was the work of five different makers.[51] Some designs barely fit inside their blocks (tips are cut off here and there by sashing or border), others are perfectly centered, and one is oriented sideways rather than top-to-bottom. All the designs are floral—nine bouquets, nine wreaths, and two floral cut-paper designs. Three blocks sport birds, all located in bouquet blocks along the top row. One of the organizing features of this quilt is that wreath designs alternate with bouquet designs, though this format does not carry

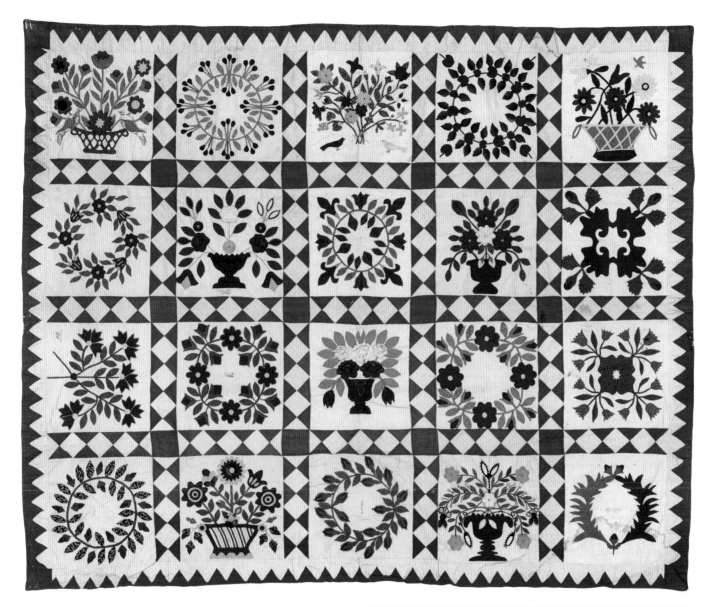

**Pentz Baltimore
Album**

Attributed to friends and
family of Julia Ann Pentz,
Baltimore, dated 1847

Cotton: 88 x 108 inches

Hand pieced, hand
appliquéd, embroidered,
stuffed work

Joyce Gross Quilt
History Collection,
W2h001.045.2008

through completely. Cut-paper designs in E-2 and E-3 foil this symmetry.

As in many Baltimore Album quilts, red and green fabrics dominate the color palette. Solid Turkey red appears in every design save one (there is only one instance of red calico, in E-3), yellow calico is the most common accent color, and small-scale printed green fabrics are in every block but one. The repeated use of different green fabrics may indicate that the quilt's makers shared fabrics or, perhaps, that they all could afford and had ready access to the same yard goods. For example, one green fabric printed with small black ovals is in five blocks strewn across the quilt top.

Other elements common to Baltimore Album quilts that appear in the Pentz quilt are ombré fabrics (blocks B-4 and C-1); lattice baskets (blocks A-1, B-4, and E-1); reverse appliqué, which brings detail to a basket in A-1 and flowers in A-2 and C-2; and embroidery to define or articulate specific features (such as dots on strawberries in A-4, rough edges on leaves in C-4, and birds' legs in E-1). Dimensional effects abound. In block B-4 especially, layers of appliqué join with yellow and ombré blue accents, reverse appliqué, and a lattice basket to bring complexity

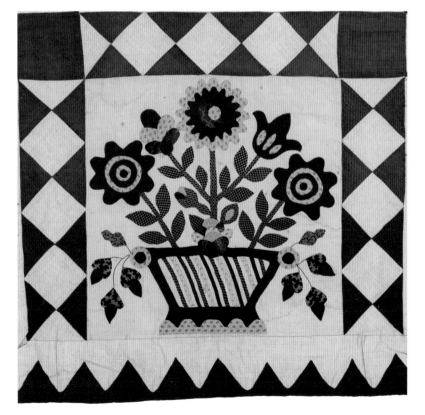

and interest. Beautiful ruched flowers join padded ones in block B-2, two padded love birds perch on a basket below twelve padded blooms and buds in block A-1, and seven lush red and white blooms burst and bow from an urn in block C-3. Bold sashing and a graphic appliquéd sawtooth border join the disparate designs.

As of this writing, the identities of this quilt's makers are unknown. Seven blocks carry names, however, which provide clues to the quilt's origins. All the inscriptions are inked, most by the same hand, and embellished with delicate inked floral designs below or to the side of the name. Two inscriptions (blocks C-2 and E-4) contain additional information: one is inscribed "Mary Frances Hare October 10, 1847," and the other reads "Julia Ann Pentz / Pitt. St. / Baltimore City / 1847." The seven inscriptions seem randomly placed and are oriented in three different directions.

Julia Ann Pentz, born in 1834, was thirteen when this quilt block was signed with her name. The other names (Eliza E. Murphy, Mary Frances Hare, Mary Ann Kidd, J. Armfield and James Y. Purvis, and [name unclear] Mary Washington) are those of children or young adults as well. US Census records indicate that in 1847 they ranged in age from eight to thirteen. What connected these young people? Who named them in this quilt and why?

A possible explanation is that the children's mothers were the quiltmakers and that their families were members of the same church, quite possibly a Methodist church. In the 1840s the Methodist Church in Baltimore was growing, with new congregations formed and churches built throughout the city. Religious affiliation and church attendance could have cut across the social boundaries that might otherwise have separated at least some of these children. Julia Ann Pentz, for example, was the daughter of an independent tradesman, a butcher. The Pentz family and four of the other families represented in this quilt lived in the "built-up portion of the city" in the 1840s. The two Purvis boys, however, were the sons of James Franklin Purvis, a former slave trader and, by 1842, a partner in a brokerage house. The Purvis brothers lived at "a country place . . . almost off the map of inhabited Baltimore" in the 1840s.[52] Perhaps the children's mothers gathered at the church regularly for a sewing circle and, around 1847, chose to follow the special quilt fashion of their city and make a Baltimore Album quilt, one they graced with their children's names.

MEXICAN WAR COMMEMORATIVE COMFORTER

The repeating image on this whole-cloth comforter depicts a Mexican War battle scene. The cylinder-printed design focuses on the moment Captain Charles May stopped General Rómulo Díaz de la Vega from firing a cannon during the Battle of Resaca de la Palma on May 9, 1846. The Mexican War continued for two more years after this early engagement, ending with the Treaty of Guadalupe Hidalgo, by which the United States gained California, Arizona, New Mexico, and the Rio Grande boundary for Texas, as well as portions of Utah, Nevada, and Colorado.

This comforter documents and commemorates an important historical event. As quilt historian Dr. Kathryn Ledbetter has noted, this bedcover is a "visual representation of patriotism in action," one textile among the profusion of news stories, books, lithographic prints, sheet music, banners, scarves, pennants, pottery, and cake boards produced during and following the Mexican War for a populace eager to strengthen its nation's identity and sense of destiny.[53]

The comforter top is composed of four panels that may originally have served as curtains. They are made of loosely woven, inexpensive cotton in muted, drab colors: brown, tan, olive green, gold, peach, and cream. The panels are hand pieced; top and back edges are turned in and crudely hand stitched. The ties appear red but in fact are made of brown thread, with red wool thread slipped under the top stitch, tied, and cut to create tufts. The batting is thick cotton. The back is composed of four panels, three from the battle-scene fabric and the fourth from a mosaic pattern of hexagons, an early example of printed patchwork.

The rendering of the Mexican War battle scene is complex—several stories unfold behind the central action between the American and Mexican officers. One soldier plants the American flag to the left of Captain May, and just beyond, two soldiers fight with drawn swords near the body of another. Dragoons charge from the left, the United States 8th Infantry advances on the right, and a large troop encampment is visible at the rear. In the upper left corner General Zachary Taylor, the hero of the Mexican War and, by 1849, the nation's twelfth president, sits astride a white horse. The entire scene repeats every 13½ inches.

Dr. Ledbetter investigated the provenance of this image as well as the origins of this textile's production. She concluded that the image was likely copied from an 1846 lithograph printed by Sarony & Major titled *The Capture of General Vega (in the Act of Discharging a Cannon) by the Gallant Capt. May of the U.S. Army, during the Engagement of 9th of May*. According to Ledbetter, the fabric could have been printed either in Britain or the United States, but she argues in favor of the textile's US origin, noting the proximity of New England textile manufacturers and reproduction artists to lithographic firms in New York and Philadelphia, including the firm that produced the original print copied for the textile.[54]

Mexican War Commemorative Comforter is one of the seventeen quilts Houston decorative arts collector Miss Ima Hogg acquired to serve as period furnishings for historic homes at her Fayette County, Texas, Winedale property. Miss Hogg intended for this comforter to continue its function as a bedcover, probably on a bed in Winedale's McGregor House.

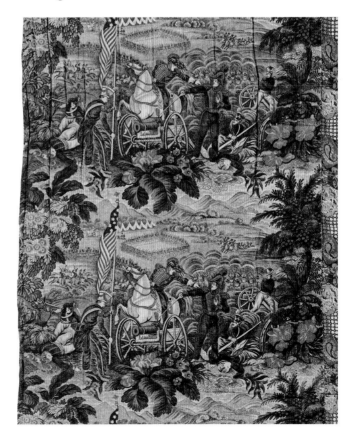

64

COMFORT
AND GLORY

**Mexican War
Commemorative
Comforter, front**

Maker unknown,
circa 1848

Cotton: 80 x 85 inches

Hand pieced, tied

Ima Hogg Quilt
Collection, W2h22.72

*Mexican War
Commemorative Comforter,*
back

-Q-
m
28
A527
R5
1846
TXC-22

The Rio Grande Quick
March, by John C. Andrews
(New York: Firth & Hall,
1846).

PINEAPPLE

Ima Hogg's hunt for nineteenth-century furniture and decorative objects with which to furnish the historic houses at her Winedale property in Fayette County, Texas, often took her on road trips to Pennsylvania. In the 1960s and early 1970s, one of her regular stops was Lamb's Mill Antiques, located in a historic mill farm just north of Kutztown, Berks County. Miss Hogg traveled to Lamb's at least twice in late 1963. During her October 14 visit she bought nineteen items, four of which she donated to Winedale: an earthenware bean pot, a walnut bench, and two quilts. One of the quilts is *Pineapple*. Miss Hogg's records do not provide information on the quilt's provenance aside from her acquisition of it at Lamb's. But the quiltmaker signed and dated her quilt in a tight pink cross-stitch on the lower left side, and so left the key to some of her and the quilt's history.

Hannah Reist (ca. 1825–1895) grew up in South Annville, Pennsylvania, and remained there her entire life. She never married, living much of her adult life with her brother John Reist. The town of Annville was originally settled around gristmills that served the area's agricultural community. US Census records for 1870 list John as a millwright along Quittapahilla Creek, which meanders through the Annville area. By 1840 the town boasted 600 people and 120 houses, and for a short time in the nineteenth century Annville was a site for silk and felt hat manufacturing.[55] In 1870 and 1880 the US Census listed Hannah's occupation as "keeping house." She made her quilt while still a young woman, probably learning her needlework skills from her mother, Nancy Reist.

Hannah's quilt features the pineapple, a recognized symbol for hospitality, welcome, and warmth used in all manner of furniture and home décor. In blocks set on point, pineapples sit on stout stems, each with leaves and a simple leaf rosette at the top. All have been finely and uniformly cut out and appliquéd. A quilting pattern of hanging diamonds in brown thread gives each pineapple a pinecone-like textured appearance. Hannah owned nearly enough fabric to make her entire quilt without resorting to piecing scraps. The single exception is on the quilt's right side, along the sawtooth inner border. Here she incorporated a second green and black calico to fill in as needed. The wide inner border, measuring a generous eight inch-

es, features a graceful row of appliquéd swags and looped ribbons, the latter stitched on the bias to create a smooth top curve on each. The quiltmaker finished her quilt with a variety of simple quilting patterns: outline quilting in the appliquéd blocks and sawtooth borders, cross-hatching in the plain blocks, and chevron quilting in the swag borders.

The quilt back is a lively warm brown and teal floral stripe, possibly a cotton furnishing print. The backing fabric is turned to the front to create a narrow binding. The pattern of fading on this quilt suggests that at some point the quilt was used on a bed near a window, regularly exposing the top center to sunlight. The border on the quilt's right side, perhaps pressed against a wall and, hence, shielded from natural light, retains its original colors—rich, deep green and strong, bright yellow.

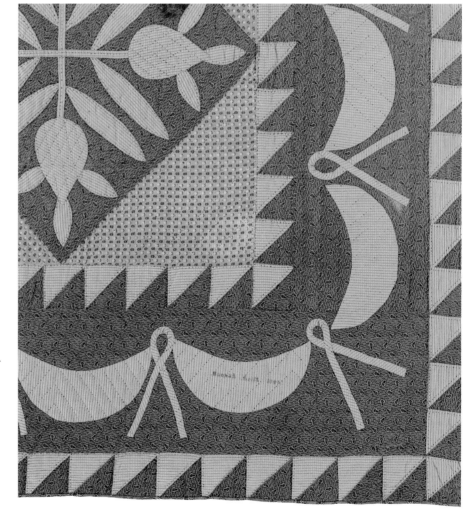

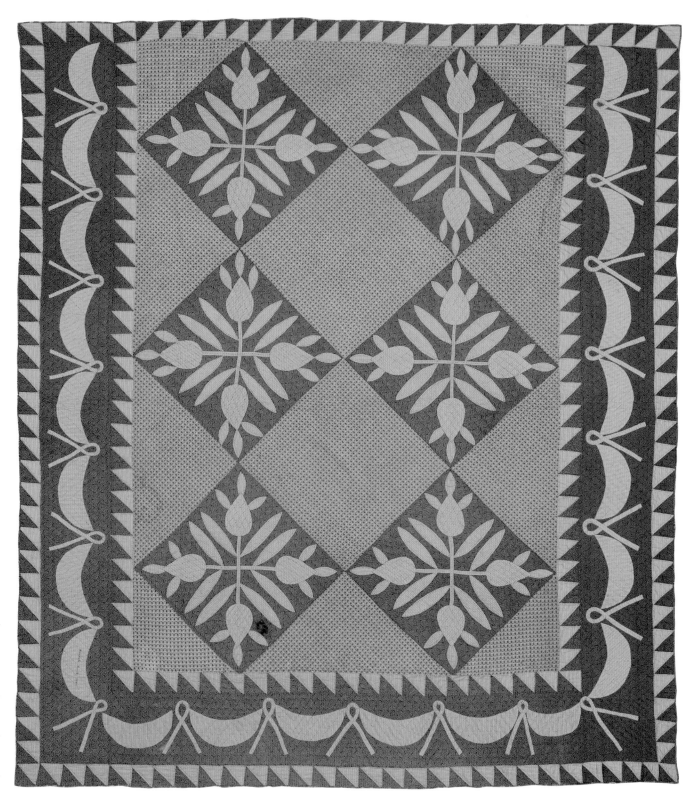

Pineapple, front

Hannah Reist, South
Annville, Lebanon
County, Pennsylvania,
dated 1849

Cotton:
75½ x 83½ inches

Hand pieced, hand
appliquéd, hand quilted

Ima Hogg Quilt
Collection, W2h5.67

Pineapple, back

PRINCESS FEATHER

An unknown quiltmaker appliquéd spiraling plumes, used solid red and green fabrics popular in floral appliqué quilts of the mid-nineteenth century, and added elaborate quilting to create her version of the popular Princess Feather pattern.[56] The result is a boldly graphic quilt unencumbered by the demands of uniformity.

The quiltmaker's appliquéd spiraling plumes are large and, in some areas, very closely spaced. The four spirals fit so snugly in the blocks that plumes nearly touch at the block seams. The large single plumes along the generous border are spaced irregularly—some are more than five inches apart, others less than three. The plumes themselves are similar throughout the quilt but not identical. The quiltmaker may have used a template to create the plumes, but she also improvised as she cut, blunting some tips, curving others, and changing the widths and lengths of lobed barbs as she sewed. In all she cut and appliquéd sixty-two deeply lobed plumes, a time-consuming and exacting task. Her appliqué stitch is very fine. She used white thread to appliqué all the red plumes but green thread for those in green.

The quiltmaker also created a central star in each spiraling design, appliquéing a thick red ring over the eight-pointed star. She took special pains to emphasize these spiral centers with a white blanket stitch along the ring's inner edge, placing the stitch's continuous line, which typically runs along a fabric edge to secure it, one-sixteenth of an inch inside the edge, creating yet another center ring, one meant to be seen.

Each deep border panel was added separately and embellished with a row of more plumes, nine to a side and six at quilt top and bottom. Some bend gracefully to the side; several stand nearly upright. The center shaft in others angles sharply to the right. The border's encircling sweep of alternating red and green plumes has an apparent misstep at the bottom left corner, where red plume meets red plume, and at the right corner, where green plumes collide. This is the inevitable result of the quiltmaker appliquéing an odd, rather than an even, number of plumes on each side. It is appealing to imagine that this was the quiltmaker's intention all along.

This quilt's stuffed work, cording, and quilting attest to its maker's expert needlework skills. Quilted feathers, some with as many as twenty-eight lobed barbs per side, are stitched between the appliquéd plumes. Each feather is long enough to span the width of the border. Given the narrow space between some appliquéd plumes, a few of the quilted feathers barely fit, though the quiltmaker managed to stitch them in, albeit only just. She also stuffed each lobe individually and corded each feather's shaft. Diagonal parallel-line quilting at eight to nine stitches per inch fills in the background, crossing all the appliquéd plumes. Here and there other stuffed floral motifs spill from quilt blocks into the border. Across the blocks, stuffed and corded floral motifs sit between the appliquéd spirals. Some are simple blooms; others are branched stems, all corded, with stuffed leaves, blossoms, and berries. Visible from the quilt back, knotted white cording at the shaft top or bottom and cotton bits protruding from stuffed work indicate that the quiltmaker introduced her padding from the back after she stitched together her quilt top, batting, and back.

At the quilt's center, the maker quilted a small plumed wreath filled with grid quilting. Embraced by four green appliquéd plumes, this wreath, though elegant, seems undersized and unremarkable. Perhaps the quiltmaker, determined to occupy every area with her lovely stuffed designs, simply quilted the wreath to fill an empty space. She certainly achieved this goal on the quilt's right side. Here she added an extra quilted feather, one that snakes along for more than thirty-three inches, representing a substantial commitment of time and labor. There is no corresponding motif on the left side.

The quilt's improvisational character and visible signs of heavy use suggest that it was created as a functional quilt rather than as an exceptional one saved for special occasions. Some owners, perhaps generations of them, had the good fortune to enjoy this unique and remarkable bedcover, one graced with the bold designs of an expert and imaginative quiltmaker.

Princess Feather is one of the quilts formerly owned by quilt historian and collector Florence Peto. As yet no information is known either about where or from whom Peto acquired this quilt or who made it or where. What is known is that Peto owned at least two quilts featuring this much-loved pattern. On October 7, 1948, she wrote

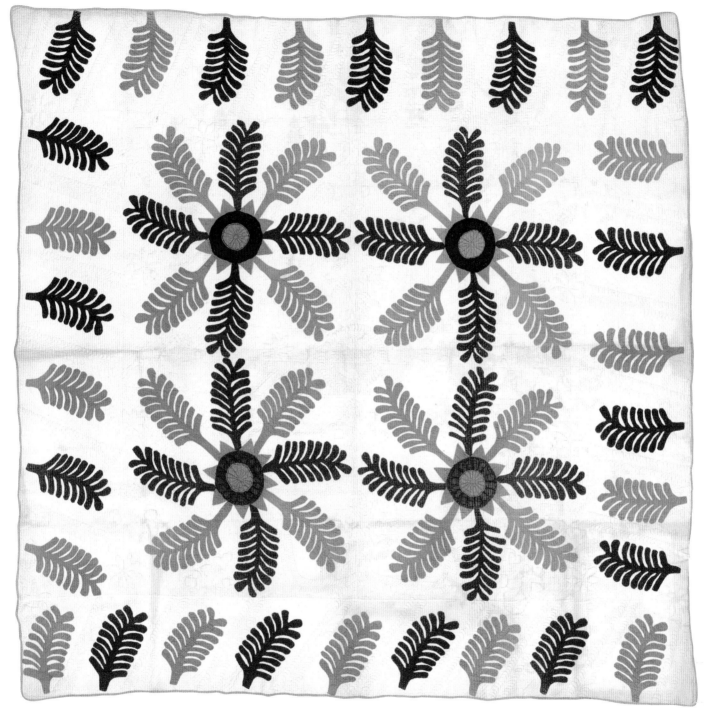

Princess Feather

Maker unknown,
circa 1840–1875

Cotton:
91½ x 90¼ inches

Hand pieced, hand
appliquéd, stuffed work
and cording, hand quilted

Joyce Gross Quilt
History Collection,
W2h001.029.2008

her friend Elizabeth Richardson with news that a trip to Pennsylvania resulted in her acquiring "three more quilts to add to the 65 that I have trouble finding places to store." Among them was her other *Princess Feather*, which Peto described in glowing terms: "One is a Penn-Dutch Princess Feather Wheel—four yard-square blocks of the 'Feather Wheel' with hex mark central motif and surrounded with lovely undulating tulip border. All in red, green, and yellow—vivid. Beautiful workmanship. Come to think of it, I doubt if I have ever seen an indifferently made Pennsylvania quilt! Some handsomer than others, but all carry neat to fine workmanship."[57]

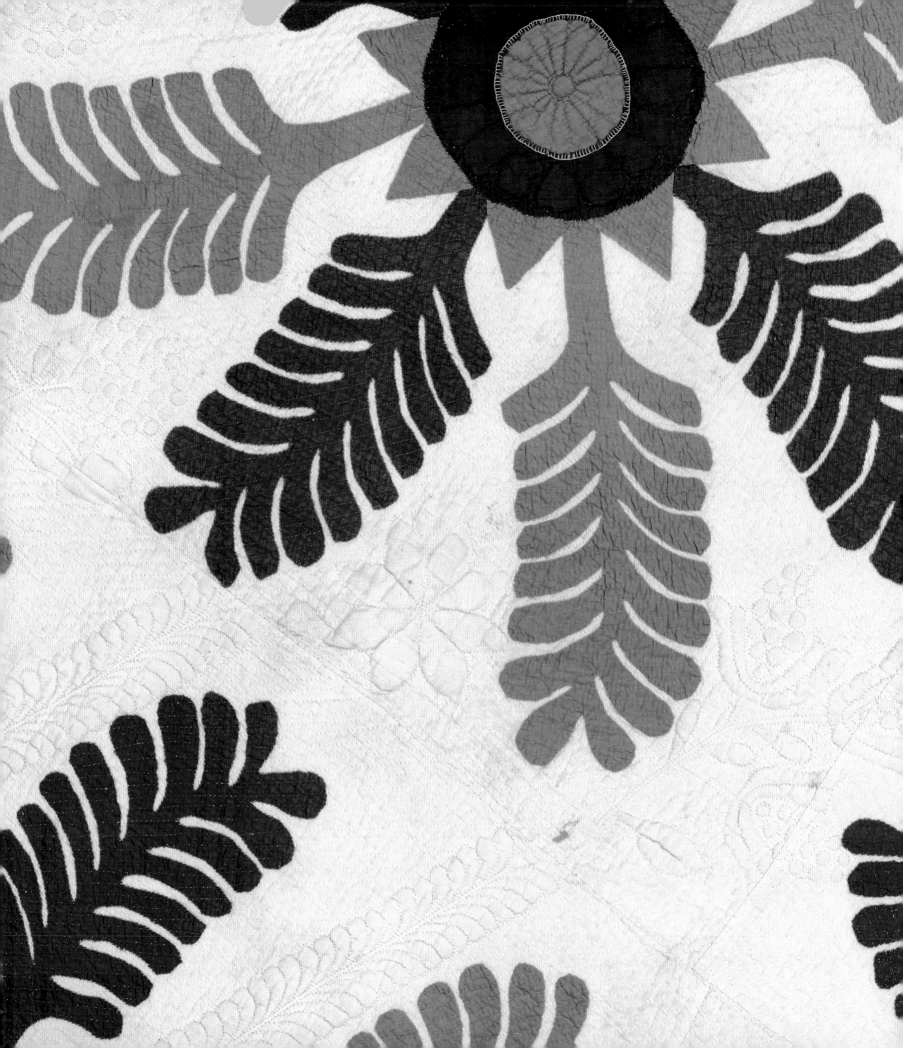

Christlicher Geburth und Tauff- Schein vor

Clarina Wagneria.

Ist auf diese Welt Gebohren, Im Jahr Christi Anno 1794 den 19 ten October. Seine Eltern sind, Christoph Wagner, Und dessen Eheliche Hausfrau, Maria Charlotta Geborne Göttelin, Seine Tauff-Zeugen sind gewessen, Henrich Guttmann, und dessen Ehefrau Clarina, gebohren und getauft In Bern Taunschip Bercks County, im Staat Pennsylvanien

Ich bin getauft ich steh im Bunde, durch meine Tauf mit Meinem Gott, so sprech ich stets mit frohem Munde

In kreuz und Trübsaal angst und noth, Ich bin getauft des freu ich mich, die freu de Bleibet Ewiglich

Birth and baptism certificate for Clarina Wagner, born October 19, 1794, Bern Township, Berks County, Pennsylvania. This example of fraktur, a Germanic style of decorative work on paper, is hand drawn and hand colored. Winedale Collection, W8b1.67.

CURRANTS AND COCKSCOMB

Currants and Cockscomb is another of the foundation quilts of the Winedale Quilt Collection. Ima Hogg donated the quilt to Winedale on August 9, 1972. The accession log lists the quilt along with seven other donations that day, including four cardboard church fans, a set of Swiss chambray curtains for one of the historic houses, and a paisley counterpane that Miss Hogg intended for use on a daybed. The records do not document where or by whom *Currants and Cockscomb* was made. One possibility is that it has a Pennsylvania-German origin and is a product of a decorative tradition that often combined naturalistic flower and bird motifs.

This red and green appliquéd quilt combines flowers, berries, vases, and birds for a wonderful folk-art look. The four spiraling flower and berry motifs are an early example of the Currants and Cockscomb pattern. The two large birds also feature cockscombs—the red crest of a rooster—although one bird's crest is now missing. The two birds' open wings, feathered tail feathers, clawed feet, and shield-like breasts, however, identify them as eagles rather than as roosters. The quiltmaker's abstract representation of four more cockscombs—the botanical version—appears in the quilt's center block, where they join to form compass points and to echo the floral cockscomb design in the four blocks. Four smaller birds, also with cockscombs (the crest-like bumps at the top of their heads), stand at the quilt's corners. The quiltmaker furnished all her birds with recognizable parts, including open eyes, which she created by stitching closely around a tiny circle of reverse appliqué.

As with the quilt's center motif, the paired berry, stem, and vase border designs in the corners are simple and abstract. Interestingly, the quiltmaker used solid green fabric to create the stems, berries, and vase bases in only three of her four border designs. In the fourth she used blue fabric for those same motifs—the same blue fabric as in the vertical cockscombs at the quilt's center. Close inspection indicates that this is indeed blue fabric, though now greatly faded, not an over-dyed green faded to blue. The quiltmaker's use of blue fabric in the center motif suggests that she chose it deliberately, not out of necessity or as an afterthought. Perhaps her choice to use blue fabric for the single border design was another touch of whimsy.

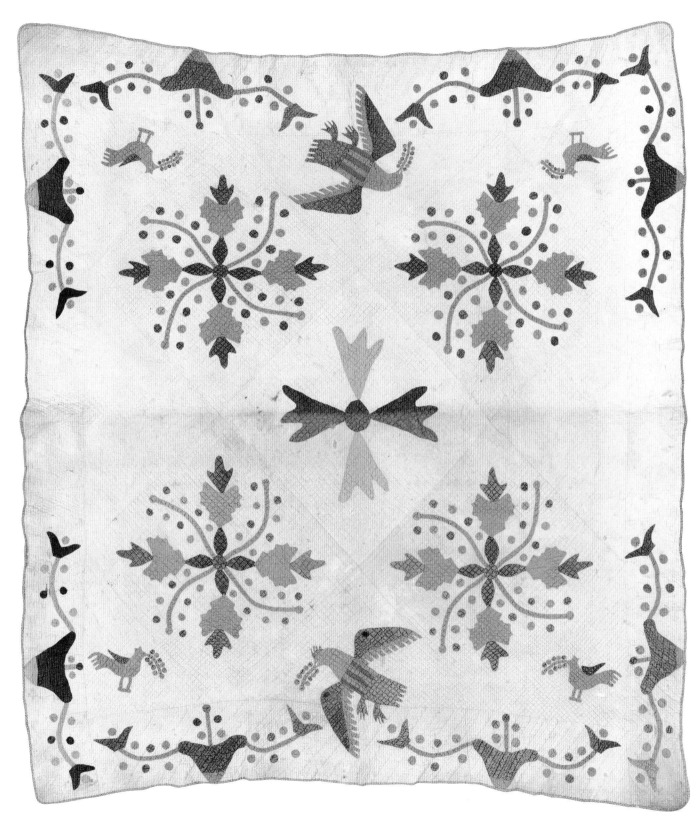

**Currants and
Cockscomb**

Maker unknown,
circa 1850–1875

Cotton: 74 x 84 inches

Hand pieced, hand
appliquéd, hand quilted

Ima Hogg Quilt
Collection, W2h23.72

By the late 1820s and 1830s, educational reformers in the United States were broadening the curriculum in some female academies and high schools to include mathematics and science. The goal was to develop a woman's mental discipline and to cultivate reasoning powers.[58] Was this quilt, with its precisely cut and hand pieced ninety blocks and more than four thousand tiny squares, created by a quiltmaker who was able to call on both her expert needlework skills and systematic training in mathematics, including geometry?

The pattern, sometimes called Single Irish Chain or Double Nine Patch, dates from the early nineteenth century. In this intricate example, the double nine-patch blocks are set on point, resulting in a straight grid over the quilt surface rather than the traditional diagonal grid. The quiltmaker pieced ninety nine-patch blocks, each one containing forty-five small green and white squares measuring a mere ⅝ inch per side. In all, she pieced 4,050 small squares. She also used the same green fabric throughout, indicating that she enjoyed the means to purchase the yardage needed for such a project. The fabric is an over-dyed green, with areas fading to yellow. The original green, still visible in a few spots, is deep and bright.

This quilt contains no batting, which probably helped the quiltmaker achieve upward of thirteen quilting stitches per inch. Like the pattern, the fine hand quilting is geometric—grids and parallel lines, all set straight across the on-point blocks. The quiltmaker used quarter-inch grid quilting in both the alternate plain blocks and in the white patches. In the nine-patch squares, however, she stitched a single line across and down the middle, quartering each square. She also quilted each block separately, and though many of the grids match up, the connections are not quite perfect throughout.

The quiltmaker also brought fine detail to her quilt corners and edges. The corners are mitered, and at the edge the front and back edges are turned in. To provide extra support along this knife edge, the quiltmaker added a separate narrow binding that is visible only from the back.

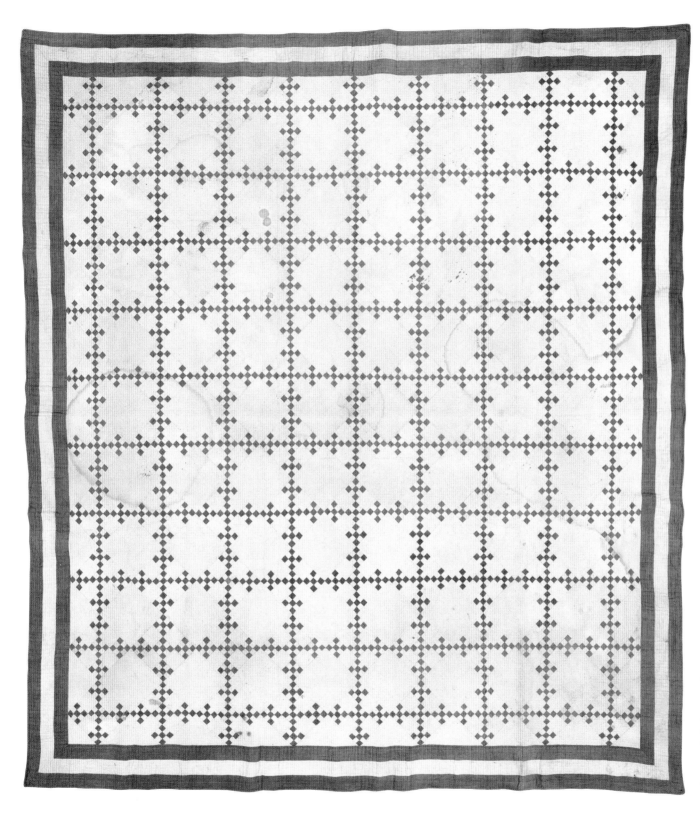

Irish Chain

Maker unknown,
circa 1850–1870

Cotton: 83¾ x 93 inches

Hand pieced,
hand quilted

Ima Hogg Quilt
Collection, W2h10.67

Wooden bride's box, late
eighteenth century. Such
boxes were made in the
United States or in northern
Europe and then brought
to America by immigrants.
They were a traditional gift
from a groom to his bride,
often meant to store special
items from her trousseau.
Winedale Collection,
W-7a1-67a-b.

This four-block quilt featuring identical potted bouquets of flowers and berries is part of the popular nineteenth-century red and green appliqué tradition in quilts and the broader tradition of decorating furniture and other household objects with painted floral designs. The quilt pattern, often called Pots of Flowers, is a complex composition that has remained popular with accomplished quiltmakers since the 1850s.[59] Ima Hogg acquired the quilt from an unknown source and placed it at her Winedale property, where it often graced a bed in one of the historic homes.

In this variation the quiltmaker used three solid colors only—Turkey red, yellow, and an over-dyed green—to create an intricate vase constructed from thirteen pieces, including base and curled handles. Stems of berry clusters and tulip-like blooms ascend from the vase, branch, bow, and stand erect. The berries are raised by having their edges turned under. Each berry is attached to a branch with a delicate length of chain-stitched embroidery. Unlike some quilts in this pattern, this one does not include birds perched at the bouquet's center branches.

One of the hallmarks of the Pots of Flowers pattern is its symmetry. In this *Potted Tulip* variation, the block designs are set opposite one another top to bottom, and side-to-side as mirror images, creating interesting secondary designs along the quilt's midlines. The quiltmaker surely intended each of her blocks to appear identical, but she improvised a bit, too. For example, she used both white and pale yellow embroidery thread to attach her berries to their stems. Her use of the colors seems random—both colors even appear in one of the blocks, and the number of berries varies per cluster.

Pots of Flowers–patterned quilts often are finished with a decorative border, one that sometimes echoes the block design by featuring appliquéd leaves, stems, and berries. This quiltmaker, however, chose simplicity. She attached a generous border on each side, leaving it free of appliqué. Aside from her four-block designs, the quiltmaker's narrow red binding is her quilt's only other color. What she omitted in border appliqué, however, the quiltmaker supplied in lavish quilting, at twelve to thirteen stitches per inch. A lush, deeply undulating feathered vine beautifully sweeps around the quilt with perfectly turned corners. She also chose only two other quilting patterns: diagonal parallel lines on the border and, as a background to the richly appliquéd blocks, simple grid quilting.

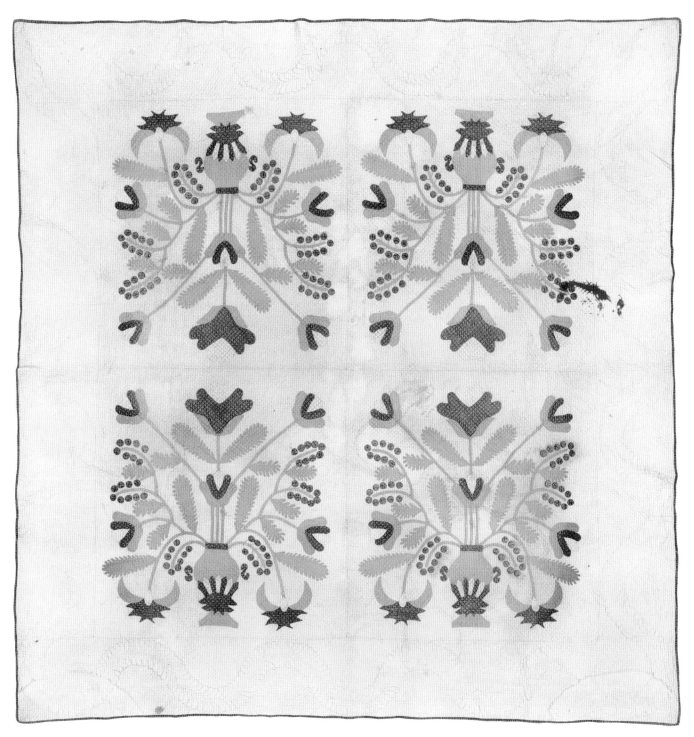

Potted Tulip

Maker unknown,
circa 1850–1860s

Cotton: 85 x 86¾ inches

Hand pieced, hand
appliquéd, hand quilted

Ima Hogg Quilt
Collection, W2h16.70

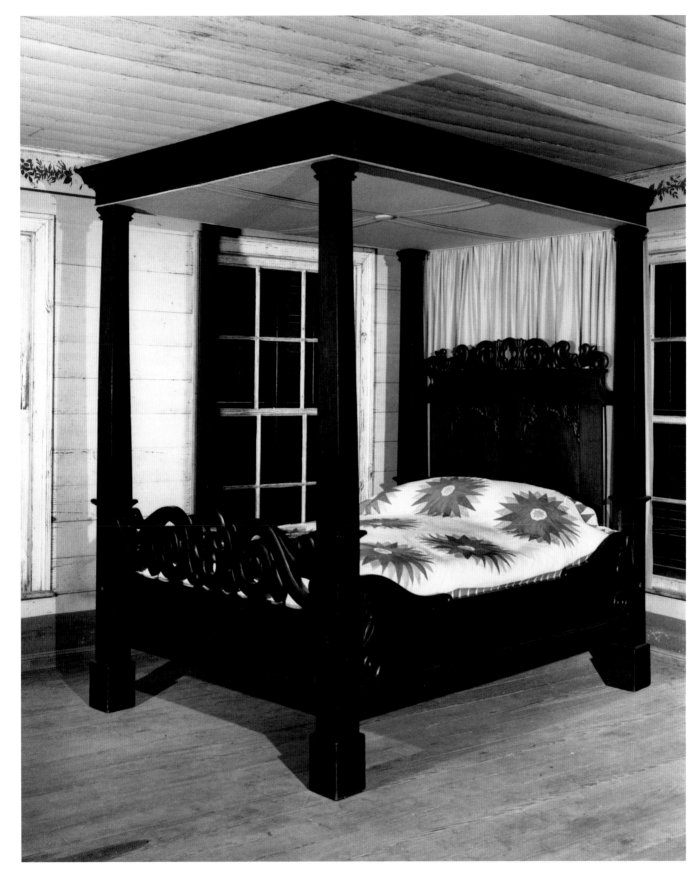

Umland bed, 1861, in
the McGregor House at
Winedale. Ima Hogg donated
the *Mariner's Compass* quilt
on the bed in 1971. Winedale
Collection.

WHOLE-CLOTH MEDALLION QUILT

This solid red quilt is closely associated with the Briscoe Center's Winedale Historical Complex, a property located on 225 acres of land near Round Top, Texas, and home to historic structures and outstanding examples of early Texas furniture and decorative arts. Ima Hogg, the patron-philanthropist of Winedale, purchased this quilt for use as a period bedcover in one of Winedale's nineteenth-century homes. She acquired it in September 1971 at Houston's annual Theta Charity Antiques Show, founded in 1952 by Kappa Alpha Theta Houston alumnae. Within days of her purchase, Miss Hogg brought it and two rugs to Winedale, a property she donated to the University of Texas in 1967 but whose structures she continued to restore and furnish through the early 1970s. Her plan was to use all three items in Winedale's McGregor House, built in 1861 in Washington County, Texas. After restoring the home, Miss Hogg furnished it only with pieces produced by known Texas furniture makers, selecting them from her own collections and purchasing others for specific rooms

in the house. The *Whole-Cloth Medallion Quilt* may have graced the home's Umland bed, a richly designed, walnut high-post bed made by Johann Umland in 1861 in Chappell Hill, Washington County, Texas.

This quilt is a bit of a curiosity. The quiltmaker's intricate designs, beautifully executed stuffed work, and silk back contrast markedly with the sturdy Turkey red cotton twill that creates the quilt front. Both the hand quilting and the channels for the stuffed work were sewn using a single strand of heavy white thread, probably to accommodate the stiffness of the twill and the thick cotton batting. The quilting stitches are large and irregular, at five to six stitches per inch. The quilting patterns, such as the grid pattern around the inner medallion, add dimension to the quilt. In the inner medallion, the quiltmaker also used stitching to create detail on several figures: wings on birds, the lamb's eye, and texture on the urn. The quilt has no separate binding—the edges are turned in and crudely whipstitched together with heavy white thread.

The solid red sets off the elaborate dimensional motifs, the compelling feature of this quilt. The focal point is the inner medallion, measuring twenty-three by twenty-five inches. In it, stuffed work creates two curving branches with leaves—probably laurel branches—that spring from an urn with handles. The branches turn toward each other, each one supporting a dove at its tip. A small heart floats between the facing doves. Centered directly below the heart's bottom tip is a triangle surrounded by thick sun's rays. An animal, most likely a lamb (with an unusually long tail), rests inside the triangle. These designs at first blush appear to be Masonic, but they more likely are Western and Christian symbols: the triangle representing the Trinity, the dove symbolizing the Holy Spirit, and the lamb a traditional representation of Jesus. Stuffed work also graces the quilt's deep border and its four lush corner motifs, each one featuring an intricate urn containing a three-stemmed plant with blooms. This floral motif is repeated along the border as an undulating vine with leaves and blooms.

Most of the quilt's backing fabric is striped silk. The quiltmaker, however, apparently lacked sufficient silk to back the entire quilt, and so took steps to achieve the necessary length. She pieced narrow bands of red twill at both

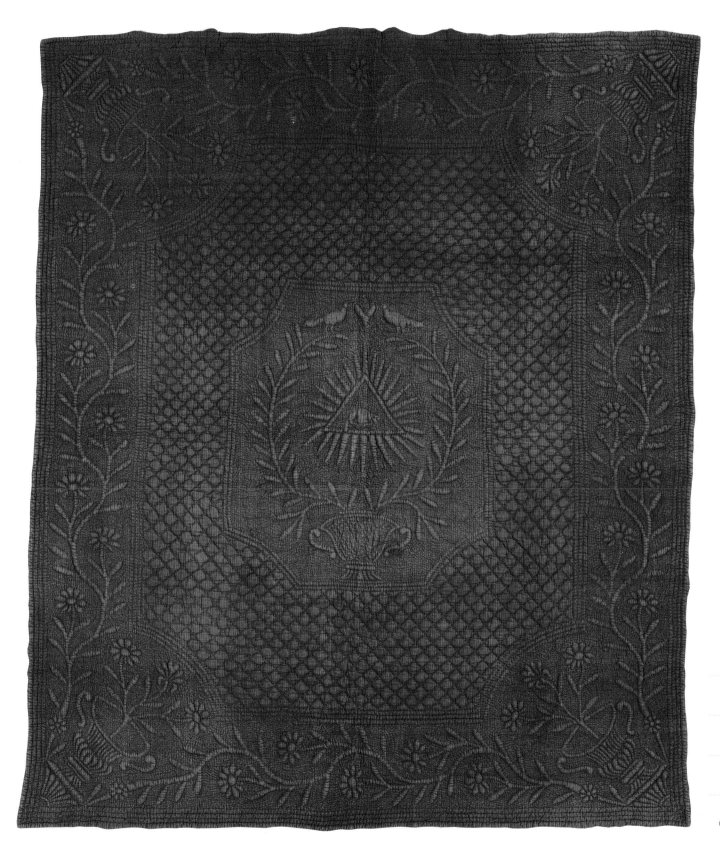

**Whole-Cloth
Medallion Quilt**

Maker unknown,
circa 1850–1870

Cotton twill, silk:
57 x 65¾ inches

Hand pieced,
stuffed work

Ima Hogg Quilt
Collection, W2h17.71

sides and at the bottom and added a narrow band of the silk along the back's top edge. Much of the silk fabric is in poor condition (noted as "badly worn" at the time Miss Hogg donated it to Winedale), with the top edge showing the greatest damage, probably from years of holding and pulling that end of the quilt. The silk fabric weave is very loose, revealing batting in many places and providing a clear view of the quiltmaker's stuffed work construction. The silk threads covering the stuffed lamb, for example, are almost entirely worn away, leaving only a dense knot of cotton padding. It is easy to see where the quiltmaker separated threads to introduce cotton padding.

*Whole Cloth Medallion
Quilt, back detail*

Mary Butler created thirty-six blocks for *Paisley Hearts*, each measuring just over one foot square. Before joining the blocks, she cut papercut motifs from paisley fabric, each as a single piece, then appliquéd one per block. Mary used two red paisley prints for her motifs, fabrics so similar that they appear identical. She then added thin batting and a back to each block, filled the block's background with diagonal parallel-line quilting, and edged each block with more red paisley. Mary finished her quilt by whip-stitching the blocks together from the back.

The construction of individually finished blocks joined to create a quilt often has been called the "quilt-as-you-go" technique. Quilt historian Pamela Weeks identified a subcategory of quilts made using this technique: "potholder quilts."[60] Weeks defines potholder quilts as those whose blocks "are not only layered and quilted individually, but [whose] edges are finished before the blocks are joined." Weeks notes that, in terms of construction, each potholder quilt block can "stand alone as a finished one-block quilt. As there are no raw edges, the finished blocks are tightly whip stitched together from the back, not seamed, to form the larger quilt."[61]

This definition describes Mary's *Paisley Hearts* precisely, and Weeks's research and findings help identify how her quilt compares to other potholder quilts. For example, Mary very likely made her *Paisley Hearts* quilt in Massachusetts, a prime source for the potholder quilts that Weeks examined. According to Weeks, 78 percent of the potholder quilts she studied (a total of eighty-one in all, dating from 1837 to 1930) are attributed to New England, with the majority of these coming from Maine or Massachusetts. Other aspects in *Paisley Hearts* are similar to many of the quilts Weeks studied, including fabric (most are cotton), pattern (half repeat a single pattern), and edge treatment (80 percent are finished with edge binding). Most potholder quilts she reviewed, however, contained little or no batting. *Paisley Hearts*, notably, contains cotton batting. Additionally, *Paisley Hearts* is not inscribed, whereas Weeks found that 59 percent of her study set had more than one inscription on the quilt front.[62]

There was only a little Butler family history conveyed to Joyce Gross in 1973 when she acquired *Paisley Hearts* from a Butler family member. This history states that quilt-

Paisley Hearts
top, *front*;
bottom, *back*

Mary Butler,
probably Cambridge,
Massachusetts,
circa 1850s

Cotton: 81 x 81 inches

Hand pieced, hand
appliquéd, hand quilted

Joyce Gross Quilt
History Collection,
W2h001.061.2008

maker Mary Butler lived for a time in Cambridge, Massachusetts, where she and husband Francis Patrick Butler raised at least one child before moving to San Francisco in 1859. Family records state that the Butlers traveled from the East Coast to San Francisco by ship and "came thru the Isthmus." By 1859 such a trip, already made for ten years by gold seekers heading to California, would have been but a brief journey by train across the isthmus, made possible by the completion in January 1855 of the Panama Railway.[63] It is poignant to consider that when Mary made *Paisley Hearts*, her move thousands of miles west was some years in the future. Perhaps she never thought of *Paisley Hearts* as a friendship quilt and, so, missed the opportunity to ask loved ones and friends to ink their names and messages of remembrance on it.

In San Francisco, Mary may have worked as a milliner, employment that possibly was the source of fabrics she used in her *Lone Star*, circa 1880s. A pieced star pattern offers a real challenge when made using silks, velvets, and taffetas, as in this quilt. Precise piecing and sharp points, hallmarks of the pattern, are often hard to achieve with these luxury fabrics. In *Lone Star*, Mary used paper piecing to help give stability to the fabrics as she created her rows of pieced diamonds. Curiously, she machine quilted the quilt top's lavender background before appliquéing onto it the central six-pointed star and its satellite stars and diamonds. Adding the backing fabric also came later; hence, the machine quilting is not visible on the quilt's back.

Lone Star

Mary Butler,
San Francisco,
circa 1880s–1890

Silk and velvet:
80 x 93 inches

Hand and machine
pieced, hand appliquéd,
machine quilted

Joyce Gross Quilt
History Collection,
W2h001.075.2008

This red and green appliquéd quilt features the bald eagle, the American national emblem since June 20, 1782, when Congress adopted the bird for the Great Seal of the United States. Since then, the eagle has been incorporated in all manner of practical objects and decorative arts, including on furniture, bandannas, metalwork, porcelain, and quilts. During war, political events and elections, and patriotic celebrations, the eagle as national symbol has been ever present.

Civil War–era Union envelopes with eagle designs. Whitney Smith Flag Research Center Collection, 2.325/AAA29.

Many nineteenth-century quilts feature the bald eagle appliquéd at the quilt center as part of a medallion or positioned four eagles around and facing a center design element, such as a wreath. But there also are quilts with four, even nine eagles appliquéd across the quilt, plus quilts with smaller eagles appliquéd as part of a border or secondary design. The typical configuration of the eagle in these quilts favors the design in the Great Seal: the bird with chest forward and covered with a shield (often represented by a contrasting color), head turned, wings outstretched, and tail feathers down and open. The eagle's legs, if present at all, are often short, and their talons carry only a faint representation of the thirteen arrows and olive branch depicted in the Great Seal.

The eagles in *Six Eagles* follow that design. Like many of their counterparts, these birds are rendered as simple, stylized forms that appear flat and rigid against a white background. Somehow, though, they also manage to be endearing, almost comical, perhaps owing to their red skullcaps and large, round eyes. These six eagles are stacked in two rows on two panels measuring 30½ × 75 inches each. The eagles are large, each one twenty-four inches from top to tail tips, with a thirty-four-inch wingspan. Altogether their figures required considerable green fabric. The quiltmaker likely cut the body shapes, including shields, eyes, and caps, from her own handmade paper templates. She did not cut the bodies whole, from a single piece of fabric. Instead, she nearly always cut the talons and wing tips separately and in varying sizes. This variation in the size suggests that the quiltmaker cut her shapes in whatever way made the most efficient use of the green fabric.

The two rows of eagles are framed on three sides by wide panels containing a decorative floral border. The bottom corner blocks sport eight-pointed stars cut from whole cloth. The over-dyed green fabric has faded to yellow, with blue swatches and streaks visible here and there. Most of the motifs in this quilt are finely appliquéd. The red buds tucked into green petals, however, have been pieced. The hand quilting, at seven to nine stitches per inch, is in a mix of patterns, including parallel lines, chevrons, and grid quilting. The edge is narrow, with the back turned to the front.

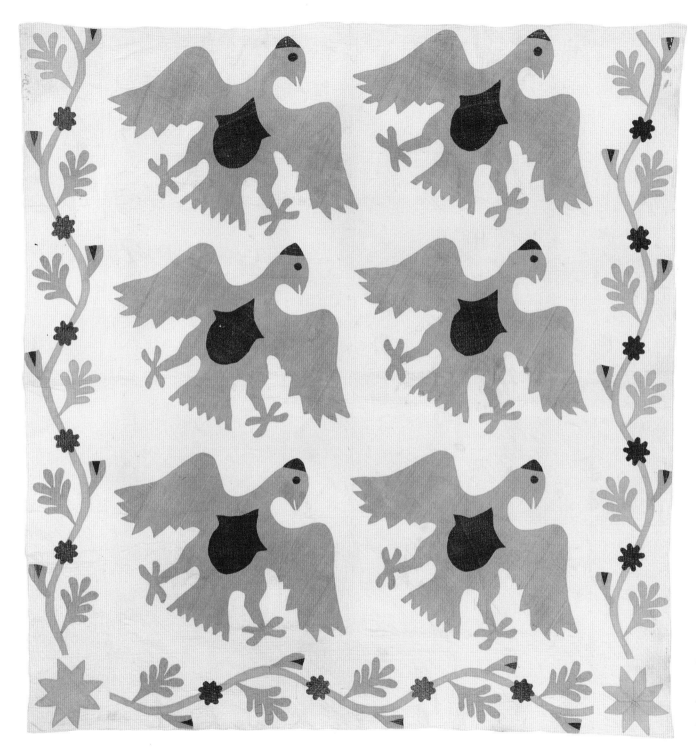

Six Eagles

Maker unknown,
circa 1850–1880

Cotton: 85 x 87½ inches

Hand pieced, hand
appliquéd, hand quilted

Joyce Gross Quilt
History Collection,
W2h001.033.2008

Sheet music with bald
eagle, 1861, honoring
Major General George B.
McClellan. Whitney Smith
Flag Research Center
Collection, 2.325/AAA4.

FRIENDSHIP ALBUM APPLIQUÉ

*Stitch by Stitch, your work is made
complete
And the knots and ties are hid so neat,
That all must say, much care's been taken,
But they'l [sic] show if a thread is broken.*

*To hid [sic] our <u>knots</u> in life, we study,
But to nick the thread, some-one's ready,
If that do'nt [sic] do, they'l turn us over;
But all our <u>Ties</u> we still may cover.*[64]

This poem comparing life's trials to stitchery is one of sixteen messages to Virginia Reiley inked by friends and relatives on a quilt probably completed in the early 1850s. Each inscription is in a different handwriting. Several are dated, with years ranging from 1849 to 1851, and four cities are recorded: Columbia, Cincinnati, and Madisonville, Ohio, and New Orleans. The quilt's inscriptions support our understanding of the close link between autograph albums and friendship quilts. Popular by the 1820s, autograph albums are tangible keepsakes that reflect and document personal and community relationships. As with these paper albums, this friendship quilt contains poems, pieties, notes of affection and friendship, and messages of hope.

Most messages in this quilt are lengthy and poetic. Their content tells us that Virginia Reiley (referred to as "Aunt" in two inscriptions) was an unmarried adult living away from friends and family, several of whom resided in or near Cincinnati. One friend's message, from Cincinnati, describes Virginia as a "distant friend." Another, written by I.P.A. of New Orleans, indicates that he may once have been Virginia's suitor: "Well, peace to thy heart, though / anothers [sic] it be / And health to thy cheek, though it bloom / not for me / ..." Still another verse refers directly to the quilt itself, expressing the hope that it will bring "peaceful slumbers and blissful / dreams ..." Was Virginia far from home and about to marry? Was she away at school? Had she left home for some distant place, in the West, perhaps? Or was Virginia seriously ill and being treated in an institution? Several inscriptions allude to the great loss should Virginia be "taken from our grasp."[65]

Friendship Album Appliqué is a single-pattern quilt made by one person, probably Virginia's mother, E. Reiley, who also signed the quilt. It is an unusual pattern, featuring a papercut motif surrounded by strawberries linked to it by slender stems embroidered with green wool yarn. There are 192 strawberries in all, each formed with a green base and a red calico berry. A complementary red calico creates the narrow homemade binding, separately applied.

The quilt is heavily and beautifully quilted. Small feathered wreaths sit between the strawberry stems, and large feathered wreaths and harps grace the alternate plain blocks. Hanging diamonds or parallel lines fill the centers of both. Parallel-line quilting fills in the background. Quilting stitches, like the appliqué and block piecing stitches, are fine and regular, at eight to nine stitches per inch. Remarkably, pencil lines that marked quilting patterns and some message placement are still easily visible. These lines plus the intact binding suggest that Virginia Reiley cherished this quilt, rarely used it, and probably never washed it.[66]

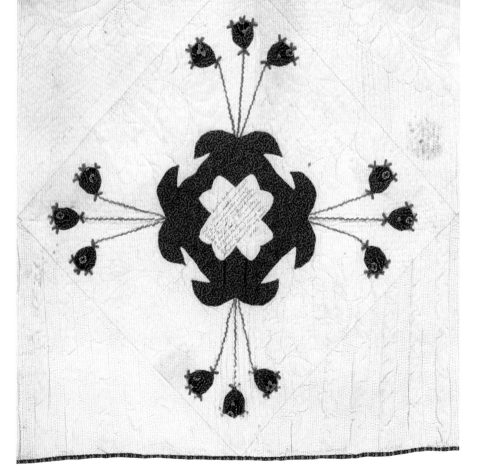

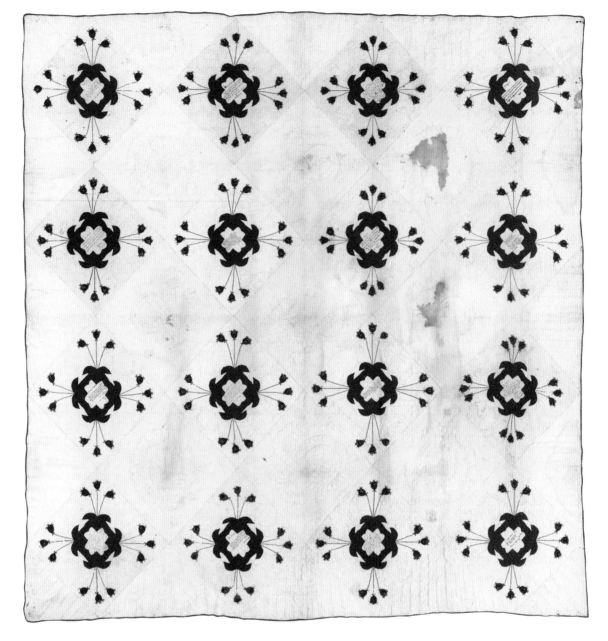

**Friendship Album
Appliqué**

Probably made by
E. Reiley, Ohio,
circa 1851–1853

Cotton: 93 x 98 inches

Hand appliquéd, hand
pieced, hand quilted,
hand embroidered

Kathleen H. McCrady
Quilt History Collection,
W2h102.06

The green papercut appliqué motif creates an un-usually large signature area. The variety of handwritings confirms that individuals wrote their own text. The dates, ranging from 1849 to 1851, indicate a quilt several years in the making. Crowded messages in some signature areas suggest that at least a few messages were inscribed on the white blocks before the papercut motif was appliquéd on to frame the inscription.

We wish we knew more about Virginia Reiley and her mother, the probable quiltmaker. We do know that E. Reiley penned her daughter a heartfelt message of hope on this quilt. It was a message her daughter could read again and again as she held the quilt close the rest of her life.

To Virginia
A bright and beautiful bird is
hope. It will come to us o'er the
darkness, and sing the sweetest
song when our spirits are saddened
and when the lone soul is weary
and longs to pass away,
it warbles its sunniest notes
and lightens again the stronger
fiber of our hearts.
Your Mother
E. Reiley
Nov. 11 1850

1.
Thy friend
Youth like those flowers
Are fine and gay
But less than hours
They turn to clay

Remember
and never forget
Sallie Holman

2.
To Aunt Jenny
The eyes that beam so fair and bright
The hands that wrought the task
Would be valued more in after years
If taken form [*sic*] our grasp

Your niece Jenny
March 19, 1851

3.
To Virginia
A bright and beautiful bird is
hope. It will come to us o'er the
darkness, and sing the sweetest
song when our spirits are saddened
and when the lone soul is weary
and longs to pass away,
it warbles its sunniest notes
and lightens again the stronger
fiber of our <u>hearts</u>.

Your Mother
E. <u>Reiley</u>
Nov. 11 1850

4.
To Virginia
May you ever under this innocence
Repose
Like the dew drop under the morning
rose
May all your days in happiness end
Is the wish of your sincere friend

Kate

[Second Row, left to right]

5.
To Jenny
Friendship can render trifles dear,
Oh! May it lend a charm to this,

Then take with it my love sincere
And wishes for your lasting bliss

Esther
Jan. 16th
1851

6.
"Let it come and not be fearful
What the plight of time may bring
Visions bright, and specters fearful
Are behind his shading wing
And to all as past he flieth
Their allotted part he bears
But his burden lightest lieth
On the heart that n'er despairs"

Madisonville, O.
J. D. J.

7.
Virginia
Accept of this moment of friendship
With the wish for an unchanged
One here, in this transitory world,
The hope of being associated in
A changeless time.

Jane
Dec. 22, 1849

8.
The earth can boast no purer tie,
No brighter, richer gem,
No jewel of a lovelier die
Than "Friendship's diadem."

Then may this ray of light divine
N'er from our bossoms [*sic*] fade,
But may it on our pathway shine,
Till death our hearts invade

I. A.
Cincinnati 1850

[Third row, left to right]

9.
To aunt Virginia
May the Wreath which encircles thy brow
Ever be as pure and as bright as now.
But alas, it must wither and go to decay
And with this, forever it must pass <u>away</u>.

Your niece
C. A. I.
Nov. 9th, <u>1850</u>

10.
To
Miss Virginia Reiley
<u>Well</u>, peace to thy heart, though anothers
[*sic*] it be.
And health to thy cheek, though it bloom
not for me!
While, far from the eye, oh! perhaps
I may yet,
Its attraction forgive and its splendor forget

I. P. A.
New Orleans
July 11th 1850

11.
"May peaceful slumbers and blissful dreams
ever attend thee, whenever thy fair form
shall be enveloped beneath folds of
this beautiful quilt, is the prayer of

your sincere friend
E. C. B.

12.
To Virginia
Sweet is
the memory of
a distant friend, like the
last rays of a declining sun
it falls sweetly yet
softly on the
Seed

———————
G. M. W.
Cincinnati

[Fourth row, left to right]

13.
To Miss V. R.
Lady, I have looked upon thy face
And beauty, kindness, virtue, grace
Have all combined to make thee fair
O! may thy fortune be as bright
As are thoes [*sic*] eyes, whose gentle light
Thy features now so softly wear.

June 19, 1850
M. M.

14.
To Jenny
Mature in every youthful grace
And more than beautiful of face
Refined of heart and free from guile
Gladdening all bosoms with her
smile.

Jane E. Reiley

15.
Columbia Feb. 9th——50
Stitch by Stitch, your work is made complete
And the knots and ties are hid so neat,
That all must say, much care's been taken,
But they'l [*sic*] show if a thread is broken.

To hid [*sic*] our <u>knots</u> in life, we study,
But to nick the thread, some-one's ready,
If that do'nt [*sic*] do, they'l turn us over;
But all our <u>Ties</u> we still may cover.

W. P. E.——

16.
To Miss Virginia Reiley,
She who most attracts
Can longest refuse.

T. A. Stevens
Cincinnati Nov. 1850

Inked inscriptions on
*Friendship Album
Appliqué*

COMFORT
AND GLORY

Georgia native Joanna E. Troutman (1818–1879), known as the "Betsy Ross of Texas," gained her legendary status in Texas history in 1835 when she designed and made a flag of white silk for the Georgia Battalion to carry to Texas as volunteers in the Texas Revolution. She also is very likely the maker of this improvisational red and green appliqué quilt.

Legend has it that seventeen-year-old Troutman saw Georgia volunteers camped near her father's Troutman Inn and "was so deeply stirred by the talk of oppression and tyranny that she longed to be of help to the Texas cause." Using two of her silk gowns—one white and the other blue—she sewed a flag with a large blue star on a white field.[67] The flag carried two inscriptions: "Liberty or Death" on one side, and the Latin phrase "Ubi Libertas Habitat, Ibi Nostra Patria Est" ("Where liberty dwells, there is our fatherland") on the other. The flag's five-pointed star is an early use of the star that appears on the Lone Star Flag adopted by the Texas Congress in 1839 as the national flag of Texas. Troutman's flag was raised at Velasco on January 8, 1836, above the America Hotel, and then carried to Goliad, where it was raised again, this time as the national flag when news arrived of Texas's declaration of independence from Mexico. Unfortunately, the flag became entangled in the halyards and was torn to shreds as it was lowered.[68] In 1913, well after Troutman's death in 1879, Texas Governor Oscar B. Colquitt petitioned to have her remains removed to Texas for reburial at the State Cemetery in Austin. A bronze statue by Pompeo L. Coppini graces this grave site, and Troutman's portrait hangs in the State Capitol. Fittingly, the statue depicts Joanna Troutman, needle in hand, sewing the flag.[69]

If Joanna Troutman is indeed the maker of the *Troutman Quilt*, she probably made it after 1851 but before 1877, two years before her death in 1879. During those years Troutman was married first to Solomon Pope, from 1837 to 1872, and then to William Vinson, from 1875 until her death. Extensive machine piecing on the quilt's border dates the quilt to sometime after 1850, probably the earliest date a private family, even one with the resources of Joanna Troutman Pope, could have owned a sewing machine. The quilt remained with Vinson family members and descendants until its acquisition by the Briscoe Center in 2013. Family stories always identified the quilt as the *Troutman Quilt* and attributed it to the Troutman family and to Joanna, stating that family members gave the quilt to Joanna's niece Ellen Roberta Vinson.[70]

The *Troutman Quilt* is a four-block, red and green appliqué quilt with chrome orange accents. The blocks, machine joined, measure about twenty-eight by twenty-eight inches. The orientation of the four large floral patterns is the same, giving the quilt an obvious top and bottom. The patterns are an original design, and a highly improvisational one, suggesting that the quiltmaker was fearless about deviating from conventions. Each block features a fanciful but vigorous thick-stemmed plant spouting up and out from a tiny red pot. The branching, central up-

Bronze statue of Joanna Troutman, by Pompeo Coppini, Texas State Cemetery, Austin. Photograph by Paul Wentzell.

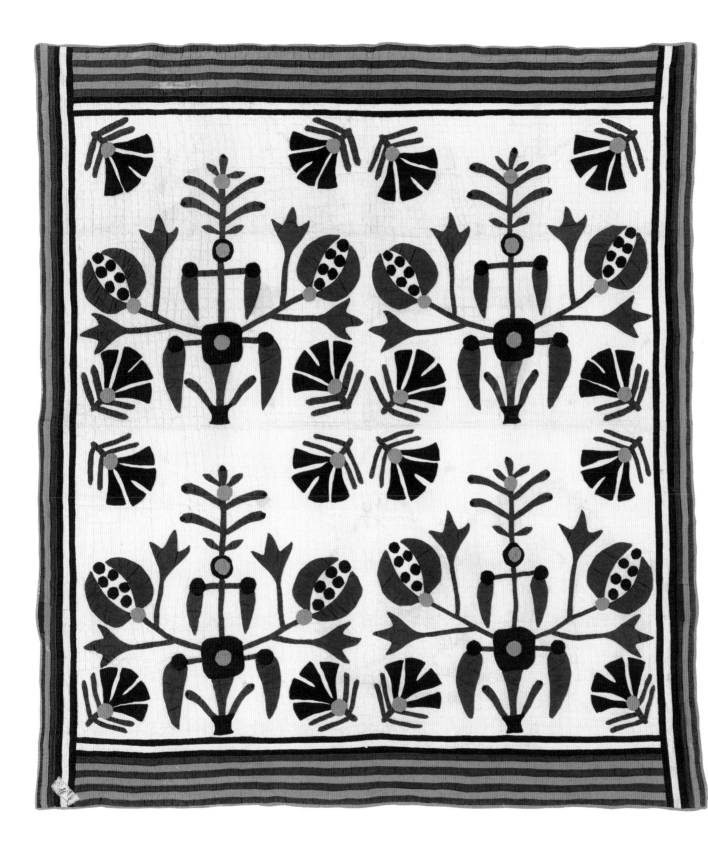

Troutman Quilt

Attributed to Joanna E.
Troutman, Crawford
County, Georgia,
circa 1851–1877

Cotton: 65 x 72 inches

Hand appliquéd,
machine pieced,
hand quilted

Karoline Patterson
Bresenhan and Nancy
O'Bryant Puentes Quilt
Collection, 2013-214

right stem resembles the popular tree-of-life pattern, but the four heavy hanging pepper-like buds contradict that form. Two branching stems sport massive blooms or fruits open to reveal seeds, surely the quiltmaker's representations of pomegranates. Identical floral designs at the corner of each block point inward, both embracing the bold plant and providing a secondary pattern at the quilt's center.

Narrow, machine-pieced strips in green and orange frame an interior border of equally narrow red and white strips. The quiltmaker's decision to mass so many strips in contrasting colors was a good one—the vivid strips perfectly complement the substantial blooms and their thick, angular stems. The narrow orange binding appears as another border strip. It is machine sewn to the front, hand

Joanna Troutman Pope. UT
Texas Memorial Museum
Photograph Collection,
2S212c.

sewn on the back. The appliqué stitching is regular but not fine. The quiltmaker used white thread to appliqué both green and orange elements in the motifs, but red thread to appliqué the red elements, including the many seeds and bud tips. There are only two quilting designs on the *Troutman Quilt*: outline quilting in the border and three-quarter-inch grid quilting to fill in the block background. Again, the quiltmaker varied her choice of thread colors: red thread on red fabric, brown (or faded green) on green fabric, and white thread on white and orange fabrics. She did not use orange thread in this quilt, which features so many orange accents and strips. The hand quilting is seven to eight stitches per inch.

Perhaps Joanna Troutman sewed this quilt near her father's Troutman Inn, at Elmwood Plantation, the family home and plantation where she grew up and spent much of her married life with each husband. The inn, near Knoxville, Georgia, is said to have been on the stagecoach line between Macon and Columbus. Elmwood Plantation, named for its many elm trees, spread across some five thousand acres along the Flint River.[71] Joanna was the well-educated daughter of a socially prominent and wealthy Georgia family. She married twice, first to Solomon L. Pope (1810–1872), an attorney and planter, and then to William Green Vinson (1816–1887), a Georgia legislator. Her thirty-five-year marriage to Pope was blessed with four sons, though only one lived to middle age. The Popes amassed large land holdings, in part through Joanna's land inheritance from her father. Records indicate that by 1860 Solomon Pope owned sixty-six slaves.[72] With slaves present at the Elmwood Plantation, it is possible that the *Troutman Quilt* was in part the work of enslaved women. No records yet discovered hint at or document this possibility, and family stories handed down do not mention the quilt as being made by slaves.

Solomon Pope died in 1872 and was buried at Elmwood. Three years later, in December 1875, Joanna married widower William Green Vinson. A native of Alabama, Vinson lived in Crawford County, Georgia, as early as 1843 and served as a member of the Georgia Legislature from that county. Joanna bore no additional children. She died in July 1879 and was buried at Elmwood beside her first husband and sons Marcellus Troutman Pope and John Solomon Pope.[73]

By the time of Joanna's death, the *Troutman Quilt* was securely tied to the Vinson family. At some point the quilt

came into the hands of Joanna's niece Ellen Roberta Vinson Hartley (1857–1951), though when or how this happened is unknown. Several scenarios seem possible, even likely. One is that Joanna made the *Troutman Quilt* during the years of her first marriage and brought it with her when she married into the large Vinson clan. Sometime before her death in 1879, Joanna gave the quilt to her niece Ellen Vinson. A second scenario is that widower William Vinson chose to pass his late wife's quilt on to a close female relative. There being no female offspring from either the Troutman-Pope or the Troutman-Vinson unions (or from Vinson's first marriage, which also produced only sons), Vinson chose to give the quilt to his late brother's family, which in 1870 included four daughters. For whatever reason, the quilt came to the second daughter, Ellen Vinson.[74]

A variation of these scenarios is also possible—that William Vinson kept the *Troutman Quilt* until 1887, the year he died, giving it to his niece Ellen Vinson on the occasion of her marriage to John Frank Hartley that same year. Or perhaps the quilt simply came to Ellen in 1887 after her uncle died that April. Whatever the case, the quilt contains a definite sign of Ellen's ownership: the first initial of Ellen's married name, an H (embroidered in black), appearing on the quilt's lower left corner. The initial is obscured somewhat by thick netting, meant to protect this detail. According to Ellen's granddaughter, the inscription once held Ellen's three initials—e H v—for Ellen Vinson Hartley, but only the H remains.[75] Ultimately, the *Troutman Quilt* passed through two more Vinson-Hartley generations before the Briscoe Center acquired it.

Georgia native Joanna Troutman seems destined to be forever linked to Texas. In 1835 she made a flag that was carried to Texas and raised there in 1836 during the Texas Revolution. As a consequence of her act of patriotism, in 1913 Joanna's remains were removed from her Elmwood Plantation home in Georgia for reburial and memorializing at the Texas State Cemetery in Austin. Her portrait, painted in 1914 by Marie Cronin, hangs in the Senate Chamber of the Texas State Capitol. And now Joanna Troutman's quilt has joined the Briscoe Center's Winedale Quilt Collection at the state's flagship university, an acquisition made possible by fifth-generation Texans Karoline Patterson Bresenhan and Nancy O'Bryant Puentes.

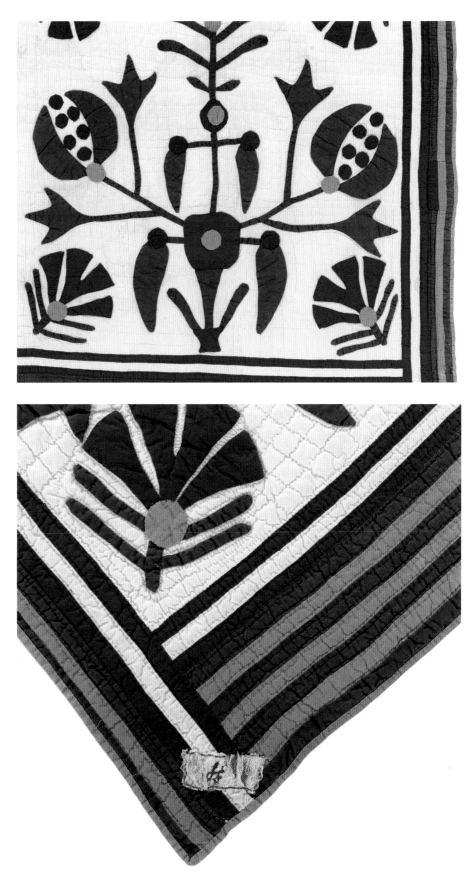

Elizabeth Louisa King (1819–1869), the mother of five children and widowed by 1844, married a second time in 1852. Her new husband was Gray Harris (1803–1880), a native of North Carolina, also widowed and a parent. Once Elizabeth and Gray's union produced three more daughters, the couple, between them, had sixteen children. Gray Harris also was a landowner in west-central Georgia. Family history states that he owned two cotton plantations, with slaves, mainly located in Muscogee and Stewart Counties, but possibly also in Chattahoochee and Talbot Counties. It is probable that Elizabeth made this striking *Double Irish Chain* quilt in the 1850s, during the early part of her second marriage and before 1861 and the outbreak of the Civil War. It seems likely that the couple's older children and help from house slaves relieved Elizabeth of some regular domestic duties, allowing her to undertake making this quilt. Or perhaps enslaved women directly contributed to the sewing project, though there is no firm evidence to support this idea.

Elizabeth Harris also may have taken advantage of locally made fabric or at least had ready access to yard goods. Georgia's Muscogee, Stewart, Chattahoochee, and Talbot Counties all enjoy the benefits of the Chattahoochee River along one of their borders. In antebellum Georgia, this river connected plantations in the region with international cotton markets and merchandise via New Orleans. In Columbus, the county seat of Muscogee County, the river gave rise to textile mills. At least three mills operated there by 1845, and the town became known as the "Lowell of the South" because of its success as a cotton center.

This *Double Irish Chain* quilt is composed of thirty-six blocks. The white setting block is unusual; it is a single piece of fabric rather than a pieced block, as is often found in this pattern. The chrome orange and the green fabrics are prints, both very faded. The orange print features a narrow green stripe with stars, plus tiny teal and black vines on the orange. Triple parallel-line quilting on the diagonal graces the white blocks, with the three lines sewn every inch. This quilt has experienced heavy use. Its over-dyed green has faded irregularly across the entire top, mainly to yellow, though in several places to blue, and its narrow orange binding is completely worn along the edge. Although Elizabeth's quilt wears, stains, and is fading from age and use, its strong colors and geometric pattern continue to charm.

Elizabeth's quilt remained with the Harris family for generations, passing continually from mother to daughter. The quilt came to Texas around 1870 along with the couple's three daughters—Ellanora, Louisiana, and Ophelia—who moved west after Elizabeth's death and Gray's remarriage. Daughter Ophelia Alice Harris (1858–1948) brought the quilt to Lamar County, Texas, where she married Daniel Usher Parsons, a farmer, rancher, and cotton gin owner. Elizabeth's quilt eventually passed to their daughter Essie Belle Parsons (1889–1980), the grandmother of the donor.[76]

Double Irish Chain

Elizabeth Louisa
King Harris, probably
Muscogee County,
Georgia, circa 1852–1860

Cotton: 86 x 96¼ inches

Hand pieced,
hand quilted

2012-254

Gift of Sherrill G.
McCullough

Three trousseau quilts made by an aunt and her niece reflect the strong bond between two Kentucky women and help document the migration west of red and green floral appliqué quilts during the nineteenth century. Mary Ann Ellington (1836–1932) was fifteen years old when her mother died, after which Mary Ann's Aunt Patsy (perhaps her father's sister Margaret) apparently acted as her surrogate mother. Less than three years later and just months before her wedding in 1855, Mary Ann's father died, making Aunt Patsy an even more important adult in Mary Ann's life. The style, fabrics, and construction of these quilts indicate that the two women quilted together, the older woman mentoring the younger.[77]

Planning, precision, and fine hand quilting distinguish the two quilts Aunt Patsy made for her niece. Her *Carolina Lily* is a two-color, single-pattern quilt. Its narrow red binding is a replacement for what was likely a similar narrow binding, also in red. The quilt features ninety-one appliquéd lilies; in all, the lily blocks contain 3,549 pieces. Aunt Patsy's hand quilting is exquisite, done in various snowflake-like patterns. Pencil marks at the quilting lines are still visible on some blocks. The family named Aunt Patsy's other quilt *Peony*, but its central blooms also closely resemble a Jefferson Rose pattern. The peony bouquets are nearly identical, including details such as the angles of the bent stems and the placement of leaves, all possibly made using templates. The bouquet's central blossom is appliquéd onto a separate 7½-inch circle, then pieced in. Aunt Patsy added accent colors, border and corner blooms, and a special border treatment on three sides. Of the pieced elements in her lush peony buds, two are in a small red and white patterned print that at a distance appears pink. She used the same fabric in each central peony and chrome yellow at the center of each flower. The narrow binding is a green, red, blue, and black calico.

Aunt Patsy framed her *Peony* quilt with an elegant border of fabric possibly imported from France. The border features medallions and the Greek key design, the latter providing a geometric counterpoint to the curving stems and blooms of the bouquets. The corroding effect of the iron mordant in the border print has caused much of the brown background fabric to drop out, leaving the red prints sitting precariously atop the cotton batting.

Carolina Lily

Aunt Patsy, Burkesville, Kentucky, circa 1853–1855

Cotton: 97 x 102 inches

Hand and machine pieced, hand appliquéd, hand quilted

TMM 2592-1

Gift of Margaret Alexander Steiner

Mary Ann Ellington's *Cockscomb* is less precise and more improvisational than her aunt's two quilts, perhaps a function of her age and fewer years devoted to quiltmaking or, perhaps, simply her personal inclination. The leaves in each cluster vary, for example, and the vining border is informal, even awkward, where it turns the corners. As with her aunt's *Carolina Lily*, the binding on Mary Ann's *Cockscomb* has been replaced; it is now a narrow reddish brown, straight-grain binding, machine applied.

Mary Ann and her aunt both lived in Burkesville, a small but growing river town located in southern Kentucky along the Cumberland River. The inventory of items donated in 1990 with the quilts—including Mary Ann's Chinese silk bridal dress and her second-day dress in plaid taffeta—are evidence of the Ellington family's wealth. One of the distinguishing features of these three quilts is that they all appear to contain the same solid red fabric, yardage no doubt purchased at some expense for these important quilting projects. The solid green fabric in both of Aunt Patsy's quilts also appears cut from the same cloth.

The quilting in all three is exceptionally fine and re-markably similar—twelve to fourteen stitches per inch. Patterns include outline stitching, intricate designs, trailing leaves, and geometric shapes. Either both women were equally skilled quilters or Aunt Patsy hand quilted each of the three quilts.

Mary Ann cherished her three trousseau quilts. She took them with her when she and husband Lauren Clauson Alexander endured the difficult trip to Texas just months after their wedding in 1855. Mary Ann probably was pregnant during the trip. But relocating meant a job for Lauren—working with his brothers in a mercantile business in the small but growing north-central Texas town of Sherman, by late 1858 a stop on the Butterfield Overland Mail route. The couple settled on a farm along the Red River and began to raise three boys. The family survived the Civil War, but Mary Ann was widowed in 1865. She remarried four years later, then moved east to Marshall, Texas, with her new husband, physician William Harrison Dial. There, in 1873, she suffered the death of her youngest son and, in 1880, was again widowed.

Mary Ann kept her trousseau quilts until she died in June 1932 at age ninety-five, in Marshall. She must have

Peony

Aunt Patsy, Burkesville, Kentucky, circa 1853–1855

Cotton: 95 x 99 inches

Hand pieced, hand appliquéd, hand quilted

TMM 2592-2

Gift of Margaret Alexander Steiner

Cockscomb

Mary Ann Ellington, Burkesville, Kentucky, circa 1853–1855

Cotton: 99½ x 97 inches

Hand pieced, hand appliquéd, hand quilted

TMM 2592-3

Gift of Margaret Alexander Steiner

used her quilts infrequently, as all survived and exhibit only minor wear. The quilts passed to Mary Ann's granddaughter Margaret Alexander, born in Marshall in 1902. It is likely that grandmother and granddaughter were very close, much as Mary Ann had been with her Aunt Patsy. They knew each other for thirty years and lived in the same town for twenty-eight. Fortunately, Margaret appreciated the quilts and honored her grandmother's attachment to them. In 1990 she donated them to the University of Texas for permanent preservation and study, noting, "All of my relatives are disappointed that I did not give the quilts to them. Ha! But I am certain I did the right thing, as many people will get to see and enjoy them there in the museum."[78]

Mary Ann Ellington Alexander's plaid silk "second day" dress, worn the day after her wedding in 1855. Material Culture Collection, TMM 2592-13a and b.

LONE STAR

This Texas-made quilt is a survivor. It traveled thousands of miles, endured a shipwreck and days in saltwater, and finally was returned to Texas eighty-eight years after it was made. The quilt was among the household possessions the quiltmaker and her family packed when they left their home in East Texas to join an organized colony that emigrated from Texas to South America after the Civil War.[79]

Family history holds that eighteen-year-old Amanda Pairalee Hammonds (1839–1909) made this quilt in 1858 while living with her parents and five siblings in Rusk County, in the Piney Woods of East Texas. Amanda's parents had survived the Texas Revolution in 1836, and in 1845 the family witnessed the annexation of the Republic of Texas to the United States. It seems likely that Amanda was expressing her patriotic attachment to her young state when she used the five-pointed Texas star design as the decorative focus of her quilt's medallion and again as a quilting pattern in the medallion background.[80]

When Amanda made this quilt, Rusk County was the most populous county in Texas and one of the wealthiest. In 1860 the county was home to more that 15,800 residents, many whom came from the Old South. Of these, 8,132 were slaves.[81] That same year, Amanda wed George Alwin Linn (ca. 1836–1882), a native of Kentucky and by then a farmer in Navarro, Texas. The couple's circumstances during the Civil War are unknown, save that they started a family. Sons William and George were born circa 1862 and 1866.[82]

The Linns' sympathies lay with the Confederate cause. Following the war, the family joined the McMullan Colony, a group of Texans determined to move to Brazil rather than live under a Reconstruction government. This colony was not an isolated attempt to relocate. After the war, plans for settlement in Brazil were discussed throughout the South. Brazilian authorities, eager to recruit farmers and technical specialists from the southern United States, actively encouraged former Confederates to emigrate.[83]

Frank McMullen spearheaded the colonizing effort that planned to guide some 150 Texans to São Paulo Province, Brazil. The colonists' gathering point was Galveston. By December 1866, families began to arrive and camp on the beach in anticipation of departure. In late January 1867, the brig *Derby* set sail for New Orleans with 154 colonists, including George, Amanda, their two young sons, and George's sister. Most baggage, including Amanda's *Lone Star*, was stored in the ship's hold. The first planned stop was at Havana for repairs. After two weeks at sea, however, a fierce tropical storm hit the *Derby*. The ship

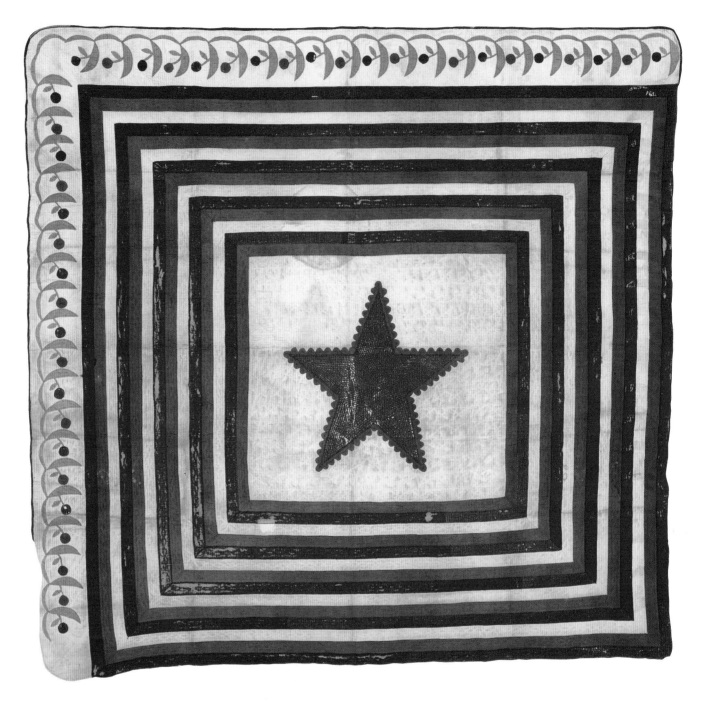

Lone Star

Amanda Pairalee
Hammonds, Rusk
County, Texas, circa 1858

Cotton: 87 x 90½ inches

Hand pieced, hand
appliquéd, hand quilted

TMM 791.1

Gift of Daisy Linn Chase

eventually wrecked on rocks off the coast of Cuba but remained upright, lodged between boulders. Amazingly, the *Derby* held together, and all crew and passengers were able to get off the ship without serious injury. But equipment and household goods—including Amanda's quilt—washed into the ocean. The colonists, with help from local residents, were able to retrieve approximately three-quarters of their possessions. Everything was set out on a sandy beach to dry in the sun. Clothing and other textiles, presumably including Amanda's quilt, were scrubbed to remove the saltwater residue. Saltwater, sun, and scrubbing surely contributed to the quilt's fabric loss, especially in its center.[84]

After several difficult and anxious weeks, the shipwrecked colonists were transported aboard the *Mariposa* to New York, where they endured weeks of waiting and uncertainty. On April 22 the group finally boarded the steamer *North America* and once again set sail for Brazil, arriving in Rio de Janeiro four weeks later. Many colonists continued to live in Brazil through the mid-1870s, and descendants of the original colonists remain there today.

Amanda and George Linn elected to return to Texas almost immediately, disillusioned, perhaps, by their long and difficult journey and a colony whose future seemed uncertain. In November 1867, the Linn family boarded the steamer *Ella S. Thayer* for New Orleans, and so began their trip back to Texas. The Linn family eventually settled in Navarro, where Amanda bore seven more children, including daughter Daisy Amanda, born in April 1876. US Census records and family genealogy state that George Linn died in 1882 and that Amanda thereafter lived in Cisco, Texas, with her unmarried daughter Daisy until her death on October 11, 1909.[85]

Lone Star quilt sometime after her mother's death. Daisy Linn probably acquired her mother's *Lone Star* quilt sometime after her mother's death. Daisy moved west by 1920, presumably with her husband Ransford T. Chase (1844–1938), a native of New York and a Civil War veteran. The couple resided in Los Angeles. They had no children. Widowed and without offspring, in 1946 seventy-year-old Daisy Linn Chase decided to return her mother's quilt to Texas. She mailed *Lone Star* to Texas Governor Coke Stevenson, who forwarded it to the University of Texas. Amanda Hammonds's remarkable *Lone Star* quilt is one of the first quilt donations to the university, which received it on January 10, 1947.[86]

Lone Star features a central medallion containing a five-pointed star framed by fourteen borders in red, blue, and white. Amanda outlined her star with a blue scalloped edge, which she constructed using continuous strips of scallops on each side of the star, plus a separate scallop for each tip. Amanda appliquéd these in place first, and then appliquéd the star on top of this decorative edging. She used the same blue fabric repeatedly—in her scalloped edge, for the quilt's five blue frames, and to construct the blue berries along the border on two sides. The blue fabric is now greatly faded and browned; it may originally have been teal or a Prussian blue. The surprising border, at the quilt's left side and top only, is a unique design, a gentle series of curved stems, with upright leaves (or are those pods?) and alternating red and blue berries. This border is original to the quilt, presenting a graceful and elegant counterpoint to the boldly graphic star and the massed frames around it. Homemade straight-grain red binding edges these two borders. At the other two sides, the quilt's front and back are turned in to create a knife edge.

The quilt shows great wear and a later repair. On the left side, for example, the binding ends abruptly eighteen inches from the quilt bottom. This portion of the side has been cut down, with the edges turned under and restitched. The quilt's entire edge, in fact, save for the lengthy repair on the left side, has been machine sewn, though crudely. There is some documentation that this machine stitching might have been done on the voyage to Brazil. A partial inventory of colonists prepared years later by another colonist recorded a Mr. Linn, his wife, and his sister as among the group. As an afterthought, the colonist also appended the following note at the bottom of her inventory: "Since writing this I remember three more names. Sailor Smith and Mr. Croney and an old maid. Forget her name but [s]he had a sewing machine the first I ever saw. She was with the Linns I think."[87] Perhaps the sewing machine she saw was used to make this repair.

Amanda finely hand quilted her entire quilt, using blue, green, and white thread and quilting nine to eleven stitches per inch. Her designs include chained ovals in the frames, outline quilting, and, inside her central Lone Star, diagonal lines that begin at each of the star's points and then angle in to meet at the star's center. As a final beautiful touch, Amanda also quilted dozens of five-pointed stars in the medallion background and between the border's floral motifs. Each quilted star echoes her central, larger Lone Star and commemorates her Lone Star State.

Hand-powered sewing machine, circa 1860–1870s. This machine produced single-chain stitching and was sold as a "common sense" or "family" sewing machine. Material Culture Collection, TMM-491-2.

MOSAIC

Show quilts made of silk and used to decorate a bed top or grace a sofa back appear as early as the 1830s, peaking in popularity in the 1880s with crazy quilts. Equally popular, and beginning just as early, were quilts made of pieced hexagons. Organizing small hexagons into larger shapes such as rosettes or diamonds produced overall patterns and offered frugal quiltmakers the opportunity to use up fabric scraps. Making overall hexagon patterns has always required great skill in measuring, cutting, and piecing, as a miscalculation early on is magnified later, distorting the entire design.

Fifteen-year-old Mary E. Perry (1845–1928) of West Feliciana Parish, Louisiana, made this silk *Mosaic*, mixing elegance with utility. Its fabrics suggest Mary used scraps as well as purchasing fabrics specifically for this sewing project. The quilt top is beautifully made, decorative, highly organized, and entirely of silk. The batting and back, however, are all about providing warmth—the batting is wool, as is the quilt's backing fabric of green wool with white dots.

The quiltmaker chose to organize her hexagon mosaic pattern as repeating diamonds, each containing two rows of hexagons around one at the center. Her arrangement of fabrics in each diamond is uniform throughout—a contrasting fabric at the center, the inner row made from one solid or patterned fabric, and the outer row of hexagons in black, or, in a few instances, dark brown. This order brought unity to the pattern but also enabled the quiltmaker to introduce more than sixty different plaids, checks, stripes, and solids in colors ranging from warm brown to ice blue and purple to pinky coral. This contrast of colors between the rows and among the diamonds enlivens the entire quilt. Mary separated her hexagon diamonds with rows of small diamonds pieced end-to-end and cut from two-toned, striped dark blue silk. Because this diamond row is narrow, it helps define the diamonds and so reduces any visual confusion of the massed hexagons. Mary almost certainly pieced her individual hexagons using English paper piecing to create precise edges. This technique calls

Examples of English paper piecing. Kathleen H. McCrady Quilt History Collection, 2006/074/1.

for the quiltmaker to fold fabric hexagons over stiff paper templates, basting the edges in place and then stitching the hexagons together from the back to create the rosette or diamond pattern. The paper is removed before the quilt is completed. In the nineteenth century, templates often were made from used ledger paper or newspapers whose writing can help date a quilt. Mary's hand quilting, at eight to ten stiches per inch, outlines the hexagons and places diagonal parallel lines along the border.

Mary also added a special, even remarkable, touch to her quilt by embroidering in silk a variety of floral motifs, celestial designs, and symbols in many of the hexagon diamonds, either on the center hexagon or on those in the inner row. These beautifully executed designs include interlocking rings, a variety of leaves, sun shapes, stars, a horseshoe that appears to contain the initials L.S., anchors, and a crescent moon with stars. Two of the most elaborate embellishments are realistic acorns with oak leaves and, near the quilt center, crossed flags. The placement of the flags near the center suggests their special importance to the quiltmaker. One flag may be Mary's

representation of the American flag; the other may be her version of the Bonnie Blue Flag—a white star on a blue background—representing the first unofficial flag of the Confederacy.[88]

Mary bordered her quilt with the same two-toned, blue striped silk she used to create the rows separating the hexagon diamonds. The border's generous width reveals the true glory of this fabric, specifically its two multicolored, ribbonlike strips that run perpendicular to the fabric's royal and navy blue stripes. The mitered corners add a tidy finish, as does the narrow binding, separately applied. The binding is made from the same blue-striped silk. As one more delightful addition, Mary cut and sewed the binding on the bias, thereby setting the fabric's multicolored strips on the diagonal and appearing at regular intervals along the quilt's edge. This is a lovely edge treatment, one that confirms Mary's mastery of manipulating fabric to achieve a beautiful design.

Mary E. "Mollie" Perry was born in West Feliciana Parish in 1845, the youngest of six children of planter John Oliver Perry and his wife, Elinor Brown Perry. According to the US Census, Mary lived with her parents at least until 1860. She probably made her *Mosaic* quilt before the early and catastrophic disruptions of the Civil War in Louisiana.

Family oral tradition holds that Mary worked as a seamstress sometime shortly after the war and possibly before or during her marriage in 1866 to Rufus King Norwood, a member of a prominent family from East Feliciana Parish. That marriage ended abruptly in 1868 when Norwood, aged twenty-three, was shot and killed. In 1872 Mary wed a second time, to Charles Edward Decker, a Louisiana planter who represented West Feliciana Parish in the Louisiana House and East and West Feliciana parishes in the State Senate. The couple had six children, though only two reached their majority and established families.

Following her husband's death in 1894, Mary moved to East Texas to live with her son Eugene Moore Decker, Sr., and daughter Sallie Decker Whiteman and their families, which were in business jointly in farming and timber. When the Whiteman-Decker Lumber Company relocated to Farmerville, Louisiana, Mary Decker moved back to her native state to live with her daughter. Mary E. Perry Norwood Decker died on November 26, 1928. Family history records that she died in her daughter's home eleven

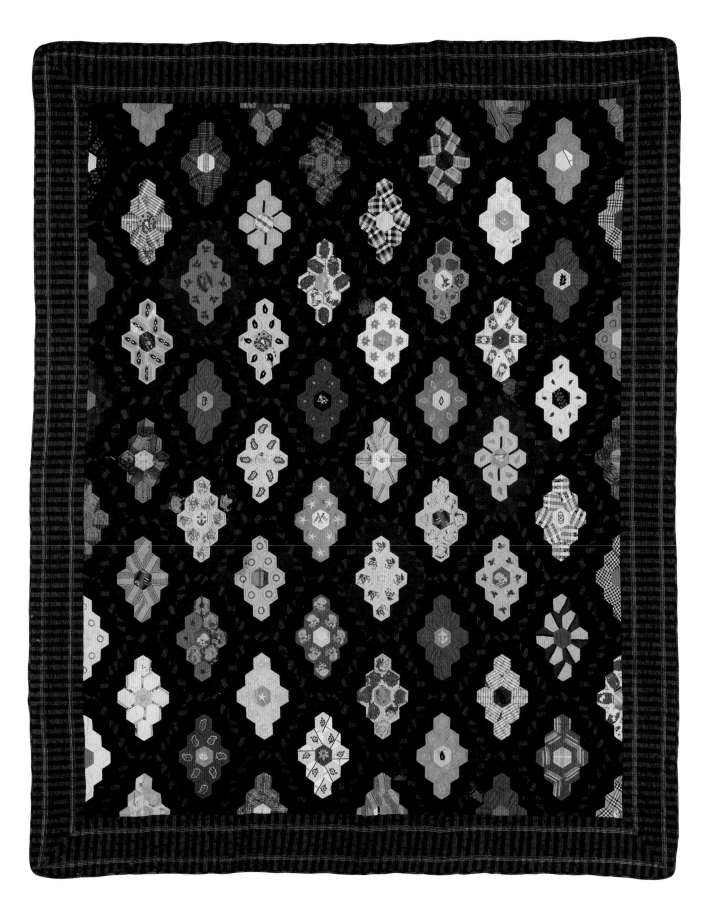

Mosaic

Mary E. Perry,
West Feliciana Parish,
Louisiana, circa 1860

Silk, wool:
70¾ x 88 inches

Hand pieced, hand
quilted, embroidered

2014-063

Gift on behalf of the
Whiteman-Decker Family

days after celebrating her eighty-third birthday. During the family's party her son toasted Mary's continued health and long life. Reportedly she responded, "No son, I have lived long enough."[89]

The ownership history of this quilt is unusual, a tale of the quilt's long separation from family while on display in a small-town library in Texas. The years *Mosaic* was exhibited rather than used by family may have saved its silk fabrics, so prone to shattering. The specifics are that following Mary Perry's death in 1928, the quilt remained with her family, passing first to her daughter Sallie and then to Sallie's youngest son, Augustus Whiteman. Following Whiteman's death in 1970, his second wife donated the quilt to the Thursday Study Club of Alto, Texas, in anticipation of the club establishing a museum. When the museum never materialized, the Study Club displayed the quilt, first in a glass case and, later, hanging it in Alto's Stella Hill Memorial Library, whose location changed during that period.[90]

Mosaic was "rediscovered" in 2010 by Dr. Deborah L. Burkett, a historian and genealogist from Cherokee County, Texas, who visited the library to lecture on quilts. Burkett was intrigued by *Mosaic*. "It's not often one spies something so beautiful about which so little is known," she wrote later, adding, "If not for the Alto Thursday Study Club's invitation to speak I wouldn't have seen the quilt hanging on the wall. I immediately knew it was something special."[91] Burkett's interest in the quilt, along with the library's files documenting its donation, eventually led to the Whiteman-Decker family's reacquisition of *Mosaic* and, in May 2014, the family's generous donation of its treasure to the Briscoe Center.

A detailed provenance plus fabrics consistent with Civil War–era textiles indicate that *Rose with Oak Leaves and Lilies* is a rarity—a surviving Confederate quilt. Family history holds that Rachel Brown sewed it for her brother, Daniel C. Brown, while he served in the Confederate Army during the Civil War. A typed note attached to the quilt and signed "Bollings" (for Emily Miller Bolling, Daniel's granddaughter) reads "This quilt was made and quilted during the Civil War, by my Great-Aunt Rachel Brown while her brother (my grandfather) was gone to war."[92] The quilt was passed along within the family until 2006, when Daniel Brown's great great grandson donated it to the Briscoe Center.

Few Civil War quilts made in the South survive, in part because of the scarcity of fabric and thread in the Confederate states during the war years, but also because of the upheavals of war. Quilts known to have been used by soldiers during the war are even more rare. This quilt's cotton fabrics and abstract floral designs date the quilt to the mid-nineteenth century. They include still-vivid chrome orange lilies; warm brown oak leaves appliquéd with brown thread, both possibly home dyed; and worn and faded remnants of lily stamens and center rose blooms, in solid red or, possibly, a double pink. The quilt is hand sewn, containing nine blocks plus three half blocks across the top, the area showing the most wear. The backing fabric is made from four panels of loosely woven cotton. The batting is thin cotton. The quilt was finished with a narrow, straight-grain white binding, though all that remains of the binding are small pieces of it along the left side. There is evidence of an attempt to stabilize the severely worn edge at a later date with a running stitch in white thread around the quilt perimeter. The hand quilting, at nine to ten stitches per inch, is an echo quilting pattern stitched in and around each appliquéd design. Diagonal double parallel lines set a quarter inch apart are quilted in the background.

The quilt's owner, Daniel Calhoun Brown (1837–1912), was born in Randolph County, North Carolina, as were his older sisters, both quiltmakers, Rachel Brown (1832–1917)

and Mary Brown (1835–1912). The Brown family moved to Pope County, Arkansas, when Daniel was five years old. As an adult Daniel worked in at least two mercantile businesses, married Emeline Hogan in 1858, and, in 1860, was elected sheriff of Pope County. He remained sheriff until he entered the Confederate Army as a first lieutenant in the Arkansas Volunteers, probably in February 1862.[93] While Daniel was in the army, his wife died giving birth, and the infant died a short time later.

Family history states that the Brown sisters quilted during the Civil War years "in order to provide warmth to the Confederate soldiers and their families."[94] It is possible that Daniel's sister presented *Rose with Oak Leaves and Lilies* to him when he first enlisted, though she may have sent or given it to him later. Daniel suffered a break in service from autumn through December 1862, reportedly from "disability caused by sickness," possibly an illness brought on by the death of his wife and infant child. He reenlisted in December and saw active service first as a lieutenant and then, in 1864, as a captain. Regardless, this quilt apparently was with him throughout his war service, possibly even when he fought in battles in Arkansas, Mississippi, and Missouri.[95]

The quilt survived an equally rigorous life after the Civil War. Daniel Brown remarried in 1866, and the couple's daughter Rachel Marie Brown (1869–1919) inherited the quilt from her father. In 1889 Rachel married James A. Miller. The couple lived in Russellville, Pope County, Arkansas, until Miller's business was destroyed during a massive fire in the town's central business district in 1906. The Millers resolved to move, and the quilt moved with them, three times during the next ten years: in March 1906 by train to settle in New Mexico; in 1909 by covered wagon to a homestead farm in Yoakum County, Texas; and in 1916 to Brownfield in Texas's Terry County. Sometime between her mother's death in 1919 and her father's death in 1932, the couple's daughter Emily Miller Bolling acquired the *Rose with Oak Leaves and Lilies* quilt. She is described as "the last family member" to use the quilt.[96]

**Rose with Oak
Leaves and Lilies**

Rachel Brown, Pope
County, Arkansas,
circa 1862–1864

Cotton: 82 x 95½ inches

Hand pieced, hand
appliquéd, hand quilted

W2h81.06

Gift of Russell James
Miller

Fourteen-year-old Lena Dancy made this homespun dress in 1864 while living on the family plantation near La Grange, Texas. Dancy made the dress and a feathered fan to show her solidarity with the Confederate cause. She also copied down her version of "The Homespun Dress," a song popular in the South during the war.

*My homespun dress is plain
I know
My fan is homemade too
But then it shows what
Southern girls
For Southern rights will do.
Hurrah! Hurrah! For the
Bonnie Blue
flag hurrah!
Hurrah for Southern Rights
And for our Southern boys!*

Homespun dress,
Material Culture Collection,
TMM 55-2.

VARIABLE STAR CRIB QUILT

Mary Bartholomew Herr hand pieced this crib quilt for her grandson Charles Henry Miller, born in 1866 in Lancaster County, Pennsylvania. Both grandmother and grandson were members of a Reformed Mennonite community, as was Charles's mother, Elizabeth Bartholomew Herr Miller. Herr pieced her stars out of various indigo blue, green, red, teal, and brown printed cottons, combining them with a plain off-white fabric, which is now brown with age. She set the thirty-six star blocks on point, alternating them with plain blocks in Turkey red or green. The border print is chintz. There are brown prints throughout—in narrow stripes, with white dots, and in florals with red and Prussian blue. Some of the quilt's fabrics date from the 1830s and 1840s, suggesting that Herr either sewed regularly and kept a scrap bag or that she made the blocks years before finishing the quilt. She hand quilted simple flowers in each of the plain blocks.

The quilt's recipient, Charles Miller (1866–1925), left the family farm and his Mennonite community during his teen years for greater educational and employment opportunities. He attended high school in nearby Strasburg and Lehigh University in South Bethlehem, Pennsylvania, graduating with honors in civil engineering. Miller worked as an engineer the rest of his life, including on bridges crossing the Mississippi River. Family history holds that the Mennonite plain clothes shown here date from after 1860 and were worn (and possibly made) by Charles's mother, Elizabeth Bartholomew Herr Miller. This unadorned summer-weight cotton clothing reflects the desire by members of her Mennonite community to avoid excessive display in dress. The ensemble is sewn by hand and machine, evidence that Elizabeth's community had access to foot- or hand-powered sewing machines by the 1860s.

Charles Miller's childhood quilt remained with the family until 2010, when it was donated to the Briscoe Center on behalf of Edna Ward Toland, the great-great-granddaughter of quiltmaker Mary Bartholomew Herr. The quilt and the summer-weight plain clothes, plus another, heavier set for winter use, and Charles Miller's five handwritten journals for the years 1890 and 1901–1904, his two elementary school readers, and his slate book (still containing school lessons written in chalk) are also at the center.[97]

Mennonite plain clothes worn by Elizabeth Bartholomew Herr Miller, circa 1860–1870, Lancaster, Pennsylvania. Miller-Ward-Herr Family Quilt Collection, 2010-019-2.

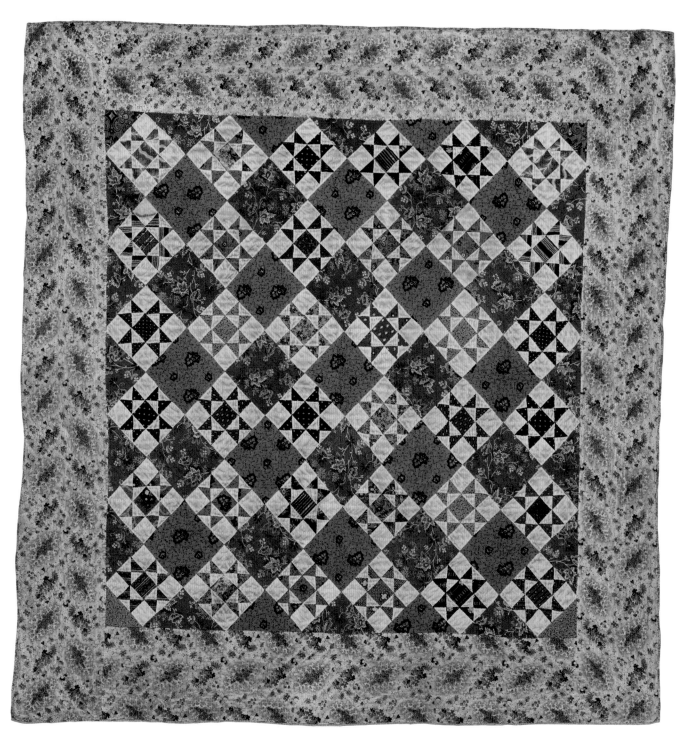

**Variable Star Crib
Quilt**

Mary Bartholomew
Herr, Lancaster County,
Pennsylvania, circa 1865

Cotton: 40 x 40 inches

Hand pieced,
hand quilted

Miller-Ward-Herr
Family Quilt Collection,
2010-019-1

Gift on behalf of
Edna Ward O'Hair
Toland

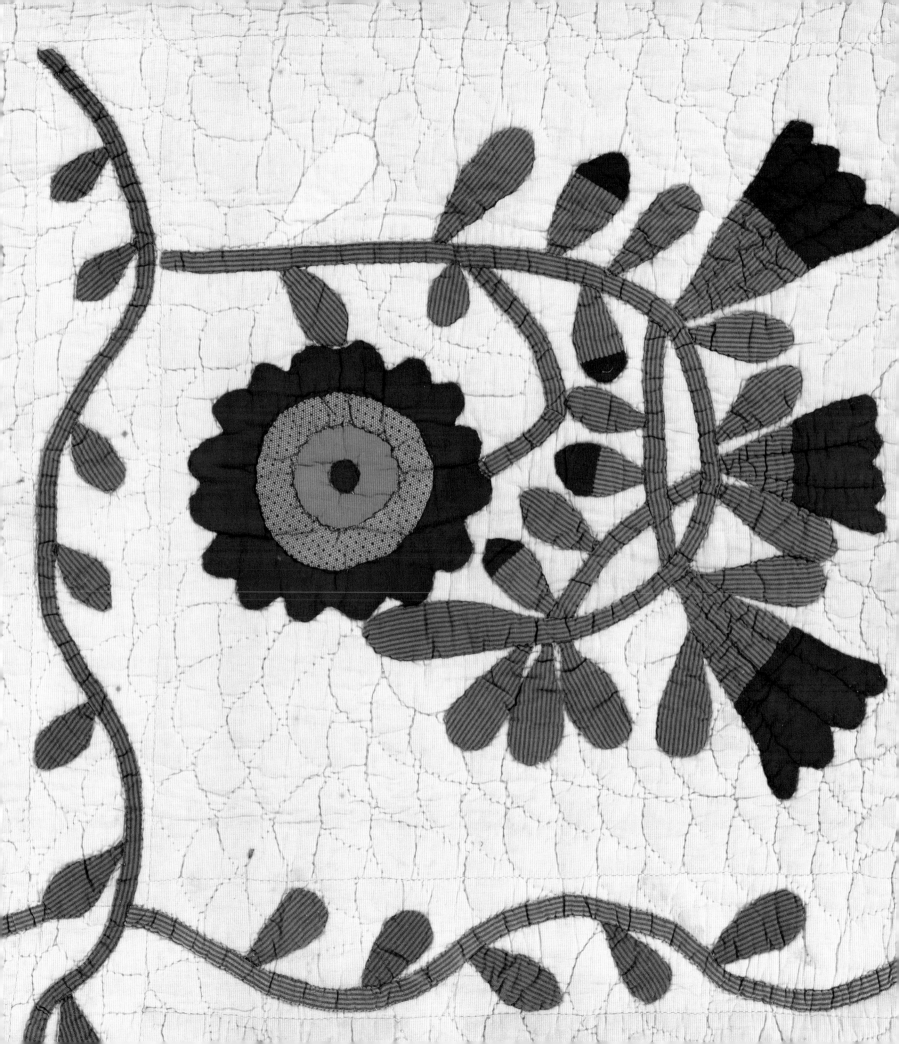

PRAIRIE ROSE

In April 1864 Miss Emily Porter Shaw (1842–1875) wrote to her suitor, Dr. Wiley T. Barnes. She lived with family near Rockwall, a small, north-central Texas community that was the focus of business for area farmers. Barnes was away, serving as a surgeon with the 2nd Texas Partisan Rangers, which was then marching from Galveston to Louisiana to take part in the Red River Campaign. Miss Shaw, eager to know her Barnes's intentions, wrote him a letter containing several lines of verse.

I surely think you have written . . . and there have been passing and good chances to send letters but if what I have heard be true, the majority of your letters travel another road, I heard somebody say that you have been writing to a widow, nearly ever since you have been out on this campaign. If this be true and she has really stolen your heart from me I am very sorry, but can't help it. But you must write to me and tell me the truth of the matter.

> *For candor is the safest guide*
> *For those who see a lovely bride*
> *And if I should forsaken be,*
> *I wish you great success*
> *And a deal of happiness,*
> *And a bride that is far better than me*[98]

Emily and Barnes married in November 1865. Emily probably made her *Prairie Rose* quilt shortly thereafter, possibly prior to the May 1867 birth of William Thomas Barnes, the couple's first child. The quilt's wear indicates that it was much loved and used often. *Prairie Rose* may have been Emily's only quiltmaking effort, however, for as a family member wrote later, "Ten years of marriage produced six children and this quilt."[99]

Prairie Rose is a wonderfully improvisational quilt whose construction indicates that what Emily lacked in sewing skills, she made up for in creativity and boldness. Her main motif is an oversized Rose of Sharon that hangs from an impossibly slender stem weighed down by the mass of blossoms. Leaves, buds, and three half-open flowers embrace the flower. Apparently unconcerned about establishing pattern uniformity block to block, Emily's rendering of each rose pattern differs. Eight of the nine main blooms contain four appliquéd layers, for example, but one bloom features only two layers and lacks the orange accent present in all the others. Stems supporting the three half-open blooms also vary, as do the lobes on the open and half-open roses, and the sizes of the blooms themselves. Some flower petals are pointed, others are rounded or blunt, some nearly overlap, others are widely spaced. One appliquéd leaf is entirely white—can you find it?

The blocks are separated by inner sashing only, a treatment almost invisible because Emily made the sashing from the same white fabric she used for the blocks. She also graced her sashing with a simple appliquéd vine-and-leaf design. Its green and black striped fabric is now faded to blue in some areas and to yellow in others. Because Emily did not cut her flower stems and sashing vines on the bias, they do not lay flat at the curves.

Emily's orientation of this quilt—and, hence, the block pattern—is unclear. If she intended the top end of the quilt to be one end of the quilt's longer side, she designated it by leaving that end free of appliqué and ready to tuck under a pillow. This orientation, however, results in her nine standing flowers being presented on their sides. Was this her plan or did Emily orient her quilt with flowers upright, leaving extra open space on the quilt's left side? The latter orientation seems the more likely. Or does it?

Prairie Rose remained within the Barnes family, handed down from mothers to daughters through three generations, from 1875 to 1998. One owner kept the quilt for more than forty years, but, according to the donor, passed it on only "after many family reunions of my pestering her about its care."[100]

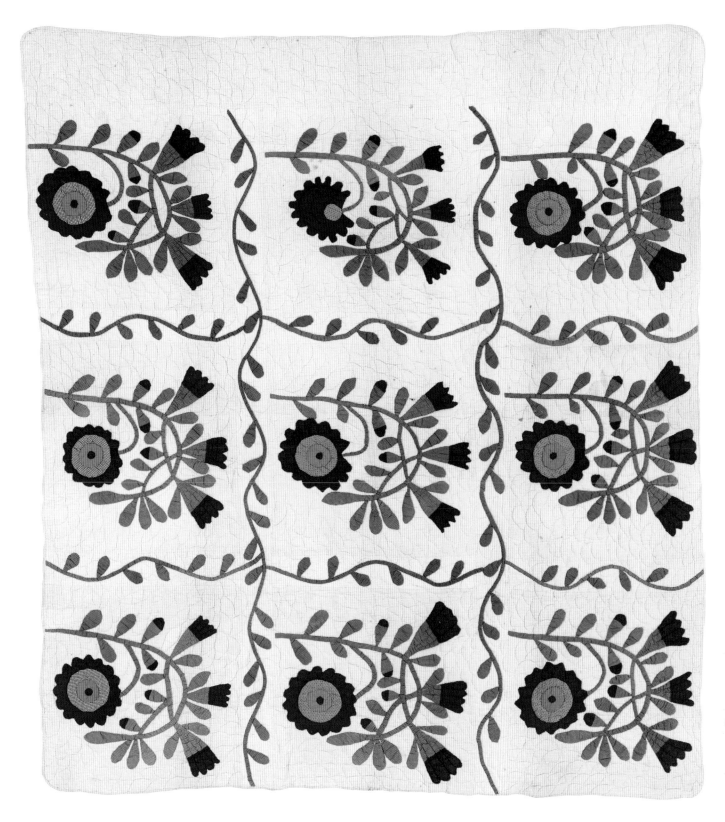

Prairie Rose

Emily Porter Shaw
Barnes, Rockwall, Texas,
circa 1865

Cotton: 66½ x 73 inches

Hand pieced, hand
appliquéd, hand quilted

2012-093

Gift of Colleen Barnes

Portrait of Mary and
Murdock McLean.
Winedale Collection,
W8d15.1978.

Mary McLean's *Spool Quilt* is closely associated with the McGregor House, one of the homes at the Briscoe Center's Winedale Historical Complex. Her quilt is thick and heavy, a utility quilt made for warmth. It is also boldly graphic, testifying to Mary's desire to imbue this functional domestic textile with liveliness. The quiltmaker chose an overall pattern that runs edge to edge; the front is turned to the back. *Spool Quilt* is composed of sixty-four blocks of four squares each. At five patches per square, this quilt contains 1,280 pieces, all of which Mary hand pieced. Her hand quilting stitches are large (from three to five stitches per inch) and her quilting simply outlines the spool designs. Mary also made a second utility quilt, now, too, a part of the Winedale Quilt Collection. Its pattern, Broken Wheel, is also graphic, and the quilt, like *Spool Quilt*, is thick and heavy. Regrettably, at some point in this quilt's life it became a comfortable, if temporary, home for a mouse, which returned the favor by leaving a sizeable hole.

The third of seven children of immigrant Scottish parents, Mary McGregor (1828–1874) was born and raised on the McGregor family farm in Cumberland County, North Carolina. In 1851 she married Dr. Murdock McLean. The couple, as well as other members of the McGregor family, moved to Texas sometime before 1861, settling in Austin County near Mary's older brother Dr. Gregor McGregor, a physician and land speculator. McGregor had settled in Texas nine years earlier, married the daughter of a wealthy German immigrant family, and established his medical practice in Washington County, just north of Austin County. There, in 1861, he built a house for his new bride that reflects the conservative taste of a wealthy planter and features extensive interior painted decorations.[101]

More than one hundred years later, philanthropist and historic preservationist Ima Hogg moved the McGregor House to Winedale, a property she gifted to the University of Texas two years before. Miss Hogg furnished the house with Texas-made furniture to represent the home of a wealthy German-American family of the 1860s. For many years, Mary McLean's *Spool Quilt* was featured on one of the McGregor House beds during home tours.

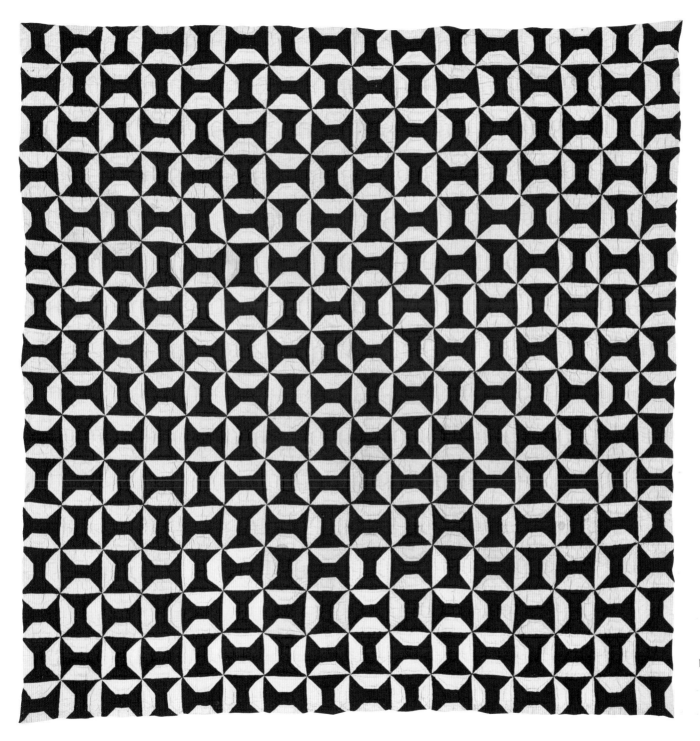

Spool Quilt

Attributed to Mary
Carmichold McGregor
McLean, Austin County,
Texas, circa 1870–1874

Cotton; 78 x 80 inches

Hand and machine
pieced, hand quilted

W2H32.78

Gift of Miss Jennings
McLean

Double Hour Glass

Attributed to Mary Ann
Pumphrey DeSellem,
Columbiana County,
Ohio, circa 1870–1879

Cotton: 79¾ x 79 inches

Hand and machine
pieced, hand pieced,
hand quilted

Joyce Gross Quilt
History Collection,
W2h001.097.2008

quilt a luminous quality. The pieced blocks each contain sixty-three triangles and squares. The quiltmaker hand pieced the inner edge of the two-inch red border to the blocks but machine sewed its outer edge to the wide green outer border. Her matching quarter-inch red binding is hand applied. The hand quilting, in brown thread, is fine and regular, at six to seven stitches per inch. To echo the quilt pattern's geometric design, DeSellem stitched only linear quilting patterns, including diagonal triple parallel lines through the borders, triple parallel lines in the pieced blocks, a precise half-inch grid in the complete plain blocks, and single parallel lines in the partial blocks. DeSellem's backing fabric offers a completely different look from her quilt front—it is a patterned print of irregularly sized small dots in red, salmon, and off-white set against a chocolate brown background.

We don't know which of the two quilts Mary Ann DeSellem made first, but they have important features in common, giving some indication of the quiltmaker's personal preferences. As she did for *Double Hour Glass*, DeSellem also chose a geometric pieced block pattern in *Framed Nine Patch* and then set her blocks against a relatively dark background, hand pieced the blocks, added an inner border and narrow binding of the same fabric, used brown thread to stitch fine triple parallel line quilting, and selected a small-scale patterned print for the backing fabric. In contrast, however, she gave *Framed Nine Patch* a rectangular shape, used both plain and printed fabrics in her blocks, and made much of the quilt's top from wool fabrics. Choosing and acquiring wools for pieced quilts was increasingly popular and common after the Civil War as domestic wools be-

Two quilts attributed to Ohio native Mary Ann Pumphrey DeSellem (1848–1880) document her love of color and her excellent needlework skills. The quilts' graphic designs, geometric patterns, color combinations, and fine hand quilting suggest that DeSellem may have been Amish, but one quilt's patterned fabrics, which nineteenth-century Amish quiltmakers did not use, argues against this conclusion. DeSellem, however, may have been part of one of the Mennonite communities in Columbiana County.

In *Double Hour Glass*, DeSellem set plain Turkey red against over-dyed green, a color contrast that gives her

came more available and affordable. Although many wool quilts from the last quarter of the nineteenth century were tied rather than quilted, DeSellem's heavy wool *Framed Nine Patch* is quilted.

Worn fabric in several places on the *Framed Nine Patch* top reveals a surprise—a layer of patterned cotton fabric just below the pieced wool top, and below that, cotton batting. Is this cotton top a recycled quilt top added to provide extra warmth, or is DeSellem's *Framed Nine Patch* top a replacement, one quilted over an older quilt constructed of the cotton fabric, batting, and backing?

The consistent feature of *Framed Nine Patch*'s twenty blocks is its center Nine Patch pattern in pale green and lavender one-inch squares. DeSellem arranged squares and rectangles around these centers in a variety of colors, including deep purple, muted brown, tan, gray-blue, a teal print, and eye-catching black dots printed over deep orange. This latter fabric, at least, may date from the 1850s. The still-vivid purple rectangles indicate how well wool fabric received and retained purple dye. Conversely, there is clear evidence of fading in the other wools, especially those dyed light blue, pale green, or lavender. Peeking between the seams reveals the much brighter original colors. These colors are also uneven and blotchy, though this does not necessarily indicate home dyeing. Large-scale copper-toned paisley in heavy cotton, possibly a furnishing fabric, makes up the inner border and binding. The quilt's backing fabric is cotton, a small-scale brown and tan vining leaf pattern overprinted with pencil-thin orange lines.

In 1973 and 1975, California quilt historian and collector Joyce Gross purchased these two quilts in San Leandro, recording the quiltmaker's name as Mary Pumphrey DeSellem of Salineville, Ohio. Genealogical research supports this attribution and offers clues to how and when these Ohio-made quilts came to California. Ohio native Mary Ann Pumphrey DeSellem (1848–1880) died at age thirty-two of tuberculosis, leaving behind her husband, Jacob G. DeSellem (ca. 1845–1909), a Civil War veteran and store clerk, and their two children, daughter Olive and son Edward, ages five and six in 1880. Mary Ann's two quilts apparently passed to son Edward Clinton DeSellem (1874–1952), who moved to Los Angeles with his wife, Viola, sometime before 1910. Edward served in World War I and held various jobs over the next forty years, working in a bakery, as a truck driver for Standard Oil Company, an

oil driller, and as a salesman. He died in 1952, and his wife died in 1961.[102] There is no record of the couple having children. It is possible that Edward, with little memory of his mother, or Viola, who never met her mother-in-law, felt little family attachment to these quilts and, therefore, did not hesitate to sell them or give them away. Or maybe the two quilts ended up being sold with all the other household goods following Viola's death in 1961.

Perhaps in appreciation of the cheerful backing fabric on DeSellum's *Framed Nine Patch*, Joyce Gross reproduced it on the inside front and back covers of her 1973 Mill Valley Quilt Authority exhibit catalog *A Patch in Time: A Catalog of Antique Traditional and Contemporary Quilts*. These end papers show a gold-colored fabric; in reality, the fabric is warm chocolate brown.

Framed Nine Patch

Attributed to Mary Ann Pumphrey DeSellem, Columbiana County, Ohio, circa 1870–1879

Cotton, wool: 73½ x 88 inches

Machine pieced, hand pieced, hand quilted

Joyce Gross Quilt History Collection, W2h001.096.2008

DCCLXXIII

NEU BRAUNFELS in TEXAS

Aus d. Kunstanst. d. Biblio gr. Instit. in Hildbh.

Eigenthum d. Verleger.

1851

25.00

Neu Braunfels, in Texas,
circa 1851. Prints and
Photographs Collection.

TEXAS SUNDAY HOUSE QUILT

Quilt historian and collector Karoline Bresenhan, well-known to quilt enthusiasts as founder and executive director of Quilts Inc. and its International Quilt Market and Festival in Houston, acquired this quilt in the late 1970s or early 1980s from an antiques picker who discovered it near New Braunfels, Texas. In 1845 the Adelsverein, or German Emigration Company, founded New Braunfels, named for Braunfels, Germany. During the nineteenth century, Germans made up the largest ethnic group in Texas to emigrate directly from Europe.[103] The quilt's name refers to a family's small second home located in town near a church and used as a weekend residence. Owning a Sunday house enabled a farmer or rancher living in a remote area to come to town on Saturday for Sunday services. In Texas, Sunday houses are closely associated with historically German communities such as Fredericksburg, New Braunfels, and Castroville.

This quilt is reversible, an atypical feature in quilts. Each side represents a pieced pattern that was losing or gaining popularity at about the same time. One side is a large pieced and framed medallion, a traditional style fashionable into the early 1830s. The other is a block format, a style that enjoyed popularity as tastes for the medallion set waned. The two sides have at least six fabrics in common, and it appears that they were sewn about the same time specifically for use in a two-sided quilt. The pieced side contains thirty blocks, each featuring the Variable Star pattern framed by triangles and divided by solid white sashing. The medley of fabrics used is considerable, including solids, ginghams, calicoes, swirling stripes, plaids, and a deep indigo blue with a chrome orange overlay. The complexity of the medallion and the greater wear on the medallion side argue that this was the preferred side, that is, the side most often used as the quilt top. Visible fading indicates repeated exposure to sunlight, and gentle soiling plus tears and worn areas bear witness to abrasion resulting from repeated use. The block format side, though stained and worn in places, remains brighter, cleaner, and more stable.

The date range of the fabrics on both sides of the *Texas Sunday House Quilt* spans upward of fifty years, from the 1830s through the 1870s, possibly even later. Most prints are small-scale, though on the block side two large-scale prints appear, notably a tan and Prussian blue floral print.

Rusty orange-red prints, a madder red common after 1860, and madder and chocolate brown prints dominate the medallion side. Tans and taupe, one tiny chrome orange print, purple prints fading to brown, cinnamon pinks, and indigo blue with a chrome orange overlay also appear, as do lengths of a white ground fabric with red dots used in one of the medallion frames.

The composition of the framed medallion deserves attention. Its design—multiple frames around a central patch—was fashionable even before 1800. An impressive nine frames surround the small central white patch, which measures less than four inches square. No less significant is the variety of the composition and fabrics used in the frames. Several are strips pieced in the flying geese pattern, another sports square-in-square blocks in a variety of patterned prints, and still others are strips made from a single fabric. Some frames have cornerstones; others do not. The outermost frame, a fabric with red dots on a white ground, is also the widest. All the strips in this frame are made from multiple pieces. One, for example, contains ten pieces, indicating that the quiltmaker lacked enough yardage to cut the strip as a single piece. Insufficient fabric may also account for this outer frame having only three sides. It is more likely, however, that the quiltmaker omitted the fourth side to help match the size of the medallion side to the block side. This construction also argues in favor of the two quilt sides being sewn about the same time specifically for use in a two-sided quilt. Blocks in the popular album pattern border the framed medallion. Fabrics used in the album blocks help confirm that the border and medallion are contemporary—the two have at least six fabrics in common.

As if two quilts in one are not enough, the *Texas Sunday House Quilt* holds yet another surprise—a third quilt, or at least a remnant of one, used as batting. Worn areas around the edge permit glimpses of small parts of this quilt, including its warm brown prints used for binding and as part of a block. Other worn areas open to cotton batting. The hand quilting, of course, cannot relate to both of the two very different pieced patterns in this reversible quilt. Hand-quilted straight and diagonal lines, often haphazard and at four to five stitches per inch, conform only to the pattern on the quilt's block side.

**Texas Sunday House
Quilt,** front

Maker unknown, possibly
New Braunfels, Texas,
circa 1870s

Cotton: 72 x 79½ inches

Hand pieced,
hand quilted

Karoline Patterson
Bresenhan and Nancy
O'Bryant Puentes Quilt
Collection, 2013-016-1

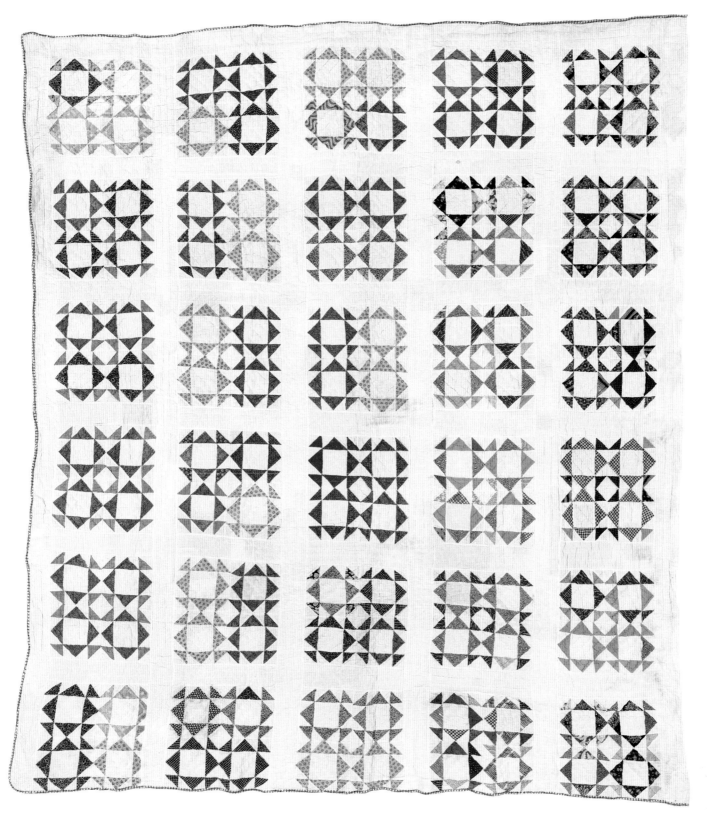

Texas Sunday House Quilt,
back

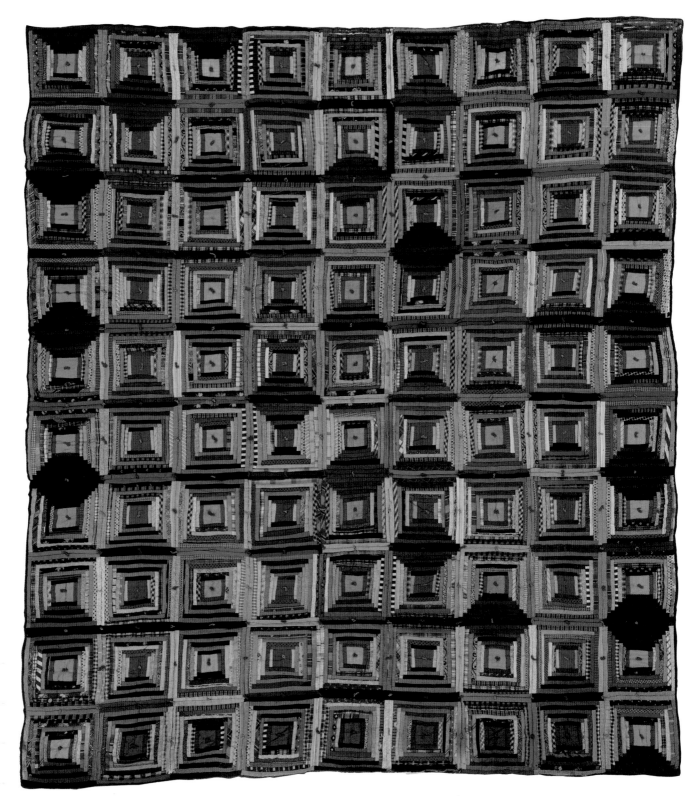

**Log Cabin,
Courthouse Steps
Variation,** front

Maker unknown,
circa 1875–1890

Wool and cotton:
77 x 85 inches

Hand pieced,
machine pieced, tied

Ima Hogg Quilt
Collection, W2h14.70

*Log Cabin, Courthouse Steps
Variation*, back

LOG CABIN,
COURTHOUSE STEPS VARIATION

Log Cabin quilts were popular with quiltmakers in the last quarter of the nineteenth century. Based on a series of straight fabric strips sewn on a foundation fabric, their construction offered many ways to alternate light and dark designs that give the illusion of movement. In this *Courthouse Steps Variation* the geometric patterned front is paired, unexpectedly, with a large-scale floral furnishing fabric on the quilt back. Texas decorative arts collector Ima Hogg acquired this quilt in 1971 near Houston, but there is no evidence that it was Texas-made.

The Courthouse Steps quilt pattern creates a block using light and dark strips (the "logs") stacked around a central patch. Its pattern changes attract and confuse the eye, as dark strips in adjacent blocks seem to merge into a square that alternately advances toward and recedes from the lighter blocks. In this example, the quiltmaker's access to a wide variety of cotton and woolen fabrics offered her near endless opportunities to join dissimilar prints within the light-and-dark scheme. In all she used nearly forty different solids and prints, including plaids, dots, stripes,

checks, and at least ten different paisleys. She sewed some strips, especially those in checks and plaids, on the bias, bringing additional movement and interest to her scheme.

Undaunted by so many fabric choices, she also imposed considerable order in the pattern. For example, the vertical rows, except those at the quilt's sides, alternate red with pale blue center patches. Green patches, now faded to tan, grace the side rows. The sequence of fabrics in the logs also is well organized. With few exceptions the order of strips moving away from the center patch mirrors the order of those moving toward the center patch in the adjacent block. Most of the quilt's foundation fabric is muslin, visible through worn areas at the edge. In one area, however, a foundation of teal cotton chintz, its glaze intact, is visible. The blocks are tied in red or green wool yarn. Most ties, but not all, are sewn through to the back.

The quilt's backing fabric is a cretonne, a printed fabric, typically cotton, used for furnishings such as draperies, furniture upholstery, and bed hangings. This example is an exuberant, large-scale print whose design features parrots, cockatiels, and other birds perched or flying among palm trees, fronds, and blooms, as well as swans and storks in water, all set against a bright Prussian blue background. The fabric may be a French textile, one designed in response to the popularity during the latter nineteenth century of private menageries and exotic and tropical birds.

This *Log Cabin* is an exceptional utility quilt. Its combined four layers—wool strips, foundation, thick cotton batting, and sturdy backing fabric—make it quite heavy, a quilt intended to provide warmth and to comfort its users by surrounding them with beauty.

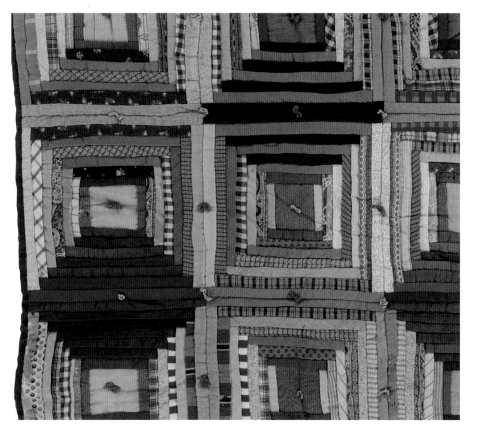

OCEAN WAVES & OCEAN WAVES VARIATION

The Ocean Waves pattern sets rows of right triangles (half squares) around a center square, often of plain fabric, to create the feeling of motion and the illusion of dimension. Although it is a block construction, the pattern gives the appearance of an all-over design. Kathleen McCrady and Marcia Kaylakie, both Austin quiltmakers, historians, and teachers—and longtime friends—each owned one of these two quilts. Each was especially attracted to her quilt's fabrics: McCrady to the double pinks and chrome yellow in her quilt, and Kaylakie to the chrome orange over-dyed indigo blue in hers.[104] Though equally dynamic, the two quilts achieve very different looks overall, indicating how strongly color can affect pattern.

McCrady's *Ocean Waves* sets right triangles of solid olive green and double pink around a chrome yellow square. The green-pink combination is electric, causing the yellow squares to pop. The unknown quiltmaker sized the pattern and border dimensions to take full advantage of this bright yellow fabric—yellow half squares sit at each corner and yellow right triangles point inward from the border's inner edge. A generous border in a dark brown floral print provides relief from the busy triangles and bright squares. This quieter fabric is used again on the quilt back as wide strips alternating with ones in a deep olive green patterned print. The hand quilting is limited to straight and parallel line designs on the border and center squares.

In *Ocean Waves Variation* the overall look is a strong dark-light contrast—indigo patterned print and solid white. At a distance, this quilt's large white blocks appear to be rectangles with notched ends. This illusion is created by the quilt's construction and two-color format, which sets the bases of white triangles against opposite ends of the larger white center square, giving the appearance of end points. *Ocean Waves Variation* no doubt was made as a utility quilt. Its lovely indigo blue fabric with striking chrome orange overlay and fine hand-quilted, parallel line and grid patterns at ten stitches per inch attest to the quiltmaker's determination to bring additional beauty to this bedcover. The narrow binding is handmade and hand applied front and back. The overall pattern of this quilt inevitably results in partial forms at the edges and corners.

Ocean Waves

Maker unknown,
probably Pennsylvania,
circa 1880–1900

Cotton: 77 x 80 inches

Hand pieced,
hand quilted

Kathleen H. McCrady
Quilt History Collection,
W2h85.06

Ocean Waves Variation

Maker unknown,
probably Texas,
circa 1875–1890

Cotton: 74 x 86 inches

Hand pieced,
hand quilted

Marcia Roberts Kaylakie
Quilt Collection,
2013-230-2

COMFORT
AND GLORY

Early Texas pioneer Annette Wheelock Killough (1821–1906) made *Snowflake*, stitching into it a single initial that honored both her family name and the small Texas town in which she spent most of her life. Annette was born in Illinois, but in 1833 the Wheelock family, along with several other families from the St. Clair County, Illinois, area moved to the Robertson Colony in Mexican Texas. There Annette married three times and was widowed twice. She married first at fifteen, but her husband, a veteran of the Texas Revolution, died of yellow fever only three months into their marriage. Annette married again one month later but was widowed again at age eighteen when her second husband died in an Indian fight in 1839.[105]

In 1841 Annette wed Samuel Blackburn Killough (1813–1876) from Tennessee. This marriage lasted thirty-nine years and produced eleven children. Three died very young—her first baby at three weeks and her twins, born in 1842, before they turned two years old—but six lived to maturity. Annette also owned considerable property, inheriting from her father, Eleazar Louis Ripley Wheelock (1793–1847), three leagues of land (more than thirteen thousand acres) near the town of Wheelock, Robertson County, Texas. Eleazar Wheelock was a prominent Texas landowner, soldier, and businessman. In 1834 he laid out the town of Wheelock, naming it after Eleazer Wheelock, his grandfather and the founder of Dartmouth College.

Wheelock became one of the best-known towns in Central Texas prior to the Civil War. In the 1830s, attempts were made to make Wheelock the state capital, and in 1837 the town was thought a possible site for the University of Texas. The town's gradual demise came after railroads bypassed it in the late 1860s.[106]

Annette and Samuel Killough remained in Robertson County their entire lives. Samuel served as the Robertson County chief justice, county commissioner, and county representative to the Third Constitutional Convention of Texas in 1875. Family history states that the couple built a large house around their original log cabin. This structure became home to several generations of Wheelocks, including Annette's mother, Mary Prickett Wheelock, and sons, daughters, and grandchildren. The family included five generations of quiltmakers. Annette Killough, considered a "firecracker," was the recognized family matriarch.[107]

It is very likely that Annette Killough's *Snowflake* began as a bright red and white quilt. The plain red fabric, probably a synthetic red, is now faded to a dusty warm brown. Much of the quilting and all of the appliqué stitches, however, are in red thread. *Snowflake* is a papercut appliquéd quilt, its nine snowflake motifs made by folding and cutting paper patterns, a technique first used in Baltimore before being adopted by Pennsylvania Germans.[108] It is very possible that Annette saw and learned the technique from German Texas quiltmakers who settled throughout south-central Texas after 1850. Annette hand quilted Ws in each of the lobes of the appliquéd snowflakes to honor both the Wheelock family name and the town name. She also graced the snowflake centers with double outlined hearts, added outline quilting around each area of reverse appliqué, stitched single lines along the curved tops of each snowflake lobe, and quilted a running double-line zigzag along the sashing. A one-inch grid pattern in white thread fills the background.

Snowflake remained in the Wheelock family until 2010, when Annette Killough's great-granddaughter Lucile R. Lockwood donated it to the Briscoe Center. The family also reported this additional tidbit concerning the quilt's history: that it had been "kept in a trunk with Samuel B. Killough's [Republic of Texas] commission in Sam Houston's army and 'yards of lace from [Mexican army General] Santa Anna's uniform.'"[109]

This photograph of Sarah Lavonia Archer carding cotton in her Limestone County, Texas, home, in 1904, echoes the description of pioneer Texas matriarch Annette Killough from nearby Robertson County. Joseph E. Taulman Collection, 3T66.

Snowflake

Annette Wheelock
Killough, Wheelock,
Texas, circa 1875–1890

Cotton: 80 x 77½ inches

Hand pieced,
hand appliquéd,
reverse appliqué,
hand quilted

2010-115

Gift of Lucile R.
Lockwood in memory of
Sally Killough Rack

CENTER MEDALLION SUMMER SPREAD

An unknown quiltmaker carefully pieced a central medallion containing a six-pointed star and rows of diamonds, rings of tulips and stars, corner floral motifs, and a tulip-and-star border to create this delightful summer spread. In all, she appliquéd more than 125 designs onto her background fabric, a white shirting with black dots.

Time, exposure, use, washing, and the properties of dyes have taken their toll on this single-layer summer bedcover. The black dots in the background fabric have dropped out here and there, the result of the corroding effect of dye fixative. Fading has affected most of the original colors, but not all, leaving startling evidence of the contrast between the original colors and those now faded. For example, although the double pinks at the center have faded to pale pink, the pinks in the stars and tulips near or at the border remain bright. The border tulip stems and outer petals and the corner stems, once a vivid green, have almost all faded to tan, suggesting the use of synthetic green dye available about 1875. Finally, a row of diamonds in the medallion and in the stem and first petals of the inner row of tulips both appear consistently tan. Was their

original color tan or were these motifs a green that has faded uniformly?

This summer spread's most extreme fading and browning occurs within the yard-wide band that runs edge to edge through the quilt's center width. Perhaps this thin bedcover occasionally covered a table. Draped across a narrow surface and positioned so that the medallion was the decorative focus, it may routinely have been exposed to sunlight. Despite its color loss, the charm and the liveliness of this summer spread remains, especially in the original corner floral motifs. Here Turkey red, cadet blue, double pink, and chrome orange flowers and buds spray off a branched stem set in an impossibly small vase. Each floral design is different—some stems end in buds, others in blossoms. All of this summer spread's pieced and appliquéd elements remain intact and attest to the quiltmaker's needlework skills. Her piecing is precise and her tidy blanket stitch, done with a single strand of off-white thread, beautifully secures the dozens of colorful flowers, stars, and diamonds.

COMFORT
AND GLORY

**Center Medallion
Summer Spread**

Maker unknown,
circa 1875–1900

Cotton: 72 x 84 inches

Hand pieced, hand
appliquéd, hand
embroidered

Ima Hogg Quilt
Collection, W2h24.67

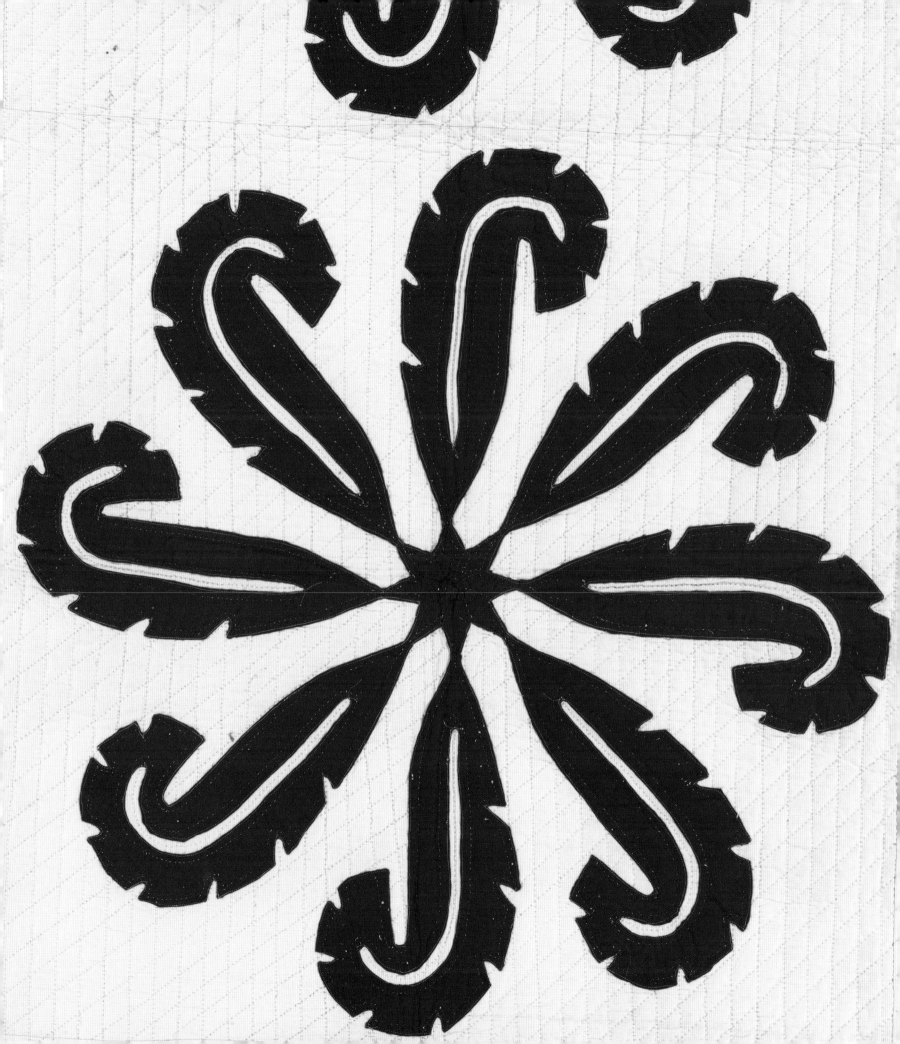

Both the maker and donor of this quilt called it *Star* or *Feathered Star*, though many quiltmakers will recognize the quilt as a variation of the popular Princess Feather pattern. In 1932, years after she had made this quilt, Sarah Shannon sent her daughter Effie Shannon Porter (1880–1953) a postcard that documents the first step in this quilt's journey, always in Texas, from her hands to those of her great-granddaughter. She wrote, "I have just received your card and am so glad that Jane gave you the Star quilt. I made it in the year 1877 when we were boarding in Dallas making it 55 years old. Is't [It's] worn or soiled but I am so glad you have it."[110]

Quiltmaker Sarah Mehettable Baker Shannon (1857–1942) was the first child of William Thatcher Baker and Emily Elvira Beeman Baker of Parker County, Texas.[111] She married James Alexander Shannon on January 25, 1877, the same year she made the quilt. Did she intend her *Feathered Star* as a bride's quilt? The quilt's penciled marking lines for its hand-quilted hanging diamond pattern remain clearly visible, suggesting that Mrs. Shannon used her quilt rarely, if at all, and may have never washed it. *Feathered Star* passed from mother to daughter twice more after coming to the quiltmaker's daughter Effie Shannon Porter. Effie Porter gave the quilt to her only daughter, Martha Porter Ritchey, who passed it to her oldest daughter, Shannon Ritchey Thompson, who donated the quilt to the Briscoe Center in 2014.

Feathered Star is a simple yet highly graphic variation of the Princess Feather pattern, often made using red and green appliquéd designs, commonly with plume or floral borders and a design focus at the quilt's center.[112] Shannon's version is a two-color, nine-block quilt of spiraling plumes, a pattern unencumbered by other designs. The scale of the spiral designs (measuring 25½ inches tip to tip), their closeness to one another (typically less than one inch), and the crispness of the deep red (probably Turkey red) against the off-white background make this quilt especially eye-catching.

Feathered Star has several distinguishing features re-lated to its construction. The most obvious is that it was machine appliquéd in white thread. Shannon used machine stitching in a contrasting color to outline and attach seventy-two plumes and the outer edges of the center stars, each made from eight diamonds. The edges of the motifs are carefully turned under, and the machine stitching is tight (the stitches measure between one-sixteenth and one-eighth of an inch) and fairly even. This stitched outline is not precise, however. It slips off the red edge here and there and regularly misses the sharp turns at the plume notches. The interior of each plume contains reverse appliqué, where the red plume is cut away to reveal the quilt's off-white background fabric. The machine stitching in this area also reveals where the quiltmaker started the stitch to secure the reverse appliqué. The stitch indicates that she began at the end closest to the center star, and then stitched around the edge of the slender cutaway loop, ending at the same place she began. At the top of the loop in some plumes it is easy to see which stitch line crossed the other, hence even revealing the direction in which the quiltmaker sewed. The red plumes and center stars are further defined in white hand-quilted outline stitches.

Sarah Shannon extended her quilt's length by adding two-inch strips of slightly darker off-white fabric along the quilt front's top and bottom and a single one-inch strip along one side of the quilt back. Curiously, she did not incorporate her overall hanging diamond quilting design in either strip on the front. The vertical diagonal lines are present, but missing are the horizontal lines that would cross them to create hanging diamonds. Along the bottom strip, marking dots indicate that Shannon planned this next step but never took it.

The quilt's backing fabric, off-white muslin, is also notable. Its width, with the exception of the additional slim strip along one side, is seventy-six inches. This single piece covers the entire quilt back, making it an unusually wide fabric for 1877. It is not yet known where this fabric was made.

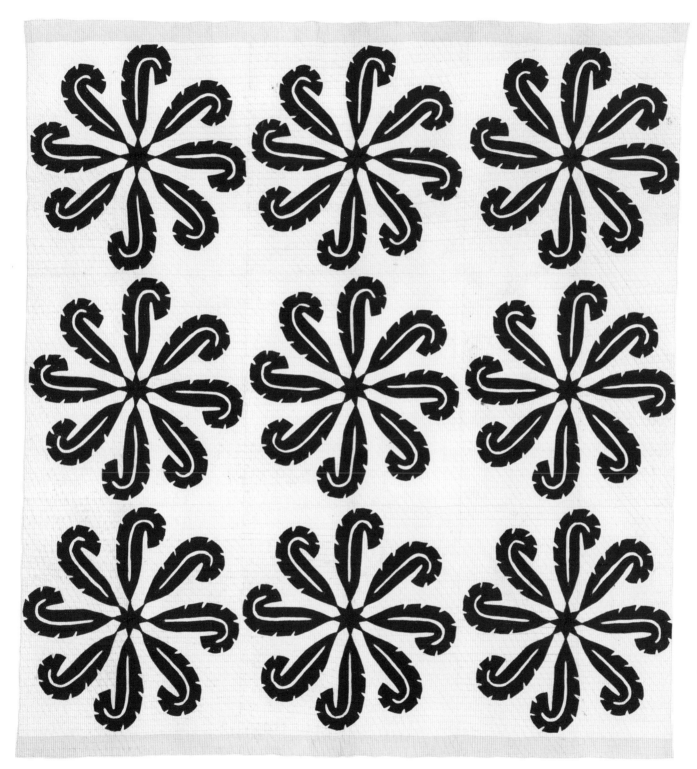

Feathered Star

Sarah Mehettable Baker
Shannon, Dallas County,
Texas, dated 1877

Cotton:
77½ x 83½ inches

Machine pieced, machine
appliquéd, hand quilted

2014-157

Gift of Shannon R.
Thompson

Quiltmaker Lucy Weeks Kendall (1858–1931) was born in Abbott, Maine, and raised in nearby Dexter, where the Sebasticook River supported both grist and textile mills. Following the death of her parents, Kendall lived with her brothers, first in Skowhegan, Maine, and, some time after 1880, in Alameda County, California. Kendall never married, and it seems she contributed to her family's income by sewing—the 1880 US Census lists her occupation as "dressmaker." It is not known if she continued to sew for pay once she moved to California, but she clearly continued to sew, as demonstrated by her extraordinary *Roman Stripe* show quilt.[113]

Quilt collector Joyce Gross saw Lucy Kendall's *Roman Stripe* at an estate sale in a fashionable home in Oakland, possibly Kendall's former residence. Joyce recalls that during the sale she asked the women in charge about quilts. One guided her through a bedroom into a bathroom, where she retrieved this quilt from behind the tank above the toilet. The woman also fetched a box of silk embroidery floss from the basement. She believed that Lucy Kendall had used floss from the box to make her quilt. Joyce did not purchase the quilt during the sale. She was

surprised and delighted when her husband gave her both the quilt and the box of floss on their next anniversary.[114]

The box of embroidery floss is labeled "Art Needlework Wash Silks" and dates from the early 1860s to 1880. The floss was manufactured and marketed by M. Heminway & Sons Silk Company, which had mills in Watertown, Connecticut. The box's eleven compartments contain a variety of labeled packets from Heminway & Sons and the Brainerd & Armstrong Company. Both companies sold silk embroidery floss during the Victorian era, a period during which women used their needlework skills to decorate their homes with silk art embroidery. This form of stitchery was characterized by botanical realism, including naturalistic color and shading. Silk art often also incorporated designs of minimal floral shapes that were based on the form of a plant. Lucy Weeks Kendall's quilt includes both types of designs.

Kendall's Victorian-era *Roman Stripe* quilt features four vertical columns, each one containing more than one hundred pieced silk, satin, and velvet strips. Most of the strips are solids, but there are also plaids, stripes, dots, checks, and small floral and geometric prints. Some may have been cut from men's ties, hat linings, or waistcoats; others possibly were scraps from dressmaker fabrics. The columns are divided and bordered by panels in rich, chocolate-colored satin and embellished by rows of intricate silk embroidery. Each row features a different series of designs in varying colors of floss, including a few variegated threads. Designs include fans, circles and half circles, sprays, curlicues, zigzags, half moons, intersecting loops, and geometrics. The execution of these complex embroidered designs is precise. In opposite corners—lower left and upper right—the quiltmaker embroidered oversized and naturalistic floral designs in silk chenille thread, one a spray of deep red poppies, the other a honeysuckle in shades of bright orange.

Roman Stripe contains a muslin foundation fabric to which the strips, the embroidery, and the corner flowers are sewn. The brown satin on the front is turned to the back at the edge, creating a one-inch border on the back. The backing fabric is a copper-colored satin hand sewn to the one-inch border. No ties or quilting attach the quilt front to the back.

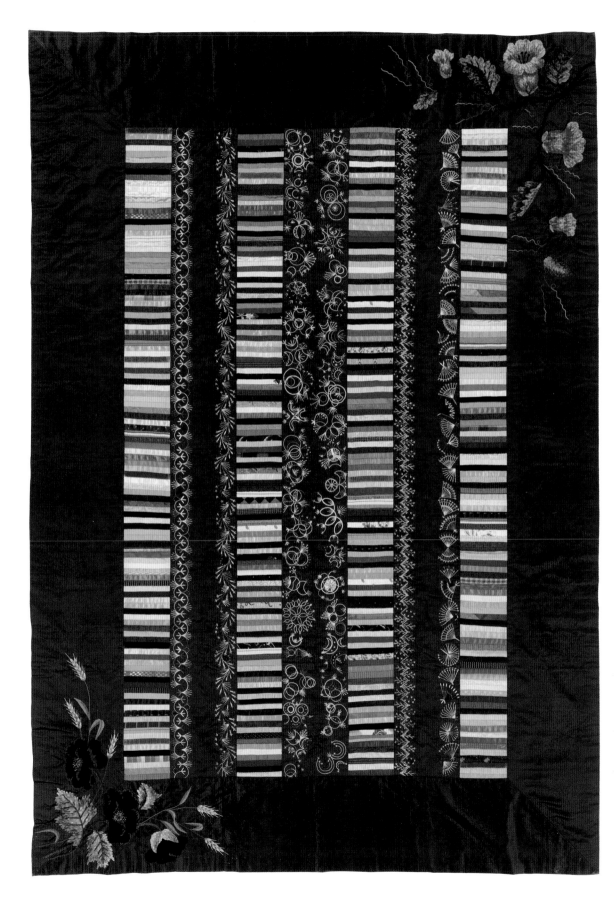

Roman Stripe

Lucy Weeks Kendall,
Oakland, circa
1880–1900

Silk, satin, velvet:
47½ x 68 inches

Hand and machine
pieced, hand
embroidered

Joyce Gross Quilt
History Collection,
W2h001.064.2008

Art Needlework Wash
Silks, M. Heminway &
Sons Silk Company, circa
1860s–1880. Joyce Gross
Quilt History Collection,
W2h001.167.2008.

YANKEE PRIDE

Ninety-nine blocks, each one containing forty-two diamonds, squares, rectangles, and triangles, alternate with plain blocks to create this striking *Yankee Pride*.[115] The multi-pieced pattern builds on a central motif of eight diamonds, a design used to piece quilts whose patterns range in complexity from the simple Le Moyne Star to the dramatic Baltimore Star. In the Yankee Pride pattern, four additional stars embrace the center and its surrounding eight patches.

This quilt is highly visual, a triumph of fine needlework and expert piecing. Its on-point blocks and pattern are so well pieced that perfectly straight rows reward views from several vantage points. At least twenty small-scale patterned prints, including dots, plaids, and florals, make up the diamonds. The quiltmaker used the same print fabric within each block, save for the four diamonds adjacent to the cream-colored patches. These diamonds are cut from the red and black print fabric used in the plain blocks—except where the quiltmaker substituted, perhaps out of necessity, two similar red prints. The quilt's color palette is a wonderful combination of the dominant, warm cardinal-red print and tones of tan, cream, muted and warm browns with red and tan, a faded purple, gray, dull green, and a black print with over-dyed deep red polka dots. The whole look is warm. *Yankee Pride* is a quilt that begs to be used.

And used it was. Austin quilt collector and historian Marcia Kaylakie saved this quilt from being used as a tablecloth. In 1998, when Marcia and her husband stayed at a bed-and-breakfast in Montgomery, Alabama, she saw this quilt on the breakfast table where two guests were eating. Fortunately, Marcia understood her duty and acted on it, negotiating with the B & B's owner to purchase the quilt. As she later recalled, "I marched back into the breakfast room. I told everyone to please lift up their food and drink and I took it directly from the table." As it turns out, the quilt had suffered a number of indignities even before Marcia acquired it. The owner stated that he bought the quilt from a woman out of the back of her car parked on the side of the road. He, in turn, kept the quilt in his car for more than seven years, often wrapping tools in it. Later he used the quilt in his B & B as a tablecloth, where at Christmas it even graced the table holding the holiday punch bowl.[116]

One anomaly of this quilt is its narrow binding, a pinky red and white patterned fabric, now frayed all along the edge. The color is at odds with the quilt's overall color palette, and the fraying makes visible the machine sewing that attached the binding to the quilt top, which otherwise was entirely hand sewn. Perhaps this quilt was a top for some years before it was finished and bound at a later date, a time when the quiltmaker had altogether different fabrics on hand. The hand quilting is fine, at from nine to eleven stitches per inch in parallel lines and hanging diamonds that perfectly suit this diamond-based pattern.

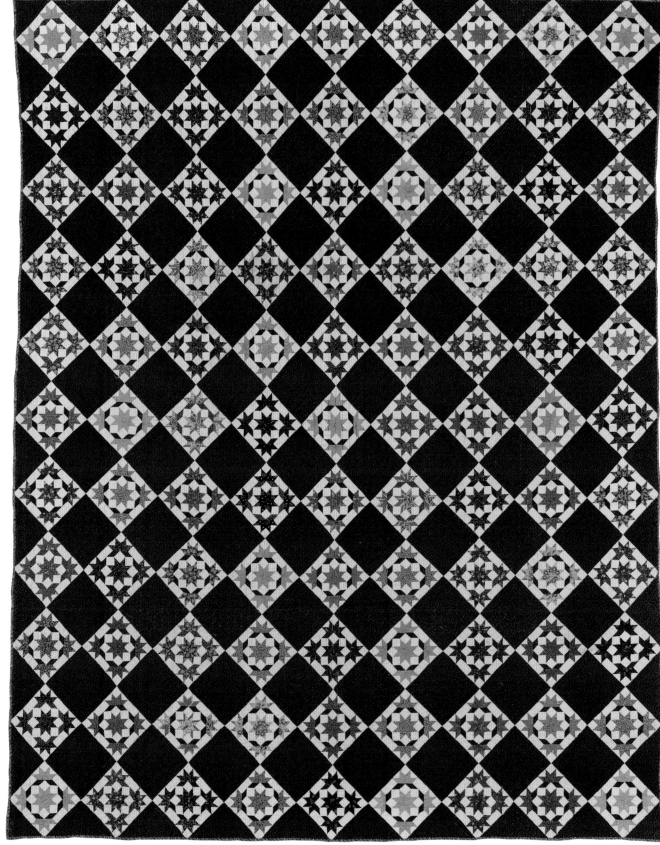

Yankee Pride

Maker unknown,
circa 1880–1900

Cotton: 86 x 107 inches

Hand pieced,
hand quilted

Marcia Roberts Kaylakie
Quilt Collection,
2013-230-1

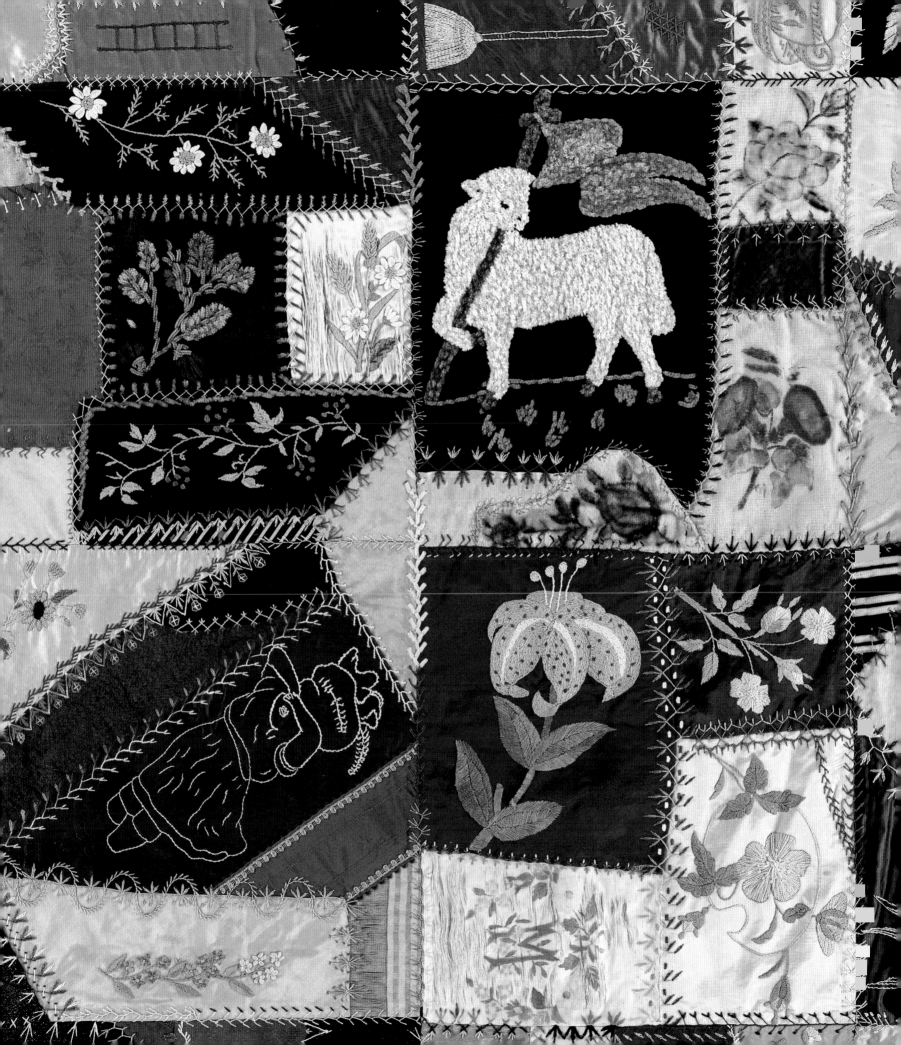

Texas quiltmaker Louise Murray Dill (1852–1941) spent a good bit of her life in dry goods stores. Her regular contact with fabrics, sewing notions, and women who sewed may have helped her develop the needlework skills showcased in this *Crazy Quilt*. Born Cynthia Louise Murray, Louise came to Texas when her father, Alexander Murray, moved his wife and baby daughter from Tennessee sometime before her sister Sarah's birth in Texas in late 1854. When the girls' mother died, Murray temporarily split up his family. He and daughter Sarah boarded with a family in Palestine, Texas. Louise lived in Palestine also but was cared for by Dr. and Mrs. William Shumatte. Dr. Shumatte was a dry goods merchant at the time and, possibly, was related to Louise. She lived with the couple again after her marriage in 1873 to Charles R. Dill, who clerked in Dr. Shumatte's store. The Dills boarded and raised their daughter Mary, born in 1878, in the Shumatte's home through 1900.[117]

Palestine, located in East Texas, 150 miles north of Houston, was growing rapidly when the Murrays moved there in 1854. At the end of the decade the town boasted a post office, newspaper, courthouse, and a school for young women—the Palestine Female Institute. Both Louise and her sister may have attended the institute.[118] By 1866 there were twelve dry goods stores in town, with commerce served by paddle-wheel steamer during high water on the Trinity River and, after 1872, by the International–Great

Northern Railroad. In 1886, when Louise Dill began her quilt, it is likely she was able to acquire the fabrics, notions, pattern books and magazines, and embellishments she needed in several ways: locally, by mail order, or by traveling by rail to Houston to purchase them.[119]

Mrs. Dill created her *Crazy Quilt* as a seventy-two-inch square composed of thirty-two blocks and a center medallion. Later, someone—perhaps the quiltmaker or her daughter Mary—dramatically increased the quilt's size by adding a six-inch top row of irregular patches and then sewing a nine-inch wide black cotton sateen ruffle around the entire quilt. This extra row and ruffle clearly are later additions. The row is stylistically at odds with the quilt's blocks in both construction and decoration, and its backing fabric is different from the fabric used for the original quilt back.

The quilt's blocks contain irregular-sized patches set in rows of blocks. A larger center block features the popular folding fan design with alternating lavender and pale yellow satin segments radiating from hand-pieced golden velvet ribs. A dizzying array of decorative stitch styles and colors covers the seams, and embroidered, appliquéd, dimensional, and painted motifs appear in nearly every patch. These include embroidered birds and flowers, Kate Greenaway children, horseshoes, anchors, hatchets, fans, spiders, butterflies, lambs, owls, and Bibles. All were popular motifs in Crazy quilts and ones Mrs. Dill may have based on commercially available patterns and stamps or purchased as embroidered appliqués ready for use.

The quilt also contains delightful motifs that appear to be Mrs. Dill's own creations and further attest to her handwork proficiency—an elaborate Chinese man constructed of pieced velvets, brocades, cotton sateen, and silk; an exquisite dimensional butterfly with a stuffed body wrapped in gold-colored floss; and an American flag featuring thirteen embroidered stars plus stripes made of pieced red and white ribbons. Finally, the quilt also features several motifs specific to the Dill family: a painted initial "M" and the embroidered name "Mary," both for daughter Mary; the date "1888"; and a silk souvenir program from the Dallas State Fair and Exposition of 1886. The latter item is embroidered with the initials "S" and "D," one in each upper corner—perhaps the initials for Shumatte and Dill.

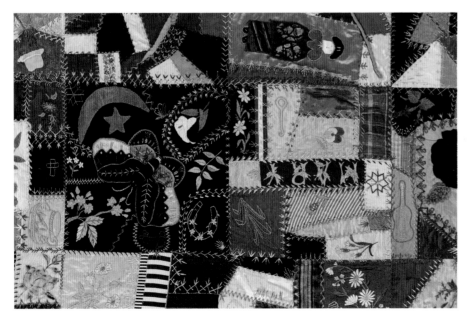

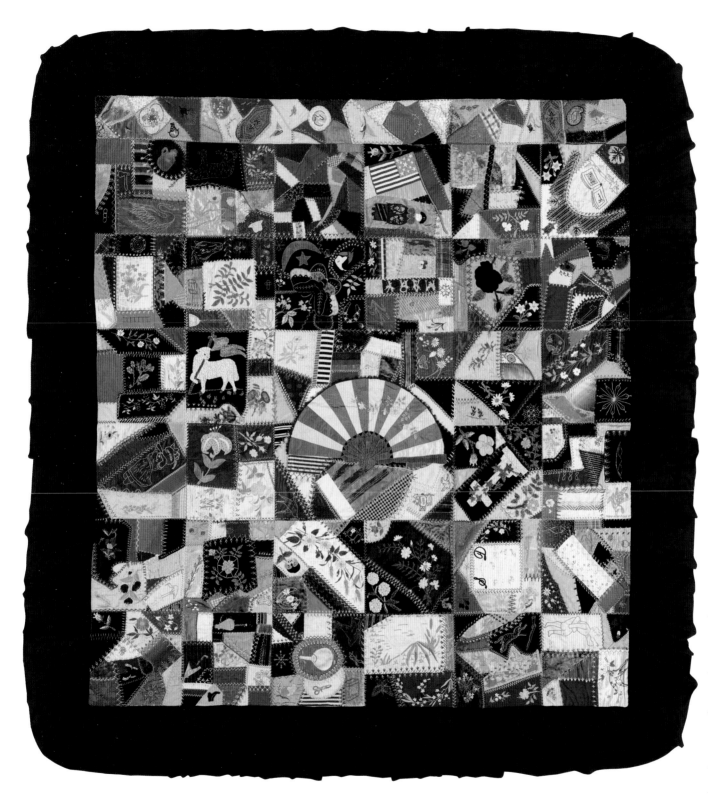

**Crazy Quilt
with Ruffle**

Louise Murray Dill,
Palestine, Texas,
circa 1888

Silk, satin, velvet, cotton
sateen: 92 x 99½ inches

Hand and machine
pieced, hand appliqué,
embroidered, painted

TMM 925.2

Gift of Mrs. W. W.
Woodson

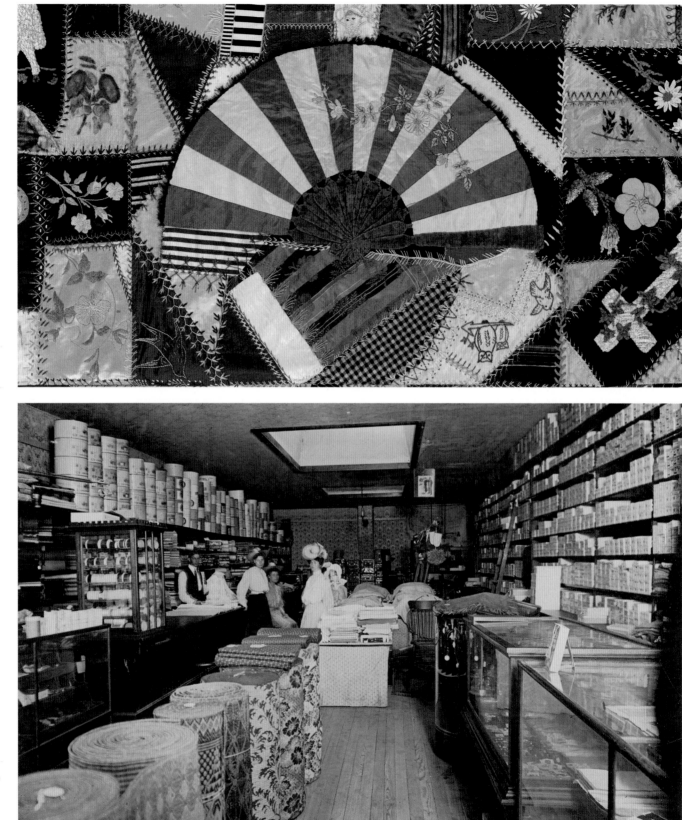

Crazy Quilt with Ruffle, detail

Dry goods store, Canadian, Texas, 1906. UT Texas Memorial Museum Photograph Collection, 3S241b.

CRAZY QUILT

Fortunately for those who love quilts, it is still possible to discover a handsome and inexpensive antique quilt for sale in a thrift shop, estate sale, flea market, or antiques store. And so it was with this *Crazy Quilt*, acquired by one of the donor's relatives around 1995 at a garage sale in Oregon. This treasure is a medley of fancy fabrics organized as a Crazy quilt, but just barely. The distinguishing feature of Crazy quilts is their many fabric pieces of irregular shapes and sizes. Most of this quilt's pieces, however, are squares and rectangles—the only irregularly shaped pieces are those squares or rectangles whose ends were lopped off at odd angles when the quiltmaker joined the blocks. In other words, the quiltmaker did not create these irregular shapes for design purposes; instead, they resulted from the construction of the quilt's blocks.

The quiltmaker used typical Crazy quilt construction methods, however, including sewing her fabric scraps onto a foundation. She used at least two different fabrics for her foundation, each visible through areas where the silk has shattered. She also incorporated decorative hand embroidery, but only on fourteen of the quilt's eighty blocks and always using very simple stitches. The quilt contains no decorative embroidered motifs, no embellishments, and no commemorative ribbons, all common in Crazy quilts. It is tied with pink floss, with knots and ties on the back. The back fabric is a dusty pink print.

Still, this *Crazy Quilt* is a treasure, one distinguished by its whimsical organization of an enormous number of period silks and velvets. A rough count indicates that the quiltmaker used more than 350 different fabrics in her quilt. Nine-patch blocks make up half of the eighty blocks, each one alternating with blocks whose patterns can best be described as "anything goes." These include single-fabric blocks, shape-in-a-square pattern blocks (always squares or rectangles), a single half-square triangle block, blocks of pieced diagonal stripes, and blocks composed of pieced narrow strips. The strip blocks vary in construction. Some have thirteen strips, one contains twenty-four; some strips run parallel, others perpendicular to each other—or both. The border is made of velvet rectangles, with single rectangles randomly interrupting repeating half-rectangle triangle blocks. The velvet fabrics are plain, checked, dotted, and plaid. The silks, in a dizzying array

of sateen, brocade, crepe, taffeta, moiré, and satin, include solid fabrics plus plaids, stripes, florals large and small, geometrics, ginghams, checks, striped grounds, circles and dots, and plain and patterned ombrés. This quilt is indeed a feast of period luxury fabrics.

Surely many of these fabrics were scraps saved from sewing projects, including women's dresses and skirts and men's vests, ties, and jacket linings. Others, however, are salesman's samples or, perhaps, fabric samples acquired from merchants. These samples include multiple colorways of at least twenty different designs. Many contain shimmering, almost iridescent colors that further enliven the quilt. The quiltmaker regularly incorporated several colorways of the same fabric into a single block, giving each of these blocks a truly special character. What a fabulous garage sale find!

Crazy Quilt, detail

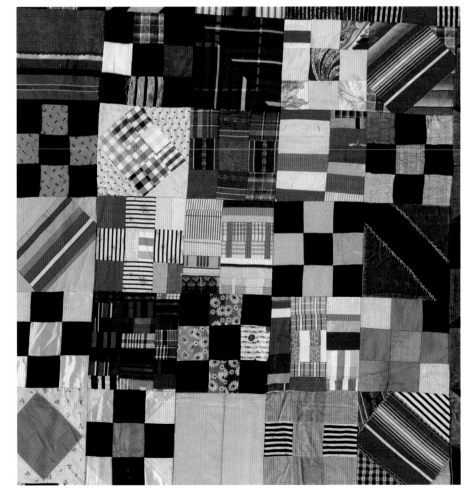

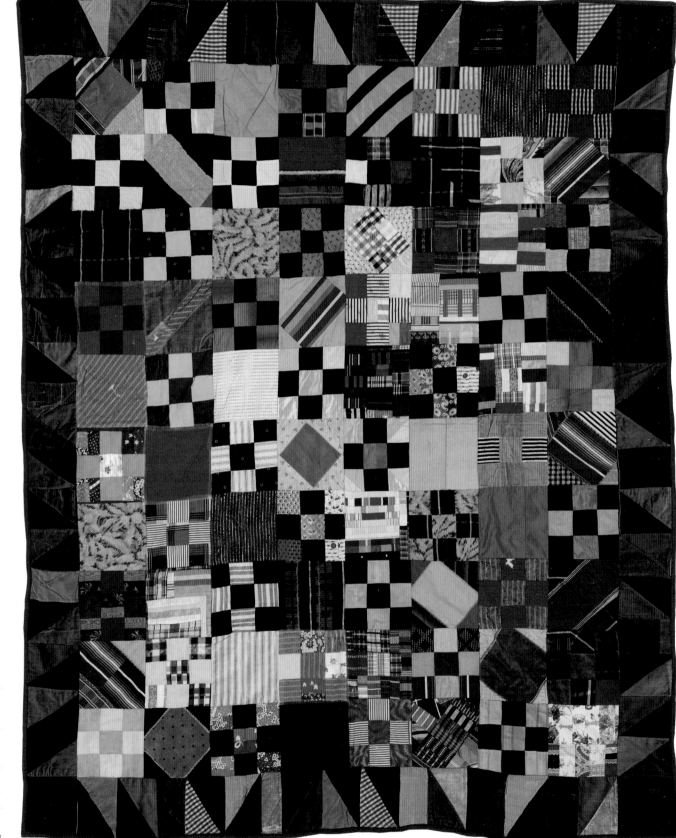

Crazy Quilt

Maker unknown,
circa 1890–1910

Silks and velvet:
58 x 72 inches

Machine pieced, hand
embroidered, tied

Sherry Cook Quilt
Collection, 2009-368-4

TUMBLER SUMMER SPREAD

This summer spread is worn, faded, and stained. It is tied, though only sparsely, and does not contain batting. Its edges are turned in and finished with a simple running stitch. Despite its lack of decorative stitching, *Tumbler Summer Spread* is tidy and superbly hand pieced. It is also a near-encyclopedia of turn-of-the-century cottons set in a single repeating shape—a trapezoid. This summer spread's overall pattern, called Tumbler, is one of the many that have great graphic appeal and present illusion, a shifting arrangement that can baffle the eye, a pattern that can be viewed in more than one way.

The piecing together of small shapes to create geometric designs has a long history in quiltmaking. As early as 1835, the popular *Godley's Lady's Book* published an illustration of a mosaic patchwork design that resulted in many variations, including the Honeycomb pattern and its later iteration, Grandmother's Flower Garden, a pattern popular in the 1920s and 1930s. By the late nineteenth century, inexpensive fabrics widely available in local dry goods stores and patterns sold commercially by mail order helped continue the popularity of these busy overall designs. The Ladies Art Company of St. Louis published the Tumbler pattern in 1898.

Tumbler Summer Spread contains 744 patches, with only a few fabrics repeated. Light patches alternate with dark ones. Most of the darks are browns, cadet blue, indigo blue, cinnamon pink, black, or red—there are very few greens. Fabrics are typical of the 1890–1910 period: light and dark grounds featuring single or multicolored prints of small florals, dots, rings, celestials, stripes, and geometrics (including the equilateral cross with four arms, known as the swastika, the symbol of the Nazi Party of Germany as early as 1920). Object prints such as dogs with cigars, nursery rhyme children, an oyster with its tiny red pearl; shirting plaids, checks, and stripes; printed patchwork (often referred to as cheater cloth); and a few mourning prints also appear. Some of the cottons are faille or chambrays, a few are cotton sateen, and several are furnishing fabrics, generally with larger printed designs.

The visual impact of this pattern is remarkable. Its single shape, repeatedly widening and narrowing, and the interaction of various lights and darks present a shifting surface. Viewed head-on while hanging, the quilt's pattern confuses the eye. Viewed along the length of the bedcover—and reinforced by the vertical orientation of the striped fabrics—the pattern is dynamic; indeed, it is hard for the eye to focus on any specific patch. Viewed across its width, however, twenty-four rows of repeating shapes appear, and order, suddenly, is revealed.

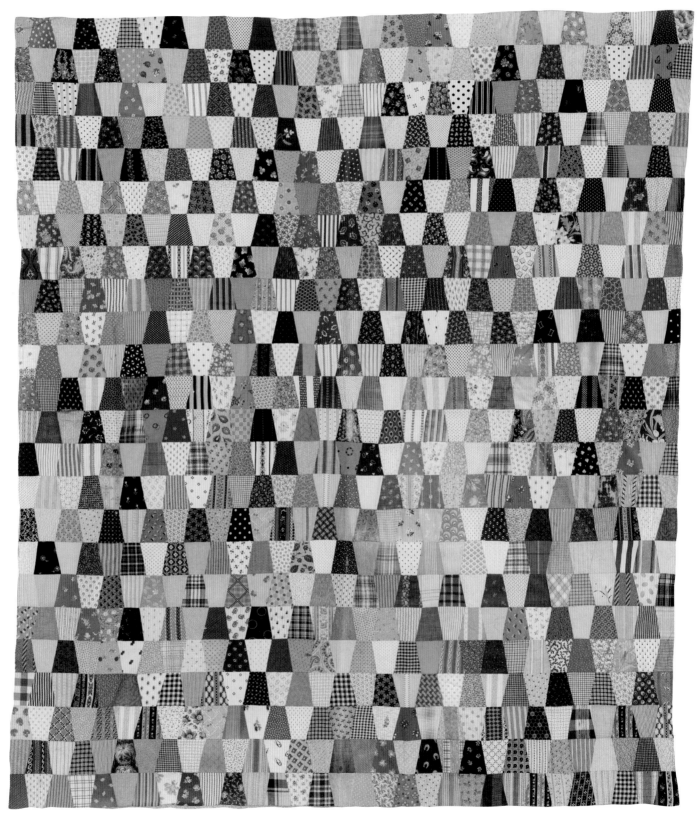

**Tumbler Summer
Spread**

Maker unknown,
circa 1890–1910

Cotton: 69 x 79 inches

Hand pieced, tied

Sherry Cook Quilt
Collection, 2009-368-6

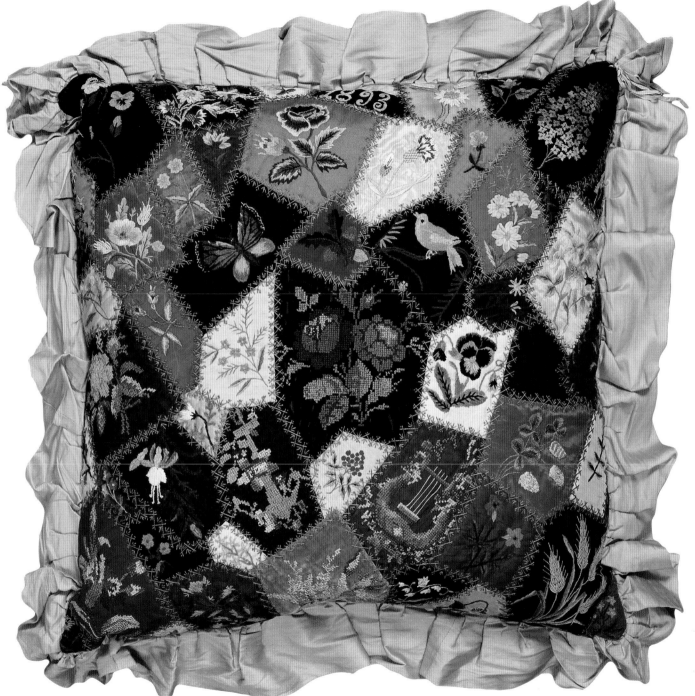

**Sickafoose Crazy
Quilt Pillow**

Mrs. A. Sickafoose,
Lyons, Iowa, dated 1893

Silk, velvet, satin:
24 x 24 inches

Hand and machine
pieced, embroidered

Joyce Gross Quilt
History Collection,
W2h001.046.2008

SICKAFOOSE CRAZY QUILT PILLOW

Quiltmakers enamored with Crazy quilts occasionally applied the showy style to forms other than quilts, including wall pockets, tea cozies, shawls, and slippers. Mrs. A. Sickafoose of Lyons, Iowa, demonstrated her extraordinary needlework proficiency on this *Crazy Quilt Pillow* that she sent to the 1893 World's Columbian Exposition in Chicago, presumably for display.

Sickafoose pillow shipping crate. Joyce Gross Quilt History Collection, W2h001.046.2008.

Mrs. Sickafoose joined more than fifty-five irregular patches with a complex decorative stitch in gold—one that combined a herringbone stitch, a straight stitch, and a knot. Although she worked with a small surface and created patches that were irregular in size and shape, the maker nonetheless brought order to her pillow top. All patches flow from a large, black velvet central patch that features twin petit point roses. Four large patches anchor the four "corners" of the center patch—a butterfly, bird, lyre, and anchor. Large botanical designs also grace the pillow's four corners. All other embroidered designs are floral. Each plant is beautifully detailed and fresh looking, just right for picking. Mrs. Sickafoose's embroidered lilac bloom, for example, contains more than seventy-five separate tiny flowers in shades ranging from pale lavender to deep purple. The maker also set all her embroidered subjects upright, then confirmed the pillow's top-bottom orientation by embroidering "1893" on a patch at the center top in white chenille floss. The pillow is framed with a satin gold ruffle and is backed in a white and gold silk print.

The World's Columbian Exposition opened in Chicago in May 1893. Mrs. Sickafoose shipped her pillow to Chicago in a custom-made wooden crate lined with pink cambric. The crate, marked with her name and hometown in oversized script, still carries two return shipping labels from the United States Express Company, each marked "World's Fair, Ill." Shipping charges were seventy cents. Regrettably, quilts exhibited at the Columbian Exposition were not well documented. Mrs. Sickafoose's pillow may have been exhibited in the fair's Woman's Building, but there is no evidence that it was displayed and or received an award.[120]

LOG CABIN, STRAIGHT FURROW

Sometime in 1905, when she was in her early seventies, Martha Mayhall (1832–1917) presented this silk and velvet *Log Cabin* quilt to her five-year-old grandson. A quilt made from such luxurious fabrics may seem an odd choice to give a young boy. Perhaps Mrs. Mayhall intended her showy quilt as an heirloom for her grandson to cherish and pass down to subsequent generations.

Martha Offutt was a native of Kentucky. In 1849 she married Samuel Independence Mayhall, a farmer, in Fountain County, Indiana. Martha and Samuel were southern sympathizers, with Samuel often swimming the Ohio River at night "carrying hard to obtain medicines south." In 1877 the couple moved to Texas, an arduous journey that included travel by boat down the Mississippi River to New Orleans, then on to Galveston and Houston, then by railroad northwest to Hempstead, and finally by wagon to Central Texas.[121] Martha and Samuel settled on a farm near Georgetown in Williamson County, just northeast of Austin.

At least three of the couple's twelve children moved with their parents to Texas. One, Joseph Lee Mayhall, the couple's youngest, married Olivia Smith in 1899. Family history states that Martha Mayhall made her *Log Cabin* quilt using scraps left over from clothing that daughter-in-law Olivia sewed for her family. Mayhall gave Olivia and Joseph's son Temple the quilt in 1905, when he was five years old. He must have cherished his grandmother's gift, for in 1984 Temple Mayhall donated the quilt to the University of Texas, his alma mater.

Martha Mayhall imposed her own brand of informality on a geometric pattern variation whose success always depends on the careful placement of light and dark fabrics. The light-dark pattern is not consistent throughout the entire quilt, and the blocks and logs are by no means perfectly pieced, giving an improvisational look to what typically is a highly structured and organized pattern. The range of fabrics used in this quilt's 342 blocks is enormous. Martha set her light and dark strips—the "logs"—around center hearths whose fabrics include velvets in wine, black, brown, royal blue, and green; plain silks in red, orange, olive green, lavender, and pink; or silk checks, stripes, and small prints. She created her light-colored logs from seventeen different silks, satins, brocades, and velvets, most in various tones of plain white or cream, but with a smattering, too, of pastel plaids, vividly striped fabrics, and one bright pink and orange print. The dark fabrics are a medley of plain and print silks in various shades of black, navy, maroon, brown, green, gold, and gray, with an occasional large geometric print or red plaid added to the mix as well. The quilt's foundation fabric, visible through the few shattered silks, is muslin. Pink silk floss ties attach the quilt back to the foundation only; no ties appear on the front blocks.

The backing fabric is turned to the front to create a one-inch binding and to hint at the surprise on the quilt's back. Here, panels of pastel aqua silk crepe surround a single large block composed of alternating strips of crepe in solid cream or a small-scale pastel print. The pastel print appears on the quilt front, but only once—in one block's hearth. This quilt back must have felt wonderful against the skin—soft, smooth, and cool. Was five-year-old Temple ever permitted to use this quilt?

**Log Cabin,
Straight Furrow,**
front

Martha Offutt Mayhall,
Taylor, Texas, circa
1899–1905

Silk, velvet:
69 x 73 inches

Hand and machine
pieced, tied

TMM 2490.3

Gift of Temple Mayhall

Log Cabin,
Straight Furrow, back

THOMASON FAMILY QUILT &
DIAMOND IN A SQUARE

Thomason Family Quilt

Attributed to Elizabeth Sides Dowdy, Erath County, Texas, circa 1900–1905

Cotton and wool: 67 x 77 inches

Hand pieced, hand quilted

2010-175

Gift of Sharon Voudouris-Ross

These two quilts connect quiltmakers within the same Texas family, women who never met, yet who were part of a strong family tradition of seamstresses and quiltmakers.[122] The *Thomason Family Quilt* is attributed to Elizabeth Sides Dowdy (1824–1909). Her great-granddaughter Eva Lea Leach (1924–2010) made *Diamond in a Square* about eighty years later. Two cousins in the Thomason family donated the quilts to the Briscoe Center.

The family's Texas origins date to the spring of 1851, when Marcus Lafayette Dowdy (1824–1897) and his wife, Elizabeth Sides Dowdy, and their four children left their home in Alabama to move to the Lone Star State. The Dowdys traveled overland by covered wagon with Mar-

cus's parents. The two families eventually parted, Marcus and Elizabeth settling in Grimes County in southeastern Texas, the parents stopping in Cherokee County in central East Texas. Marcus and Elizabeth, who added eight more children to their family over the next sixteen years, moved at least four more times before settling in 1871 southwest of Dallas in Erath County, possibly to be near a Primitive Baptist Church of their liking. In Erath County, Marcus probably farmed or sold cotton, the area's major crop until about 1910. Both Marcus and Elizabeth are buried in the county's Clairette Cemetery.[123]

Dowdy descendants now live all over Texas, as well as in Arizona, Oklahoma, Georgia, and Missouri. Members of the Thomason family branch, including descendants of Marcus and Elizabeth's daughter Phebe Dowdy Thomason (1867–1945) and her husband, Benjamin Franklin Thomason, gathered in 2003 to explore the family history and to fill in the "clan chart."[124] The *Thomason Family Quilt* and *Diamond in a Square* are connected through Phebe Thomason. Phebe's mother is the likely maker of the first quilt and Phebe's granddaughter is the known maker of the second.

The *Thomason Family Quilt* is a turn-of-the-century cotton and wool utility quilt made for warmth. It is a scrap quilt, containing more than forty different fabrics, including solids, chambrays, florals, plaids, mourning prints, ginghams, polka dots, and printed patchwork. Some fabrics appear only once or twice. The quilt's simple strip pattern forms blocks divided by bright red sashing. Each block contains four to six strips, which themselves are often composed of pieced scraps. One block of six strips, for example, is constructed from fifteen scraps; others have as many as eight or eleven. The thick batting's content is unknown, though it is most likely cotton, especially given that the quilt was made in cotton country. The backing fabric is gray striped cotton flannel, often used on the back of comforters. It has been turned back to front and machine stitched to create the half-inch edge. The hand quilting, at four stitches per inch, is an overall fan design, often called Baptist Fan.

The quiltmaker understood how to bring great visual appeal to a utility quilt. The bold red sashing that frames the blocks provides a defining grid that unites the random-

ness of each block's fabric combinations and strip widths. Alternating rows of the vertical and horizontal set of the strips add movement and interest. The quiltmaker's random repetition of a few strong colors, especially the black in four different mourning prints, draws the eye. The regular use of pale pink strips, usually of chambray and often pieced to black strips, provides both contrast and continuity. There are also several blocks featuring the identical strip sequence. The most noticeable are those containing a wide strip of large white polka dots on taupe, always bordered by a strip of cadet blue and two in plain off-white. Viewed from a distance, these blocks pop. As with the other blocks in this quilt, there is no rhyme or reason for placement, which simply adds to the quilt's charm.

The *Thomason Family Quilt* eventually came into the hands of Eva Lea Leach, Elizabeth Dowdy's great granddaughter and the maker of *Diamond in a Square*, a 1990s scrap quilt in a format similar to the *Thomason* quilt. Its strong black sashing frames the repeating pattern and multiple fabrics placed randomly from block to block. This quilt's blocks, however, are further defined by two borders and contrasting cornerstones. The quiltmaker, a lifelong seamstress, probably mined her deep scrap bag for the dozens of different 1980s and 1990s fabrics that make up the squares and backgrounds in the quilt's 120 blocks. Many are novelty, juvenile, or patriotic prints and printed patchwork. Leach carefully paired each interior diamond with a complementary fabric. She hand quilted *Diamond in a Square* at five to six stitches per inch, using in-the-ditch stitching around the blocks and quilting intertwining waves on the pieced border and continuous loops on the outer border, where her white quilting thread contrasts nicely against the black border fabric.

Eva Lea Leach (1924–2010), an Austin native, was an accomplished seamstress from an early age, finding time even as a teenager to sew a few quilt tops. Her daughter Cynthia Leach recalls that her mother made school clothes for her, often buying fabrics at Mission Valley Textiles, a mill and fabric store located in nearby New Braunfels along the Guadalupe River. Founded in 1921 as Planters & Merchants Mill, Mission Valley Textiles at one time employed more than six hundred workers to manufacture yarn-dyed woven fabrics. The mill closed in 2004, a victim of consolidation with another plant and the flood of cheap imports. As Cynthia recalls, "We would drive down to New Braunfels in the summer to the mill

store right on the river to pick out gingham fabric for my dresses, which she would make me before school started. She could mend anything to make it look brand new. You literally could not tell where she worked her magic."[125]

Mrs. Leach took up quilting in earnest upon retirement from various jobs in retail. She was a member of the Austin Area Quilt Guild and sewed monthly with a bee that also was a source for quilt patterns and fabric. For several years Mrs. Leach and her husband owned a meat business. Her daughter Cynthia believes her mother expressed her fondness for cows through her use of several cow fabrics in this quilt.

Diamond in a Square

Eva Lea Leach, Austin, dated 1992

Cotton:
77½ x 92½ inches

Machine pieced, hand quilted

Eva Lea Leach Quilt Collection, 2010-152-4

A CORNER OF THE FINISHING ROOM

Advertisement for Planters and Merchants Mills Inc. ginghams and the company's finishing room. *Bluebonnet News* (New Braunfels, Tex.) 1, no. 1 (January 1, 1925).

TO TEXAS MERCHANTS

YOU KNOW

Your customers ask for ginghams which do not fade.

Your customers prefer Texas-made goods if quality and price are equal.

Your customers buy goods with an established trade-mark.

DO YOU KNOW

Bluebonnet and Comal Ginghams are guaranteed fast colors?

Bluebonnet and Comal Ginghams compare favorably with the same grade of goods made anywhere?

The following Texas Jobbers handle BLUEBONNET and COMAL Ginghams:

M. Halff & Bro. ···San Antonio
A. B. Frank Company ··························San Antonio
McKean-Eilers Company ···························Austin
Waco Dry Goods Company ·························Waco
Perkins Dry Goods Company ·················Dallas
Higginbotham, Bailey, Logan Co. ·········Dallas
Monnig's Dry Goods Co. ··························Ft. Worth

BUY GOODS

MADE BY TEXANS
FROM TEXAS COTTON
AT A TEXAS OWNED FACTORY

PLANTERS AND MERCHANTS MILLS, INC.

NEW BRAUNFELS, TEXAS

Josephine Rossi Starr (1871–1947) made *Cracker* for her young niece Lucy Rossi (1908–2011) sometime around 1915. Lucy later recalled using the quilt when she slept on the floor during the few years she lived with her aunt and family in Austin. Lucy cherished this quilt, keeping it until she donated it to the University of Texas in 1985. The few known specifics of the quiltmaker's life provide a window into the world of some residents in turn-of-the-century Austin and offer evidence of quiltmaking's enduring attraction to a member of an immigrant population. *Cracker* remains an artifact of assimilation made and used to warm a loved one.

Born in Milan, Italy, Josephine Rossi came to Texas when she was fifteen after arriving in Veracruz, Mexico, with her family in 1886. Once in Austin, her father, Peter Rossi, sought work as a stonemason during the construction of the new Texas State Capitol, which opened to the public on April 21, 1888. Josephine married Louis Starr (1859–1902) in 1886, at age sixteen, possibly in an arranged marriage. Starr, also a native of Italy, was a landlord with "houses in the west part of town." The Starrs lived in one of these houses, a small, one-story frame structure located at 504 West 2nd Street. This part of Austin now is a trendy area dominated by upscale restaurants and boutiques,

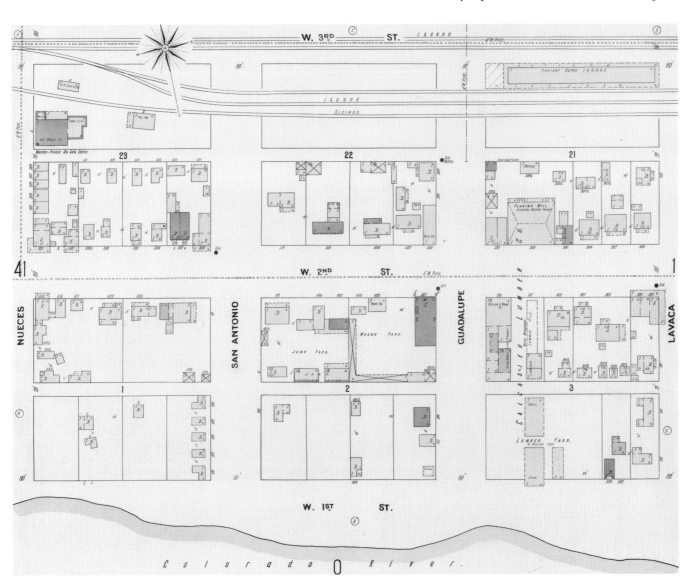

Josephine Rossi Starr's house, 1900—shown on this fire insurance map of a portion of Austin—is the third separate structure at the northwest corner of West 2nd Street and San Antonio. Sanborn fire insurance map, Austin, Texas, Sheet 42, 1900; Sanborn Map Collection.

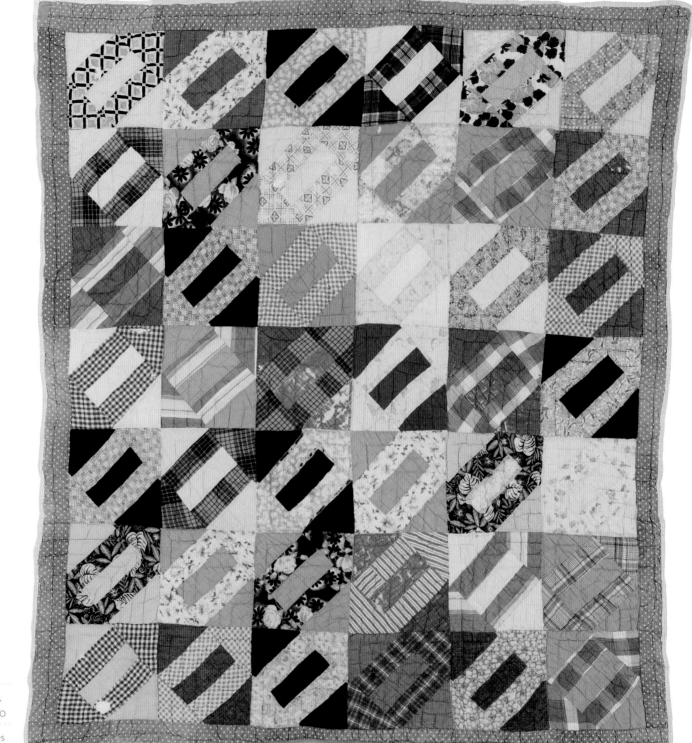

Cracker

Josephine Rossi Starr,
Austin, circa 1915–1920

Cotton: 65 x 74 inches

Hand pieced,
hand quilted

TMM 2515.1

Gift of Lucy Rossi
Meserole

and, nearby, Austin's City Hall and the famed Austin City Limits live music venue. In 2017, this area on West 2nd Street will be home to the new twenty-nine-story office tower named 500 W. Second St., which will also feature ground-floor restaurants and retail space.[126]

Though less than one mile from the State Capitol, this area for years was still the western edge of Austin, a jumble of commercial and residential structures bordered by the Colorado River two blocks south and east-west railroad tracks to the north. Area streets were unpaved, and small grocery stores flourished next to saloons. By 1900 a junkyard and wagon yard occupied the lots kitty-corner to the Starr home. One block east was the substantial brick J. P. Schneider & Bros. mercantile store built in the late 1880s. Nearby, the Calcasieu Lumber Company, established in 1883, was slowly growing into a business that by 1910 owned seven city lots and bordered the Starr home on two sides. Austin's notorious Guy Town neighborhood, home to hundreds of prostitutes until it was eliminated in 1913, was just a few blocks east.[127] Josephine lived in the house on West 2nd Street for sixty-one years, until her death in 1947.

In the early 1900s, the West 2nd Street area was a diverse working-class neighborhood, home to Mexican and Italian immigrants as well as whites from various southern states. Quilt donor Lucy Rossi Meserole recalls that at one time several of her aunt's relatives lived nearby, including her sister. The 1910 US Census lists the occupations of Josephine's neighbors as laborers, carpenters, washerwomen, and housekeepers; many residents' occupations are recorded as "None." It also lists Josephine's occupation as "owner income," presumably referring to her ownership of area houses she managed after her husband's death in 1902. The 1910 census also records the occupations of Josephine's three children, Peter, Rosie, and John, as carpenter, office girl, and blacksmith, respectively. Two important pieces of information add to our understanding of Josephine Rossi Starr: the 1920 US Census records that she could neither read nor write, and her niece Lucy remembers her aunt as being "noted as a nurse/midwife" within Austin's Italian community.[128]

Lucy Rossi, Josephine's niece, lived with the Starr

family for several years sometime between 1911 and her marriage to Joe Meserole in 1928. Lucy must have had a great affection for her Aunt Josephine, because she always referred to her as "mother."[129] In 1985, at the time Lucy donated her *Cracker* quilt to the University of Texas, she named her Aunt Josephine as both her mother and the quiltmaker. According to Lucy, Josephine made the quilt for her when she was seven or eight years old and living with her aunt at the West 2nd Street home. The quilt was Lucy's bedding—she slept "on the floor wrapped in this quilt."[130]

Lucy confirms that her Aunt Josephine sewed often and used fabric scraps and old clothes to make her *Cracker* quilt. According to the niece, Josephine "made up the pattern & 'scrapped it the best way she could.'" Lucy even recalled the origins of two of the quilt's fabrics—the brown and white check came from Josephine's apron and the blue and yellow flower print from one of her dresses. The bold patterns and colors in the quilt are consistent with Josephine's personal tastes. As Lucy recalled, Josephine "always dressed her children in bright colors."[131] It is probable that Josephine acquired her fabrics at the nearby J. P. Schneider & Bros. An early photograph of the store's interior clearly shows bolts of fabric on the shelves.[132]

Josephine Starr's much-loved *Cracker* quilt is worn and very soft. It's a scrappy quilt, entirely hand pieced, suggesting that Josephine did not own a sewing machine, probably because of the cost. In all, the quiltmaker used thirty-nine different solid and patterned fabrics to create her blocks, including large and small plaids, florals, geometrics, stripes, checks, and a juvenile print. Several of the solids are chambray. The deep purple fabric and several bold plaids especially attract the eye, as does the cheery pink and white dot fabric used for the border. The batting is cotton, and the back is constructed from two panels of thin, loosely woven cotton fabric. The yellow binding is homemade and hand sewn. Josephine hand quilted her *Cracker* quilt at four to five stitches per inch in a repeating right angle pattern, with lines set more than an inch apart. Large sections of the binding were replaced during a later quilt stabilization project.

This single-layer redwork summer spread contains a curious but fascinating mix of embroidered designs, some original to the maker and others selected from a variety of commercial pattern sources spanning nearly twenty years. Each of the seventy-two blocks is made of the same lightweight white cotton, as is the deep border. This summer spread is a top only. Design markings in blue are visible, and the busy, intricate stitching on the underside can be easily examined. French seams join the blocks, and the border is pieced using a very fine machine stitch.

The uniformity of the fabrics in the blocks indicates that the maker may have purchased her patterns for transfer onto her own background fabric or simply copied available patterns rather than buying prestamped blocks. The maker also chose to include a wide assortment of popular redwork embroidery subjects in her summer spread, including animals, commemorative images, floral designs, nursery rhymes, buildings, and children. Prominent among the subjects are nineteen US presidents, three of whom (Abraham Lincoln, James A. Garfield, and William McKinley) are clustered together on one block as "Our Martyred Presidents."

The pattern sources for some of the motifs are known. The moose, for example, was a stamped pattern designed for quilt blocks and commercially available by the early 1920s from the Victoria Art Manufacturing Company of Cleveland, Ohio. The polar bear with fish was probably available by 1915. The bonneted girl with the lost shoe is part of an 1886 design, as is the squirrel, which was adapted from a larger perforated pattern that sold for forty-five cents in 1886. The motifs of eleven buildings featured in the 1901 Pan-American Exposition in Buffalo, New

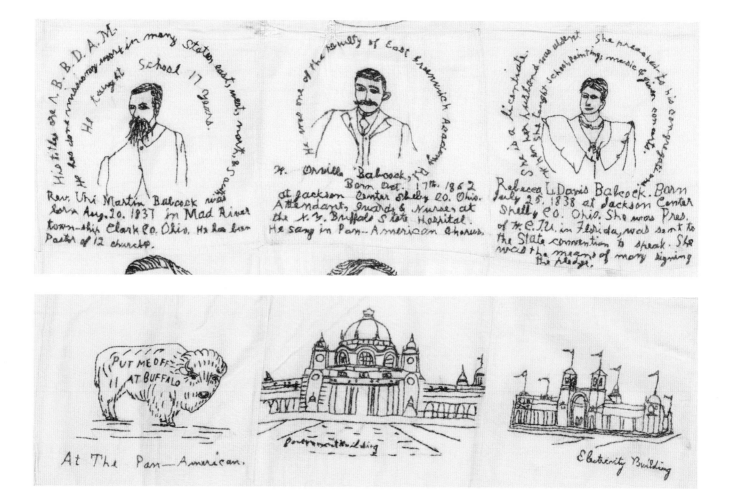

**Red on White
Embroidered
Summer Spread**

Possibly Margaret
Babcock, Buffalo,
New York, circa 1920s

Cotton: 72 x 85 inches

Machine pieced,
hand embroidered

Kathleen McCrady
Quilt History Collection,
2011-182-9

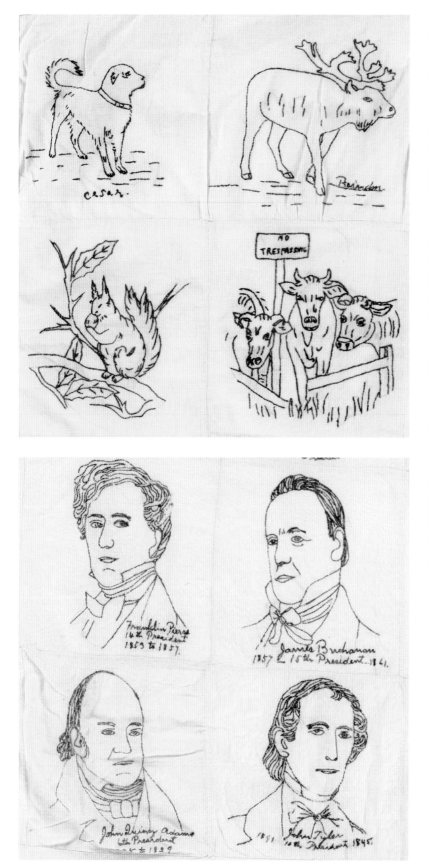

York, plus the buffalo with "Put Me Off at Buffalo" embroidered on its side and "At the Pan-American" below, were based on the commemorative penny squares available for purchase at the exposition. The block near the center of the summer spread (just above the buffalo) is the embroidered version of the exposition logo. It depicts two women clasping hands, swathed in flowing robes shaped to represent North and South America. They are meant to personify the exposition's slogan "To Unite the Americas in Bonds of Peace and Prosperity."[133]

The most unusual embroidered designs in this bedcover are those depicting three members of the Uriah Babcock family and giving brief descriptions of their accomplishments. The likenesses probably were copied from photographs. The embroidered script supplies the following information: Rev. Uriah Babcock (b. 1837) taught for seventeen years and served as pastor in twelve different churches; wife Rebecca Babcock (b. 1838) was president of the Women's Christian Temperance Union in Florida; the couple's son Orville Babcock (b. 1862) is credited with singing in the Pan-American chorus.

There is no indication as to the bedcover's maker. The presence of at least one quilt pattern dating from the early 1920s (the moose), however, argues against it being Rebecca Babcock, who died between 1910 and 1920. In 1920 she would have been eighty-two and perhaps not up to the challenge of so intense a needlework project. Her daughter-in-law, Orville's wife Margaret, who was in her early sixties in 1920, may have been the artist. Perhaps Margaret made this summer spread to honor her husband and her in-laws.

This charming and beautifully constructed flower quilt features nine blocks of stylized tulips symmetrically arranged, multiple borders, fine appliqué (including reverse appliqué), thin batting, narrow binding, and dense, intricate quilting—all characteristics of mid-nineteenth-century floral appliqué quilts. Its pastel palette, however, dates this quilt to the 1920s or 1930s, when softer colors, such as this quilt's green and two tones of pink, replaced the deep reds, blacks, browns, greens, and navy blues of the previous century. By merging contemporary pastel fabrics with earlier quiltmaking traditions, this quilt's maker was following a decorative fashion popular during America's Colonial Revival period of the early twentieth century, a time when people embraced their history and glorified a perceived past as part of a renewed interest in earlier quilting styles. This quiltmaker used modern fabrics to make a historically inspired quilt. She created her own heirloom.

Bowl of Tulips is entirely hand sewn, and its quilting is exquisite. The outer border features perfectly executed quilted tulips that echo those in the appliquéd vases, all surrounded by a grid of stitch lines a quarter inch apart. Single cables and double parallel zigzags alternate in the five pink and white borders, and dense double arcs in the vases create the illusion of stuffed work. The quiltmaker's most masterful quilting pattern is her sunflowers, whose petals and curlicue leaves sit at the junctions of four blocks and in the corners of the inner frame. Three-quarter-inch grid quilting fills in the background.

This quilt's estimated age is confirmed by the "Cloth of Gold" mark that appears four times on the selvage of the quilt's backing fabric panels. J & J Cloth of Gold was the trademark for fine fabrics created by Jackson & Jackson of Tryon, North Carolina. The company created the Cloth of Gold name in 1901 and later licensed it to other mills producing fine fabrics. In the mid-1920s the Warren Featherbone Company, which in the early 1880s introduced featherbone as an alternative to whalebone in garments and corsets, used J & J Cloth of Gold fabrics to create a popular bias fold tape in a variety of colors.[134]

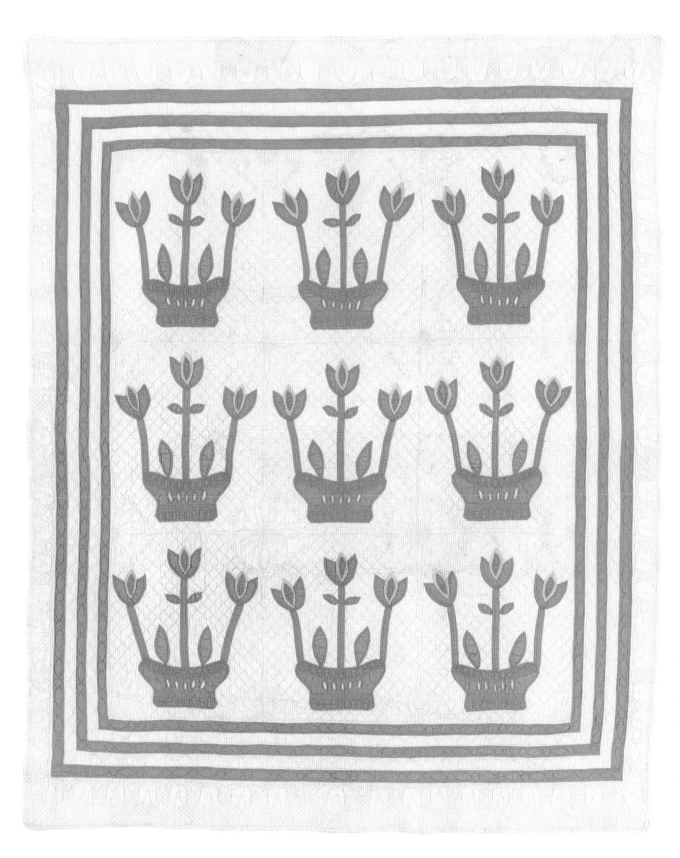

Bowl of Tulips

Maker unknown,
circa 1920–1939

Cotton: 65 x 79 inches

Hand pieced, hand
appliquéd, reverse
appliqué, hand quilted

Joyce Gross Quilt
History Collection,
W2h001.089.2008

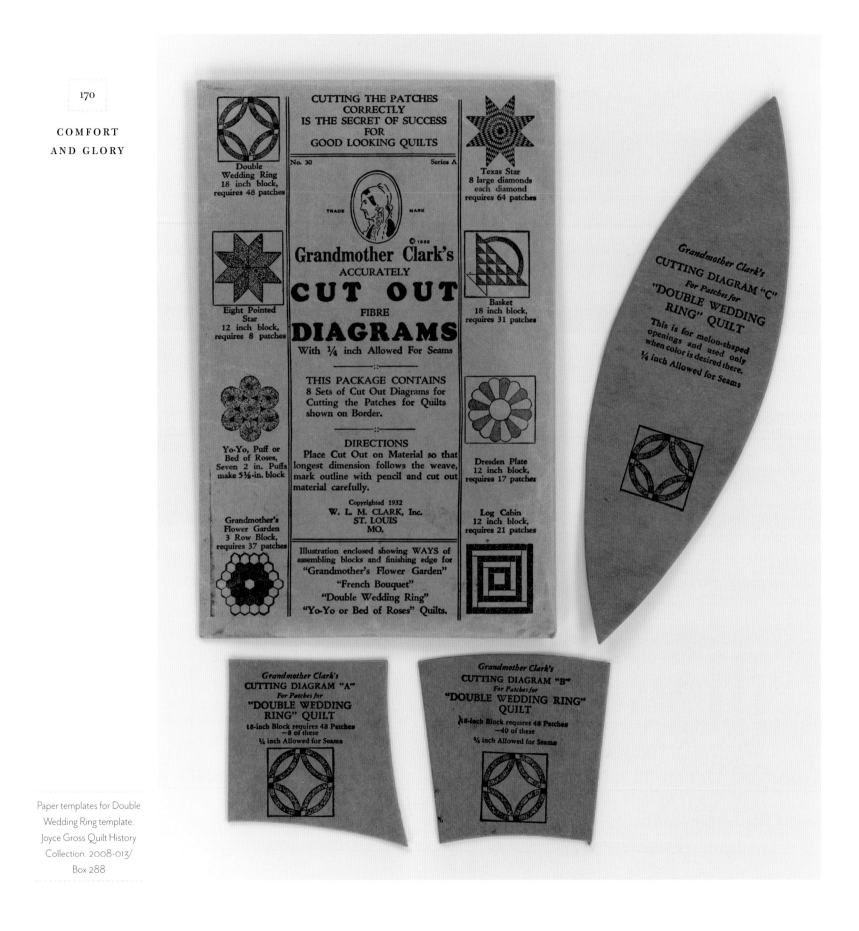

Paper templates for Double Wedding Ring template. Joyce Gross Quilt History Collection. 2008-013/ Box 288

DOUBLE WEDDING RING

The fashion—perhaps better labeled "the craze"—for making Double Wedding Ring quilts peaked in the 1930s, though quiltmakers continued to take up the challenge of this complex pieced pattern well into the 1970s and beyond.[135] Part of the pattern's popularity was that it invited the use of scraps. The pattern's requirement for small pieces in the interlocking rings offered frugal quiltmakers of the 1920s and 1930s the chance to turn their leftover fabrics into an endless variety of attractive combinations. Templates and patterns to make a Double Wedding Ring also were readily available from commercial sources such as W. L. M. Clark Inc. of St. Louis, which marketed quilt patterns beginning in the early 1930s using the name "Grandmother Clark."

Instead of using scraps, however, Austin quiltmaker Birdie Pickle chose to create her *Double Wedding Ring* with specific, complementary green and pink fabrics, setting them on an off-white background. She joined plain squares at the ring intersections and pieced only eight different print fabrics in the ring curves to create four paired combinations throughout her quilt. The solid patches, which to the eye read darker than the mix of small-scale prints in the curves, appear to sit atop the ring intersections. Pickle arranged the four different rings in a repeating sequence left to right and top to bottom. This order

also produced a diagonal sequence. Look for the identical fabric combinations in rows as the rings run diagonally across the quilt from lower left to upper right and for alternating fabric combinations in rows that run diagonally from lower right to upper left. Despite this careful planning, there is one apparent misstep—the quiltmaker created a single ring segment whose fabric does not follow her design scheme. This anomaly is on the quilt's right side along the outer edge of the second ring from the top. Was this mismatch caused by insufficient fabric or introduced on a whim? Or perhaps Birdie Pickle simply made a mistake.

Pickle did not date her *Double Wedding Ring*, but she may have created it to celebrate her daughter's marriage to Temple B. Mayhall in 1925. Mildred Mary Pickle Mayhall (1902–1987), the quilt's recipient and an Austin native, earned her PhD at the University of Texas in 1939, where she taught anthropology for twenty years. Mayhall's husband, Temple Mayhall (1900–1991), a native Texan as well, also came from a quiltmaking family. The couple donated the *Double Wedding Ring* to the University of Texas in 1984 along with a silk and velvet *Log Cabin* quilt, circa 1899–1905, made by Temple Mayhall's paternal grandmother. That quilt also is shown in this book.[136]

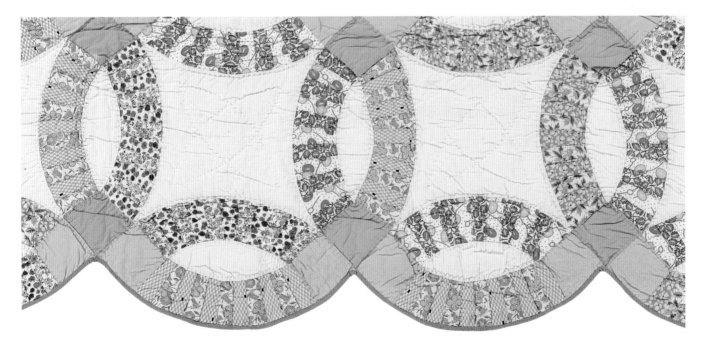

COMFORT
AND GLORY

**Double
Wedding Ring**

Birdie Givens Pickle,
Austin, circa 1925–1935

Cotton: 69 x 85 inches

Hand pieced,
hand quilted

TMM 2490.1

Gift of Temple and
Mildred Mayhall

**Woman's
Shakespeare Club
Friendship Quilt**

Members of the Woman's
Shakespeare Club,
Fort Worth, circa 1927

Cotton: 66¾ x 77 inches

Machine piecing, hand
embroidery, hand quilting

2012-195

Gift of Martha Ingram
McCormick

This quilt's design and provenance document the membership, presidents, and study focus of Fort Worth's Woman's Shakespeare Club for the period from 1905 to 1926. Past president Mattie Mae E. Brinton Ingram probably received the quilt either as a presentation quilt honoring her service as club president or as a prize in one of the club's fund-raising raffles. The arrangement of the many signatures, each one a spoke in a wheel-like design, mark this quilt as part of the turn-of-the-century tradition popular in signature-based fund-raising quilts. In this instance, club members may have solicited donations to sponsor their signatures on the quilt blocks.

A graduate of Baylor University, Mattie Ingram (1891–1965) taught English in Fort Worth's Central High School but retired in 1923 when her only child, daughter Martha, was born. Her membership in the Woman's Shakespeare Club dates from around that time, presumably as she sought the company of women with similar interests in literature. Mrs. Ingram remained an active clubwoman for years, serving as president of the Shakespeare Club before 1927 and as an officer of the Woman's Club of Fort Worth beginning in 1926 and, from 1950 to 1952, as its president.[137]

Quilt donor Martha Ingram McCormick, Ingram's daughter, acknowledges that her mother was neither a quiltmaker nor a seamstress and, in fact, did not care about this quilt at all.[138] Ingram received the quilt unfinished—it lacked a binding—and stored it, unfinished and unused. At some point she passed the quilt on to her daughter, who stored it until the mid-1970s, when she finished the quilt by turning the back to the front and hand stitching the edge down.

The *Woman's Shakespeare Club Friendship Quilt* is a single-patterned album quilt consisting of twenty-three signed white blocks alternating with solid blocks in medium blue. The embroidered pattern is a circle, with up to sixteen names forming spokes radiating from a center ring. As many as twenty-three club members made the blocks, each one embroidering whatever names she chose in whatever fashion she wished. Not all names represent club members. Mrs. Ingram's block, for example, includes her name as "Mrs. E. B. Ingram"; it is surrounded by names her daughter identified as her mother's relatives, college pals, and friends. Variations in embroidery floss color and the presentation of the names indicate that the quilt was the work of many hands. The embroidery style and quality varies block to block, as does the content of the names. Some names are presented as personal names, others include "Mrs." plus a surname, and still others record only first names.

Two blocks document the Woman's Shakespeare Club leadership and study focus. One presents the names of the club's past presidents from 1905 to 1926—including Mrs. E. B. Ingram. Another supplies the names of sixteen literary giants the club studied, including Alexander Pope, William Shakespeare, John Keats, Percy B. Shelly, and Samuel Taylor Coleridge.

BOUDOIR QUILT AND SHAM

Several women in Columbia, Illinois, chose to make this sophisticated whole-cloth quilt as a gift of appreciation for their children's first-grade teacher, Josephine Emma Wecker (1901–1973). They presented the quilt and sham to Miss Wecker as a wedding present on the occasion of her marriage to Ira Mund in November 1928.

Josephine Mund taught school for thirty-one years in several small Illinois communities set on the bluffs above the Mississippi River across from St. Louis. A plaque in the high school library in Dupo, Illinois, describes Mund as "exceptionally gifted and skilled at teaching young children" and as "always striving to nurture them and bring out the best in each." Although Mund loved teaching, she retired at the end of the 1928–1929 school year once she married. Mund's daughter Dr. Jeanne Lagowski recalls that her mother was very pleased when the war effort required her to return to the classroom in 1943. She continued to teach until 1966, retiring at age sixty-five, then the age for mandatory retirement.[139]

Several women made this boudoir quilt and sham using a shimmering fabric in a high-fashion color and then adorned it with an elegant feathered quilting pattern. This quilt style reflects an aesthetic influenced, even in a small Illinois town, by the popularity of what one quilt historian has labeled the "colonial-boudoir" style. Renewed interest in the handcrafts of colonial and Revolutionary War ancestors and the adoption of modern European fashion and home furnishings helped fuel this mix of styles.[140] As many American women turned their energies to redecorating, popular magazines such as *Harper's Bazaar*, *The Modern Priscilla*, *Ladies' Homes Journal*, and *Needlecraft Magazine* encouraged them to outfit their bedrooms in this style with comforters, puffs, cushions, pillow scarves, and the popular "boudoir set," a matching boudoir quilt and sham. The March 1928 issue of *Needlecraft Magazine*, for example, presented its readers with two options for embroidered quilts and matching shams in the style of Mund's quilted ensemble. It described the benefits of creating these "wonderfully attractive" designs for a woman's "own little special sanctum":

Somehow the room in which one sleeps seems the most intimate, friendly part of the house—doesn't it? When cares perplex and troubles double, one can hie away to this haven and shut the door in the face of everything that annoys; then after a little quietude the shadows are very sure to take wings and shine reign again . . . Again, there is a quaint notion, which is not at all fanciful, that the brighter and cheerier the furnishings of a bedroom are, the happier the dreams of the sleeper within its walls.[141]

Mund's quilt and sham each feature a central oval medallion of lush feather quilting surrounding a diagonal grid pattern. In the bedcover, undulating feather quilting is repeated outside the medallion along with arched and circle feather patterns. Grid quilting fills the background. The sham was designed to drape across two pillows, its oval medallion lying horizontally to provide contrast to the quilt's vertical medallion. Both quilt and sham feature a deep scalloped edge, though one rather crudely finished with a narrow bias binding, probably cut from the original gold fabric.

In selecting brassy-gold acetate fabric for the quilt and sham, the Columbia quiltmakers chose a fabric with a luxurious soft feel, a silky appearance, and excellent draping qualities. Mund's daughter speculates that only five or six women worked together on this elegant boudoir set and that they may have been neighbors in Columbia's tight-knit community. It is evident that one or more of the quiltmakers possessed fine needlework skills. There is a noticeable difference, however, between the high quality of the grid and feathered hand quilting and the odd quilted blooms and the uneven scallops that ring both quilt and sham. Pencil lines are visible on both, especially at the quilt's top end. There, extra pencil marks indicate a plan for the quilting design at the top center, one never used.

Josephine Mund treasured this quilt and sham. She never used the ensemble as a bedcover and never washed it. Instead, Mund kept the two cherished pieces carefully folded, wrapped in a pillowcase, and stored on the top shelf of her linen cabinet. She displayed them only on very special occasions, showcasing them draped over a bedskirt on the bed in her master bedroom. Her daughter recalls that whenever she saw the *Boudoir Quilt and Sham* on her parents' bed she knew that her mother had just entertained visitors. Her first thought, she noted, was "Who's been here and are there any cookies left?"[142]

**Boudoir Quilt
and Sham**

Mothers of students
taught by Josephine
Emma Wecker Mund,
Columbia, Illinois,
dated 1928

Acetate: quilt,
83 x 85½ inches; sham,
86 x 32¼ inches

Machine pieced,
hand quilted

2009-143

Gift of the Austin Area
Quilt Guild on behalf of
Dr. Jeanne Lagowski

Forget-Me-Not

Attributed to the
Wilkinson Quilt
Company, Ligonier,
Indiana, circa 1929–1930

Cotton sateen:
68 x 108 inches

Hand appliquéd, reverse
appliqué, hand quilted

Sherry Cook Quilt
Collection, 2010-296-14

This elegant appliquéd boudoir quilt was marketed by, though probably only finished at, the Wilkinson Quilt Company of Ligonier, Indiana, one of several quilt cottage industries that flourished in the early decades of the twentieth century. Sisters Ona (1876–1949) and Rosalie (1892–1976) Wilkinson established the Wilkinson Quilt Company in 1914, first in their home and later in a two-story quilt "factory" that once stored wool. At its peak, the company housed a showroom, offices, storage for fabric and supplies, and work areas for quiltmakers and their quilting frames. Quilt historian Marilyn Goldman, who has researched the Wilkinson Quilt Company for more than ten years, believes that Ona Wilkinson may have outsourced some of their quilt orders—including for some of their appliquéd quilts—to quiltmakers in Kentucky, even mailing them fabric for quilt tops, then having Wilkinson Company employees wash, quilt, and finish the quilts. It may be that the Wilkinson sisters ordered this *Forget-Me-Not* as a quilt top to specification from a Kentucky quiltmaker working on commission, then finished it and sold it under their company name.[143]

The Wilkinson sisters viewed themselves as artists who designed, made, and sold original, luxury quilts in silk, satin, taffeta, sateen, and velvet. They targeted an elite and wealthy clientele, marketing their quilts aggressively through innovative techniques that included selling trips and exhibitions, often at resort hotels; advertisements in popular women's magazines; and their own distinctive printed catalogs. Wilkinson quilts available for order included crib quilts, quilts for baby carriages, and four different sizes of bed quilts. Most were whole-cloth quilts, with pattern names such as Rose Scroll, Oriental, Tulip, Wild Rose, and Honeymoon. The company's circa 1920 catalog trumpeted the special nature of its quilts, proudly announcing that their product had "an exclusiveness fully appreciated by all discriminating lovers of out-of-the-ordinary bedding." The catalog also promised that an owner of "one of these wonder-quilts" would have the satisfaction of knowing that "she possesses something exclusive in conception and superior in workmanship."[144]

The Wilkinson Quilt Company also offered appliquéd quilts made with gingham, a muslin backing, and cotton batting. The company's Forget-Me-Not quilt pattern, for example, was listed in the company's 1920s catalog and was introduced in the October 1929 issue of *Harper's Bazaar* magazine. The ad described and pictured a "lovely new Wilkinson spread," one "especially desirable" for Florida or California homes and "adaptable to any colors and launders perfectly." The magazine ad also priced its "inexpensive spread" with the unbleached muslin background at $32.50 for a twin-sized and $40.00 for a double.[145]

The Briscoe Center's *Forget-Me-Not* boudoir quilt is made of rose sateen on front and back, with an elegant appliquéd center medallion echoed by thick swags at the border. Four bouquets of six blossoms gathered into ribbons and a bow quarter the medallion and four additional bouquets anchor swags at border corners. A pale silver-green is the predominant color in the appliquéd design, though medium green sateen forms the stems and each bloom sports a bright yellow center. These lush designs have been carefully appliquéd in matching threads, including in the reverse appliqué in the ribbons and bow motifs.

The hand quilting, in pink thread at eight stitches per inch, is a double diagonal straight-line pattern with feathered wreaths. The diagonal quilting in each quarter of the medallion and background meets to form perfect chevrons. The binding on the scalloped edge is rose sateen, machine sewn to the front and hand stitched on the back. Unfortunately, this *Forget-Me-Not* lacks the distinctive Wilkinson Art Quilts label that would confirm its origin. Although the label is missing, evidence of a label remains—thread and stitches at a back corner indicate that a label once was present.

1933 inauguration ticket, front and back. John Nance Garner Papers, 2F302.

COMFORT
AND GLORY

In 1932 Mrs. Minnie Rucker (1870–1952) of Franklin, Texas, made *Texas Star* to celebrate the election that year of Franklin D. Roosevelt and John Nance Garner as president and vice president. She sent her quilt to Texas's own "Cactus Jack"—John Nance Garner of Uvalde, Texas. Rucker made the quilt during the months between the Democratic Convention in Chicago in June 1932 when Garner and Roosevelt were nominated, and November, when they were elected. Reportedly, she sent the quilt to Garner on Wednesday, the day after their landslide victory.[146]

Rucker created the single large star out of solid red, white, and blue cotton fabrics to add a patriotic and political flare to her quilt through color. Although this quilt does not feature the five-pointed Texas star, Rucker added distinctly Texas touches through her embroidery and quilting. The outlined-letter embroidery above the star, with words drawn from the University of Texas's much-loved spirit song, convey to Garner that all of Texas was watching and, perhaps, urging him to make the state's citizens proud. Below the star, the candidates' names—Garner's coming before Roosevelt's—leave no doubt about the

quiltmaker's loyalty to and affection for the state's favorite son and her fellow Texan. Rucker also quilted outlines of five-pointed Texas stars along the border and graced each corner with a yellow rose to evoke "The Yellow Rose of Texas," a popular song associated with Texas history.

Upon receipt of the quilt, Garner instructed his wife to thank the quiltmaker. Ettie Garner obliged, writing Mrs. Rucker that "the quilt is so beautifully made, the sentiment embroidered on it, the patriotic colors—well, everything about it caused a thrill in the hearts of each of us that cannot be put into words. This gift will be one of the historical treasures of our family, and, I hope, handed down from generation to generation long after we have passed away."[147]

Texas quiltmaker Minnie Rucker (1870–1952) worked hard and loved making quilts. Widowed in her early thirties and with three young children, in 1904 Rucker moved her family to Franklin, the county seat of Robertson County, Texas. There she purchased the National Hotel and managed it for more than thirty years. Rucker considered her boarders family. Many guests returned year after year, and relatives visited often. In addition to raising her children and helping raise grandchildren, Rucker also maintained a large garden (which included a Texas star flowerbed), canned vegetables and meat, raised chickens, worked on behalf of the Woman's Christian Temperance Union, and became the first female member of the Franklin Chamber of Commerce.[148] In addition, Rucker's hands were often busy with needle and thread. She was both an avid seamstress and a constant quiltmaker. Her daughter Ruth Lemming recalls that her mother could "cut out a dress . . . after two p.m., prepare and serve supper in between, and have an attractive garment finished . . . to wear somewhere that night."[149] As for quilts, Lemming credits her mother with making more than one thousand in all. She gave many to family and friends; others graced the beds in her hotel rooms. Quiltmaking was also Rucker's solace. She often sewed all night and was "never more relaxed than when she was making a quilt." As her daughter recalled, "Making quilts . . . satisfied a basic desire in her nature—the creation of Beauty. She worked on them for the need of it."[150]

Vice President John Nance Garner and President Franklin D. Roosevelt, circa 1932–1935. John Nance Garner Papers, 2F302.

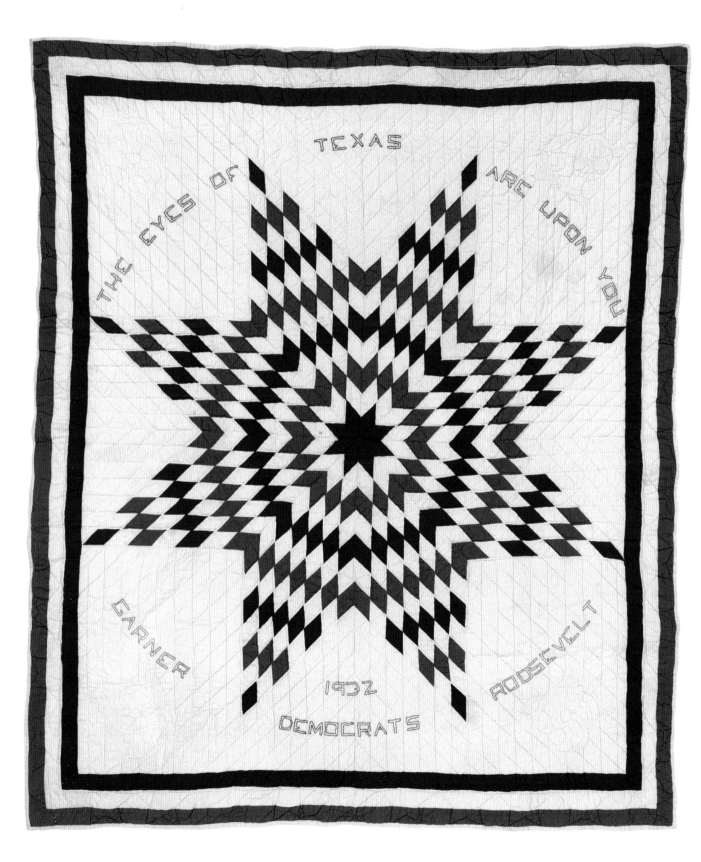

Texas Star

Minnie Lee Holton
Weeden Rucker, Franklin,
Texas, dated 1932

Cotton: 62 x 71 inches

Machine pieced, hand
quilted, embroidered

Briscoe-Garner Museum
Quilt Collection,
2007-151-71

Emma Mary Martha Andres (1902–1987) spent most of her life in Prescott, Arizona, where she grew up working in her father's cigar store and learning the value of quality needlework from her mother. In 1931 Andres made her first quilt, an appliqué design in the Tiger Lily pattern, using a mail-order kit from *Woman's World* magazine. She followed that quilt with a pieced one, and then began her third quilt, one of her own design that she called *Silhouette* or *Lady at the Spinning Wheel*.

Andres's decision to make a pictorial design was influenced by another pictorial quilt, one she greatly admired: Charles Pratt's *Ninety and Nine* (1927). Pratt sewed his quilt from tiny silk squares that together depicted the parable of the Good Shepherd. Andres based her quilt's pictorial design on the small cross-stitch pattern shown here, substituting red squares for the cross-stitching. The cat in the corner was her own addition. She repeated the image on her dressmaker labels. In 1933 Andres entered *Lady at the Spinning Wheel* in the Sears, Roebuck and Company's Century of Progress Quilt Contest, a competition intended to promote interest in "an art that is uniquely American." She received a Merit Award ribbon for her effort.[151]

As with many pictorial quilts, *Lady at the Spinning Wheel* is best appreciated hanging on a wall and viewed from a distance. Indeed, the scale of the design, the size and quantity of the squares (more than 3,600 one-inch squares), and the quilt's light-and-dark contrast give *Lady* a pixelated quality. The design of the quilt is best served by there being some distance between it and the viewer. A close look at the quilt, however, also rewards, as it reveals Andres's meticulous cutting and hand piecing. Her narrow, separately applied binding in blue adds a distinctive touch. Andres hand quilted diagonal parallel lines across her quilt design and used feather quilting to span the two solid white and red borders.

After her father's death, Andres converted his cigar store into her Happiness Museum, where she displayed her quilts and her vast collection of dolls, ceramics, bottles, toys, crafts, flower arrangements, and quilt-related memorabilia, including her thimble and needle. She shared her quilts through exhibitions and lectures, which she often held in her museum. An avid letter writer, Andres corresponded regularly with quiltmakers such as Charles Pratt, Carrie Hall, Bertha Stenge, and, beginning in 1939, with the famed New Jersey quiltmaker and historian Florence Peto. Andres and Peto wrote each other often, sometimes even daily or weekly, until Peto's death in 1970. In late 1947 or early 1948, Peto sent Andres a nineteenth-century brass and iron sewing bird, which she described as "an unusually fine specimen of antique."[152] The two friends met at least once—at Peto's home in Tenafly, probably in the summer of 1964, an occasion documented by a color snapshot, which quilt historian Joyce Gross reproduced in black and white on the cover of her *Quilters' Journal* in the summer 1981 issue.[153]

Andres finished her last quilt, *Ninety and Nine*, in 1947. It was her reproduction of Charles Pratt's quilt by the same name. Joyce Gross interviewed Andres twice, including in the summer of 1981. Shortly thereafter, Gross reported in her *Quilters' Journal* that Andres had retired her quilting thimble by putting it in a glass case in her Happiness Museum, observing that "quilting is not part of my life now, but most of the wonderful things that have happened to me are somehow connected to quilting."[154] In 1984 Emma Andres was named Arizona's Quilter of the Year and received the state's first Quilt Artisan Award.

Emma Andres used this cross-stitch pattern as the basic design for her *Lady at the Spinning Wheel*. Joyce Gross Quilt History Collection, 2008-013/ Box 151.

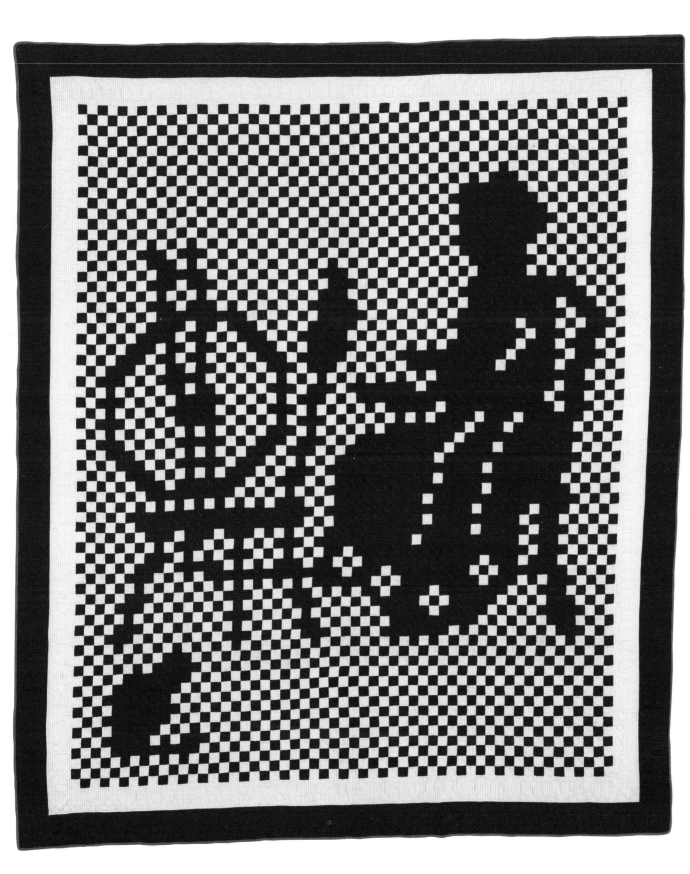

**Lady at the
Spinning Wheel**

Emma Andres, Prescott,
Arizona, dated 1932

Cotton: 71 x 83¼ inches

Hand and machine
pieced, hand quilted

Joyce Gross Quilt
History Collection,
W2h001.013.2008

Nineteenth-century sewing bird. Joyce Gross Quilt History Collection, 2008-013/Box 254.

Dressmaker's label. Joyce Gross Quilt History Collection, 2008-013/Box 151.

Florence Peto, left, and Emma Andres, right, corresponded for more than thirty years yet met only once, an occasion documented by this snapshot. Joyce Gross Quilt History Collection, 2008-013/Box 151.

Elizabeth Carolyn Kelley Anthony (1889–1987) was a seamstress and quiltmaker whose Texas counties quilt has always been known in the family as Aunt Bettie's *The Texas Quilt*. Its creation is linked to Mrs. Anthony's years of service with the Texas Home Demonstrations Association, specifically with her term as president from 1931 to 1933. The quilt is Mrs. Anthony's original design of a map of the state of Texas featuring hand-pieced counties, each identified by its name embroidered in black cotton thread.

Mrs. Anthony intended the quilt to commemorate her time in office. She planned a small quilt, and family history states that she used an old map as a guide as she cut the scraps representing each of Texas's 254 counties. Mrs. Anthony incorporated a variety of solids and prints in her map, often piecing several scraps to create her miniature county shapes. In the larger counties she also quilted in two or more outlines of a Lone Star. Mrs. Anthony appliquéd her counties map onto plain tan cotton fabric, then added outline quilting in each county and diagonal-line quilting across the background. As an added decorative

and historic touch, she quilted into the background many small representations of each of the six national flags that have flown over Texas (Spain, France, Mexico, the Texas Republic, the Confederate States of America, and the United States), as well as tiny outlines of the state.

Mrs. Anthony believed passionately in the Texas Home Demonstration Association's mission to improve homemaking on Texas ranches and farms through home demonstration clubs and councils. Perhaps the high point in her tenure as association president came in April 1933, at the depth of the Depression, when she addressed the Texas Legislature, calling on members to stop their threatened funding cut for home demonstration agents. Mrs. Anthony prepared carefully for the event. She made herself a white dress, had her hair done, and donned white gloves, a hat, and a short black coat (she described herself as a "symphony in black and white"), all so she "could be conspicuous enough so that I could be pointed out and found in a crowd." Anthony then led a procession of more than 1,300 friends, farmers, and fellow association members up Austin's Congress Avenue to the State Capitol.[155]

Elizabeth Anthony spoke only for a few minutes but, in the words of one admirer, "every word she said was a high-powered rifle ball that busted the bull's eye wide open." Her request was straightforward:

We come asking you, the statesmen of our great state, to think liberally, and give back to us a liberal portion of that which we at so great cost have paid into the coffers of the State, to the end that all Texas may have occasion to rejoice in the forward movement of farming and ranching. I ask this not for ourselves alone, but for all Texans, for, as go farming and ranching, so goes all Texas.[156]

The legislature voted to keep the association's funding secure.

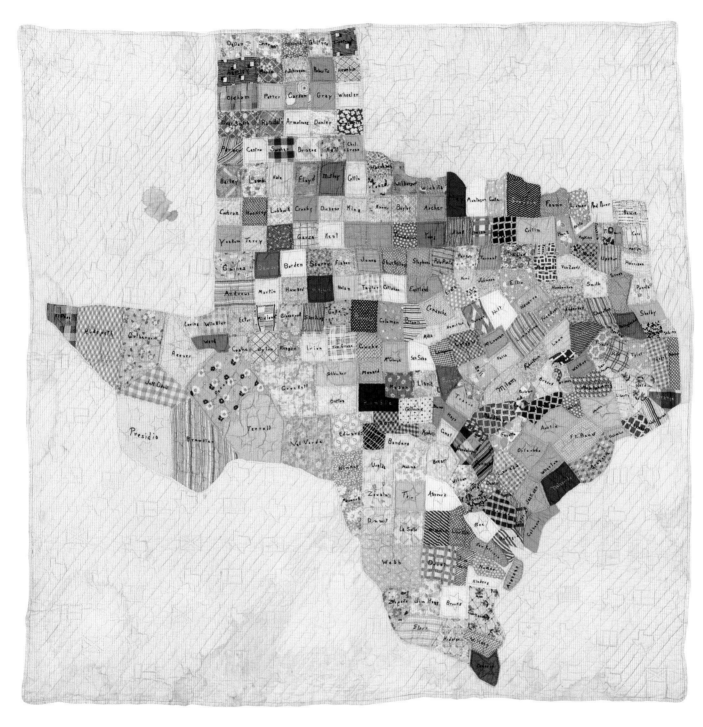

The Texas Quilt

Elizabeth C. Kelley
Anthony, Mineola, Texas,
circa 1933

Cotton: 73¼ x 73 inches

Hand pieced, hand
appliquéd, hand
embroidered,
hand quilted

2010-289

Gift on behalf of
Fount N. Kelley and
Harriet Chase Kelley

Portion of the pattern for Stenge's *Lotus* published in "The Superb Mrs. Stenge," by Cuesta Benberry, *Nimble Needle Treasures*, Summer 1971, 4–8. Benberry greatly admired Stenge's "innovative talent" as both designer and quiltmaker. Joyce Gross Quilt History Collection, JGSC Box 38.

The Winedale Quilt Collection contains seven quilts made by the award-winning Chicago quiltmaker Bertha Shermansky Stenge (1891–1957). The Briscoe Center acquired six of them in 2008 as part of the Joyce Gross Quilt History Collection. The Quilt Conservancy donated the seventh Stenge quilt, *Lotus*, to the Briscoe Center in 2008. All seven quilts are included in this essay and the next six essays in the order Stenge made them.[157]

California-born Bertha Stenge was well-known and highly praised for her needlework skills and imaginative

Lotus-Traditional Design

SCALE

COLOR CHART
C - CREAM
D - DARK GREEN
R - ROSE
L - LIGHT GREEN
P - PINK

quilt designs. Formally trained in art, Stenge moved to Chicago in 1912, where she married attorney Bernhard Stenge and raised three daughters. She began quilting in 1929 while in her late thirties, an activity that became an essential source of artistic expression for her. In a 1933 letter to the editor of *Woman's Home Companion*, Stenge hints at the importance she placed on quiltmaking, urging other women to "take time out, if not daily at least weekly," to "keep in touch" with their talents. Such investment in self-expression, she suggested, would have a big payoff: "When the time comes that [women] find themselves unnecessary to the welfare of the family they can easily slip into other joyful work and not become superfluous, a neurotic, a prying mother-in-law, or a member of the gossiper's chorus."[158]

Stenge's original designs and superb needlework produced some of the most creative quilts made from the early 1930s through most of the 1950s. Stenge regularly entered her quilts in county and state fairs, winning dozens of ribbons, including at the prestigious Canadian National Exhibition in 1936 and at the 1940 New York World's Fair. In 1942 Stenge won the Grand Award in the *Woman's Day* National Needlework Contest for her *Victory* quilt, accepting her prize at Madison Square Garden in a ceremony broadcast over NBC Radio. Her quilts also received national exposure at exhibitions, including in 1941 at the University of California Art Gallery and in 1943 at the Art Institute of Chicago, and through national women's magazines such as *Ladies' Home Journal*. In 1955 the *Chicago Daily News* reported on Stenge's many successes, praising her as an "artist with a needle" and dubbing her "Chicago's Quilting Queen."[159] The quilt community was stunned and saddened upon hearing of Stenge's death in June 1957. In a letter dated June 24, her friend, fellow quiltmaker, and longtime correspondent Florence Peto wrote Stenge's daughter Frances Traynor to express her sympathy. "The world has lost a magnificent needlewoman; there isn't another with the skill and ingenuity she displayed," she wrote, adding "I am going to miss your mother's letters to me more than I can possibly make you believe."[160]

Lotus may have been the fourth quilt Bertha Stenge made. It is her adaptation of Whig's Defeat, an old and

Lotus

Bertha Shermansky
Stenge, Chicago,
dated 1934

Cotton: 76 x 85 inches

Hand pieced, hand
appliquéd, hand quilted

Joyce Gross Quilt
History Collection,
W2h001.012.2008

Gift of the Quilt
Conservancy

much-loved quilt pattern whose name grew out of a political dispute finally settled in 1844, when Democrat James K. Polk defeated Whig candidate Henry Clay for the US presidency. Stenge's version added the bold scalloped border that enhances the pieced curves. Her pattern became a popular one, reproduced often. In September 1947 *Ladies' Home Journal* offered the pattern for sale, picturing Stenge's *Lotus* on a canopy bed. *Nimble Needle Treasures* printed the pattern in its summer 1971 issue, and Joyce Gross reprinted the pattern in her *Quilters' Journal* in June 1984.

Lotus also was featured at Chicago's Art Institute in August 1943 as part of Stenge's one-woman show containing seventeen quilts. The previous year Stenge had won the Grand Award in the *Woman's Day* National Needlework Contest; hence, by the time of the Art Institute exhibition, Stenge was nationally recognized as an award-winning quiltmaker. The exhibition was a great success. Mildred Davison of the Art Institute's Decorative Arts Department wrote Stenge to commend the display as "one of the most popular exhibitions the Decorative Arts Department has ever shown."[161] *Newsweek* magazine covered the exhibition in a "Quilts as Art" column, published August 2, which unfortunately introduced a sour note into Stenge's show. "Quilts as Art" labeled the display "a summer show of—of all things—patchwork quilts, and

modern ones at that" and identified quiltmaker Stenge as a "52-year old Chicago grandmother who got her first inspiration from a newspaper contest." The magazine also described Stenge's *Lotus* inaccurately, as "a bright green and rose affair on a lavender background" and noted that Stenge's husband and daughters Prudence, Frances, and Ruth had another name for the quilt: "Frances's Nightmare."[162] Upset with *Newsweek*'s coverage, Stenge contacted the magazine to express her displeasure. Art Editor Hilda Loveman responded by letter, apologizing for the column's inaccuracies and explaining her unsuccessful attempts to correct the correspondent's mistakes. In all, Loveman noted, "the whole thing was an incredible mess."[163]

The Briscoe Center acquired Stenge's *Lotus* from the Quilt Conservancy, a nonprofit organization whose mission was to facilitate the acquisition of quilts for museums. The conservancy acquired *Lotus* around 1989 and housed it with Joyce Gross for safekeeping. The organization donated *Lotus* to the center in memory of Cuesta Benberry (1923–2007), one of the nation's leading historians and scholars of American quilting and a longtime friend and colleague of Joyce Gross. The Briscoe Center added *Lotus* to its Joyce Gross Quilt History Collection in order to pay tribute to these two eminent quilt historians and to document their friendship.

Rachel's Wreath is one of Bertha Stenge's early, perhaps even her earliest, quilt to feature stuffed work and cording. Stenge first became acquainted with the technique, often called trapunto, at the 1933 Chicago World's Fair, where she saw the grand prizewinning quilt *Star of the Bluegrass* by Margaret Rogers Caden. Stenge taught herself this exacting technique of bringing dimension to a quilting pattern by adding padding, later describing its process in a 1936 issue of *Prairie Farmer Magazine*: "I sew a thin lining on the back of the design. . . . Now, from the back of the design, [I] spread the threads with a wooden toothpick, poke Germantown knitting wool through the opening, then close."[164]

An original design, *Rachel's Wreath* is formal and elegant, bearing witness to Stenge's already expert trapunto technique after practicing it for only two years. The quilt is composed of five blocks of beautifully appliquéd wreaths in green with pink blossoms. But it is Stenge's extraordinary stuffed work and cording that draw the eye. To frame each wreath, Stenge created raised diamonds, each eighteen inches long and three inches at the widest point. She stuffed each diamond's scalloped edge, added cording and stuffed leaves along the center of each diamond, and set a pair of heavily stuffed flowers at the center of each. Stenge also added her elaborate trapunto design in the deep border, where she grouped partial diamonds along each side and increased their number to perfectly turn each corner.

Stenge kept a roster of professional quilters she relied on to finish her quilts. For *Rachel's Wreath*, her quilter filled every open space in blocks and borders with a cross-hatch grid pattern of thirteen to fourteen stitches per inch. The quilt's edge features two Stenge trademarks: a double piping inset (one pink, one green) and her homemade bias binding. In 1940 *Ladies' Home Journal* published three of Stenge's original quilt patterns, including one for her *Rachel's Wreath* quilt. The pattern (no. 1602) was offered for ten cents in the November issue.

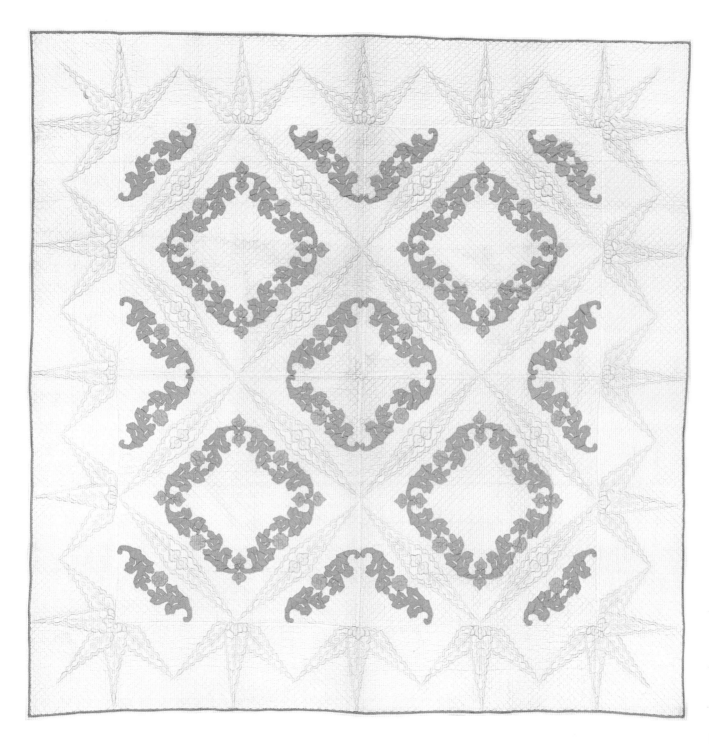

Rachel's Wreath

Bertha Shermansky
Stenge, Chicago,
dated 1935

Cotton:
74½ x 74½ inches

Hand and machine
pieced, hand appliquéd,
stuffed work, cording,
hand quilted

Joyce Gross Quilt
History Collection,
W2001.007.2008

TIGER LILY

Bertha Stenge entered her *Tiger Lily* quilt in the "trapun-to work section" of the Kentucky State Fair in September 1941, where it was judged the most unusual quilt at the fair and awarded a blue ribbon. *Tiger Lily* followed *Rachel's Wreath* as another of her original designs featuring stuffed work and cording. The two quilts have much in common: fine appliqué, lavish dimensional designs, contrasting inset piping at the edge, and expert crosshatch grid quilting that fills in the blocks and borders. The hand quilting appears to have been done by the same professional quilter Stenge hired to quilt *Rachel's Wreath*.

Tiger Lily is a small quilt, much loved for its originality and meticulous workmanship. The framed center contains twelve blocks of densely appliquéd and dimensional patterns set on a golden-yellow background. Each four-petaled flower—a dogwood-like blossom—is beautifully stitched and stuffed or corded. Paisley arches define the blossom edges, and at the center four dimensional leaves and a single tiny paisley square set on point further enrich the blossom. Deeply lobed green leaves outside the bloom merge at the block intersections to help define the flower design and present a secondary pattern.

Multiple borders frame the medallion, including a wide border distinguished by trapunto designs that echo the curved designs of the corded edging in the blocks. Stenge finished this tour de force of appliqué and lavish trapunto designs with inset piping in brown paisley and edged the quilt in a straight, separately applied binding in golden yellow. She used the same yellow fabric on her quilt back. The quiltmaker's modest label—her name sewn in green cursive on a small white strip—is sewn in the center of the quilt back.

In 1971, some years after Stenge's death, one of her daughters sold several of her mother's quilts, including *Tiger Lily*. No records of the sale were kept, but in 1983 two of these "missing quilts" were located. Quilt historian Joyce Gross helped arrange for their exhibition at quilt conferences in Oregon and Missouri, and, in 1989, Gross was able to purchase *Tiger Lily* for her personal collection.[165]

Tiger Lily

Bertha Shermansky
Stenge, Chicago,
dated 1940

Cotton: 63 x 79 inches

Machine pieced, hand
appliquéd, stuffed work
and cording, hand quilted

Joyce Gross Quilt
History Collection,
W2001.006.2008

Bertha Stenge named this quilt *Star Quilt*, but her family also referred to it as *Old Star*. But, as is sometimes the case when a quilt changes hands, a new owner renamed it. When Joyce Gross acquired this quilt in 1997 from Stenge's daughter Prudence Fuchsmann, she named it *Stars with Wavy Sashing*. Stenge made this quilt using an antique quilt top, possibly one she received from her friend and fellow quiltmaker Florence Peto.[166]

Bertha Stenge's 1940s *Stars with Wavy Sashing*, as its name indicates, features blocks separated by sashing made using fabric with a wavy pattern. The graphic quality of this fabric and the vertical set of its wavy lines give this quilt its startling boldness, one reinforced by thirty bright stars set against light-colored backgrounds. This dark–light contrast is repeated in the eye-catching border design, where pieced rectangles march around the quilt perimeter even as wavy strips perfectly frame the lengths of the borders along the sides. Stars, blocks, and border rectangles were made from the same color palette of strong reds, dark blues, and warm browns featuring a mix of shirtings, conversation prints, and small-scale designs. The quilt is hand pieced at seven stitches per inch in white thread, using a simple outline stitch. As with her *Rachel's Wreath*, Stenge hired a professional quilter to complete *Stars with Wavy Sashing*.

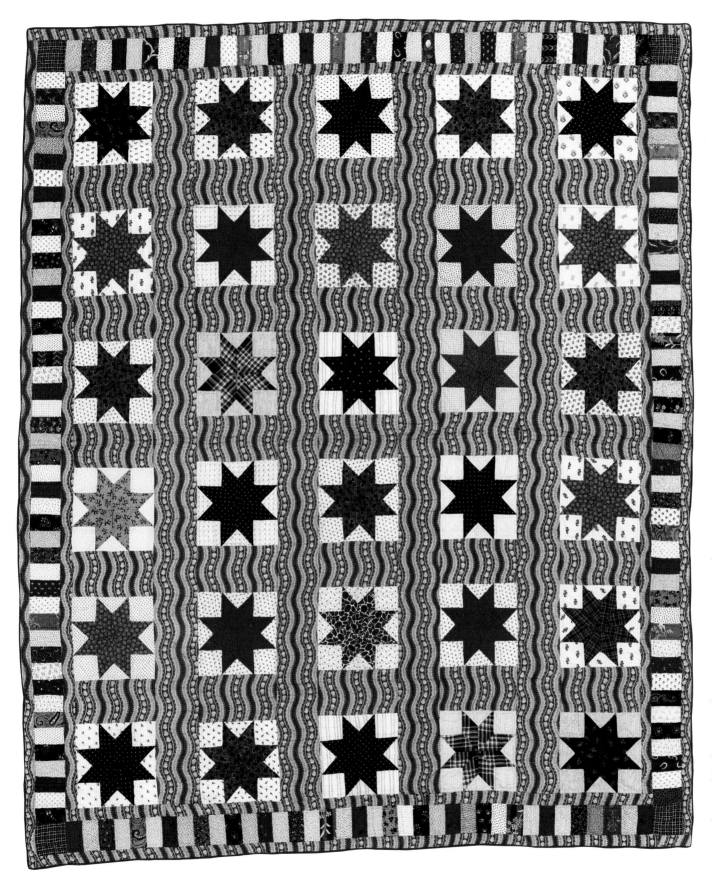

Stars with Wavy Sashing

Bertha Shermansky Stenge, Chicago, dated 1940s

Cotton: 72½ x 87 inches

Hand and machine pieced, hand quilted

Joyce Gross Quilt History Collection, W2001.011.2008

Serpentine and Stars, which Bertha Stenge called *Pennsylvania Dutch* or *Penn Dutch*, is one of Stenge's lesser-known quilts. Stenge probably exhibited this quilt infrequently, though it was included with twenty-nine other Stenge quilts at the thirty-first annual Women's International Exposition in New York City in 1954.[167]

Stenge's *Serpentine and Stars* combines disparate designs—richly elegant all-white dimensional flowers that look ready to be picked and simple appliquéd stars and circles made from cheerful pastel and printed fabrics. This unusual combination, which so impressively succeeds, testifies to the hallmarks for which Bertha Stenge is best known: innovation and extraordinary needlework artistry.

It is not often that a quilt's border is its exceptional feature. But in this quilt a generously wide swath of white contains both a soft sprinkle of small stars at the edge and an inner surround of twenty-four identical large floral sprays (eleven inches tip to tip), each containing branching stems, two blossoms, two buds, and multiple leaves. The designs are beautifully conceived, perfectly executed, and extraordinarily dimensional. Light pencil marks on some of the flowers indicate where Stenge marked the areas she planned to raise with padding.

Moving inward, Stenge created a folded-ribbon medallion frame by piecing and appliquéing squares and parallelograms from chartreuse cotton. This serpentine frame effectively divides the formal dimensional designs from the lighthearted medallion interior of blocks set on point that hold curvy circles in floral printed fabrics layered with softly curved stars and large dots. Alternate blocks feature additional flowers quilted in and centered with appliquéd dots. These contrasts of color (all white versus springy prints), dimension (stuffed work versus layered appliqué), and design aesthetic (formally elegant versus cheerfully lighthearted) give this quilt enormous appeal.

Joyce Gross loved this quilt. It seemed fitting, therefore, that on the evening of November 20, 2009, at the Briscoe Center's reception opening its exhibition "A Legacy of Quilts: The Briscoe Center's Joyce Gross Collection" at the Bob Bullock Texas State History Museum in Austin, Joyce was able to enjoy *Serpentine and Stars* in two versions: the glorious quilt Stenge made and an edible reproduction of it in the form of an enormous sheet cake.

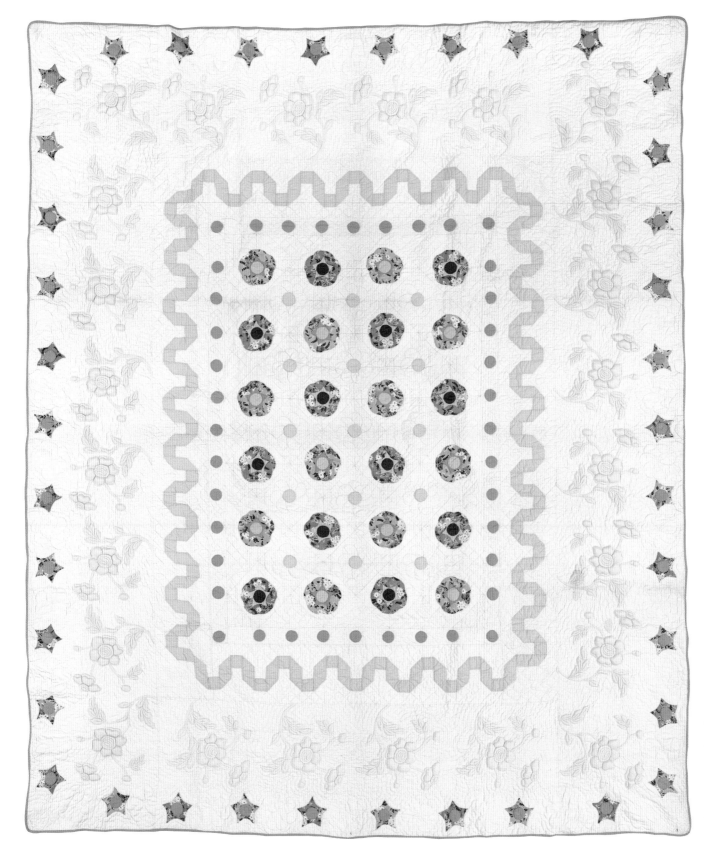

Serpentine and Stars

Bertha Shermansky Stenge, Chicago, dated 1948

Cotton: 82 x 99 inches

Hand and machine pieced, hand appliquéd, stuffed work, hand quilted

Joyce Gross Quilt History Collection, W2001.010.2008

DOVE AND RING

In 1950, despite competition from a New York decorator, quiltmaker and quilt historian Florence Peto successfully bid at auction on several pieces of a red copperplate toile. In an effort to persuade her friend Bertha Stenge to use vintage fabrics in her quilts, Peto sent her a box of vintage patriotic fabrics plus two long strips of the toile. Peto identified the fabric as "Amorini and Medallions," an 1810 French toile she later called "dove and ring." Peto used it in her own *Hearts and Flowers* quilt, which she finished in 1954. Stenge returned all the fabrics to Peto except for the toile, which she incorporated into this quilt, finishing it in 1953. The quilt has had various names: *Dove and Ring*, *Ring and Dove*, *Peto's Angels*, and *Love Birds*. The fabric's images are typical of the neoclassical style: cherubic angels, doves, and a framed classical head, all set against a background of small hearts pieced by arrows.[168]

Stenge ingeniously incorporated the toile throughout her quilt to use its designs to their best advantage. Inside the medallion, portions of the toile appear in the quilt's thirteen rectangular and four square blocks—paired angels appear in five rectangle blocks and single angels in all four square blocks. The ringed classical head appears only in the three rectangles set vertically along the midline. Bits of the fabric make up the pieced folded-ribbon frame around the blocks and in parts of the pieced diamond border at the quilt's edge. Cut-out and appliquéd cherubs holding the ring and dove grace the wide outer frame.

Stenge brought extra color and definition to her quilt by adding lively flowered sashing around the alternating blocks and pieced into her diamond border. Stenge, or perhaps the professional quilter she hired, hand quilted *Dove and Ring* in pink thread at nine stitches per inch, outlining the figures in the toile, filling in with diagonal parallel lines and clamshell patterns, and adding a floral motif at each corner.

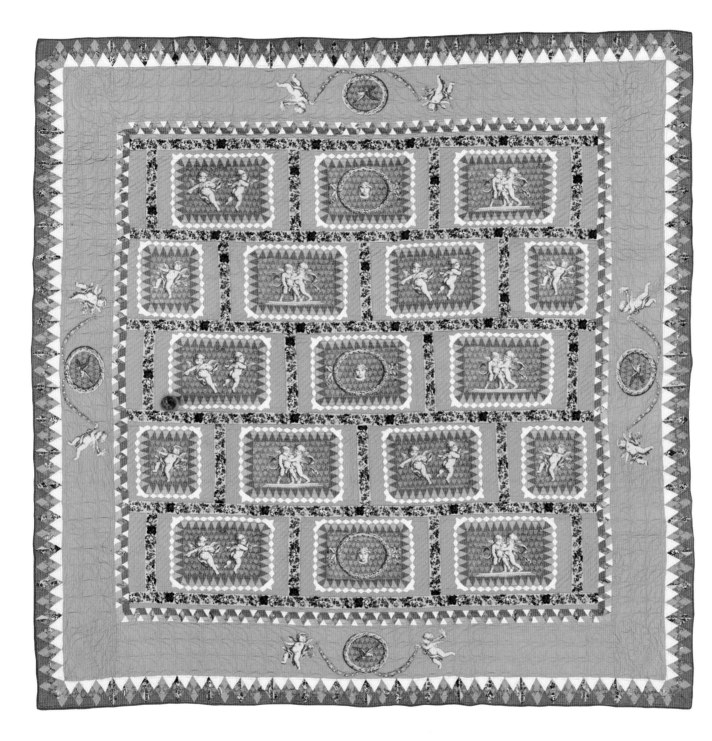

Dove and Ring

Bertha Shermansky
Stenge, Chicago,
dated 1953

Cotton: 80 x 82½ inches

Hand and machine
pieced, hand appliquéd,
broderie perse,
hand quilted

Joyce Gross Quilt
History Collection,
W2001.008.2008

Bertha Stenge created this original design by beautifully combining double eight-pointed stars, appliquéd circles, six-patch chevrons, sashing with cornerstones, triangle borders, and a contrasting binding. For good measure, she fussy cut her printed fabric, orienting the pieces top to bottom, and set a contrasting red piping inside the green binding. Stenge acquired her black, red, blue, and green fabric during a trip to Mexico.[169] It features six different cartoonlike representations of Mexican men and women wearing a version of older, perhaps rural, traditional dress—men in sombreros and serapes, women in flowing skirts and sandals, carrying baskets of fruit.

As with all her quilts, Stenge's design and workmanship are exquisite. She organized this complex quilt into sixteen blocks, each containing 101 separate pieces, beginning with a circle appliquéd at the center of an eight-pointed blue star, and including eight kite shapes (quadrilaterals), eight triangles made of small squares, plus four corner triangles. The interior and outer sashing contain cornerstones, each fussy cut to showcase one of the Mexican figures. The outer cornerstones are paired with border triangles in Nile green. All other border triangles are pieced from the Mexican character print (all fussy cut to show a character's face) or from off-white fabric. As a final detail, Stenge added a green kite shape at the base of each corner.

Stenge often employed a professional quilter to hand quilt her masterpieces, and it is very likely that she did so for her *Mexican Dancers*. Outline and grid quilting patterns help define the quilt's motifs, including the characters in each of the circles and cornerstones. The sashing is heavily quilted with a diamond outline along the length of each segment, with triple parallel-line quilting filling the background. Quilting pencil marks are still visible.

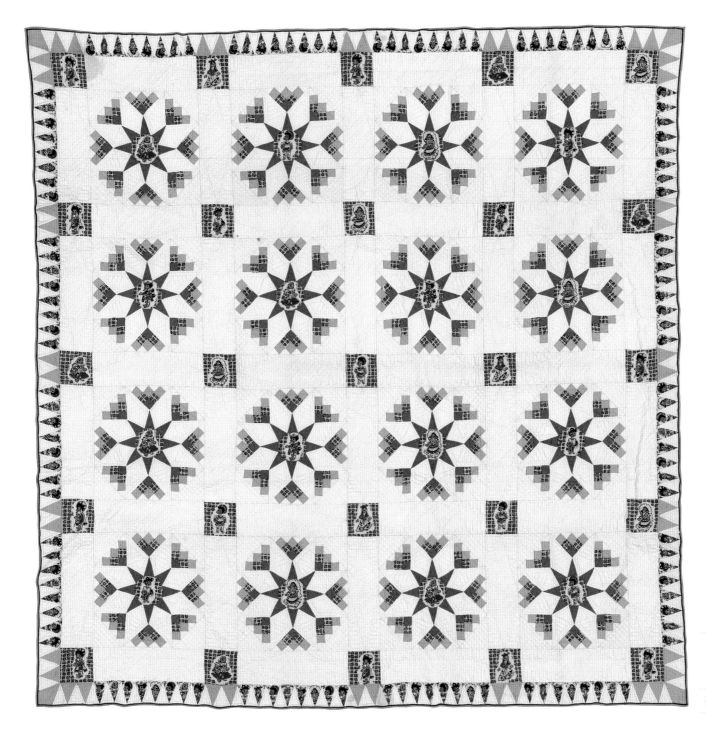

Mexican Dancers

Bertha Shermansky
Stenge, Chicago,
dated 1953

Cotton: 87 x 87 inches

Hand and machine
pieced, appliquéd,
hand quilted

Joyce Gross Quilt
History Collection,
W2001.009.2008

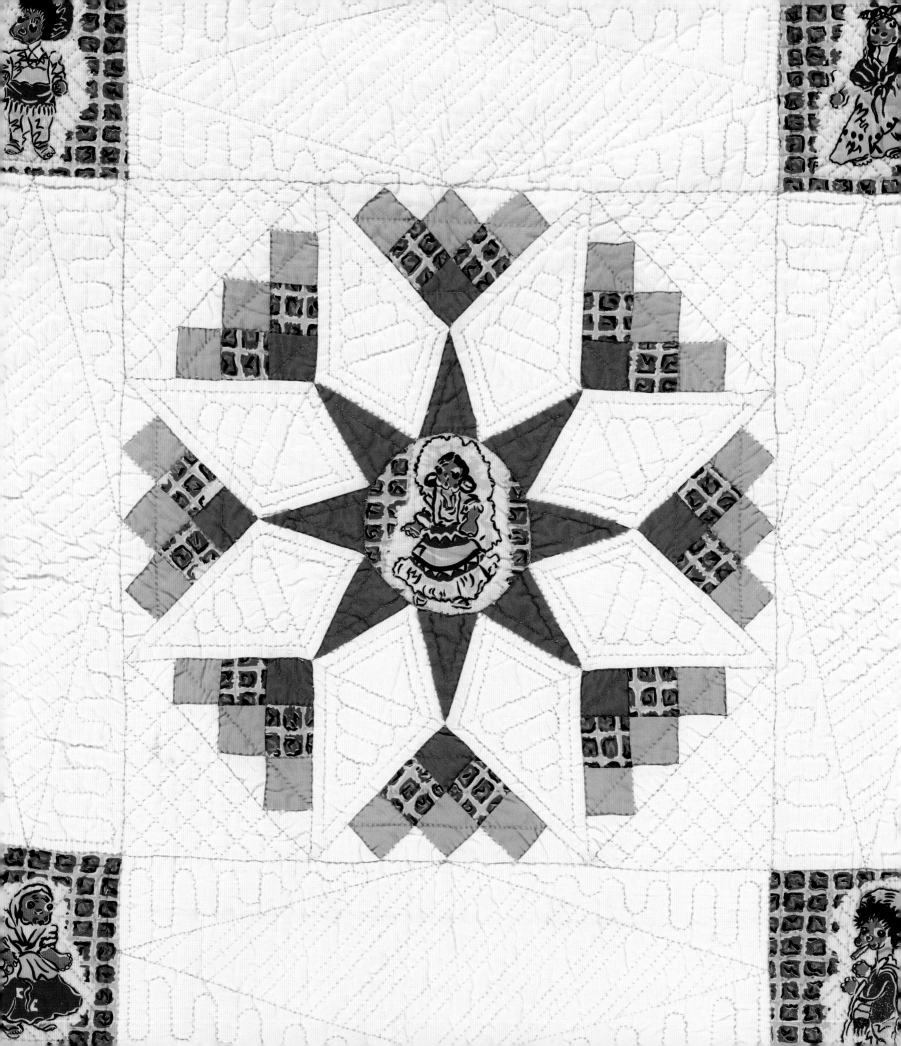

QUILTERS' JOURNAL

P.O. Box 270 · Mill Valley, Ca 94941 · (415) 388-7578

SUMMER 1979 · VOL. 2 NO. 2

BERTHA STENGE poses at her quilt frame surrounded by some of her prize winning quilts. Mrs. Stenge liked to work on her quilts early in the morning from 6 a.m. to 9 a.m.

Bertha Stenge's photo graced the cover of a 1979 issue of *Quilters' Journal*. Joyce Gross's five-page article on Stenge in *QJ* included excerpts from correspondence files made available to Joyce through Stenge's daughter Frances Traynor.

Artist, quilter, milliner, and doll maker Callie Elizabeth Jeffress Fanning (1881–1946) of Sulphur Springs, Texas, is remembered both for her fine needlework and for her oil and watercolor paintings. She studied art at the Eastman College and Conservatory of Music and Art in Sulphur Springs and at the St. Louis School of Fine Arts. Fanning, more widely known as Callie Jeffress Fanning Smith, made several pictorial quilts in which she incorporated appliqué, embroidery, and painting.[170] All featured people. Her *Leading Ladies* quilt (ca. 1940) depicts female movie stars in various roles, and her *Eleanor Roosevelt Picture Album* (1940) contains twelve blocks showing Mrs. Roosevelt at different stages of her life.[171]

In 1934 Fanning created her pictorial quilt named *Storybook*, which won a prize at the State Fair of Texas in 1935. The quilt's name is a bit misleading. Of the twenty blocks, only two contain obvious storybook or nursery rhyme characters: Alice in Wonderland appears in the corner block at the lower right, and the Little Dutch Girl is in the block above her to the left. Other blocks contain the artist's original designs of bonneted girls at play, with pets, or smelling flowers. In the cornerstones Fanning added

Beatrix Potter–like rabbits, a chicken, and an assortment of ducks, small dogs, and potted flowers. Colorfully realistic butterflies appear at each junction between the sashing and the border.

Fanning's appealing and naturalistic figures combine pieced and appliquéd fabrics, embroidery, and oil painting. The girls' clothing, including hats and aprons, are fabric, as are objects such as umbrellas, a balloon, and two watering cans. Children, animals, plants, and objects are outlined with embroidery. Painted details, including the facial features, hair, arms, and legs of the girls; the hair, feathers, and fur of the animals; and the colors and textures of the assorted objects, enrich each block. Look for the scooter, the jump rope, a toy wagon, a chalk slate, a tree branch, and a striped vase containing a lush bouquet of flowers. Fanning's artistry, including expert manipulation of fabric, painted shading, and embroidered details, brings movement and depth to her characters' clothing, delineating the folds in a child's dress and puffed sleeves or the ruffles and swing of a full underskirt. The combination of artistic techniques in her quilts also presages the art quilt movement still many years in the future.

Storybook

Callie Elizabeth Jeffress
Fanning, Sulphur Springs,
Texas, dated 1934

Polished cotton, crepe:
58 x 73 inches

Hand pieced, hand
appliquéd, hand quilted,
hand embroidered,
painted

2010-303-2

Gift of Jo Ann Durham

The Sulphur Springs
Women's Embroidery Club,
1914. Callie Elizabeth Jeffress
Fanning is standing second
from left. Callie Elizabeth
Jeffress Fanning Quilts File,
2010-303, WQC.

MILLS'S BUTTERFLIES

In addition to the 1934 date embroidered on a back corner, this quilt's repeating object design, paired plain and printed fabrics, light background, and pastel gray–green fabric, often called Nile green, help identify it as a Depression-era quilt.

This butterfly pattern required many different fabric pieces. Given the quilt's creation during the hard times of the 1930s, a natural assumption is that a frugal Anna Hardt Mills relied on scraps from past sewing projects. Mills had other, more likely, fabric sources available to her, however, including mail-order catalogs and women's magazines that sold factory cutaways. In 1934, for example, the Sears, Roebuck and Company catalog sold packages of cotton scraps for as little as twenty-two cents per packet.[172] Mail order may also have been the source of this butterfly pattern. Popular by the early 1930s, butterfly patterns were readily available commercially as block sheets, in booklets, in kits, or as design templates. For example, *Grandmother Clark's Patchwork Quilt Designs from Books 20-21-23*, a leaflet published in 1932, advertised "Accurately Cut Out Fibre Diagrams" for two different butterfly designs: "Egyptian Butterfly" and "Plain Butterfly," both in its Book 21, available for fifteen cents from W. L. M. Clark Inc. of St. Louis.[173]

Anna Mills created fifty-four butterflies in color-coordinated pairings of printed and plain fabrics. Although she repeated solid fabrics, she used each print on one butterfly only. Each butterfly contains five appliquéd sections, with plain-colored lower-wing segments overlapping print upper ones, and the slender body, in the same print, sitting atop the whole. Eyes and antennae in black embroidery thread help bring the butterflies to life, and the black blanket stitch outlining each segment further defines the insect. Generous inner borders effectively divide three successively larger groups of butterflies, bringing organization and some visual relief to an otherwise busy pattern.

Mills demonstrated her sewing skills in her needlework. Her butterflies are tidy, her fabrics are well paired, and her quilt lies perfectly flat. Mills's hand quilting, however, proved her undoing. She clearly planned a hanging diamond pattern to cover the entire front of her quilt, one interrupted only at each appliquéd butterfly. Unfortunately, although Mills's stitches are fine, her stitch lines go terribly awry as she quilted from the center outward. This quilt has never been washed and appears little used—basting threads are still present in some butterfly designs—and quilting pencil marks, some of which document Mills's failed attempts to match her quilt lines, remain easily visible. Perhaps the quiltmaker, disappointed and frustrated with the look of her finished project, simply stored her delightful butterfly quilt away, unused.

Mills's Butterflies

Anna Hardt Mills,
possibly California,
dated 1934

Cotton: 77 x 88 inches

Machine pieced, hand
appliquéd, embroidered,
hand quilted

Joyce Gross Quilt
History Collection,
W2h001.050.2008

Rodah Welch's homemade holder for embroidery floss, made from sugar sacks, circa 1940. Rodah Elliott Welch Embroidery Floss Collection, 2012-278.

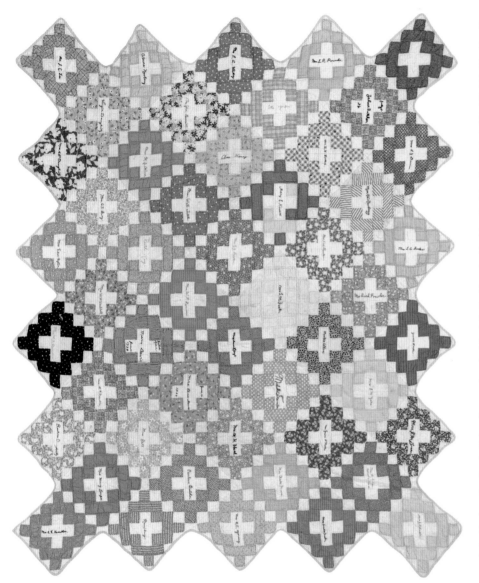

Album Patch

Made by relatives and friends of Alta Butcher Bramblett, Brownfield, Texas, circa 1934

Cotton:
69½ x 84½ inches

Hand and machine pieced, hand quilted

2011-336

Gift of Claud A. Bramblett

Quiltmakers living in rural West Texas, where cotton farming was the economic backbone, used cotton sacks to create all manner of clothing and household items, including this *Album Patch* friendship quilt, made during the hard times of the 1930s. Family history holds that friends and family members created this quilt for Alta Butcher Bramblett (1902–1968), a woman known for her love of needlework, gardening, and cooking. Forty-nine women signed the quilt, each one embroidering her name in the center patch of an album block; one block remains unsigned. Alta probably received the quilt as a welcoming gift sometime after her arrival, with husband, Orgel, in Brownfield around 1932 or 1933.[174] The quilt contains the embroidered names of at least three of Alta's female relatives: her sister, her niece, and her sister-in-law. Two of these signature patches are dated June 1934. A woman living in Detroit, Texas, a town more than four hundred miles east of Brownfield, also signed a block, indicating that the quiltmakers solicited blocks from very far afield in order to feature the names of Alta's friends.

Although it seems unlikely that each of the forty-nine women made a block in this fifty-block scrap quilt, it is apparent that several hands collaborated on the project. The blocks show various skill levels; some are pieced by hand, others by machine. The fabrics vary block to block, fifty different fabrics in all, including some cotton sack fabrics. A few blocks are made from solids, but most are pieced from small prints, including mourning prints and object prints, as well as floral and striped cottons. Most signatures are oriented in the same direction, giving the quilt a definite top and bottom. A distinctive and charming feature of this quilt is its giant sawtooth border, the result of the blocks being set on point and the quilt lacking a separate border. *Album Patch* is finished with a bias binding machine applied and simple outline quilting at four to five stitches per inch.

Alta Bramblett sewed regularly, always using a treadle sewing machine, which one of her sons still owns. She also made quilts for the family beds, quilting on a frame made by her husband, an accomplished carpenter. By the early 1950s, however, Alta tired of quilting and turned her needlework talents to crocheting. *Fan Quilt* may be one of

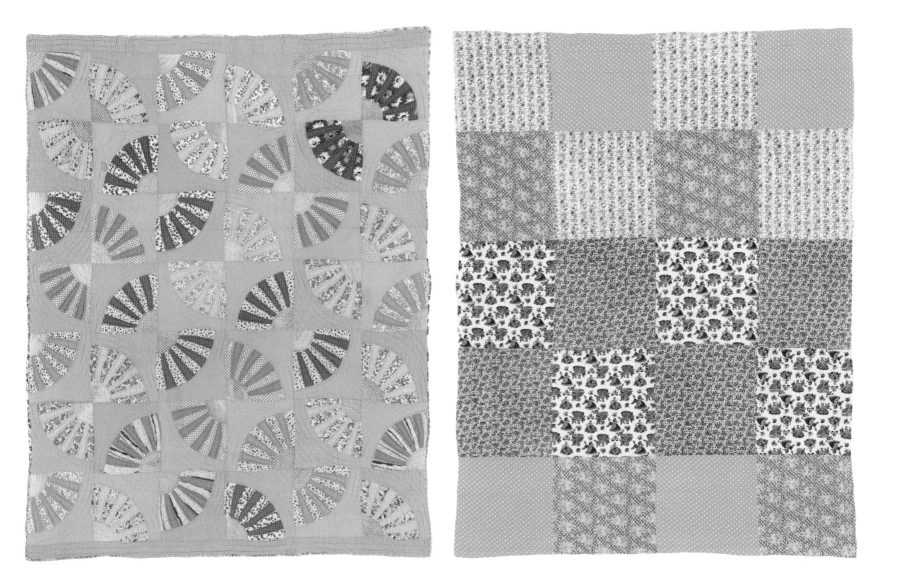

the last quilts she made. It is a utility quilt, which Alta created entirely out of cotton sacks, a reliable source of fabrics for many home-sewn projects from the 1920s through the 1950s. It is likely that she purchased the cotton sacks at Speer's Grocery in Carrizo Springs, a small town in far southwest Texas. The family moved to Carrizo Springs from Brownfield around 1937 in hopes of finding some relief for Alta's asthma.

Alta sewed forty-two blocks out of cotton sacks in solid colors and printed designs, carefully coordinating the fabrics block to block, and then setting matching fans end to end, thereby creating a secondary pattern on the quilt front. She added a strip of green fabric along the quilt top and bottom, probably as an efficient way to increase her quilt's length. Alta made her quilt back in an eminently practical way and still managed to achieve a pleasing result. She pieced her quilt back using twenty large blocks made from five different cotton sack prints, none of which appears on the quilt front. Alta then finished her quilt by turning the back fabrics to the front. The result is clever and attractive—the quilt top is edged with repeating lengths of different prints every sixteen inches.

Fan Quilt
left, front; right, back

Alta Butcher Bramblett,
Carrizo Springs, Texas,
circa 1947–1950

Cotton:
65½ x 83½ inches

Machine pieced,
hand quilted

2012-247

Gift of Claud A.
Bramblett

Nine of Pine Eisfeller's Hawaiian quilts, with annotations about awards from the 1936 New York State Fair. Eisfeller Scrapbook, Joyce Gross Quilt History Collection, 2008-013/Box 38.

LILIA O KE AWAWA (LILY OF THE VALLEY)

The Winedale Quilt Collection contains six quilts made by Pine Lorraine Hawkes Eisfeller (1894–1990), two of which were voted among the best one hundred American quilts of the twentieth century. This essay and the next five tell her story as a quiltmaker. California quilt historian and collector Joyce Gross helped reintroduce the extraordinary quiltmaker to the public through her *Quilters' Journal* and quilt exhibitions. Gross's story of her "discovery" of Eisfeller is worth repeating. According to Gross, Donna Renshaw, author of *Quilting: A Revived Art* and a quilt teacher during the 1970s quilt revival, urged her to get in touch with a friend whom she described as "a fantastic Hawaiian quilter"—Pine Eisfeller. Gross wrote Eisfeller's name and address in a notebook and then shelved the notebook. As she recounted, "Some years later [quilt historian] Cuesta Benberry wrote me a letter listing the winners of the 1942 Women's Day National Needlework Contest. For no apparent reason I put the letter down and picked up a notebook to a page with a name and address written on it. Much to my surprise it matched the name of the Second Grand Prize Winner!"—Pine Eisfeller. Gross immediately telephoned Eisfeller, who by then lived in Oroville, California, a mere two hundred miles north of Gross's home in Mill Valley. "We have had many visits since then. My admiration for her quilts has grown."[175]

Eisfeller learned to tat and crochet from her mother and began to quilt with the help of her grandmother. But she only started quilting in earnest in 1930 when she and her husband, Robert Eisfeller, moved to Oahu, Hawaii, where he was stationed at Schofield Barracks with the US Army Medical Corps.[176] As she later recalled, "I had always been interested in needlework and while my husband was on a tour of duty . . . I undertook to finish a quilt as a pleasant means of earning some extra money. This was a commercial quilt, simple and pretty, and after finishing it I made a similar one for myself. I sold [it] before it was finished! That's how it began."[177]

While in Hawaii, Eisfeller also was introduced to Hawaiian quilts and later recalled seeing her first one: "One day I was asked if I had ever seen any Hawaiian quilts. I hadn't and from the descriptions I was unable to picture them in my mind. But I inquired among my friends and eventually found a woman who knew a woman who owned one and off we went to see this Hawaiian quilt. I found it truly beautiful and different."[178] Eager to make her own, Eisfeller began acquiring patterns by visiting a Hawaiian quilt shop and sketching patterns in a small notebook. Eisfeller probably made her first Hawaiian quilt, *Lilia O Ke Awawa* (Lily of the Valley) in 1934. By the time Eisfeller left Hawaii for New York in 1935, she had assembled a collection of patterns and had cut and basted many Hawaiian quilts.[179] *Lilia O Ke Awawa* may be one of the first Hawaiian quilts Eisfeller ever made and kept. She completed the quilt in Hawaii. Her daughter Dorothy Patterson confirms this, writing Joyce Gross in May 1993, within days of Gross's purchase of *Lilia O Ke Awawa*, "I'm glad that you were able to keep it with the 'collection' [Joyce's collection of Eisfeller quilts] as it *is* a Hawaiian Quilt. She made it while *in* Hawaii."[180]

This early Eisfeller quilt does not contain the extraordinary hand quilting found in *The Garden*, *Tree of Life*, or *White Magic*, all award-winning quilts she made just a few years after finishing this traditional Hawaiian quilt. Nonetheless, Eisfeller cut and appliquéd its intricate pattern beautifully, achieving sharp points, deeply lobed flowers, and graceful curves. She also used reverse appliqué to further define the center design and the eight corner designs. Her pattern in soft Nile green achieves a quiet contrast against the white foundation, giving this quilt a sense of serenity. The quilt pattern contains two separate designs: a large center motif and a separate, continuous border with corner motifs that mingle with and repeat those at the center. Although Eisfeller joined the pattern pieces in at least sixteen locations, her junctions are flawless—without close inspection the design appears seamlessly whole. Eisfeller used contour quilting, at seven stitches per inch, to echo the pattern shape.

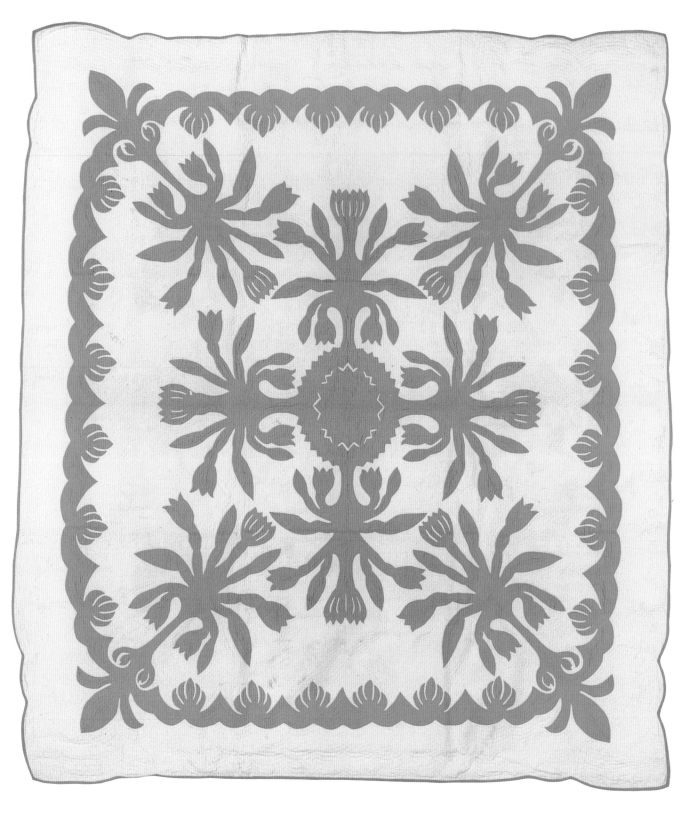

**Lilia O Ke Awawa
(Lily of the Valley)**

Pine Eisfeller, Schofield
Barracks, Oahu, Hawaii,
circa 1934–1935

Cotton: 85½ x 95 inches

Hand appliquéd, reverse
appliquéd, hand quilted

Joyce Gross Quilt
History Collection,
W2h001.002.2008

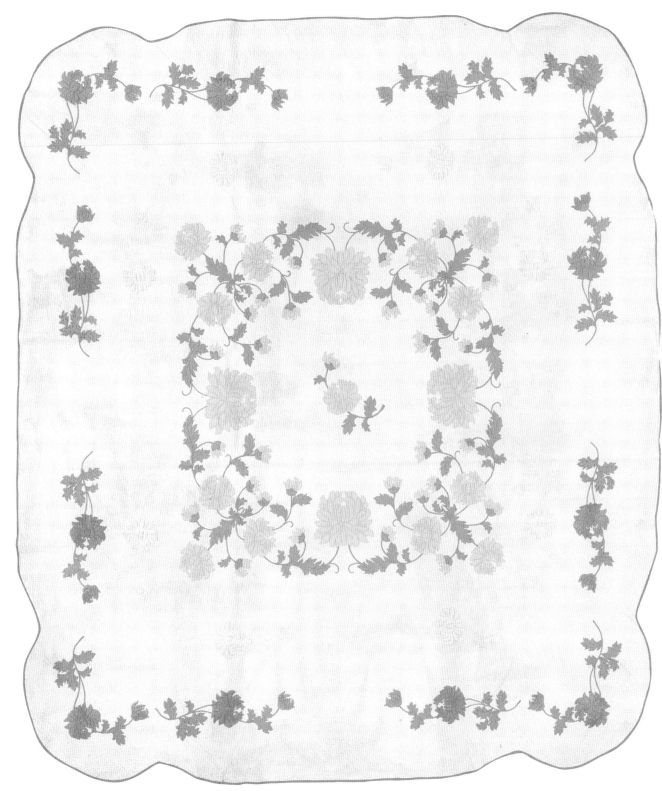

Chrysanthemum

Pine Eisfeller, probably
Oswego, New York, circa
1935–1937

Cotton: 87 x 99 inches

Hand pieced, hand
appliquéd, stuffed work,
hand quilted

Joyce Gross Quilt
History Collection,
W2h001.001.2008

In 1935 Robert Eisfeller was transferred to New York. It is there that Pine Eisfeller's love of quilting truly blossomed—it was there, she said, that "I took my hobby seriously."[181] Eisfeller may have begun making *Chrysanthemum* in Hawaii, finishing it only after the move. Joyce Gross, who acquired the quilt in April 1993, dated the quilt to circa 1940. But a photograph of *Chrysanthemum* in Eisfeller's scrapbook suggests an earlier date. The photo appears alongside snapshots of several of her Hawaiian quilts, including ones she exhibited at the New York State Fair in 1936 and 1937, suggesting that *Chrysanthemum*

Advertising leaflet for Rock River Cotton Company's cotton batting, with an endorsement by Pine Eisfeller, 1937. Consumers were urged to see Eisfeller's exhibit at the New York State Fair and "get the benefit of her Quilting experience." Joyce Gross Quilt History Collection, 2008-013/147.

dates from those years as well.[182] In style and workmanship *Chrysanthemum* also appears to predate Eisfeller's two most recognized quilts: *The Garden* (1938) and *Tree of Life* (1939).

Eisfeller made *Chrysanthemum*'s appliquéd designs using scraps she saved from two earlier Hawaiian quilts. The quilt contains only four colors: yellow, a mustard-gold, blue-green, and, for the binding, Nile green. It features a center medallion—a gloriously large floral frame around a single sprig of two blooms with leaves on a slender stem. The frame is anchored by four large yellow chrysanthemums and joined by medium and small blooms and foliage. The size and composition of this frame is lush and intricate, and its scale nearly overpowers the delicate center flower. Eisfeller's largest blossoms are oversized, measuring eight inches at their widest and containing more than forty curved petals that overlap to create each lush bloom. The stems, all of which curve and flow, are classic Eisfeller: handmade, one-eighth inch wide, and perfectly uniform. The quilt's border design is much more sparse than the inner frame, but it is equally well planned. Mustard-gold flowers replace yellow ones in a trio of identical linear floral designs that grace each corner. Eisfeller used the center motif in each trio to turn the corner, positioning its large bloom as the corner's anchor. In each trio, all blooms and leaves point toward their counterparts in the opposite corner at quilt top and bottom. The effect of the pattern is that of a gentle floral embrace of the center medallion.

This quilt's surprise is its trapunto, a combination of stuffed work and cording that appears between the inner frame and the border. Was this Eisfeller's first use of trapunto in a quilt? Certainly she used the technique to great effect just a few years later in *The Garden* (1938) and her stunning *White Magic* (1940). In *Chrysanthemum*, Eisfeller created eight stuffed and corded designs, each one identical to the appliquéd designs in the border. She placed each directly next to its appliquéd counterpart, a dimensional echo of the gold and blue-green flowers and foliage. Eisfeller finished *Chrysanthemum* with diagonal parallel-line quilting at nine stitches per inch. At the edge, she used her own homemade quarter-inch bias binding. Its green color is a close, but not perfect, match for the blue-green of the quilt's appliquéd leaves and stems.

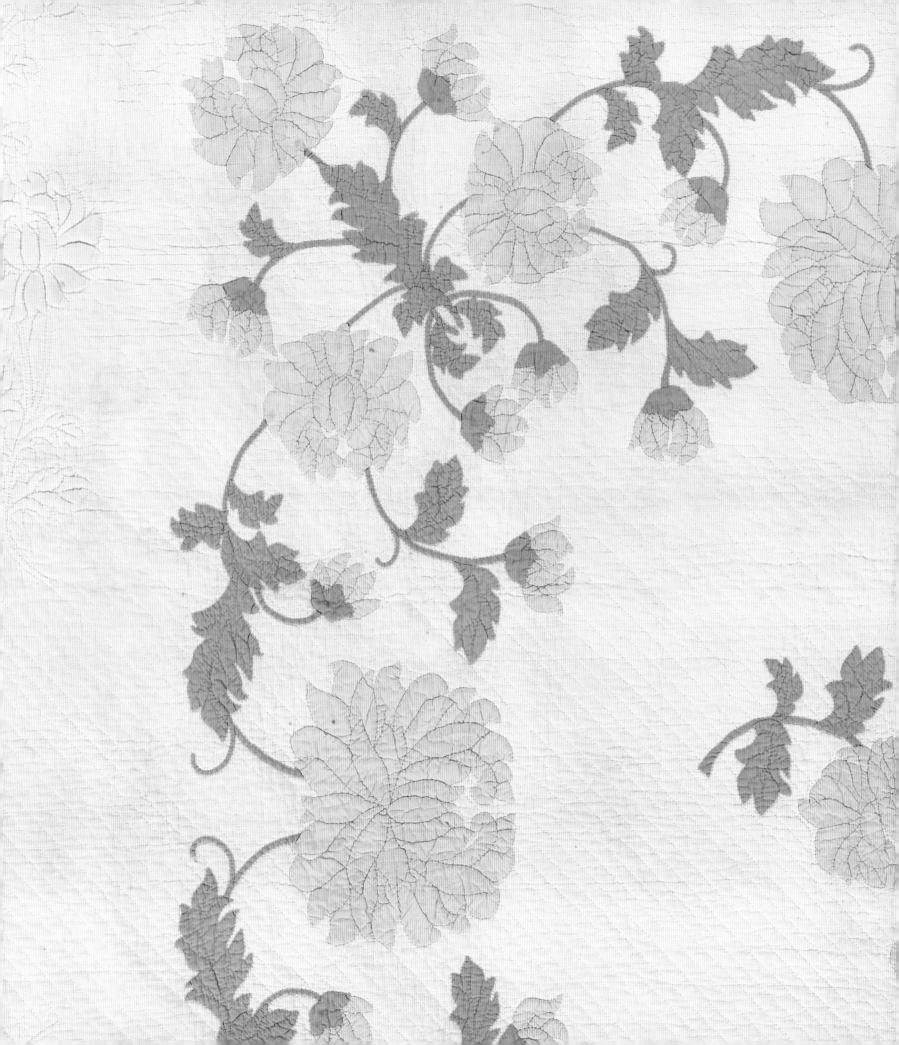

By 1936 or 1937, in addition to completing *Chrysanthemum*, Eisfeller finished at least four other quilts she had started in Hawaii, lectured frequently on Hawaiian quilts, and even tried making simple appliqué patterns. At the urging of friends, she also began entering quilt contests. Eisfeller won numerous awards, including prizes for four of her Hawaiian quilts at the 1936 New York State Fair held in Syracuse. She then gained national recognition in 1942 when she won three top prizes in the *Woman's Day* National Needlework Contest, including the Second Grand Award and the First Prize for Quilting for her quilt *White Magic*. Before she could accept her awards, however, the Eisfellers moved to Spokane, Washington. Tragically, some of her quilts, possibly as many as eighteen, were lost during shipment.[183]

Eisfeller drew inspiration for her famous quilt *The Garden* from an 1857 quilt pictured in black and white in Ruth Finley's *Old Patchwork Quilts and the Women Who Made Them* (1929). Finley attributed the earlier quilt, also called *The Garden*, to Arsinoe Kelsey Bowen (1812–1868) of Cortland, New York. Finley described Bowen's quilt as "appliquéd of many colors on white, liberty blue and shades of red and pink predominating," adding that "words can barely describe this triumph of the needle."[184] Eisfeller probably became acquainted with Finley's book and Bowen's masterpiece not long after her move to New York. Perhaps she even began her own version of *The Garden* in response to the author's lavish praise of Bowen and her quilt: "Not one woman in a thousand, though all them were ever so expert with a needle, could have accomplished, let alone conceived, anything approaching its beauty."[185]

To create *The Garden*, Eisfeller acquired a photograph of Bowen's quilt and then made a pattern from the photo. She planned her quilt to be different from the earlier version—more flowery and with less white space. Her work

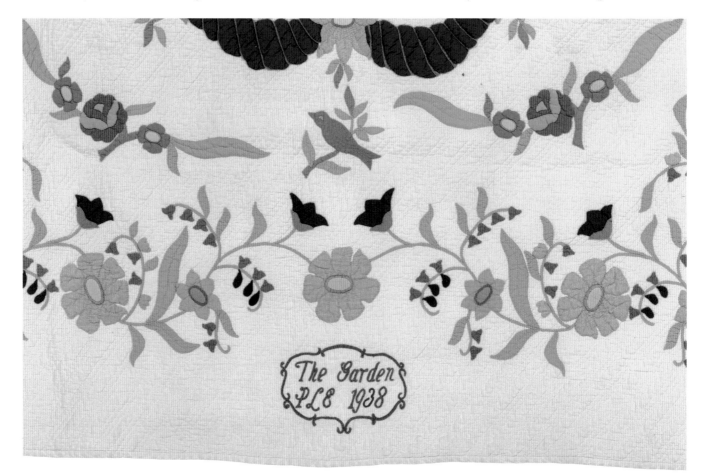

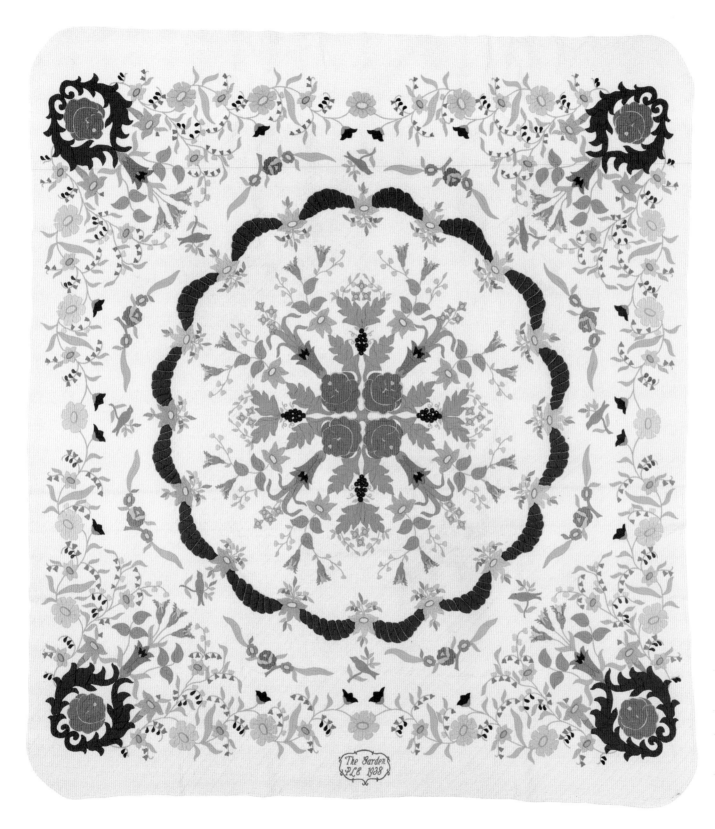

The Garden

Pine Eisfeller, Oswego,
New York, dated 1938

Cotton: 84 x 93 inches

Hand appliquéd,
hand quilted

Joyce Gross Quilt
History Collection,
W2h001.003.2008

required cutting thousands of small fabric pieces, which she kept in carefully marked envelopes.[186] By her own admission Eisfeller was particular about her fabric, thread, and batting choices, using a Sharps number 11 needle for appliquéing and a number 10 for quilting. She preferred cotton sheet batting with a glazed finish for her large quilts, and, for her quilt's background fabric, a "lovely broadcloth, [the] best your pocketbook affords." Eisfeller also liked to make her quilts "a generous size, with plenty to cover bed and pillows and to hang down." Eisfeller entered *The Garden* in the 1942 *Woman's Day* National Needlework Contest. The following year, *Woman's Day* advertised a modified version of Eisfeller's pattern, cautioning readers that the quilt would require great expertise and months of patient work to complete. The pattern was

Pine Eisfeller wearing a *Holoku*, the traditional Hawaiian native dress, and lei, New York, 1938. Eisfeller Scrapbook, Joyce Gross Quilt History Collection, 2008-013/Box 38.

republished at least twice, in *Nimble Needle Treasures* in 1971 and in *Quilters' Journal* in 1981.[187]

The Garden's elaborate pattern contains hundreds of delicate floral motifs—a rough count indicates that Eisfeller appliquéd about seven hundred different motifs in each quarter of her quilt. Her appliquéd inscription at the quilt's bottom, for example, contains twenty-five separate pieces. Eisfeller also used stuffed work to bring dimension to many of her motifs—the grapes, the garland, and the centers of flowers, for example. In all, she incorporated thirteen different solid colors, including two shades of blue, two greens, and two lavenders, plus pink, rose, purple, yellow, tan, peach, and deep red. The bulk of the colors are pastels, a favorite color palette in the 1930s and 1940s. Interestingly, motifs in the two blues, peach, and deep red appear only in or outside of the garland framing the medallion, not inside the medallion itself.

As with Bowen's 1857 quilt, Eisfeller appliquéd eight bluebirds (each with a yellow eye) perched on sprigs that circle the garland. She often layered her appliqué, including in the large roses and the centers of every open pink and peach flower. Eisfeller always appliquéd these centers in contrasting colors—yellow on tan, yellow on green, and green on lavender. *The Garden*'s appliqué is entirely made up of curves—there isn't a straight line anywhere on this quilt. Eisfeller's hand quilting, however, is straight and finely stitched at eleven to twelve stitches per inch in diagonal, triple parallel lines. The quilting runs across the quilt face, carefully stopping and restarting at each of the hundreds of floral motifs, large and small, wide and narrow.

The Garden's colors have faded, and some of the dimensional motifs (the grapes especially) are worn. Joyce Gross saw this quilt in Eisfeller's home as early as 1975 and took note of the quilt's condition. A few years later she concluded her 1981 *Quilters' Journal* biography of the quiltmaker with this description of her quilts: "Her . . . quilts are not as bright now as they were in those early magazine pictures. They haven't been exhibited much but they have been used and washed many times. And Smokey [Eisfeller's much-loved black cat] likes to sleep on them. They are quilts deserving of a place in a museum and more recognition from the quilt world."[188] In 1999, quilt experts named *The Garden* one of the one hundred best American quilts of the twentieth century.

TREE OF LIFE

One year after Eisfeller completed *The Garden*, she finished another appliquéd tour de force: *Tree of Life*. As with her earlier masterpiece, Eisfeller's inspiration for the quilt came from a black and white photograph of a textile published in an early quilt history text. The book was Marie Webster's *Quilts: Their Story and How to Make Them* (1915) and the textile was a seventeenth-century Persian quilted linen bath carpet owned by the South Kensington Museum (now the Victoria and Albert Museum) in London.[189] Webster's photo came from Alan S. Cole's article "Old Embroideries," which appeared in *Home Needlework Magazine* in January 1901. Cole titled the photo "Persian Quilted White Linen Bath Carpet, Embroidered with Colored Silks, a Specimen of the Work of the 17th Century Style." He described the textile as a typical Persian embroidery: "A linen prayer or bath carpet, the bordering or outer design of which partly takes the shape of the favorite Persian architectural niche filled in with . . . delicate scrolling stem ornament" and, beneath the niche, "a thickly blossoming shrub, laid out on a strictly formal or geometric plan, but nevertheless depicted with a fairly close approach to the actual appearance of bunches of blossoms and of leaves in nature." Cole also noted that the embroidery was a chain stitch in silks of white, green, and red, and that "before this embroidery was taken in hand the whole of the linen was minutely quilted."[190]

Working only from a copy of the black and white photograph in Webster's book, Eisfeller had no knowledge of the textile's dimensions or colors. Nonetheless, her version is remarkably faithful to the original in terms of pattern, though not in proportion, colors, and technique. Eisfeller's quilt is less rectangular than the bath carpet, with more open space between the shrub and the sides of the niche and less white space at top and bottom. But the pattern of the two textile objects is the same: a central blooming shrub set in an architectural niche that is framed with borders. The design particulars are also quite similar. For example, the center shrub in each textile is made up of thirteen floral clusters that spring from stems attached to the shrub's main stem. In both carpet and quilt, a canopy-like structure at the top of the architectural niche frames the top third of the shrub, and, at the shrub's base, fourteen leaves run horizontally, seven on each side of the stem. The Persian bath carpet has seven or eight blooms per cluster; Eisfeller's quilt has eight.

Eisfeller's *Tree of Life*, like *The Garden*, is a medley of appliquéd pastels, though this quilt introduces a strong forest green for many stems and leaves. Eisfeller used at least fourteen colors in this quilt, repeating many she used in *The Garden*, such as blue, lavender, pink, and peach. The quiltmaker uniformly ordered the blooms in each cluster. For example, a blue blossom is always at the cluster's apex, and two drooping blooms, always in faded rose red, round out the cluster at its bottom. Even the blossom's centers, each made of a smaller center appliquéd onto a larger center, are uniform throughout, with the blue flower at the cluster's peak always having a center of white on light blue and the peach bloom at the cluster center always sporting a green-on-rose red center.

For *Tree of Life*, Eisfeller reproduced the Persian carpet's middle border design almost exactly. It is a repeating scrolling stem with a single bloom at the center of each round and a scattering of buds along the scrollwork. Eisfeller's blooms are rose red with centers of peach on dark red, a dramatic contrast to the forest green and light green stems and leaves. She planned and executed her scrollwork so deftly that in each corner and at the bottom center the leaves, buds, and stems meet to create secondary patterns. Eisfeller, of course, made all her own narrow vining and scrolling stems, which range from a sixteenth to an eighth of an inch wide. Eisfeller's quilting, at thirteen to fourteen stitches per inch, includes single diagonal-line quilting in the center; the stitches do not cross the appliquéd designs. Outside the border, she used diagonal grid quilting, and inside the three borders, perhaps as a nod to the Hawaiian quilts she so loved, Eisfeller added contour quilting, quilting each border separately.

Tree of Life's colors have suffered some fading. The vividness of the rose red blooms in the middle border vary greatly, for example, and, possibly, the quilt became soiled from regular use, including by Eisfeller's beloved cat. In September 1981 the Textile Conservation Workshop in Winters, California, washed the quilt in a flat bath.[191] Gross may have been readying *Tree of Life* for its showing at the November 1981 exhibition of Eisfeller's quilts at the Shibui Art Gallery in Paradise, California. As with *The Garden*, Pine Eisfeller's *Tree of Life* was named one of the twentieth century's one hundred best American quilts.

This seventeenth-century
Persian quilted linen bath
carpet was the inspiration
for Pine Eisfeller's *Tree of Life*
(1939). The Persian carpet
was pictured in Marie D.
Webster, *Quilts: Their Story
and How to Make Them*
(1915). Webster's book
is a signed presentation
copy to Kansas quiltmaker
and historian Rose
Kretsinger, who glued extra
photographs of quilts into
the book and annotated the
images. Joyce Gross Quilt
History Collection.

PERSIAN QUILTED LINEN BATH CARPET
Seventeenth century

Tree of Life

Pine Eisfeller, Oswego,
New York, dated 1939

Cotton: 91 x 97¼ inches

Hand appliquéd,
hand quilted

Joyce Gross Quilt
History Collection,
W2h00l.005.2008

WHITE MAGIC

Woman's Day wrote the following about Pine Eisfeller in May 1943, after she won two major prizes for her *White Magic* in the 1942 National Needlework Contest sponsored by the magazine: "Perhaps more than any other form of needlework, quilting demands fine workmanship. It was a combination of careful stitching and beautiful design that won for Mrs. Robert Eisfeller of Spokane, Washington, the $300 Second Grand Award as well as the $100 first quilting prize in our needlework exhibition."[192]

As recipient of the competition's Second Grand Award, Eisfeller fell just behind Chicago quiltmaker Bertha Stenge and her *Victory Quilt*. In the quilting category, however, Eisfeller bested Stenge and Rose Kretsinger of Emporia, Kansas, to win top honors and the blue ribbon. The following year the magazine featured *White Magic* in its article "Prize-Winning Quilting." In it, Eisfeller described her award-winning quilting technique, "a great deal" of which, she reported, she did "freehand, and without conscious planning":

My quilts are laid out on the floor. I have sandbags or old electric irons for weights. The underside is put down first, wrong side up, and smoothed very carefully, then the cotton interlining and lastly the top. When these are satisfactorily arranged I press lightly with a warm iron. . . . I take off my shoes and sit in the middle of the quilt, and baste from the center to the four sides, then across on the quarters to make sixteen squares. Sometimes if I feel real ambitious, I baste diagonally from the half mark of each side to the one adjoining. Then I baste all around the edge. Sometimes when the quilting is very intricate I use a few pins as I am quilting. To quilt, I use good glazed thread about 32 inches long, run the thread an inch or so between the materials and take a back stitch for the first one on the wrong side and bring the needle up through to the right side. I pierce the material four times with the needle for one operation, in other words, take two running stitches. The underside must be eased along and not smoothed as the tendency is to do. With this method I have been able to make 28 stitches to the inch [on both sides].[193]

Eisfeller also quilted using a board on her lap, occasionally checking the width between her quilting lines with a small piece of cardboard pinned by a string to her dress.[194]

White Magic showcases Eisfeller's continued masterful command of needlework as expressed in quilts, and it brings to full flower her use of trapunto, a swag border, and exceptional hand quilting. The quilt's central medallion, a circle formed by a double ring of cording, measures just over thirty-five inches in diameter. It contains a single

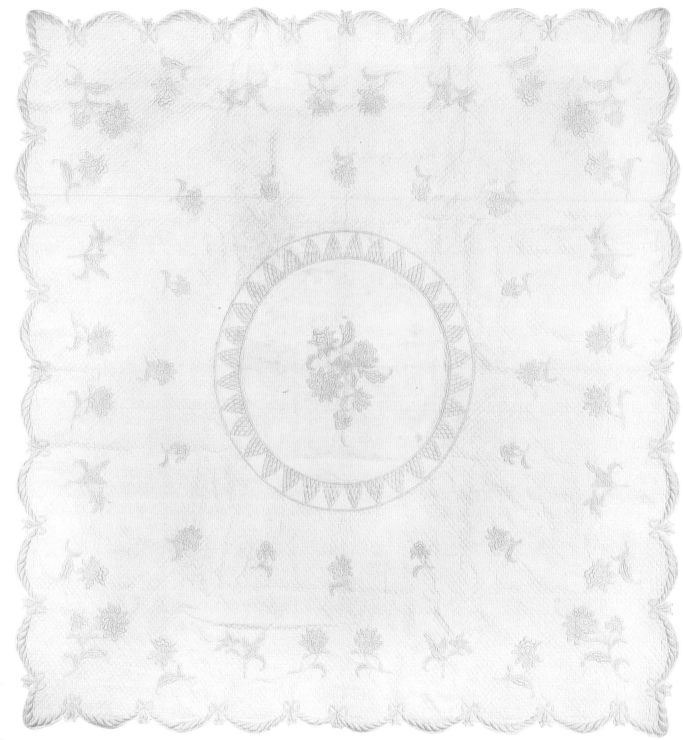

White Magic

Pine Eisfeller,
Schenectady, New York,
dated 1940

Cotton: 90 x 95 inches

Hand quilted, stuffed
work and cording

Joyce Gross Quilt
History Collection,
W2h001.004.2008

floral sprig. Contour quilting at thirteen to fourteen stitches per inch flows from the sprig to the medallion's doubling-ring frame. Between the rings are bowed half diamonds, each one containing smaller diamonds, all dimensional. The area between the medallion frame and swag edge contains two rows of stuffed-work designs. All are floral, with birds added to some in the outer row. As an elegant touch, Eisfeller created each design as a mirror image of the design on the opposite side.

She inscribed *White Magic* "PLE 1940" on the quilt's back center bottom with her handmade, narrow appliquéd bias strips. As always, her initials are in cursive. An intricate edge treatment gives *White Magic* a delightful sculptural shape. The stuffed garland of twisted ribbon, which gathers up bows every eight inches, is set off by handmade bias binding.

White Magic was not Eisfeller's first all-white quilt featuring trapunto. That status, it seems, goes to her *Victoria Bier*, which Eisfeller made sometime before 1937, when it won first prize in that year's New York State Fair. Little is known about this quilt's appearance save through a few photographs in Eisfeller's scrapbook, files in the Joyce Gross Quilt History Collection, and a photograph of the quilt, unnamed, in an article Eisfeller wrote for *The American Home*.[195] *Victoria Bier* is full of stuffed work and cording, including a medallion with a stuffed snowflake wreathed by eight apple-shaped motifs and an elaborate vining border and a filigreed motif in each corner. Whether Eisfeller's quilt was named for and resembled the drape over Queen Victoria's casket in 1901, said to be all white, remains to be discovered. Regrettably, it seems this quilt no longer exists. A typed note in Joyce Gross's files relating to Pine Eisfeller reads "In 19[blank] when jg visited her [Eisfeller] in Paradise [California] she had shown me the rest of her qlts [quilts] she brought this out. She was slightly embaressed [*sic*] as she evidently had washed it in too hot water and it had shrunk beyond recognition. I do not know what she did with it but her daughter has not seen it since she passed away."[196]

Joyce Gross loved Pine Eisfeller's *White Magic*, which she acquired in November 1992. Some years later she recalled seeing the quilt for the first time in the quiltmaker's home:

I was at her door, shaking her hand and we were both talking at once. It took awhile to get caught up on events. . . .

Then she ushered me into her bedroom. There on her bed was "White Magic"!! But there nestled on top with her head on [the] pillow was "Smokey" her cat. I gasped and she said calmly "He likes to sleep there." The beautiful "White Magic" was slightly grey, but Pine assured me she washed him [the cat] frequently. When I recovered she brought out the rest of the quilts as I "ohed" and "ahed." Never did I expect to own one of these fabulous quilts! I love to share them.[197]

After 1945, Eisfeller and her husband moved to California, though in 1953 Robert Eisfeller moved to Spain and never returned. Pine Eisfeller remained active in the quilt community through the end of the 1940s. In March 1945, for example, she wrote "Heirlooms for Tomorrow" for *The American Home* magazine, and in 1948 and 1949 she received awards for the quilts she entered in the California State Fair. Although Eisfeller seems to have vanished from the public quiltmaking scene during the 1950s and 1960s, she enjoyed at least one heady moment of public recogni-

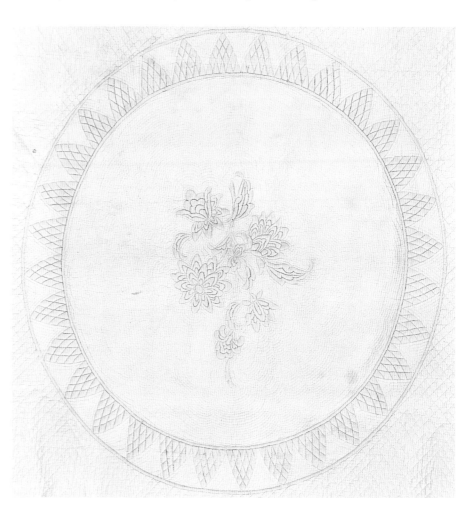

PARADISE POST FRIDAY, OCT. 23, 1981 B — 1

Skylife

This Hobby Kept Her In ...

STITCHES

Not everyone has a candy box full of blue ribbons

Quilting's out but Pine Eisfeller can still do intricate bead designs

Quilter's signature adds value as well as style

Pine Eisfeller and prize-winning Hawaiian quilt

the quilting world lots to admire. Her Hawaiian-style quilts received blue ribbons wherever they were shown and in 1942 she took a first prize in the quilting class of the

the ridge just for the show.

"Oh, I'll just go and see what happens," she says with characteristic modesty. "It should be fun."

For most people, viewing quilts such as Eisfeller's is a completely new experience. Many are familiar with quilts in which multi-colored squares and triangles of material

quilts, Eisfeller says she found them "truly beautiful and different."

That's when she decided to give them a try.

"I'd seen a lot of quilts that people were making and they were just lousy," says Eisfeller. "People thought I couldn't make a good quilt because I was left-handed, so I decided to make a Hawaiian quilt just to show them.

"That's how you can get me to

tion in July 1968 when California Governor Ronald Reagan accepted her handmade replica of the California State Seal. According to press reports, Eisfeller worked thirteen months to create the seal, which contained more than eighty-seven thousand beads.[198]

Eisfeller made her last quilt, a Hawaiian quilt, in 1974. In November 1981 Gross helped publicize the quiltmaker and her extraordinary quilts by publishing a brief, separate biography of her through the *Quilters' Journal* and then reprinting portions of the biography in the Winter 1981 issue of *QJ*. That year Gross also helped sponsor an exhibition of Eisfeller's quilts at the Shibui Art Gallery in Paradise, California. Eisfeller enjoyed the exhibit tremendously. As Gross recalled, "We hung all her quilts, her daughter played the organ and we all danced, including jitterbugging Pine. It was the first time she had ever seen her quilts hung and she was pleased with the way they looked. Her family was there and the local newspaper gave her [a] front-page spread. Everyone told her how wonderful her work looked."[199]

Pine Eisfeller died in 1990 at age ninety-six. Two years later, in 1992 and 1993, Joyce was able to purchase five of Pine's quilts from Dorothy Patterson, Pine's daughter. In 1999 the Ultimate Quilt Search helped ensure Eisfeller's reputation when it named *The Garden* and *Tree of Life* among the one hundred best American quilts of the twentieth century.

"This Hobby Kept Her in Stitches," *Paradise* (Calif.) *Post*, October 23, 1981, Joyce Gross Quilt History Collection 2008-013/147.

Blue ribbon awarded to *White Magic* in the *Woman's Day* National Needlework Contest, 1942. Joyce Gross Quilt History Collection, 2008-013/147.

Eisfeller presenting her replica of the California state seal to Gov. Ronald Reagan, July 1968. State of California press release, copy in Joyce Gross Quilt History Collection, 2008-013/147.

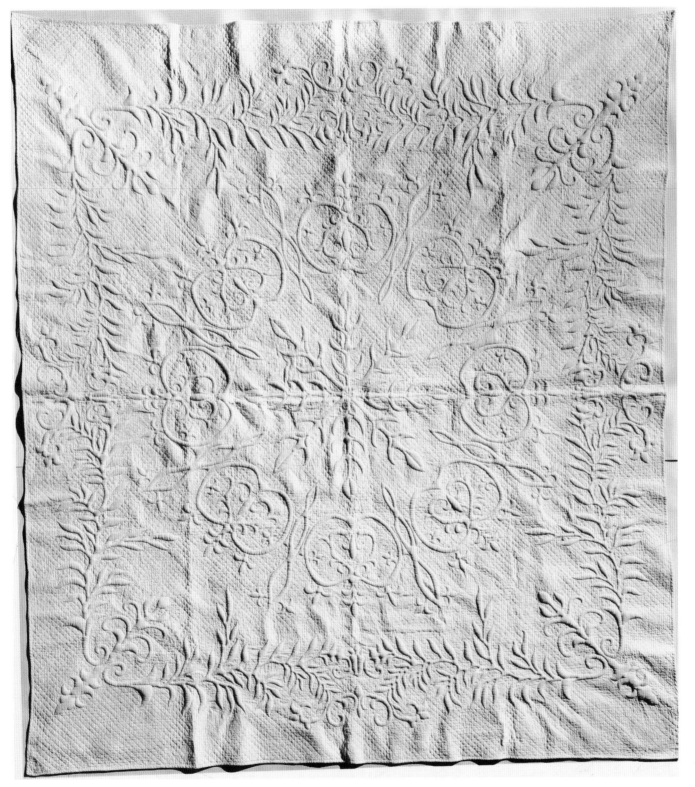

Photograph of Pine
Eisfeller's *Victoria Bier* quilt,
circa 1936. Joyce Gross
Quilt History Collection,
2008-013/147.

This remarkable quilt is an example of what one Texas quiltmaker was able to create using small cotton sacks during the hard times of the 1930s. Effie Roe (ca. 1887–?) collected and stitched together 576 cotton tobacco pouches to make her unique *Tobacco Sack Puff Quilt*. Roe grew up on farms in Bastrop and, possibly, in Kimble and Taylor, Texas, one of eight children of William and Della Roe. Her whereabouts after 1910 are unknown, though family history indicates she never married.[200]

To create this quilt, Roe used sacks measuring about 2½ × 3½ inches. She took each one apart (including removing the top's drawstring), washed them, home-dyed them in shades of brown, blue, gold, and green, stuffed each one with cotton, and then sewed them closed. Roe whipstitched the sacks together end to end across the width of the quilt (sixteen sacks across, thirty-six sacks top to bottom) in no apparent order with respect to color.

The quilt's back is simply the other side of the tobacco sacks.

Effie Roe probably used Bull Durham brand tobacco sacks to make her quilt. The production of these small muslin sacks for loose smoking tobacco is part of the colorful history of Bull Durham Tobacco, owned by W. T. Blackwell & Company of Durham, North Carolina. Initially these tobacco sacks were cut and sewn by independent bag-makers, mainly women working out of their homes in Durham and area communities. Demand outpaced production, however, giving rise in 1885 to a machine that could produce between ten and fifteen thousand bags a day. By 1887 the Golden Belt Manufacturing Company was operating in the Bull Durham Tobacco Factory, its machines churning out two million tobacco bags each month. Within five years Golden Belt's factory began producing bags in different sizes and to store other consumables, including salt.[201]

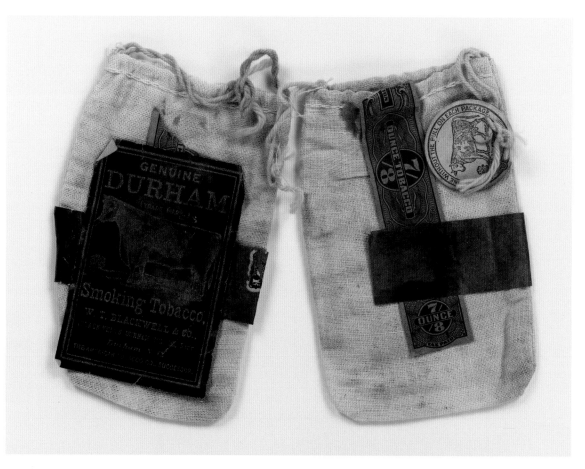

Bull Durham tobacco sacks. Kathleen McCrady Quilt History Collection, 2006/074-2.

**Tobacco Sack
Puff Quilt**

Effie Roe, possibly
Kerrville, Kerr County,
Texas, circa 1930s

Cotton: 56 x 81 inches

Hand pieced

Kathleen McCrady
Quilt History Collection,
W2h89.06

What inspired an unknown quiltmaker in the late 1930s or early 1940s to combine into one original pattern the three designs that dominate this quilt: the large initials "WPA"; ten identical structures that suggest specific buildings; and an equal number of Colonial Ladies, a design offered in quilt patterns and kits by the early 1930s? Information on the quilt's provenance is sparse and does not clarify the maker's purpose. The quilt possibly was made in the Midwest by a Mrs. Starr—the donors confirm this surname, and it is printed on the quilt's back, perhaps as a laundry mark. Mrs. Starr's daughter inherited the quilt, and at some point both daughter and quilt came to north-central Texas, where she married. Not long after her death in 1989, the quilt seemed destined to pad furniture during the widower's impending move. It was saved, however, when he offered the quilt to friends—the donors—on hand to assist with the move.[202]

The *WPA Quilt* alternates three different patterns with twenty-four solid white blocks, each one containing center and corner patches. The beefy crossed initials are the undisputed focus of this quilt. They are ringed by the two unrelated patterns—ten well-articulated structures, possibly cabins, and ten Colonial Ladies, whose apparel introduces a cheery printed fabric that perfectly complements the medium-blue fabric used elsewhere. Hand quilting in the outline pattern helps define the hand-pieced elements.

The initials refer to the Works Progress Administration (1935–1943), the ambitious New Deal agency whose goal was to provide paid employment for people on relief. WPA projects, which were coordinated with state and local governments, included construction projects, such as schools, libraries, roads, bridges, amphitheaters, and park facilities. Because WPA state park construction efforts included building cabins, the structures on this quilt may represent WPA-era cabins in a specific state park. Their uniformity and detail (windows, a porch, steps, and chim-

neys) suggest that Mrs. Starr was representing actual structures. The embroidered number on each cabin—always 2490, followed by a different letter—reinforces this idea. The significance of these embroidered numbers remains a mystery. The number may identify a specific construction crew or project. Perhaps this is a commemorative quilt, one intended to mark a husband, brother, or son's participation in an important parks project undertaken by the WPA.

The ten Colonial Ladies are a curious addition to this quilt's pattern. Why did the quiltmaker pair two such disparate patterns: cabins and ladies in fancy dresses? Perhaps the pairing simply sprang from the maker's well-developed desire to follow her personal fancy. The quiltmaker constructed each lady from nine pieced motifs that are appliquéd onto blocks and completed with embroidered feet, arms, neck, and parasol handle. This is surely the quiltmaker's own version of this popular pattern—the pieces are simple and the embroidery minimal. More elaborate interpretations of this pattern include greater detail, such as flowers on the bonnet, ruffles along the dress edge, and additional defining embroidery. Note that in this version each lady's arms hang stiffly at her sides. What, then, supports her fancy parasol?

The Works Progress Administration included women's programs, many of which offered jobs consistent with the traditional roles of homemakers, such as food distribution, housekeeping, childcare assistance, and sewing. WPA "sewing rooms" seem to have existed all over the country. Although there is documentation of quiltmaking in some, much of the sewing seems to have been directed toward making new garments and repairing used ones. In Fort Worth, for example, seamstresses claimed that the initials "WPA" stood for "We Patch Anything." There is no evidence that Mrs. Starr made her quilt as part of a WPA program.[203]

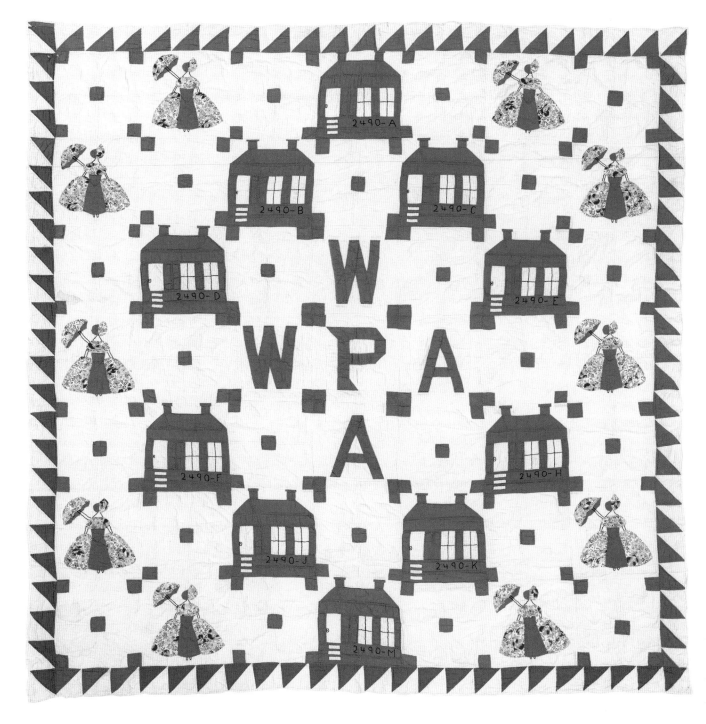

WPA Quilt

Mrs. Starr, circa
1936–1945

Cotton: 81 x 79 inches

Hand and machine
pieced, hand appliquéd,
hand quilted

2011-178

Gift of Donna and
Joe David Miller

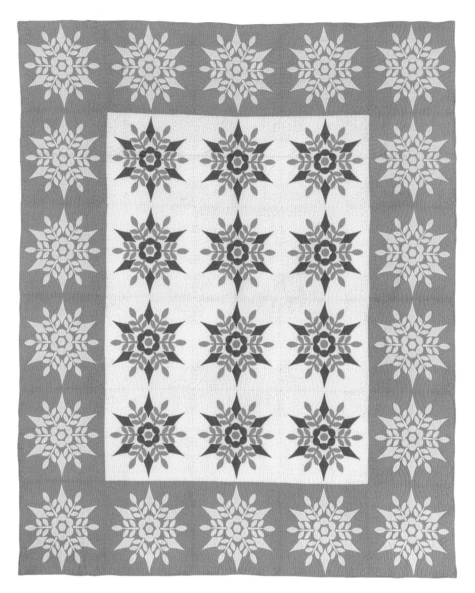

Snowflake

Maker unknown,
probably Texas,
circa 1937–1940

Cotton: 81 x 99 inches

Machine pieced, hand
appliquéd, hand quilted

Joyce Gross Quilt
History Collection,
W2h001.066.2008

In 2002, quilt collector Joyce Gross was offered five quilts made by a Texas quiltmaker in the 1930s and 1940s, each one from a commercial quilt kit. By then Gross had stopped actively collecting; nonetheless, she found this offer tempting. As she later recalled, "As I thought about the group, I remembered my favorite motto, 'It is never the quilt you buy that you will regret, it is the one you don't buy,' and so I bought all five. After all, how often does one get the chance to buy five quilts made by the same quilt maker?"[204]

Three of these five quilts are shown here. The two others are *Trapunto Flower Basket*, made with Bucilla kit no. 1732, and *Spring Flowers* (Gross's name for the quilt), probably made using a Homeneedle Craft Creations kit, available around 1935. The five quilts show little wear and appear unwashed, suggesting that the Texas quiltmaker was more dedicated to the process of quiltmaking than she was motivated by the need for bedcovers.

Together the five quilts help document the floral patterns, pastel colors, and quilt designs that commercial kits offered by the 1920s and 1930s, a time when the mass media and marketing were altering the making of quilts. Patterns, traditionally passed down within a family or exchanged among friends, were, by the 1920s and 1930s, widely available commercially in newspapers, women's magazines, catalogs, and as mail-order quilt kits from companies such as Progress, Paragon, and Bucilla, all of which offered full instructions and fabrics premarked for cutting, stitching, and quilting. *Snowflake*, for example, was made using Paragon Quilt no. 01001 Snowflake Block Design, published in 1937 by the Paragon Pattern Company of New York. The kit sold for $6.95 and included thread, blue and white cotton fabrics marked for appliqué and quilting, and instructions. Gross was familiar with this pattern, which Kansas quiltmaker Charlotte Jane Whitehall had used in 1940 to make her well-known *Snowflake Quilt* housed at the Denver Museum of Art. Gross also had seen the actual quilt kit, reporting on its "discovery" in her *Quilters' Journal* in November 1986. By 2002 Gross was delighted to acquire a *Snowflake* quilt of her own, noting, "This quilt has been a favorite, which goes to prove that all blue quilts are good quilts!"[205]

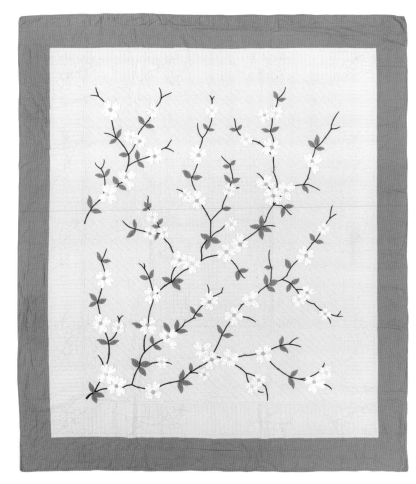
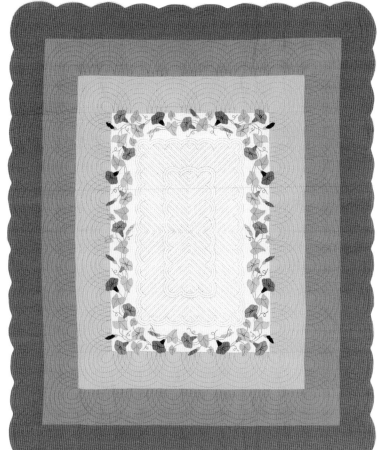

Dogwood was made from Paragon Kit no. 01090. There is considerable appliqué in this quilt—more than fifty-five dogwood blooms inside the border, all on branches that spray up and out from the lower left corner. The quiltmaker carefully executed the detail that the kit calls for: the cluster of yellow French knots at the center of each bloom, gray embroidery that defines each petal, and pink stitching that creates each petal's characteristic notch. Fourteen quilted dogwood sprays march around the kit's original border. This quilt's dark green border was not part of the kit pattern and may have been added at a later date.

The last of the five quilts Joyce purchased was called *Shades of Orange*. She called it "a show stopper!" and noted that its "three shades of orange flowers . . . made me know I had to have it!"[206] The quilt was made using a 1938 kit named Bucilla Appliqué Bedspread Quilt "Morning Glory" Design no. 2005. The kit was available in orange and green versions.[207] It required five pattern shapes, two for the flowers and one each for buds, sepals, and leaves, plus three shades of orange, two greens, and one rich chocolate brown for the flower base. Embroidered vines and interior lines in the blooms and at the flower base add graceful movement and help define the flowers. Three orange borders that gradate from the soft cream center to the near-electric orange outer border heighten the drama achieved by the complex morning glories. Brown thread helps highlight the graduated hand quilted arcs in each border and the double scalloped medallion with diagonal quilting.

Dogwood

Maker unknown, probably Texas, circa 1940

Cotton: 92½ x 104 inches

Machine pieced, hand appliquéd, embroidered, hand quilted

Joyce Gross Quilt History Collection, W2h001.068.2008

Shades of Orange

Maker unknown, probably Texas, circa 1940

Cotton: 78 x 93½ inches

Machine pieced, hand appliquéd, embroidered, hand quilted

Joyce Gross Quilt History Collection, W2h001.067.2008

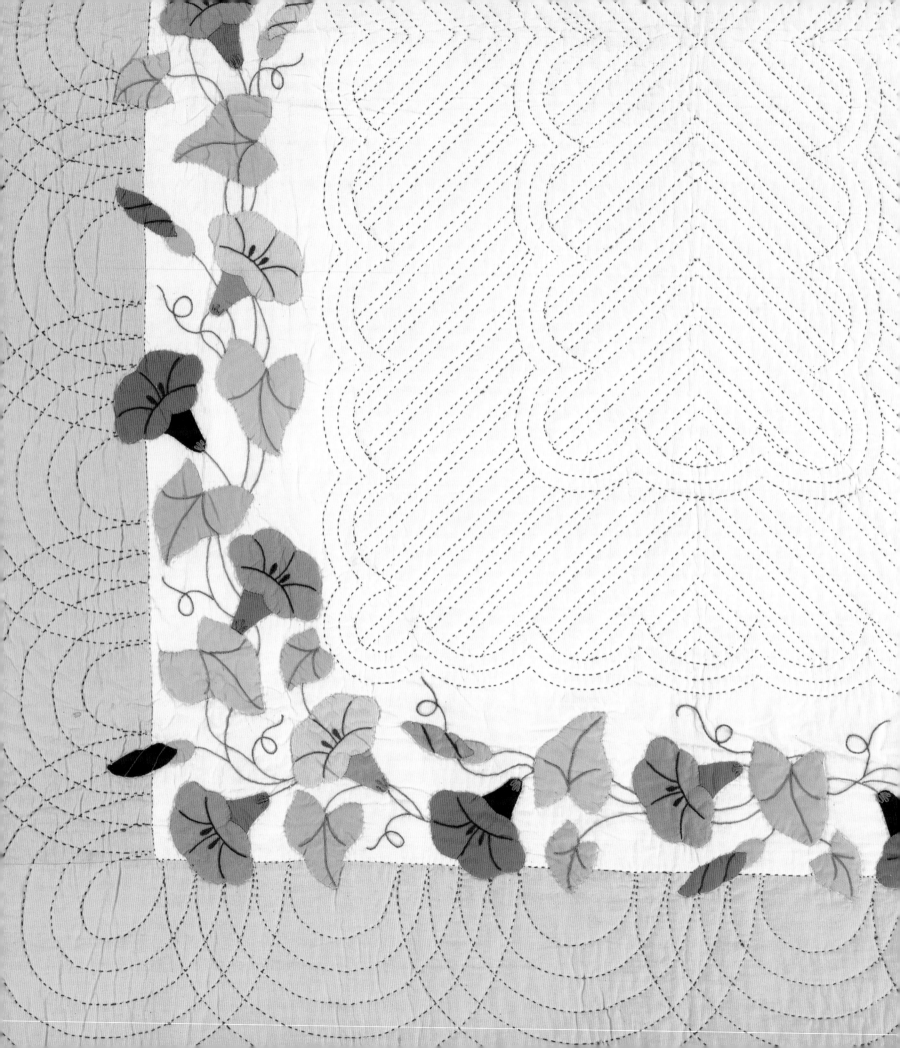

Little Brown Koko doll, 2014-109, left, and Blanche Seale Hunt, *Stories of Little Brown Koko* (Chicago: American Colortype Company, 1953).

In her 1983 article in *Uncoverings*, quilt historian Cuesta Benberry traced the changes in white perceptions of African Americans in quilts and related media. Benberry focused on "white-made quilts that have black people as the prime subject matter," because they "offer a visible form of white people's perceptions of blacks."[208] Powerful examples of these quilts from the late 1930s and 1940s are the ones based on several Little Brown Koko books and additional stories appearing monthly for many years in the *Household Magazine*, published in Topeka, Kansas, by Capper's Publications. These quilts depict episodes in the life of an African American boy and his family and friends. As with the published stories and illustrations, the related quilt designs present racial stereotypes not unlike images from blackface minstrel shows. In the 1930s and 1940s the books and stories simply affirmed views and beliefs held by many white Americans. Some quiltmakers also found these depictions familiar and acceptable.[209]

Children's book author Blanche Seale Hunt (1912–1973), an Oklahoma schoolteacher who began writing for publication in 1935, enjoyed huge success for her Little Brown Koko books and stories, reportedly selling some six hundred thousand copies of her books.[210] Hunt described Koko as "the shortest, fattest little Negro you could ever imagine. He had the blackest, little wooly head and great, big, round eyes, and he was the prettiest brown color, just like a bar of chocolate candy."[211] Little Koko regularly got in and out of trouble: losing his school books, eating a whole cake, neglecting his chores, breaking plates, and so forth, usually because of his preoccupation with food. The illustrations, an essential part of the Little Brown Koko stories, were the work of Dorothy Wagstaff, who also illustrated the popular children's magazine *Wee Wisdom: A Magazine for Boys and Girls*. A circa 1940 advertisement for Little Brown Koko as "an ideal Christmas gift for kiddies" described Wagstaff as "an illustrator with the rare ability to give the child a stimulating picture from which his imagination may travel its own delightful paths."[212]

Hunt's books, stories, and fictional characters (especially Koko and his dog Shoog) were widely marketed. Around 1940, for example, one dollar and a magazine coupon could buy one Little Brown Koko book and an eighteen-month subscription to the *Household Magazine* with its monthly Little Brown Koko stories. The characters also were reproduced as dolls, puzzles, lawn ornaments, planter boxes, a coloring book, and even as a mail-order bank full of chocolate bars called the "Little Brown Koko Thrift Bank."[213]

Little Brown Koko characters also were reproduced as transfer patterns for quilts through Aunt Martha's Hot Iron Transfers sold by Colonial Patterns Inc. of Kansas City, Missouri. The transfers are faithful, if slightly modified, reproductions of the published illustrations. This *Little Brown Koko* quilt contains twelve blocks, whose pictorial depictions were based on Numo Hot Iron Transfers no. C9040. The packet contained three transfers to a sheet and included instructions for embroidery, background, sashing, and border colors.[214] This quilt is backed with a juvenile circus print. As per the instructions, it was hand quilted with diagonal lines.

Quilt donor Mary Anne Pickens has fond memories of her grandmother reading Little Brown Koko stories to her "as we rocked in her favorite chair on the front porch of her 1840s log home. She would read all about Little Brown Koko, his dog Shoog, his little girl friend Snooky, and his wonderfully wise Mammy. I loved the stories and always looked forward to the next time one would appear" in the *Household Magazine*. When she was eight years old, the donor's grandmother gave her a collection of Little Brown Koko stories and, about that time, the Little Brown Koko ragdoll, shown on page 239. Years later, Mary Anne's mother acquired this quilt.[215]

Little Brown Koko

Maker unknown,
circa 1938–1945

Cotton: 32 x 41 inches

Hand pieced,
hand quilted, hand
embroidered

2011-038

Gift of Mary Anne
Pickens

Little is known of the provenance of this quilt. Austin quilt-maker and historian Kathleen McCrady purchased it from an antiques store in Lockhart, Texas, in 1992. The dealer explained that the quilt had come from the home of Molly Laramore, a quiltmaker who, by 1992, was living in a nursing home. The dealer also owned a framed photograph of Molly and her sister and allowed Mrs. McCrady to take a photo of it. The image probably dates from around 1920 and shows two African American girls. Molly, to whom this quilt is attributed, is on the right.

In her book *Quilts: Their Story and How to Make Them* (1915), influential quilt designer Marie Webster described how making a slight alteration in a common pattern often resulted in a corresponding change to the pattern name. She cited several examples, including the effect of a minor change in the Nine Patch pattern when the center block is cut larger and the four corner blocks are reduced in size. "This slight change," Webster wrote, "is in reality a magical transformation," one that turns the "staid" Nine Patch pattern into a "lively" Puss in the Corner.[216]

Molly Laramore (ca. 1905–1993) created her *Puss in the Corner* using twenty nine-patch blocks, each set on point and made in the Counterpane pattern, which features a large center square (in red) framed by four small corner squares (in red) with rectangular patches (in white) between. The nine-patch blocks alternate with twelve blocks in solid white. Repeating the red and white nine-patch block in the Counterpane pattern creates a deceptively intricate inner border that adds great interest to this quilt. No longer set on point and now separated by a slim strip in a red-white-red sequence, these nine-patch blocks look fencepost-like: upright and regularly spaced. Indeed, it takes close study to isolate the Counterpane nine patch from yet another nine-patch block in the border—one formed by neighboring sides of two Counterpane blocks plus the slim red-white-red strip between them. The quilt-maker seemingly made no attempt to accurately merge the patterns in the border corners in order to turn the corners gracefully. Indeed, Counterpane patterns on opposite sides rarely match up. Laramore's method for constructing and adding the inner border seems to have been simply to create lengths of the pieced pattern, attaching the top and bottom lengths first. The side lengths followed, overlaying (or being pieced to, in the lower left corner) whatever design they met at the corners.

The Laramore sisters, circa 1920. The quiltmaker is on the right. *Puss in the Corner* quilt file, Kathleen McCrady Quilt History Collection, 2011-380-2.

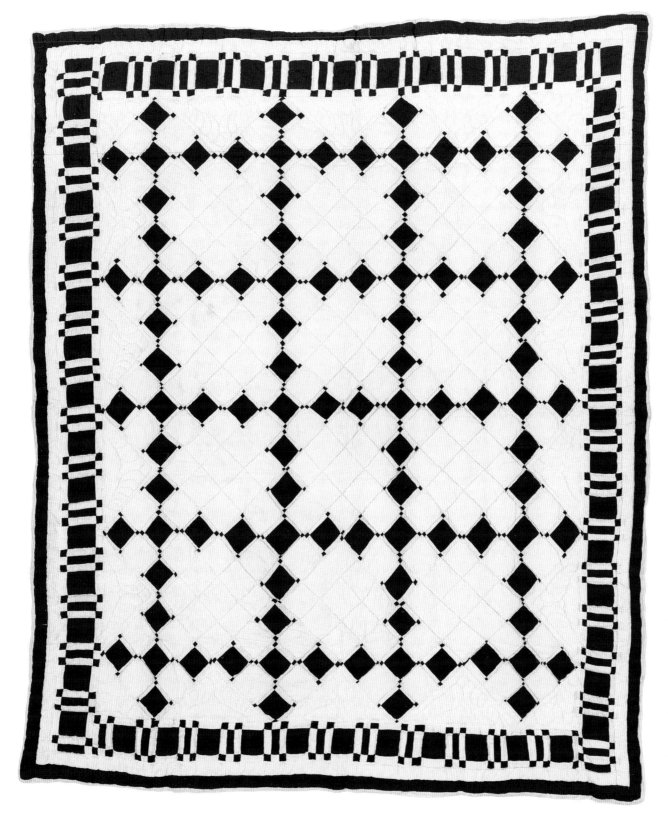

Puss in the Corner

Attributed to Molly
Laramore, probably
Lockhart, Texas,
circa 1940

Cotton: 68 x 81 inches

Hand and machine
pieced, hand quilted

Kathleen McCrady
Quilt History Collection,
2011-380-2

Quiltmakers often use simple geometric shapes to create overall patterns. In this example, Leota Lillian Deardorff Johnson (1898–1985) used a single shape, the triangle, repeating it and alternating light- and dark-colored fabrics to achieve vertical lines that seem to shift and pulsate.

Lillian Johnson began quilting in the 1930s and made many quilts for friends. As an economy measure, she often used fabric scraps, including floral prints sent by her brother from California. Lillian also recycled cotton sack fabrics, incorporating them in her *Streak of Lightning* quilt. She carefully planned, cut, and pieced her quilt, often piecing two, even three scraps to create a single triangle. Johnson also matched or coordinated the fabrics in each pair of opposing triangles and alternated the pairs from light to dark vertically. The quilt is hand pieced and hand quilted, with quilting one-quarter inch on either side of the seam at eight stitches per inch.

Lillian married Charles Herman Johnson (1889–1977), a fiddler and a farmer, in 1920. The couple raised two sons and spent their entire married lives in rural Bachelor, Calloway County, Missouri, which is now a ghost town. Following Lillian's death in 1985, many of her possessions were sold in an estate sale. Alma Smoot, possibly the quiltmaker's aunt, was eager, but unable, to attend the sale, and so dispatched a niece with enough money to purchase Johnson's *Streak of Lightning*. Quilt collector Sherry Cook acquired the quilt from Alma Smoot.

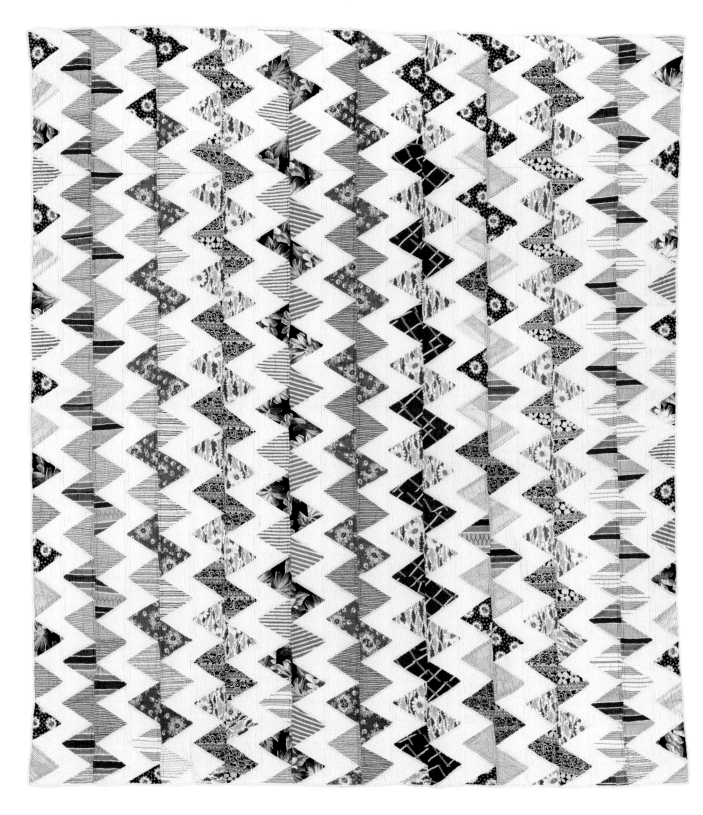

Streak of Lightning

Leota Lillian Deardorff
Johnson, Bachelor,
Calloway County,
Missouri, circa 1940s

Cotton: 70 x 78 inches

Hand pieced,
hand quilted

Sherry Cook Quilt
Collection, 2010-296-6

MODERNISTIC STAR &
NINE PATCH DOLL QUILT

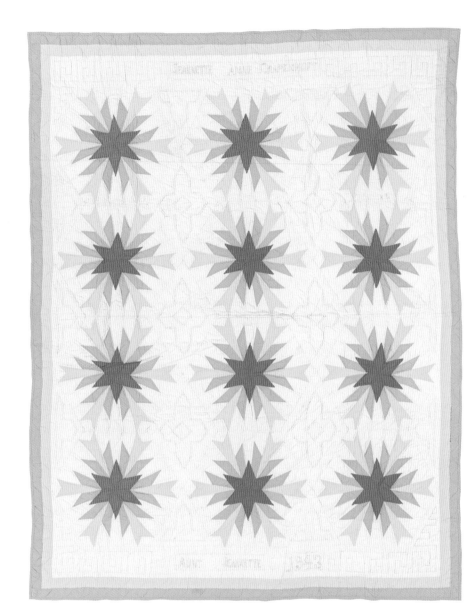

Dr. Jeannette Throckmorton (1883–1963) came from a family of physicians and may have become a doctor at the insistence of her father. She practiced medicine from 1907 to 1919, worked for the US Public Health Service, and from 1929 until her death served as medical librarian for the Iowa State Medical Library. Throckmorton suffered twin tragedies in her life: deafness beginning in her mid-thirties and her husband's death just days after their marriage in 1928.[217] In 1975 quiltmaker Maxine Teele remarked on Throckmorton's special grace in the face of tragedy and handicaps, calling her fellow Iowan "a woman's libber in the very best sense," noting that "she faced life with zest, optimism, and a complete lack of bitterness. Her accomplishments are remarkable today. When we take into consideration the era in which she was born, they are monumental."[218]

Exceptional quilts are among Throckmorton's most enduring accomplishments. She began quilting in 1907, the same year she passed the Iowa State Medical Board examination. She probably made as many as fifty-five to sixty quilts by the time of her death in 1963. Dr. Jeannette, as friends often called her, gave many away, her family owned several, and she donated five to the Art Institute of Chicago. One of the five, a *Feathered Star* quilt, was lost when the Art Institute loaned it and it was never returned.[219] *Modernistic Star* and *Nine Patch Doll Quilt* date from the years the quiltmaker worked at the Iowa State Medical Library in Des Moines. Joyce Gross acquired *Modernistic Star* from Throckmorton's niece Jean Martin, who owned the quilt at least until 1979. Gross did not record the date she purchased this quilt.

Modernistic Star

Dr. Jeannette Dean Throckmorton, Des Moines, Iowa, dated 1943

Cotton: 65 x 82 inches

Hand pieced, stuffed work, hand quilted

Joyce Gross Quilt History Collection, W2h001.014.2008

Throckmorton based *Modernistic Star* on a pattern designed by a Nebraska quiltmaker who won a quilt contest sponsored by Aunt Martha Studios of Kansas City, probably in 1930. The pattern was available in *Prize Winning Designs*, a booklet sold by the Modern Woodman, a fraternal life insurance society located in Rock Island, Illinois. The society's magazine, also named *The Modern Woodman*, regularly contained information and advertisements about quilts.[220] The booklet's description of the Modernistic Star pattern announced that the original design "typifies all that is lovely in today's trend in line and color, yet carries us back to the tranquil atmosphere of yesteryear."[221] Throckmorton followed the published pattern, cutting several sets of homemade templates from paper or cardboard.[222] She hand pieced twelve hexagonal star blocks using Nile green and bright yellow solid fabrics, topping them with pieced six-pointed stars in peach, which she appliquéd on. From there she deviated from the published pattern, joining the blocks with diamonds instead of triangles; setting her stars side by side instead of staggering them, thereby eliminating the pattern's multiple borders in favor of one yellow and one green border; and adding a wide band across the quilt top and bottom onto which she added inscriptions flanked by a Greek Key quilting design. The two inscriptions read "Aunt Jeannette 1943" at the bottom and "Jeannette Anne Crapenhoft" at the quilt top. This latter inscription probably refers to one of Throckmorton's friends, rather than to a relative.

Throckmorton also used cording to add dimension to *Modernistic Star*. The two inscriptions and the outlines framing them are corded, as are the three different geometric designs she incorporated into the diamonds that separate the stars and the triangles bordering them. Throckmorton's hand quilting, at eight to nine stitches per inch, is outline quilting, except in the top and bottom bands, where she introduced the Greek Key design. Pencil markings for the quilting remain visible.

She regularly annotated pattern booklets, and her copy of *Prize Winning Designs* is no exception. Her pencil notes next to the Modernistic Star pattern state "made one. attractive" and indicate that she considered a number of color combinations for this quilt: pink, orchid, and green; blue, orange, and green; yellow, orange, and green; and, her ultimate selection, "peach, yellow—bright, and green—medium."[223]

Throckmorton's *Nine Patch Doll Quilt* is small, tidy, beautifully hand pieced, and inscribed. She probably

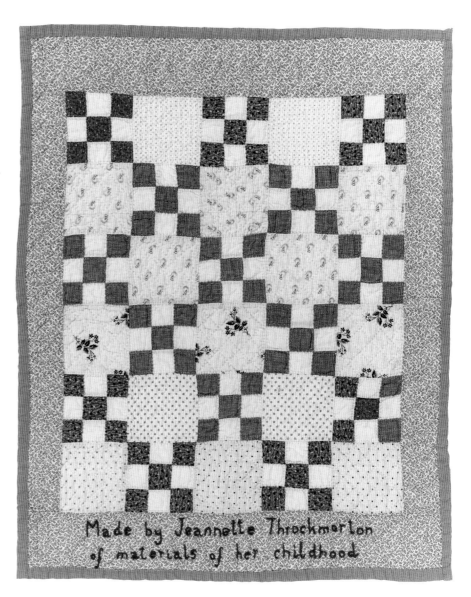

started the small quilt years before she edged it with a 1950s hot pink binding. A bright pink embroidered inscription on the quilt front reading "Made by Jeannette Throckmorton of materials of her childhood" dates the fabrics from about 1888, when she was five years old, to 1900, the year Throckmorton turned seventeen. The fabrics probably came from worn family clothing. They include shirtings, a red chambray, double pinks, and one conversation print—all fabrics readily available in the late nineteenth century. The hot pink binding is from a later era, however, and the irregularity of the stitches attaching the binding supports the idea that Dr. Throckmorton finished the doll quilt late in her life, when her eyesight was poor. The hand quilting, at eight to nine stitches per inch, is a grid pattern in the plain blocks and outline quilting in the nine-patch blocks.

Nine Patch Doll Quilt

Dr. Jeannette Dean Throckmorton, Des Moines, Iowa, ca. 1950s

Cotton: 16½ x 20 inches

Hand pieced, hand quilted, embroidered

Joyce Gross Quilt History Collection, W2h001.015.2008

Prize Winning Designs, cover, circa 1931, and patterns for the *Modernistic Star* quilt, in *Prize Winning Designs*. Joyce Gross Quilt History Collection, 2008-013/164.

Joyce Gross already owned Jeannette Throckmorton's *Modernistic Star* by the time she saw *Nine Patch Doll Quilt* for sale at the New York Festival of Quilts in 1991. Connecticut antiques dealer Martha Jackson had the quilt displayed on a circa 1920 doll bed when Gross spied it. "The embroidered name of Jeannette Throckmorton leapt out at me," Gross later recalled, adding that when she heard the quilt's price she "was slightly overwhelmed." Since she already owned one Throckmorton quilt, Gross decided to pass up the doll quilt. But she was uneasy with this decision. "I didn't tell my fellow quilters about it. I guess I was afraid someone else would buy it. The next morning . . . I knew I had to have that quilt! I grabbed a cab, rushed to the festival and as soon as the doors opened, I rushed to the booth. The quilt was still there which surely was a sign it was meant for me!"[224] Some months later, a friend sent Martha Jackson an article Gross had written about Jeannette Throckmorton, possibly a copy of Gross's 1979 article in *Quilters' Journal*. Jackson found the article fascinating but also, she wrote, "so sad in many ways." She noted that "I have to feel her [Throckmorton's] quilting brought her peace as she struggled with a career and life that was very 'male' dominated." Jackson nonetheless was pleased with the disposition of the *Nine Patch Doll Quilt*, explaining that by selling the quilt to Joyce Gross, "I feel that the quilt is really with the right person and that makes me happy."[225]

Dr. Jeannette Throckmorton
on her wedding day,
March 1928. Joyce Gross
Quilt History Collection,
2008-013/164

Patriotic expressions in time of war and memorials to the fallen take many forms in textiles, including as banners, handkerchiefs, bandanas, flags, pennants, pillow tops, and quilts. The *American Veterans of World War II Council Memorial Quilt* is a patriotic and commemorative quilt whose design recognizes the service of the 420 military personnel from Travis County, Texas, during World War II. In that global conflict, more than 750,000 Texans, including 12,000 women, served in the armed forces. Of these, an estimated 22,022 were killed or died of wounds.[226] The *American Veterans of World War II Council Memorial Quilt* was a project of members of the American Veterans of World War II Council no. 1, Austin. The council's list of charter members records ninety-six women.[227]

Donation records describe this memorial quilt as being made for sale at a wartime fund-raiser, with proceeds used to buy war bonds. Members donated the quilt to the University of Texas in March 1947. It was never intended as a bedcover. The quilt is made of two layers only—a front and back; there is no batting. Simple white thread tacking, not quilting, joins the pieced top to the plain muslin back. The top contains 420 names in all, organized in fourteen vertical rows of rectangles alternating in blue and white,

each "brick" containing a single embroidered name and rank—black embroidery on white rectangles, white on the blue ones. Each of two strips of horizontal red sashing above and below the center medallion holds ten names embroidered in white. The center design is an elaborate, commercially embroidered emblem of the American Veterans of World War II Council. Blue dots still mark the careful positioning of the emblem on the center white panel. Stylistic aspects of the embroidery indicate that at least five different women sewed the names, though they also suggest that only one person embroidered all twenty names on the two red strips. The rectangles probably were embroidered separately, perhaps each one embroidered after funds were donated on a subject's behalf.

Of the 420 names on this quilt, only one is an Austin woman who served during the war. She is listed as "Miss Jerry Wilkie, Am Red Cross." Another serviceman named on the quilt, "Chester V. Kielman, Pvt.," has a strong connection to the University of Texas and to the history of its Briscoe Center for American History. Until 1979, Dr. Kielman was University Archivist and director of the Eugene C. Barker Texas History Center, the American history library and archives that served as the foundation for the Briscoe Center.

There is also a very special addition to this quilt—a simple but heart-wrenching symbol marking the names of Austinites who died during their war service. It is a small gold star, the kind a teacher pasted on an elementary school chart to record a student's achievement. These stars are glued next to eighteen names. One of the starred names memorializes Homer T. Hornberger, aged twenty-five, who died near Altenbeken, Germany, on April 13, 1945, less than one month before Germany signed unconditional surrender documents in May. First Lieutenant Hornberger served as a co-pilot in the 441st Squadron, 100th Troop Carrier Group. The April mission was intended for resupply and evacuation, but it resulted in Hornberger's death along with the deaths of four other crewmembers and a flight nurse. Hornberger was survived by his parents, four brothers (two of whom also served in the military and whose names appear on this quilt), and his wife. He is buried in the Netherlands American Cemetery and Memorial, in Margraten, Netherlands.[228]

**American Veterans
of World War II
Council Memorial
Quilt**

American Veterans of
World War II Council,
Council No. 1, Austin,
circa 1945–1946

Cotton: 79 x 82 inches

Machine pieced,
embroidered,
embellished, tied

TMM 799.1

Gift of the American
Veterans of World War II
Council, Council No. 1,
Austin

TEELE/PETO MEDALLION
& ODD FELLOWS BLOCK

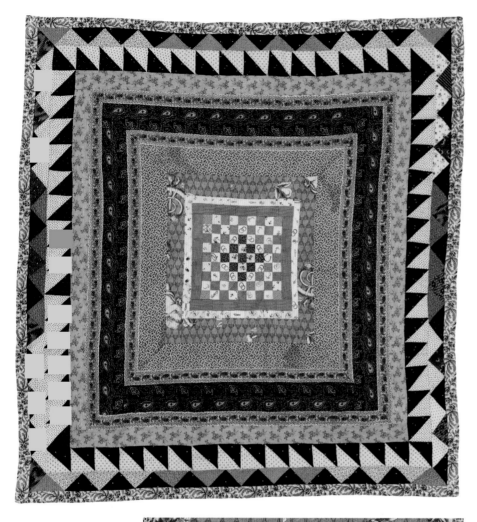

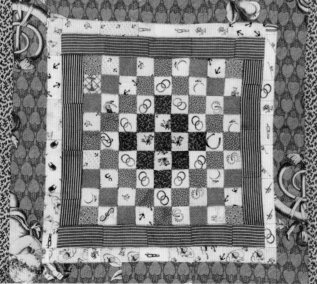

Teele/Peto Medallion, top

Maxine Teele, Muscatine, Iowa, circa 1965–1970

Cotton: 41 x 42 inches

Hand pieced

Joyce Gross Quilt History Collection, W2h001.018.2008

Quilt historian, educator, and maker Maxine Choulet Teele (1914–1977) did not consider herself a quiltmaking perfectionist. Rather, she described her sewing talents this way: "I had to make peace with the fact that I could not match my mother's work so rather than give up entirely, I do the best I can without a nervous breakdown."[229] Between 1956 and 1977 Teele made more than seventy quilts and tops, often turning antique tops and blocks into finished quilts and incorporating vintage fabrics into her quilts.

Teele's life with quilts was, in part, bracketed by her friendships with two outstanding quilt collectors and historians: Florence Peto of New Jersey and California native Joyce Gross. Teele began corresponding with Peto in 1956, and their letters continued until Peto's death in 1970.[230] The two women met in 1963 when Teele and her husband, Henry, visited Peto at her home in Tenafly. Teele later described her visit: "After a phone call, we stopped by her home. For the next two hours, she pulled quilts from closets and chests. She showed us (my husband said) ninety-five of her eighty-five quilts . . . she bubbled over with joy at our interest in her amazing collection."[231]

Peto also gave or sold antique fabrics to Teele, encouraging both her appreciation for vintage textiles and her willingness to use them in her own quilts. For example, in 1965, she offered Teele a "quantity of old fabrics . . . some large, some small pieces," plus a quilt top in "Victorian green and Turkey red calicoes" for $5.00, and, later, oiled calicoes and historical printed textiles. In the last months of her life, Peto also arranged for her son to send Teele a gift box of antique fabrics, including several manufactured in 1876 to commemorate 1776. Teele planned to "combine them in some fashion for 1976."[232]

Maxine Teele and Joyce Gross also crossed paths and became instant friends, corresponding by mail and telephoning each other often. They met in July 1976 when both attended a bicentennial quilt show in Lawrence, Kansas, where Teele served as judge.[233] In September, Teele and her family visited California, enjoying a two-day stay with Gross at her home in Mill Valley. Teele wrote about the visit in her quilt club's *Needle's Eye* newsletter:

Her home is fascinating with quilts spilling out of every box and cupboard, displayed over stair rails, hung in halls

and draped over screens. She has an office work room where "business" is taken care of and a sun porch set up for sewing. There are so many goodies in each, that one is frantic with desire to see all and the sure knowledge that it is impossible! A large group of quilters gathered one day for Show and Tell. Again—it sounded like Iowa. Several showing and telling all at the same time and no one ever finished a sentence. I felt right at home. Perhaps the sharing of such a satisfying interest eliminates whatever strangeness would normally be present, or maybe our hostess was just extremely capable of making us feel at home. Whatever the reason, it was a joy and a privilege for me.[234]

Maxine Teele died on March 18, 1977; she had been diagnosed with Lou Gehrig's disease (amyotrophic lateral sclerosis) in the spring of 1976. A memorial exhibition of Teele's quilts held during the National Quilt Association's annual show in Washington, D.C., in June featured her notebooks and photo albums, plus sixteen of her quilts, including her *Honey Bee* quilt (1973) and a quilted frog pillow cover, both now in the Briscoe Center's Joyce Gross Quilt History Collection, as are portions of her collection of antique fabrics acquired from Florence Peto. *Patchwork Patter* reported on the exhibit, calling it the "highlight of this year's Show" and describing Teele as representing "a small group of individuals from different parts of the country who bridged the span between this generation's quilt enthusiasts to earlier writers and quilt conservators."[235]

Teele made the small quilt top known as *Teele/Peto Medallion* as a nod to nineteenth-century quilt styles and fabrics and, possibly, as a way to honor Florence Peto, her friend and mentor. It was Peto who introduced Teele, at least by 1965, to the pleasures of incorporating antique fabrics into quilts. Peto began making medallion quilts using antique fabrics in the early 1950s. Several of her quilts, such as *Where Liberty Dwells* (1953) and *Hearts and Flowers* (1954), may have inspired Teele. In the *Teele/Peto Medallion* top Teele used at least two antique fabrics that Peto used in her *Hearts and Flowers*—the red and white copperplate Dove and Ring toile (1810), which forms the wide border just outside the center medallion, and a small red and tan paisley print, which creates two borders, one on either side of a wider brown paisley border. Peto sent examples of both fabrics, and possibly others in this quilt top, to Teele sometime during or after 1965. Other fabrics in this quilt top generally date from 1860 to the turn of the

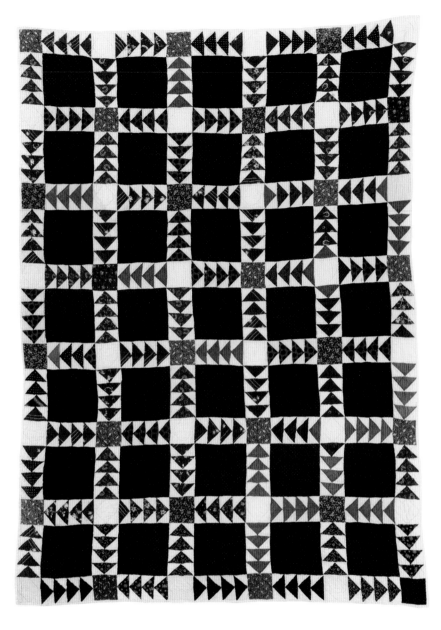

century. They include conversation prints, prints in chocolate browns and double pink, a tiny minty green print, mourning prints, and several shirtings with tiny motifs in black or red.

On the back corner of her *Odd Fellows Block* Maxine Teele has embroidered

<div align="center">

Quilting
Maxine Teele
1968

</div>

Teele may have acquired the beginnings of this quilt as turn-of-the-century quilt blocks or, more likely, as a top that she backed, hand quilted, and bound. Whatever its

Odd Fellows Block

Blocks or top by unknown maker, circa 1880–1910; quilted by Maxine Teele, Muscatine, Iowa, dated 1968

Cotton:
49 x 67½ inches

Hand pieced, hand quilted

Joyce Gross Quilt History Collection, W2h001.019.2008

STAR OF BETHLEHEM
WITH
CHRISTMAS ROSE

Florence Peto made small greeting cards to give to friends. The Crazy quilt card contains her handwritten greeting "Isn't it fun to have a Crazy Quilt Patch Block wish you a very Merry Christmas?" Maxine Teele received Peto's ink-and-trim bird card, then passed it on to Joyce Gross in 1976. Peto sent her Star of Bethlehem with Christmas Rose card to Emma Andres in Prescott, Arizona, as a Christmas greeting. Joyce Gross Quilt History Collection, 2008-013/149

history, this quilt's small size, tidy pattern, and overall appearance as a two-color quilt (though the red tones include burgundy and its several red prints include black, tan and, in one fabric, pink) suggest a simplicity that belies its clever design and piecing. An experienced quiltmaker pieced this quilt top. The quilt's thirty-five plain burgundy blocks are surrounded on each side by four flying geese triangles set on a white sashing with cornerstones. Each string of triangles is pieced to move counter to the string above, below, or opposite it; this configuration remains true throughout the quilt. The quiltmaker alternated two fabrics—an off-white and a burgundy with white resist—to create her inner cornerstones. She also pieced all the flying geese to point toward the burgundy cornerstones and away from those in off-white.

This is quite likely a scrap quilt. The red print fabrics include two faded Turkey red prints and several deep, bright red prints, including two conversation prints, a floral, and several geometrics, plus at least seven different burgundy prints. Teele's hand quilting is quite plain: diagonal parallel lines in alternating directions grace the plain blocks, and outline quilting helps define the sashing.

The frog pillow cover was Teele's thank-you and gift of remembrance for Joyce Gross for her hospitality during her 1976 visit to Joyce's home in Mill Valley, California. The pillow features a smiling frog and contour quilting. The green fabric used for the frog is an over-dyed green. Frog objects of all kinds, whether textile, plastic, ceramic, or printed, were one of Joyce's collecting favorites and the gift of choice from her many friends. Joyce's love of frogs came from her husband, Ed, who used to refer to himself as "The Frog" and to Joyce as "His Muffin" in notes of affection.[236] At the memorial service for Joyce held on January 27, 2013, guests were invited to select a frog from her collection.

Frog Pillow Cover

Maxine Teele, Muscatine
Iowa, circa 1976.

Cotton: 12 x 12 inches

Machine pieced, hand
appliquéd, hand quilted

Joyce Gross Quilt
History Collection,
W2h001.182.2008

Texas author and book illustrator Betsy Warren didn't think about making a quilt when she sewed her first-ever quilt block—the prickly pear—out of fabric scraps given to her by a friend. But one block led to another and then to another, until she had created a quilt of twenty-five blocks, each one depicting some aspect of Texas's history and natural setting—Davy Crockett at the Alamo, cowboys and oil wells, a log cabin schoolhouse, cactus, and armadillos. Mrs. Warren set her designs of people and historic events in chronological order, beginning with a Tejas Indian in the block in the upper left and concluding with a block representing NASA's moon landing on July 20, 1969, in the lower right. Her Seal of the State of Texas graces the quilt's center block.

Patches of Texas History was Mrs. Warren's first and only quilt, and she used her artist's eye to create cleverly embellished and detailed designs. In her Log Cabin Schoolhouse block, for example, she divided a bright brown and orange calico by a chain stitch to suggest hewn logs and built a stone chimney out of gray and black striped polyester fabric. In other blocks she gave the explorer LaSalle an undercoat made of silver brocade, protected the astronaut in a spacesuit of white satin, and outfitted Davy Crockett with a faux fur coonskin cap, canvas powder horn, and boots that lace up with embroidered ties.

Betsy Warren used her *Patches of Texas History* quilt to share her state's history through words and pictures. Mrs. Warren also authored children's books about Texas history, including *Twenty Texans: Historic Lives for Young Readers* (1986), *Explorers in Early Texas* (1996), *Moses Austin and Stephen F. Austin: A Gone to Texas Dual Biography* (1996), and *A Kid's Guide to Exploring LBJ National Historical Park* (2000). She finished *Patches of Texas History* in 1975 to help celebrate the US bicentennial and then displayed it at the Old Bakery on Congress Avenue in downtown Austin. From 1976 to 2007, Mrs. Warren used her delightful quilt as a teaching aid when she lectured on Texas history in more than twenty-five elementary schools in Austin and nearby Lockhart.

**Patches of
Texas History**

Betsy Warren, Austin,
dated 1975

Cotton, satin, polyester:
69½ x 82½ inches

Hand and machine
pieced, hand appliquéd,
embroidered,
embellished

W2h112.07

Gift of Mrs. Betsy Warren

$4.95

APPLIQUE STITCHERY

Jean Ray Laury

Jean Ray Laury, *Appliqué
Stitchery* (1966).

Quilt collector Joyce Gross acquired Jean Ray Laury's *The Housewife's Fantasy No. 5* in October 2005, just in time to include it in an exhibition of quilts from her collection at that year's International Quilt Festival in Houston. Joyce Gross and Jean Ray Laury were longtime friends. Years earlier, Laury had written to Gross about their special bond: "Your friendship has meant a lot to me over the past few years, Joyce. I don't see you often, but I feel a special kin-ship that is something more than just our both being interested in quilts. There is something more which strikes a responsive chord . . . maybe it's recognizing that we share an intensity in the way we go about pursuing our interests."[237]

Jean Ray Laury (1928–2011) was recognized during her lifetime as an artist, designer, quiltmaker, teacher, author, and pioneer of the modern quilt revival and fiber art movement. Her extraordinary quilts, often called "message quilts," are characterized by strong colors, original designs, and her opinion expressed with humor through cloth. One of Laury's most famous quilts is *Barefoot and Pregnant* (1985), which was referred to as "a soft version in the best of political/social cartoon tradition" and named among the twentieth century's one hundred best American quilts.[238]

Laury published her first book, *Appliqué Stitchery*, in 1966. In 1977, by then having published seven books and many magazine articles, Laury wrote one of her most popular volumes, *The Creative Woman's Getting-It-All-Together at Home Handbook*. Based on responses to a questionnaire she sent to needleworkers and other creative women who worked from home, she compiled her own thoughts about and advice for leading a balanced life that embraced family, home, and creative work. Chapters include "On Being Superwoman," "The Playpen in the Studio," and "Coping with the Mess."[239]

Beginning in the 1970s Laury created *The Housewife's Fantasy* series, a group of eight rectangular panels bursting with color and humor and containing what Laury considered positive statements about women. These panels included depictions of winged housewives hovering over an ironing board, floating behind a vacuum cleaner, and drifting aloft, suspended by a whirling eggbeater, or of Rubenesque women celebrating love and flipping fried eggs. Laury referred to *The Housewife's Fantasy No. 5* as her "Things Are Cooking" panel. It was the last of the original eight panels she still owned when Joyce Gross asked to purchase it in 2005.[240]

The Housewife's Fantasy No. 5 features a winged housewife, well dressed and smiling, bearing a bowl of steaming food as she floats through the air. The housewife is set into a fanciful niche that resembles an ornate movie-house marquee—featuring the housewife as the star attraction. Laury used colored felt throughout, with the exception of a grosgrain ribbon in fuchsia that serves as the banner for the vivid green appliquéd title. All the motifs are beautifully appliquéd in matching thread. 1970s colors adorn the panel and embroidery and French knots create the face, embellish the dress and the shoes, and outline the wings. The lavender felt background on the front wraps around a wood panel to the back, where it is almost completely covered with a bright yellow felt rectangle secured by glue.

In addition to her original eight fantasy panels, Laury created at least one other fantasy panel in the late 1970s. In it a woman flies with her sewing machine, writing "Sew Far Sew Good" in the sky. Laury wrote about these special panels in the spring 1981 issue of *Needle and Thread*: "The women in the fantasies are wonderful. They are housewives, and I am one of them. And I too have fantasies." Referring to her "Sew Far Sew Good" fantasy panel, she noted, "In considering fantasy we tend to take a mundane, day-to-day activity and make it glamorous or exciting by placing it into a new setting. That's what fantasy is all about—it lets a housewife soar with her sewing machine. And in this fantasy, her sewing machine is sky-writing into the bargain!"[241]

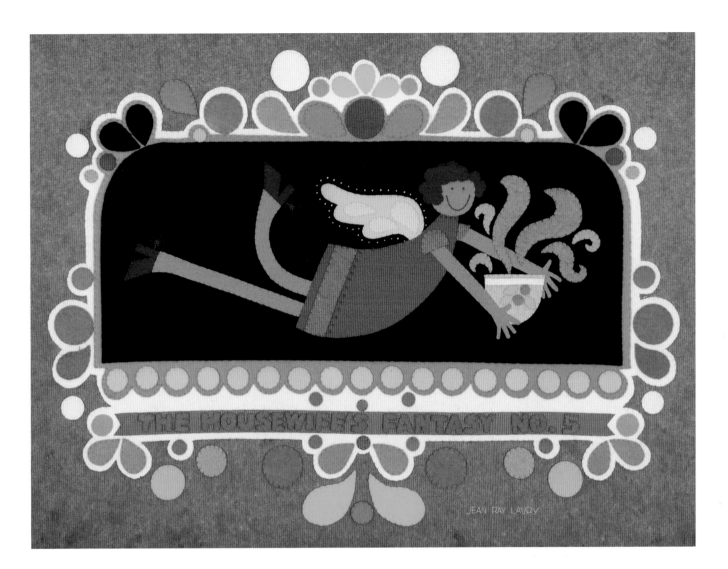

**The Housewife's
Fantasy No. 5**

Jean Ray Laury, Clovis,
California, dated 1976

Felt: 29 x 22½ inches,
framed

Hand appliquéd,
embroidered

Joyce Gross Quilt
History Collection,
W2h001.074.2008

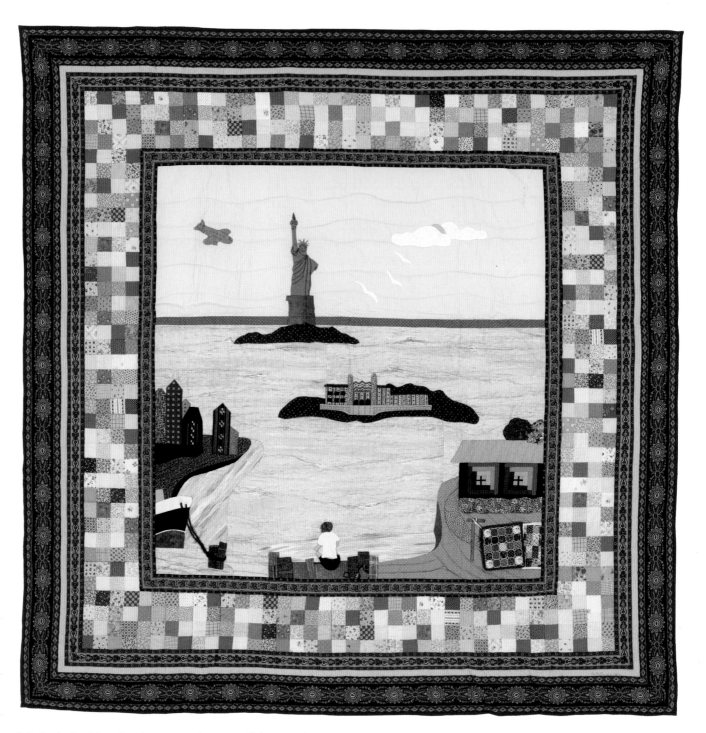

Freedom to Dream

Marie Anita Murphy,
Kountze, Texas,
dated 1986

Cotton and cotton
blends: 70 x 70 inches

Hand and machine
pieced, hand appliquéd,
hand embroidered,
hand quilted

Anita Murphy Quilt
Collection, 2009-296-17

Marie Anita Murphy (1927–2011) was well-known for her pictorial wall quilts. Her 1986 award-winning *Freedom to Dream*, for example, depicts a boy gazing out over New York Harbor at the Statue of Liberty. As the quiltmaker described it, the boy represented the freedom to dream.

Murphy's quilt was the Texas state winner in the Great American Quilt Contest, a 1986 Museum of American Folk Art event presented by 3M Scotchgard products that celebrated the Statue of Liberty's centennial.

Mrs. Murphy made creative use of fabrics from unex-

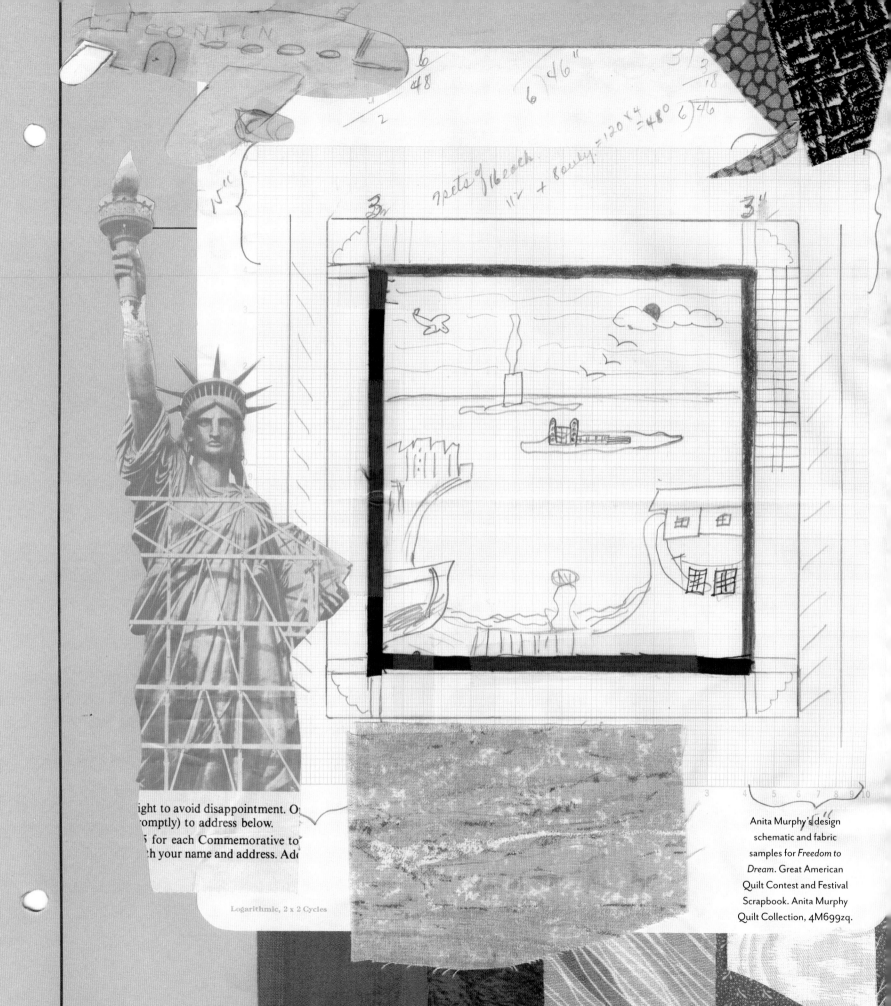

CONTEN

6
4)48
2

6)46"

5)3
18

7 sets of 16 each
11" + 8 each = 120 × 4 = 480 6)46

3 3"

Logarithmic, 2 x 2 Cycles

...ight to avoid disappointment. O...
...omptly) to address below.

...5 for each Commemorative to...
...ch your name and address. Ad...

Anita Murphy's design
schematic and fabric
samples for *Freedom to
Dream*. Great American
Quilt Contest and Festival
Scrapbook. Anita Murphy
Quilt Collection, 4M699zq.

ing The Lady." She infused her composition with meaning: the log cabin represents humble beginnings; the hanging quilts express the warmth they bring into the home; Ellis Island honors her immigrant mother-in-law, who was born aboard ship as it waited to dock; and the airplane commemorates the first time she saw the Statue of Library—"I was a hostess for Continental Air Lines [and] the pilot . . . dipped the wings so the passengers could get a better view of The Lady. It was magnificent, and something I never forgot."[243]

In April 1986 Mrs. Murphy attended the Great American Quilt Festival in New York City, which recognized and celebrated each state's winning quilt and quiltmaker. She used that occasion to create her *Great American Quilt Contest Signature Quilt*, which commemorates her visit with signatures she acquired at the festival. Design plans and fabric samples for this quilt are also in Murphy's impressive contest and festival scrapbook. The eight fans surrounding the center medallion carry the signatures of the state winners; the outer fans feature signatures of others associated with this special event, including sponsors, directors, and well-known members of the quilt community. Mrs. Murphy even added the signatures of the airline pilot and chauffeur who helped transport her from South Texas to the festival in New York.

A lifelong quilter, Anita Murphy founded and served as president of the Golden Triangle Quilt Guild, which met in Beaumont, Texas, but drew members from twenty-three area cities. She was also a part of the nine-member team that established the Texas Quilt Heritage Society, which sponsored eighteen quilt identification days across the state in the mid-1980s. More than 240 of the surveyed quilts were featured in the society's *Texas Quilts, Texas Treasures*, published in 1986.

Great American Quilt Contest Signature Quilt

Marie Anita Murphy, Kountze, Texas, dated 1986

Cotton: 58 x 59 inches

Machine pieced, hand appliquéd, signed, hand quilted

Anita Murphy Quilt Collection, 2009-296-16

pected sources for *Freedom to Dream*. She pieced the airplane out of chintz and sewed the Statue of Liberty from "a lovely old piece of cotton sateen." The 560 earth-toned squares framing the picture are cotton scraps donated by quilting friends, the ocean was once a drapery sample, and Murphy cut the wooden dock from a shampoo cape. Murphy's "Great American Quilt Contest and Festival Scrapbook," part of the Anita Murphy Quilt Collection, is filled with her design plans for and mementoes associated with this quilt and the contest of which it was a part.[242]

Mrs. Murphy entered the Great American Quilt Contest because she loved the challenge and "the theme honor-

CAPTAIN TOM, A TALL TEXAN

In 1986 Texas celebrated the 150th anniversary of the establishment of the Republic of Texas. Texas sesquicentennial events took place all over the state in communities large and small—more than 3,700 history pageants, frontier days, heritage tours, main-street celebrations, cook-offs, parades, county fairs, history exhibits, rodeos, and other celebrations peppered the state during the year. Quilt enthusiasts also embraced the sesquicentennial. The Texas Sesquicentennial Quilt Association, led by Karoline Patterson Bresenhan and Nancy O'Bryant Puentes, capped off its massive Texas Quilt Search with an exhibition of antique quilts in the State Capitol, held over a weekend in April 1986 to commemorate the decisive Battle of San Jacinto, fought on April 21, 1836, during the Texas Revolution. The Texas Heritage Quilt Society issued *Texas Quilts, Texas Treasures*, based on the society's quilt search days, and Bresenhan and Puentes published the first volume in their landmark *Lone Stars* trilogy with *Lone Stars: A Legacy of Texas Quilts, 1836–1936*. Individual quiltmakers also created iconic Texas quilts to help celebrate Texas's 150th birthday, and local quilt exhibitions offered quilt lovers a chance to view the state's quiltmaking heritage. The *Official 1986 Sesquicentennial Guidebook* urged residents and visitors alike to "Have a Big Time in Texas," and Lady Bird Johnson's guidebook introduction evoked the Lone Star State's history rich in "fascinating characters . . . [and] sweeping drama that wraps the mind in wonder and pride in our heritage."[244]

Shirley Fowlkes Stevenson, a fifth-generation Texan, made *Captain Tom, a Tall Texan* both to celebrate the Texas sesquicentennial and to honor the life of one of these "fascinating characters"—John Files Tom (1818–1906), her great-grandfather and a veteran of the Texas Revolution. Shirley calls her quilt a "Texas Album Quilt." Its twenty complex appliquéd and embroidered designs mix events in the life of her pioneer ancestor with important and enduring state symbols.

Shirley's layout for the quilt—four large blocks surrounded by side panels and four corner blocks—organizes her narrative. Designs in the top panel represent John Tom's journey from Tennessee to Texas in 1835, including his family's travels by paddle-wheel steamer and ox cart before settling in Washington-on-the-Brazos. In the bottom panel, the cannon, the intricate rendering of the Alamo, and the endearing depiction of John Tom wearing girl's stockings all refer to his service during the Texas Revolution. Joining the volunteer army at age seventeen, John participated in several important battles, including

the Battle of San Jacinto, which secured Texas's independence from Mexico. Andrew J. Sowell, a chronicler of early Texas pioneers and Indian fighters, recorded the tale of John's skirmish with a girl's stockings as follows:

When John Tom, then a youth of 17 years, announced that he was going to join the army of General Sam Houston his mother tried to keep him from going on account of his tender years and as an argument stated that he had worn out his socks in the previous campaign, and that he could not go until she knit him some more. A neighbor girl who was present and heard the remark retired and pulled off her stockings, presented them to John, requesting that he wear them to the army. He put them on and then a pair of buckskin moccasins, mounted his horse, bid farewell to all and set out to find the retreating army of Houston.[245]

The designs in three interior blocks document John's nearly forty years of service to the state of Texas. The San Jacinto Monument, dedicated to the "Heroes of the Battle of San Jacinto and all others who contributed to the independence of Texas," commemorates John's participation in the battle, during which a musket ball shattered his knee. According to A. J. Sowell, after being hit, John, then just one day shy of his eighteenth birthday:

tried several times to raise himself high enough above the tall grass to take a look at things, but soon became very weak from loss of blood and had to be still. Fortunately he fell in what we old Texans called a hog-wallow and it had mud in it which he banked around his wounded leg and helped to stop the flow of blood. . . . Finally his two neighbors . . . came hurriedly to the spot and bore him tenderly in to camp. In removing the stocking from the shattered leg it was noticed that the ball had cut the top off of it. He suffered for a long time and was carried home as soon as possible, where kind and affectionate hands dressed his wound and nursed him until the limb healed.[246]

The quiltmaker's depiction of John on horseback refers to his years during the Civil War as a Texas Ranger when his assignment was frontier protection. The detailed illustration of the Texas State Capitol honors his service in the Fourteenth Texas Legislature in 1874–1875. The front and back of the Texas State Seal flank the State Capitol dome. The fourth large block is an elegant composite of Texas symbols: the mockingbird (state bird), bluebonnet (state flower), pecan (state tree), and "Friendship" (state slogan). Texas star quilt patterns grace the top corners, each one wreathed by blooms and leaves. At the bottom left, a sheriff's star-shaped badge records John's service

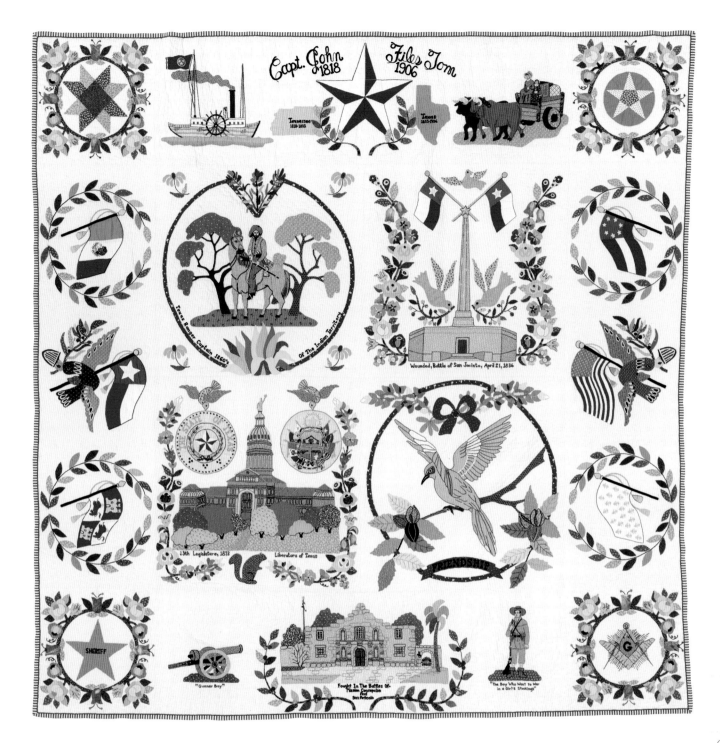

**Captain Tom,
a Tall Texan**

Shirley Fowlkes
Stevenson, Dallas,
dated 1986

Cotton: 72 x 72 inches

Machine pieced,
hand appliquéd,
hand embroidered,
hand quilted

Shirley Godbold
Fowlkes Stevenson Quilt
Collection, 2014-174-4

as sheriff of Guadalupe County from 1856 to 1859. In the right corner, a masonic square and compass form a starlike shape and document John's membership in the Masons beginning in 1867.[247] Beautifully detailed flags along the sides represent the six countries that have had sovereignty over Texas: Spain, France, Mexico, the Republic of Texas, the Confederate States of America, and the United States.

Shirley Stevenson's *Captain Tom, a Tall Texan* is an extraordinary achievement of pictorial quiltmaking. Images made using more than fifty different fabrics, layered appliqué, and finely embroidered details (note the rifle stocks, shields in the beaks of birds carrying the Texas and American flags, and the wrought iron gate at the Alamo, for example) create astonishingly realistic images. Buildings have perspective and architectural features, birds have articulated wings, and national flags and the Texas State Seal contain all the necessary details. Flowers are everywhere, wreathing five-pointed Texas stars, encircling flags, and elegantly framing two of the four largest designs: the Texas State Capitol and the San Jacinto Monument.

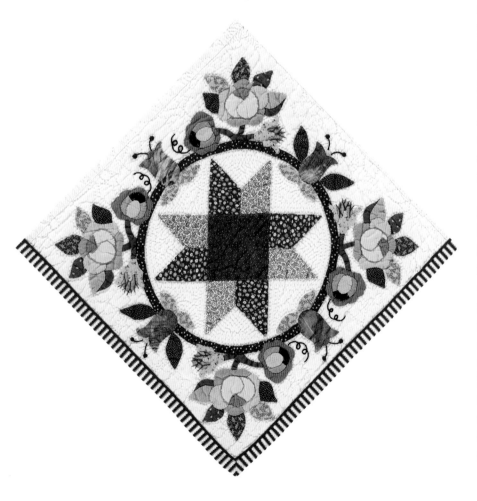

Opposite them, perfect rings in red calico help define the image of John as a Texas Ranger and the composite of Texas state symbols. The agave at the bottom of the Texas Ranger ring is instantly recognizable, and the pair of bluebonnets nearby is, in the words of Karoline Bresenhan, "the MOST realistic bluebonnets I have ever seen in a quilt. They are nothing short of fabulous!"[248] Shirley finished her quilt with all-over hand quilting that repeats shapes of the appliquéd flowers, leaves, and stars. The stars, densely quilted, are most easily seen. Her binding of red, white, and blue striped fabric plus narrow red piping perfectly frames this quilt masterpiece. *Captain Tom, a Tall Texan* was judged Best of Show, Artisan Category, at the International Quilt Festival in 1986.

Shirley Stevenson grew up on a ranch in Leakey, Real County, Texas, not far from the cemetery where her great grandfather is buried. Her father raised cattle, sheep, quarter horses, and registered Angora goats. She learned to sew by watching her mother stitch using a New Home treadle machine. Shirley sewed her first clothing—a pair of shorts—by making a pattern based on her own long pants and cutting up her mother's "retired" robe of polka dot fabric with a pink cabbage rose border. Shirley recalls that whenever she wore the finished shorts she had "big pink roses on my bottom." By age twelve she was selecting fabrics and patterns and making dresses all on her own. Art education classes at the University of Texas gave her a solid academic foundation in art and served, along with sewing, as the springboard to careers as a public school art teacher, a studio artist, and an interior designer.[249]

Shirley came to quiltmaking through sheer serendipity. Married, with two children, and living in Dallas by the late 1970s, she saw an advertisement for a quilt show at a Dallas YMCA. She went in, toured the show, and soon after joined the Quilter's Guild of Dallas. Her first quilt was a queen-sized *Cathedral Window*. It "weighed a ton," recalls Shirley, who admits to using it as a bedcover for overnight visitors whose lengthy stays she hoped to discourage.[250] She designed several quilts for the Texas sesquicentennial and eventually broadened her quiltmaking activities to include wearable art and commissioned quilts, plus a successful career designing, publishing, and marketing patterns. Now a resident of Sherman, Texas, Shirley has returned to what gives her the most pleasure—designing and making one-of-a-kind art quilts.

Shirley Stevenson's Shirley
Poppy dress and jacket,
1997. Stevenson used
free-motion appliqué and
thread painting to create the
realistic and dimensional
poppies, which she based
on the Shirley Poppy, a
variety of poppy developed
by Rev. W. Wilkes, vicar of
Shirley in Surrey, England.
Shirley Godbold Fowlkes
Stevenson Quilt Collection,
2014-174-4.

Three quilts made by Beth Thomas Kennedy bear witness to the extraordinary broadening of the world of quilts and quiltmaking that began in the late 1970s as quilters began to create art quilts. Each quilt in this trio also marks an important transition point in Beth's career as she moved from traditional quiltmaking to become a renowned art quilter and textile artist. Known for her love of color ("Orange and turquoise are my neutrals," she says), Beth's art quilts stand on the sturdy foundation of a lifetime of sewing and traditional quiltmaking.[251]

Beth grew up in Dallas, where she started sewing her own clothes on a Singer Featherweight while in junior high school. She still has vivid memories of making a brown pencil skirt and coordinated vest with buttons. The buttons, she recalls, cost more than all the fabric.[252] Beth started quilting in 1979 after opening High Cotton, a store in north Austin that specialized in natural-fiber fabrics. When she and her business partner offered quiltmaking classes at the store, Beth signed up and so was introduced to piecing, appliqué, and block design. She was hooked. But Beth also experimented, adding "a little something here and a little more there to put my own mark on my work." She readily acknowledges that traditional quiltmaking gave her "the skills of precision and care in workmanship" that she believes should be present in all art and fine craft.[253] When the partners closed High Cot-

ton after two years, Beth sought other sources of income, a quest that led her to teach quiltmaking, to participate in quilt shows, and, ultimately, to enter the art quilt world "through the path of tradition." Simply put, Beth "wanted to be more free."[254] Beth started professional quilting about the same time she was drawn toward art quilts. Her work is recognized for its strong colors, surface embellishment, her hand-dyed and hand-printed fabrics, silk screening, painting, beading, embroidery, wearable art, and series quilts. "I am fascinated," she says, "by the limitless scope of working with fabric."[255]

For Beth, a commission in 1985 to make *Our Texas Heritage* marked the first time her work was recognized. This public acknowledgment contributed to her decision to become a serious quilter.[256] She won the commission when the Texas Memorial Museum at the University of Texas at Austin invited area quilters to submit original designs for a quilt that commemorated both the museum's fiftieth anniversary and the Texas sesquicentennial in 1986. The Texas Memorial Museum was the first state museum in Texas (it later was transferred to the University of Texas). Ground breaking for the structure began in June 1936, with President Franklin D. Roosevelt attending the ceremony while in Austin campaigning. He even set off the dynamite that began construction. Paul Cret, supervising architect of the University of Texas campus, designed the Texas limestone structure in the Art Deco style, complete with a thirty-five-foot Great Hall whose walls were decorated with the seals of the six nations that have ruled Texas. The museum opened in January 1939.[257]

Beth's winning design created a framed medallion quilt featuring Texas wildflowers, border patterns representing some of the museum's architectural features, and colors that evoke the Texas flag—red, white, and blue. The square and diamond pieced patterns in the two decorative borders, for example, are based on tile patterns on the museum's main, third, and fourth floors, and the hand-quilted Greek Key design in the middle border echoes the design along the wall on the main floor. The focal point in the quilt's medallion is an appliquéd yellow and gold five-pointed Texas star, an adaptation of the Texas State Seal, which graces the museum's front entrance and is repeated on the main floor. The wildflowers circling the seal are all Texas favorites, including bluebonnets (the

Texas Memorial Museum's main floor exhibit area, with Greek Key design and the Texas State Seal gracing the walls. Photo by Frank Armstrong, University of Texas News and Information Service, Prints and Photographs Collection.

Our Texas Heritage

Beth Thomas Kennedy,
Austin, dated 1986

Cotton;
68½ x 81½ inches

Hand pieced, machine
pieced, hand appliquéd,
hand embroidered,
hand quilted

TMM 2511.1

Gift of Beth Thomas
Kennedy

state flower), Indian paintbrush, and purple coneflowers. Beautifully rendered with multiple layers of appliqué, defining hand stitching, and embroidery, the wildflowers are Beth's versions of original needlepoint patterns created by Dee Silverthorne, a member of the Austin Stitchery Guild. Silverthorne and other guild members used these patterns to create needlepoint wildflowers for chairs in the Texas Lieutenant Governor's Chambers in the Texas State Capitol. The background fabric in the medallion and middle border is Tattersall cotton in pale blue and white. Beth recalls being especially pleased that the regularly spaced thin blue lines in the Tattersall effectively guided her diagonal parallel-line hand quilting, eliminating the need to mark quilting lines.[258]

A Nuestra Señora,
Virgen de Guadalupe,
detail

A NUESTRA SEÑORA, LA VIRGEN DE GUADALUPE

By the end of the 1980s Beth Kennedy began matching her growing love affair with surface embellishment with her determination to express support for women through her art. Her *Matriarchal Rituals*, an eight-quilt series, celebrates the impact of women on culture and society. Beth began *A Nuestra Señora, La Virgen de Guadalupe*, fourth in the series, at a class taught by pioneering art quilter Nancy Crow at the International Quilt Festival in Houston. She recalls clearly that Nancy emphasized the importance of creating quilts in a series as a way to explore variations in a specific theme. As she did with *Our Texas Heritage*, Beth based her Virgin of Guadalupe quilt on a traditional appliquéd medallion pattern. This quilt, however, features striking surface embellishment, including a sequined icon, *milagros* (miracle) charms and ornaments, more than thirty small cloth and yarn dolls, a rosary, lace,

dimensional flowers, and prayer cards. Beth loved making this quilt and notes that "of all the quilts that I have had published or shown this is the [one] that has gotten the most press." *A Nuestra Señora* was selected for exhibition, for example, at Quilt National in 1991, at the Dairy Barn Arts Center in Athens, Ohio. A venue for contemporary art quilts, Quilt National's international juried exhibition offers quilt artists the opportunity to show original works that possess the basic structural characteristics of a quilt.[259]

The paper and sequined depiction of *La Virgen de Guadalupe* at the center of *A Nuestra Señora, La Virgen de Guadalupe* is one Beth acquired in Mexico in the 1960s. She was attracted to the icon because it was the only female representation in Mexican culture she could find that was not submissive. She saved the icon for the "right" moment—this quilt, adding a sealant to the Virgin's paper face and hands to protect them. Flowers at the Virgin's feet and lower right are cut from oilcloth, a fabric traditionally used in the Mexican home—one place, Beth notes, where women have power in the Mexican culture. Other fabrics and embellishments in the quilt include a border made from a sari of red polyester with gold flecks; dimensional flowers cut from fabric scraps from other quilt projects and stiffened with a paper-backed fusible bonding; dolls that represent those who pray to *La Virgen de Guadalupe*; a Guadalupe rosary and a membership pin and ribbon from the Guadalupano Society, whose members pray to *La Virgen*; and an outside border made of hand-painted fabric. Beth made the quilt back using irregularly sized blocks intended for the quilt front but never used there. Several of the block fabrics came from Mexico, including a cotton peyote painting scarf and several tissue paper prayer flags, which Beth covered with netting and bonded onto the background. She machine quilted her quilt with nylon thread.

Beth considers her *Matriarchal Rituals* series the high point of her career using commercial fabrics and one of the most joyous artistic periods of her life. "I had never felt such joy," Beth recalls, adding, "I loved the work and the subject. I mourned the completion of each piece even as I rejoiced in the anticipation every new one brought. Life was good. I had found my place."[260]

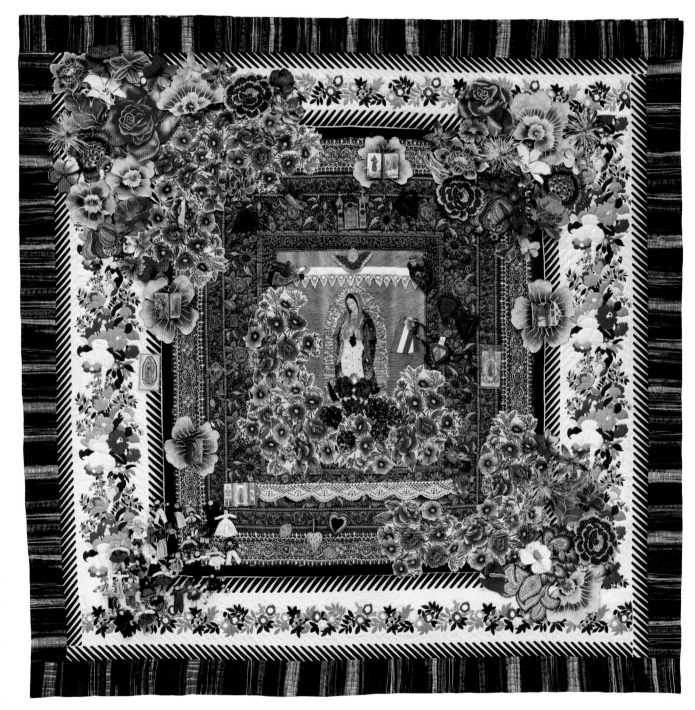

**A Nuestra Señora,
La Virgen de
Guadalupe,
Matriarchal Rituals
Series No. 4**

Beth Thomas Kennedy,
Austin, dated 1990

Cotton, polyester,
oilcloth, acetate:
77 x 78 inches

Machine pieced,
embellished,
machine quilted

Beth Thomas Kennedy
Quilt Collection,
2014-212-1

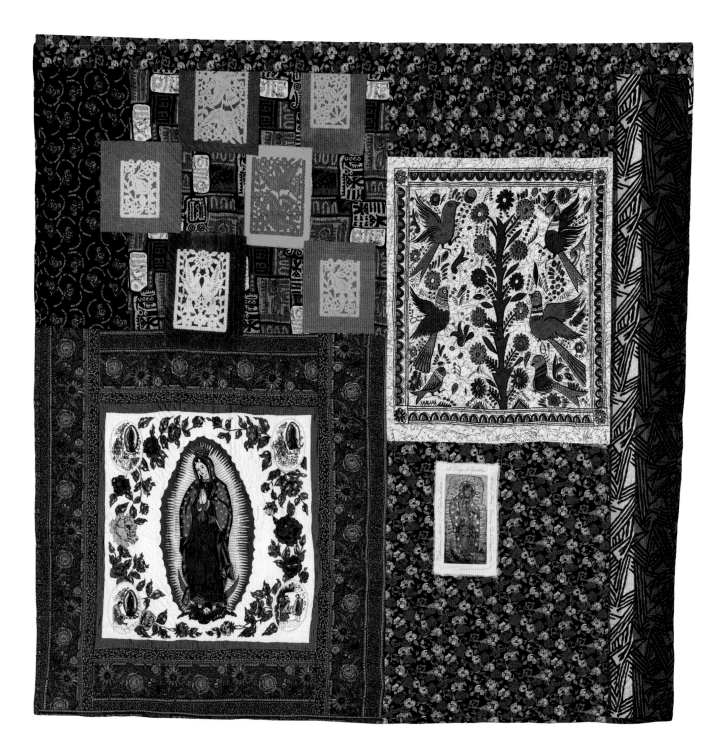

A Nuestra Señora,
La Virgen de Guadalupe,
back

When Beth Kennedy completed her *Matriarchal Rituals* series, her passion for her art flagged. "I floundered around for a year or so, seeking a natural continuation of the passion that had consumed my time and work," she states.[261] Beth rediscovered her passion when she began to hand dye her own cloth. Hand dyeing introduced Beth to a quiltmaking approach that led her away from planning her work beforehand to one that required her to wait to see what the dye pot revealed, then proceeding from that point. Beth loved it: "It was a completely different style of creating, to work so freely and without preconceptions of process or product." Beth's new passion also literally took over the Kennedy home—four of its seven rooms morphed into studios. The living room became Beth's design and sewing studio, for example, and the back porch (after the roof fell off and the porch was enclosed) served as her dye studio.[262]

Fire, the third of four quilts in Beth's *Spirit Dancers* series, was a product of what she called "this new adventure." The series was her first using noncommercial fabric. Her hand-dyed fabric in this series forms the background for additional layering and printing of female imagery based on Spanish cave art. Beth silk-screened the red center and orange border with images of abstract dancers in black, red, and gold, many of which overlay one another. The outside border is pleated and stitched. Edges are burned to look charred, an effect that Beth intensified with black permanent marker. Red foiling covers some of the dancers to make them shiny, even luminous. Machine quilting and embroidery in coppery red and bronze metallic thread evokes licking flames. The conspicuous tail at the bottom left corner references the pagan belief that such a tail offers protection—evil spirits will be drawn to it, enter, and remain trapped. The commercial backing fabric, a mottled black and white, evokes ashes. Beth also made the other three quilts in the series—*Earth*, *Air*, and *Water*—in 1994. All are about the same size and made using the same techniques. All celebrate life.[263]

In recent years Beth has found new creative passions—her two grandsons ("I am the best grandmother in the world," she says) and beading, the latter a continuation of her love of embellishment that dates back to the special buttons she purchased for the vest she made in junior high school. She has taken full advantage of the rich inventory and classes available in Austin's bead stores. Beth also is now part of a beading group that meets weekly to work on individual projects and to share ideas. The few quilts she still makes are for family, friends, or an occasional quilt guild show. Her beaded jewelry—necklaces, sculptural pendants, rings, bracelets—all alive with color and dimension, joyfully embellish a bathroom in her home, where they are draped over all manner of hooks and small pedestals.[264]

**Fire, Spirit Dancers
Series No. 3**

Beth Thomas Kennedy,
Austin, dated 1994

Hand-dyed cotton:
50 x 49 inches

Silk screened, printed,
foiled, burned, machine
embroidered and quilted

Beth Thomas Kennedy
Quilt Collection,
2014-212-2

As with many quiltmakers, Helen Wade used cotton sack fabrics to make pieced quilts. But she did not make cotton sack quilts during the Depression years or out of necessity. Rather, Mrs. Wade was determined not to let cotton sack quilts become a thing of the past and, so, she began making cotton sack quilts in the 1980s during her retirement years. Mrs. Wade created more than thirty-eight such quilts by 2010, plus several others that incorporated a few cotton sack scraps.

Snowball Quilt contains vintage cotton sack fabrics that Wade acquired mainly from her own stash, which she started in the 1950s, and from her grandmother's scrap bag or by swapping fabrics with friends. Each octagon in *Snowball* is made from nine patches in different fabrics, all hand pieced. Mrs. Wade used outline quilting in the octagons made of printed fabrics and quilted flower designs in the alternating white octagons. The quilt back is composed of two panels of print cotton sack fabric, probably from flour sacks.

A native Texan, Mrs. Wade grew up on a farm in Deanville, Burleson County. She was one of six children, and she remembers picking cotton, sewing for her family, wearing cotton sack clothing until her high school years, and seeing her mother and aunts gathered around a wooden quilting frame. When Helen left home, she swore she would never again wear feed-sack clothing. In 1945 Mrs. Wade settled in Georgetown, just north of Austin, with her husband, Edwin Wade. She ran the US Post Office in nearby Andice and owned and operated The Serendipity, a crafts store where she sold her handmade clothing and decorative items. When the Wades retired in 1980, Helen tried her hand at oil painting and pottery. At the suggestion of a friend she also tried quiltmaking, and, in her own words, "Quilting really caught on fast for me." After that, while her husband spent his time outdoors, quiltmaking became her favorite "inside outlet." In all, Mrs. Wade has made more than three hundred quilts, wall hangings, and pillows, many of which have won awards at the Georgetown Quilt Show. She entered the last quilt she made—a *Starburst* quilt made with batiks—into the Georgetown show in 2010. It received a People's Choice Third Place ribbon. Mrs. Wade's quilts are distinguished by her frequent use of small pieces ("because so much of the time that is all I had"), her precision piecing, and her fine hand quilting.[265]

Snowball Quilt

Helen Gertrude Wade,
Georgetown, Texas,
dated 1987

Cotton: 70 x 86 inches

Hand and machine
pieced, hand quilted

2009-144

Gift of Helen Gertrude
Wade

Vernice Thorne of Sebastopol, California, organized and guided the creation of this award-winning pictorial quilt. A member of the Santa Rosa Quilt Guild, Thorne worked with nine other members to craft blocks for this fairy-tale wall hanging. Thorne designed the quilt's layout, purchased the pastel blue fabric for the background, and chose the stories she wanted illustrated. She asked the quilters to use pastel fabrics only—"Thus 'Little Red Riding Hood' was to be 'Little Rose Riding Hood.'" When Thorne received the quilters' blocks, she found that her friends "had outdone themselves to make them special." She reworked a few parts of several, added embroidery here and there, but left others as they were—"so perfect nothing was needed." Because none of the quilters had made a "Snow White and the Seven Dwarfs" block, Thorne created it. She also painted and embroidered an eleventh block at the quilt's center. It features a magical village, complete with castle ("the castle was the hard part"), cottages, and a lake and mountains, all embraced by fairies, tiny elves, vines, flowers, butterflies, and mushrooms.[266]

Before Thorne assembled the blocks into a quilt, she packed them in a suitcase to show off during an out-of-town visit with family. In a dramatic episode worthy of

a fairy tale, the suitcase was stolen from the car when Thorne and her husband stopped for malts along the way. Thorne feared the worst ("Imagine my beautiful blocks in the garbage!"), but the story had a happy ending—the suitcase was found along the side of the road and returned to the quiltmaker within days.[267]

Fairyland Revisited is a delightfully original pictorial quilt. Ten blocks, each one a different size and signed by its maker, illustrate ten much-loved tales: "Rumpelstiltskin," "Snow White and the Seven Dwarfs," "Sleeping Beauty," "Little Red Riding Hood," "Jack and the Bean Stalk," "Goldilocks and the Three Bears," "Cinderella," "Snow White and Rose Red," "Bluebeard," and "Hansel and Gretel." Layered appliqué and lavishly embroidered details bring the characters to life. Extra features (a wand made from gold metallic thread in the "Cinderella" block, embroidered flower wallpaper in "Goldilocks," and beautifully rendered floss straw and gold in "Rumpelstiltskin") reward each block's close scrutiny. Thorne's thick blue border around each block both frames each fairy tale and helps unify the different illustrations. Her excellent hand quilting (at ten stitches per inch) forms clouds, adds architectural elements, and helps define landscapes.

Fairyland Revisited received considerable public attention. Thorne entered the quilt into the Sonoma County Fair in 1987, where it won First Place in the wall-hangings category and Best of Show. Two days later, representatives from Disneyland, including Mickey Mouse, attended the fair. They interviewed Thorne and presented her with another ribbon. The local Sebastopol newspaper covered the event, captioning its photograph of Thorne, the quilt, and Mickey Mouse as "Fantasyland for All."[268]

Vernice Thorne displayed *Fairyland Revisited* in her home for the next ten years. When quilt collector Joyce Gross offered to buy it, Thorne declined. By 2002, however, concern for her quilt's future led Thorne to inquire if she was still interested. Joyce was, and the two struck a deal. Years earlier, Joyce had taught Thorne in a class for beginning quilters; she was thrilled to finally own *Fairyland Revisited*. When Joyce exhibited the quilt at the 2005 International Quilt Festival in Houston, her display label read "It is a great treat to have the quilt in my collection!"[269]

Fairyland Revisited

Vernice Thorne, Betty Thorn, Lois Stephens, Julie Verran, Cheryl Kaul, Vivian Danz, Dorothy Ingham, Gene Isaacs, Katie Alix, and Verlenge Leigh, California, dated 1987

Cotton: 42 x 51 inches

Hand and machine pieced, appliquéd, painted, embroidered, embellished

Joyce Gross Quilt History Collection, W2h001.065.2008

The annual Point Bonita Quilt Retreat, or "Getaway," as it was sometimes called, was one of Joyce Gross's many legacies. She began the retreat in 1981 as a weekend for quilt enthusiasts to immerse themselves in quiltmaking and quilt history. The weekend soon turned into, in Joyce's words, a "week-long-look-forward-to-it-all-year" event.[270] Participants in the annual retreat made these two quilts, both of which help document the history of this much-loved annual gathering.

Much of the substance of the retreat was its intense collaborative research and study. Joyce always brought along files from her quilt history documentation collection, and she and other quilt historians, including Cuesta Benberry, Barbara Brackman, and Kathy Ronsheimer, busied themselves with quilt history topics in one room, encouraging other "campers" to get involved in a research topic. Another room, known as the "Factory," was home to the quiltmakers. The retreat's accommodations were less than ideal—group showers seem to have been a top complaint. What Joyce described as "rustic" was always the source of much hilarity and many fond memories. Participants recalled other icons and iconic moments from the week-long event: washing Patch, Joyce's dog, in tomato juice, presumably after an encounter with a skunk; the three croaking frogs behind the rubber tree in the dining room; and the time Ann Merrell and her saxophone led a parade of "Scissorhands" quiltmakers through the Factory to the tune of "When the Saints Go Marching In."[271]

The *Point Bonita Friendship Album* helps document the fun, friendships, and generosity that were part of the Point Bonita Retreat experience. This quilt was the brainchild of Odette Goodman Teel of Long Beach, California. She intended it as a thank-you to Joyce, built around the theme "Have a Heart," one of Joyce's favorite expressions. Bettina Havig, who made one block and hand quilted the quilt's top, later recalled Teel's plan:

Teel was the prime mover. She came to the retreat that year [1988] prepared to engineer the quilt top. She secretly told everyone to make a block with a heart of some sort or reference to a heart. Joyce was fond of using the phrase "have a heart" when asked to tend to things like get the heat on or what about shower curtains. We all fell into step with Odette and by Thursday she and her worker bees had almost completed the top. The idea was to surprise Joyce Thursday night when her husband would be joining the group for dinner. Ed was in on the surprise. As it turned out the top was still not quite fully assembled so Joyce was presented with three panels which were swiftly reclaimed so that Odette and her helpers could finish by Friday morning. I volunteered to quilt the top. . . . I actually made my block right in front of Joyce. I just said I was making another stupid friendship block for someone. She never asked that second question . . . "For whom?"[272]

Forty-seven of the forty-nine blocks were designed and sewn by retreat participants; each is signed. Joyce's family, including her husband, two daughters, and grandsons, contributed two blocks. Every block contains one or

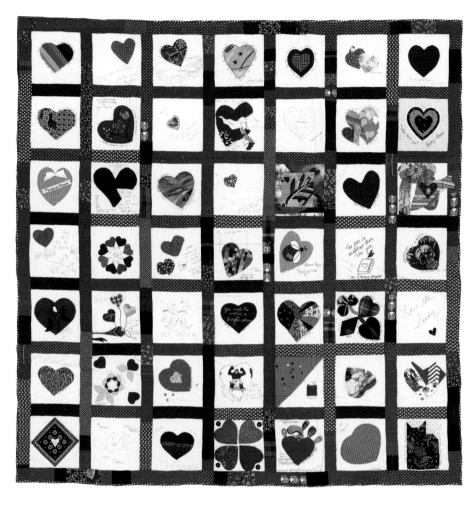

Point Bonita Friendship Album

Point Bonita Getaway Participants, Point Bonita, California, dated 1988; quilted by Bettina Havig, Columbia, Missouri, dated 1988–1989

Cotton: 69½ x 69½ inches

Machine pieced, hand appliquéd, stuffed work, embellished, hand quilted

Joyce Gross Quilt History Collection, W2h001.038.2008

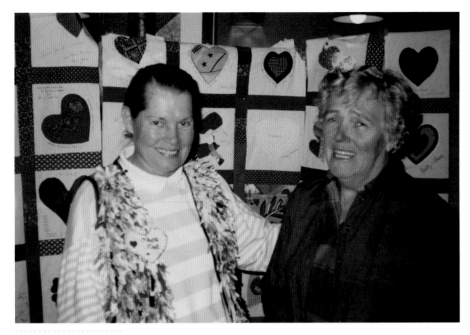

Odette Goodman Teel with Joyce Gross, as she receives the *Friendship Quilt*. A note on the photo states, "Joyce finally realizes this quilt, still in pieces, is going to be for her!" Joyce Gross Quilt History Collection, 2008-013/177.

Point Bonita Getaway announcement, 1994. Featured quilt artists that year included Bettina Havig, Laurel Horton, Nancy Halpern, and Lucy Hilty. Joyce Gross Quilt History Collection, 2008-013/177.

more hearts. The sashing is a medley of plain and printed red fabrics pieced in random lengths; the batting is cotton. Bettina Havig chose to hand quilt hearts on all the sashing in keeping with the quilt's theme. She also outline quilted each of the hearts in the blocks. Quiltmaker Jan Coor-Bender Dodge's block may best convey the sentiment of the quilt. She inscribed her block around a central red velvet heart, writing "Joyce says she is a REPOSITORY, but we know she is a NATIONAL TREASURE."

Five years later, retreat participant Bobbi Finley responded to a challenge issued by New Pieces, a quilt shop in Berkeley, California, to create a quilt relating to the Point Bonita Retreat. Bobbi's *Pt. Bonita—A Little West of the Golden Gate* quilt immediately grabbed Joyce's attention, and she offered to purchase it. As Bobbi recalls, "I was shocked and amazed that Joyce Gross wanted to own my quilt. How could I refuse her?"[273] The quilt's image, which Bobbi based on her own photograph taken at Point Bonita looking back at the Golden Gate Bridge and San Francisco, became the symbol of the annual retreat. It appears on various retreat souvenir items, including tote bags and bookmarks. When retreat "campers" chided Joyce in jest for not crediting the iconic image, Joyce thereafter always included "Quilt by Bobbi Finley" and "Collection of Joyce Gross," even on the retreat's twenty-fifth anniversary cake.[274]

The scene depicted in the quilt is one of the quiltmaker's "favorite things about Point Bonita." Bobbi loved being able to look out to sea and feel the remoteness of the location, "and then turn around and see the bridge and the bay and the city and civilization so close."[275] She created her pictorial quilt with a hand-appliquéd landscape, a machine-pieced Ocean Waves patterned border, and machine-appliquéd lettering.

As a further remembrance of the Point Bonita Retreat, Bobbi inscribed her quilt back with more than seventy phrases that she collected and recorded during her several years of working in the "Research Room" at the retreat. All are phrases that "gave us many laughs or happy memories." Some of them are:

> *Always straightening, never straight.*
> *Kathy, do you want a check for the whole thing?*
> *Does this wash out?*
> *That's an opportunity for growth.*
> *No, it's not a Christmas Quilt.*

PT. BONITA -- A LITTLE WEST

OF THE GOLDEN GATE

**Pt. Bonita—
A Little West of the
Golden Gate**

Bobbi Finley, San Jose,
dated 1994

Cotton: 35 × 35 inches

Machine pieced, hand
appliquéd, stuffed work,
hand quilted

Joyce Gross Quilt
History Collection,
W2h001.039.2008

*Synthetic dyes fade to dun.
Research—"The pen is loftier than the pin."—
B. Brackman[276]*

In March 2001, Joyce Gross notified her many Point Bonita colleagues that she was passing the retreat's administrative torch to her friend and colleague Kathy Ronsheimer. Joyce had managed the retreat for twenty-one years and, she wrote, "You all must know the wonderful memories I hold in my heart," adding, "If Pt. Bonita is one thing it is 'laughter.' I'm proud of you all and what we made of it. It would not be Pt. Bonita without you all!"[277]

**Hands across
the Sea**

Blocks made by Yasuki
Saito, Yukiko Itagaki,
Yuko Ueda, Masako, and
Sayuri Yamano Sagada,
Japan. Quilt finished by
Anne Blake, San Antonio,
2003

Cotton, silk, satin:
43 x 43 inches

Hand and machine
pieced, hand and
machine appliquéd,
hand embroidered

Reflections on 9/11 Quilt
Collection, 2009-159-13

These three quilts are part of a group of forty in the Reflections on 9/11 Quilt Collection. Together they testify to the healing power of quilts and quiltmaking. Each quilt began as a block made by a quiltmaker in Japan immediately after the terrorist attacks on September 11, 2001. Quiltmakers from Central Texas finished the blocks into quilts.

The Reflections on 9/11 Quilt Project began to coalesce at the 2001 International Quilt Festival in Houston, only weeks after September 11, when festival volunteers Marty Kishiro of Osaka and Barbara Gilstad of San Antonio discussed the heartrending events. Even before the festival opened, Marty had rallied quiltmakers in Japan to make ten-inch quilt blocks expressing condolence and support; by October he had received 139 blocks. Shortly after the festival ended, Marty e-mailed Barbara, asking if she could find quiltmakers who would turn the blocks into finished quilts. As Barbara later recalled, "Without even thinking I said 'Yes'; I couldn't say 'No.'"

Barbara enlisted the help of Ruth Felty, a fellow member of the Greater San Antonio Quilt Guild, and together they assembled forty-seven San Antonio–area quiltmakers. Each quilter selected one or more blocks and was responsible for layout, fabrics, and techniques. By late 2004 the 139 quilt blocks had become forty finished quilts. This three-year collaborative project was a healing experience for participants in both Japan and Texas. The designs and messages printed, stitched, or embroidered on many of the blocks express hope, caring, and sympathy—hearts, a rainbow, or a dove grace quilt blocks next to the words "love," "freedom," and "peace."

For the Texas quiltmakers, turning these blocks into quilts became a way to express their feelings after the September 11 tragedy. Participants recorded on a questionnaire what working on the project meant to them. Their sentiments capture the healing power of this collaborative quiltmaking project. Project director Barbara Gilstad, for example, wrote this about finishing *Framework for Peace*:

Working on this quilt gave me the time I desperately needed to comprehend and come to terms with what happened to not only our country, but to the world, on September 11, 2001. The gracious beauty and thoughtful expressions of love and caring which permeated the 139 blocks we received from Marty Kishiro of Osaka, Japan, soothed my aching heart like nothing else could. When I saw the dove block made by Shigeko Ikuta of Japan, I knew immediately that it was the one I wanted to design a layout for and that is precisely what I did. For me, Shigeko Ikuta's dove symbolizes what I think we all yearn for in the deepest recesses of our soul: that is, peace and harmony.[278]

Peace and Unity

Block made by Yoko Takahashi, Japan. Quilt finished by Beverly A. Adkins, San Antonio, 2004

Cotton: 18 x 18 inches

Hand and machine pieced, machine appliquéd, hand quilted

Reflections on 9/11 Quilt Collection, 2009-159-23

Framework for Peace

Block made by Shigeko Ikuta, Japan, dated 2001. Quilt finished by Barbara Gilstad, San Antonio, and Ruth Felty, Helotes, Texas, dated 2003

Cotton: 28 x 27½ inches

Hand appliquéd, machine pieced, hand and machine quilted

Reflections on 9/11 Quilt Collection, 2009-159-3

Sherry Cook and Joy Nichols worked together to design, piece, and appliqué their *Log Cabin, Pineapple Variation* and then enlisted the services of Amish quilter Frances Yoder to complete it with hand quilting. Sherry and Joy originally intended their quilt to be Vancouver, Washington's Northwest Fiber Arts Center's raffle quilt for the spring of 2006. Although that goal was never realized, this *Pineapple Variation* nonetheless testifies to the ongoing popularity and continuation of several long-standing quiltmaking traditions: collaboration among quiltmakers, the never-ending appeal of traditional patterns, the continued popularity of an exacting and old appliqué technique, and the use of scraps in a quilt project.

Sherry and Joy's 2005 collaboration grew out of their joint effort to make a raffle quilt for the NWFAC's 2004 Columbia River Gorge Quilt Show. That quilt was also a Log Cabin, but one that featured Lewis and Clark images on the border to commemorate the anniversary of their landmark expedition from near St. Louis to the Pacific coast between 1804 and 1806. Scraps from that quilt—all reproduction prints from the Smithsonian Institution's quilt collections—form the pieced strips and the rich *broderie perse* detail that wraps around the border's corners in Sherry and Joy's *Log Cabin, Pineapple Variation*.

Sherry credits Joy with much of the quilt's design, calling her "one of the best quilt designers I have ever met." Each quilter appliquéd half of the quilt's border. The pair's needlework skills were so evenly matched that even Sherry finds it hard "to tell who did what."[279] The exacting *broderie perse* technique, often referred to as "cutout chintz appliqué," calls for the quiltmaker to cut out specific designs from patterned fabric, often large-scale chintz floral prints, and to arrange and appliqué them onto a neutral background. It is an old technique, too, one fashionable in the first half of the nineteenth century in chintz appliqué quilts from the Carolinas, Virginia, Pennsylvania, Maryland, and New Jersey. In *Log Cabin, Pineapple Variation* the appliqué stitch is visible only with very close inspection. Frances Yoder's hand quilting in the ten-inch border, at seven to eight stitches per inch, repeats the lush appliquéd floral and vine design, interrupted only by vertical parallel-line quilting.

The versatility of the Log Cabin pattern is beautifully showcased in this *Pineapple Variation*, which uses contrasting light and dark fabrics and five paired or opposing graduated logs with angled intersections to create a dynamic pattern. Continuity is provided through each block's central square of brown and tan fabric and the repetition of dark blue and pale tan angled strips. For some viewers, these pineapple shapes also resemble windmill or propeller blades in motion. Precise piecing is required to create this pattern. That Sherry and Joy achieved precision is perhaps best demonstrated by the excellent quality of the intersections where blue and tan right triangles meet to create squares across the face of the quilt.

**Log Cabin,
Pineapple Variation**

Sherry Cook, Stevenson,
Washington, and Joy
Nichols, Portland,
Oregon; quilted by
Frances Yoder, Guys
Mills, Pennsylvania,
dated 2005

Cotton:
89½ x 100 inches

Machine pieced, hand
appliquéd, hand quilted

2010-264

Gift of the Northwest
Fiber Arts Center,
Vancouver, Washington

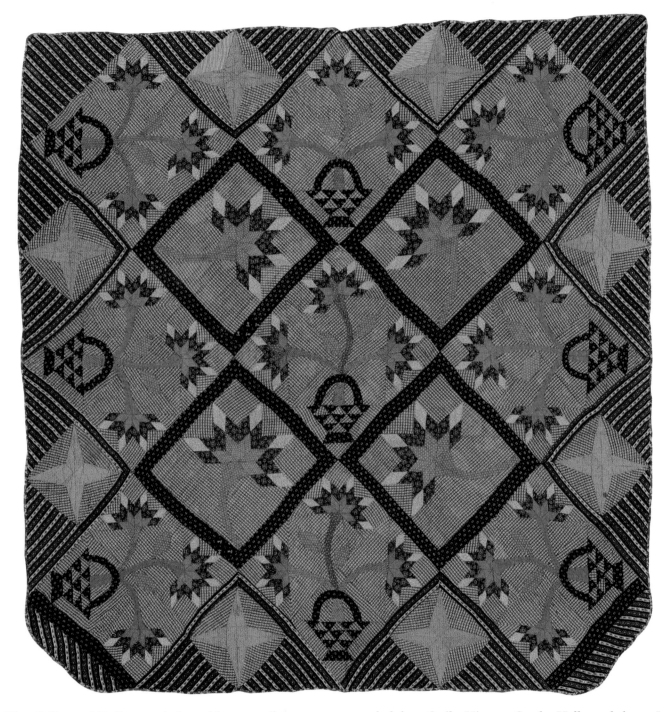

Lilies

Maker unknown, possibly
Pennsylvania, circa
1880–1885

Cotton: 75 × 76 inches

Hand pieced, hand
appliquéd, hand quilted

Katherine J. Adams Quilt
Collection, 2013-120-1

The Gallery of Quilts concludes with two quilts, one a reproduction of the other. *Lilies* and *Folk Art Lilies* bear witness to a very important person in my life with quilts and, in a larger sense, represent the bonds of friendship that a love of quilts can generate. Austin quiltmaker Kathleen Holland McCrady and I met in April 2001 when I attended her Quilt History Study Hall workshop. In fact, I attended the last class she held. Soon thereafter, and with gentle nudging from Karoline Bresenhan and Nancy O'Bryant Puentes, Kathleen and I discussed the merits of her donating portions of her Study Hall quilts and quilt history documentation to the Briscoe Center's

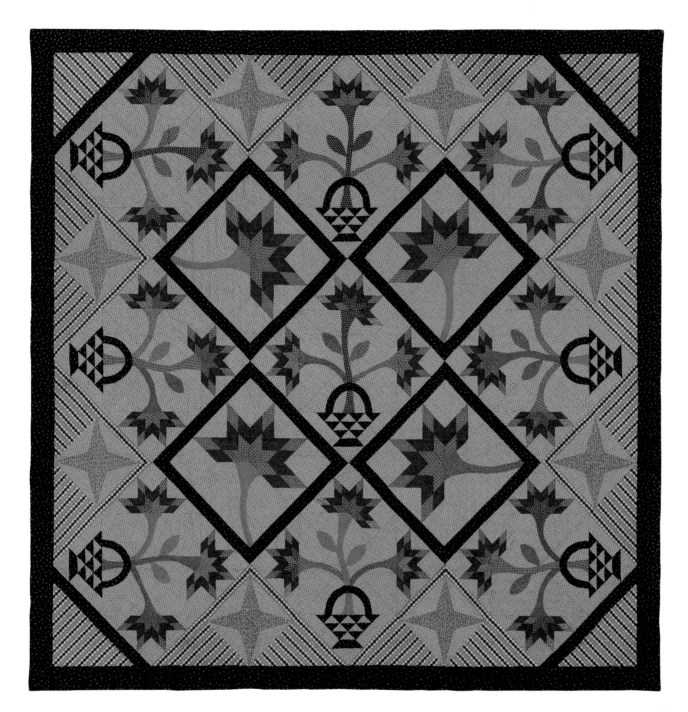

Folk Art Lilies

Kathleen Holland
McCrady, Austin,
dated 2009

Cotton: 81 x 81 inches

Hand pieced, hand
appliquéd, hand quilted

Katherine J. Adams Quilt
Collection, 2013-120-2

Winedale Quilt Collection as a way to preserve and share them, to broaden our collection, and to honor her. In 2002 Kathleen made her first significant donation, gifting both quilts and documentation and establishing the Kathleen H. McCrady Quilt History Collection. In the years that followed, Kathleen donated additional quilts and textiles to her collection, helped me sew sleeves on many quilts selected for exhibition, and stabilized several quilts in desperate need. When the center acquired the Joyce Gross Quilt History Collection in 2008, Kathleen joined me to review and describe dozens of spectacular quilts. Her sharp eye caught many details I missed.

Over the years it has been my pleasure to include quilts from Kathleen's collection in many of the center's annual quilt exhibitions at its Winedale Historical Complex. In 2008 I helped curate "Honoring Her Legacy: Kathleen McCrady's Quilt History Collection" to recognize Kathleen's extraordinary quilt collection and her lifetime of art, teaching, and sharing her love and knowledge of quilts. In addition to being my good friend, Kathleen has served as my personal quilt history mentor. Kathleen and I continue to meet occasionally for lunch, almost always with my pal and Kathleen's longtime friend Suzanne Labry, sometimes for burgers and malts at Top Notch Hamburgers near Kathleen's house.

I acquired a quilt, which I named *Lilies*, in 2008 at the International Quilt Festival in Long Beach, California—it was my first serious antique quilt purchase. I enjoyed the quilt for five years before donating it to the Briscoe Center. I showed *Lilies* to Kathleen, of course, and she used it to create her glorious reproduction *Folk Art Lilies*, which,

fittingly, is now part of the Winedale Quilt Collection as well. Both Kathleen and I were drawn to *Lilies* for the same reasons—its whimsy and quirkiness. Looking at the quilt, we both wondered about a quiltmaker who was so inventive and improvisational—so original. We asked one another, often, "What was she thinking?"

Lilies is a block quilt packed with pieced and appliquéd motifs: single and triple lilies on thick stems, baskets, four-pointed stars, thick block frames, and large triangles along the sides. The quilt's busy exuberance springs from this abundance and from its still-bright coppery madders and warm chocolate browns, double pinks, and over-dyed greens, plus from a variety of patterned fabrics that range from bold stripes to small-scale dress prints. Added to this mix is the quiltmaker's mystifyingly uneven needlework, so elegant and precise in some areas (the lily blooms of many pieced diamonds and their appliquéd stems and leaves are beautifully done) and haphazard in others. Consider, for example, the piecing of the brown and white check fabric patches that makes up the background of the floral blocks. In each block, this background is an assembly of many large and small scraps needed to accommodate the designs. Seventy-five different pieced and appliquéd designs are in each of the nine three-flower blocks, for example. Some are appliquéd onto the checked fabric, and others are joined by piecing. The quiltmaker did not (or could not) align the checks piece to piece, settling instead for a triumphant mismatch of pattern that delights. It's so quirky. Did two quilters create *Lilies*? Did a proficient quiltmaker piece the florals and then leave the quilt assembly to another, less expert seamstress? Kathleen and I do not know.

Perhaps the most unexpected design decision is the quiltmaker's orientation of the four single lilies, each one in a separate block that surrounds the central lilies-and-basket block. Most quiltmakers would have set the lilies in matched or mirrored pairs or in a sequenced arrangement. This quiltmaker did not. Kathleen and I mused about this many times. Although the lily blooms all turn toward the center block, the lily stems orientation—two vertical and two horizontal—confuses the eye, which seeks a more predictable order. This symmetry adds to the playful character of the quilt.

Lilies is a scrap quilt, and several of the fabrics may have been left from sewing projects. Small patches, some

in near-identical fabrics, others sharply contrasting, appear here and there, indicating that the quiltmaker lacked sufficient quantities of some to complete every portion of her project. The most obvious example is the gray and white striped fabric that replaces the brown and white checks in the star blocks at the quilt's top. Some fabrics may date from the 1870s or even earlier. These include the three different over-dyed greens, the madder browns, and the double pinks. The quilt's backing fabric, a bold purple stripe, has faded unevenly to brown, a victim of exposure to light and, probably, the quilt's repeated washings. The back also is made of remnants and scraps. It contains nine pieces in various sizes ranging from quilt-length panels to three-inch patches. The hand quilting, in white or brown thread, is stitched in simple diagonal parallel line and outline patterns at six to nine stitches per inch, with lines irregularly spaced. A single line of quilting in brown thread bisects each basket handle. The replacement narrow binding is hand sewn and applied.

Kathleen McCrady's *Folk Art Lilies* is a faithful reproduction of *Lilies*. Its meticulous construction demonstrates Kathleen's exquisite hand piecing, appliqué, and quilting skills. Kathleen had access to many fabrics, though she acknowledges, "It's hard to find fabrics that fully match fabrics in the original." Following the example the quiltmaker set in *Lilies*, she mixed six greens and featured the same brown patterned print in both baskets and block borders. Overall, *Folk Art Lilies* is brighter than the 1880s *Lilies*, but it retains the same color balance throughout. In both quilts, it is the brown-bordered lily blocks that catch the eye, drawing it to each flower's thick green stems and hefty blooms. Kathleen's main departure from the original quilt was her decision to square the bottom corners and add a 3¾-inch border.

The appeal of both quilts is the quirkiness of the pattern. As Kathleen noted, "The uniqueness and unusual setting just spoke to me to reproduce it." She confirms that she needed the original *Lilies* to draft her own ver-

Kathleen and Kate.
Photograph by Alex Labry.

sion—"With stems turned in different ways, and offsetting blocks having an unusual arrangement, I would never have figured it out without the real quilt. It was fun to make."[280]

Quilts bring people together. They brought Kathleen and me together long before I acquired *Lilies* and she made *Folk Art Lilies*. These two wonderful quilts will always remain tangible evidence of our friendship and the special bonds quilts can foster.

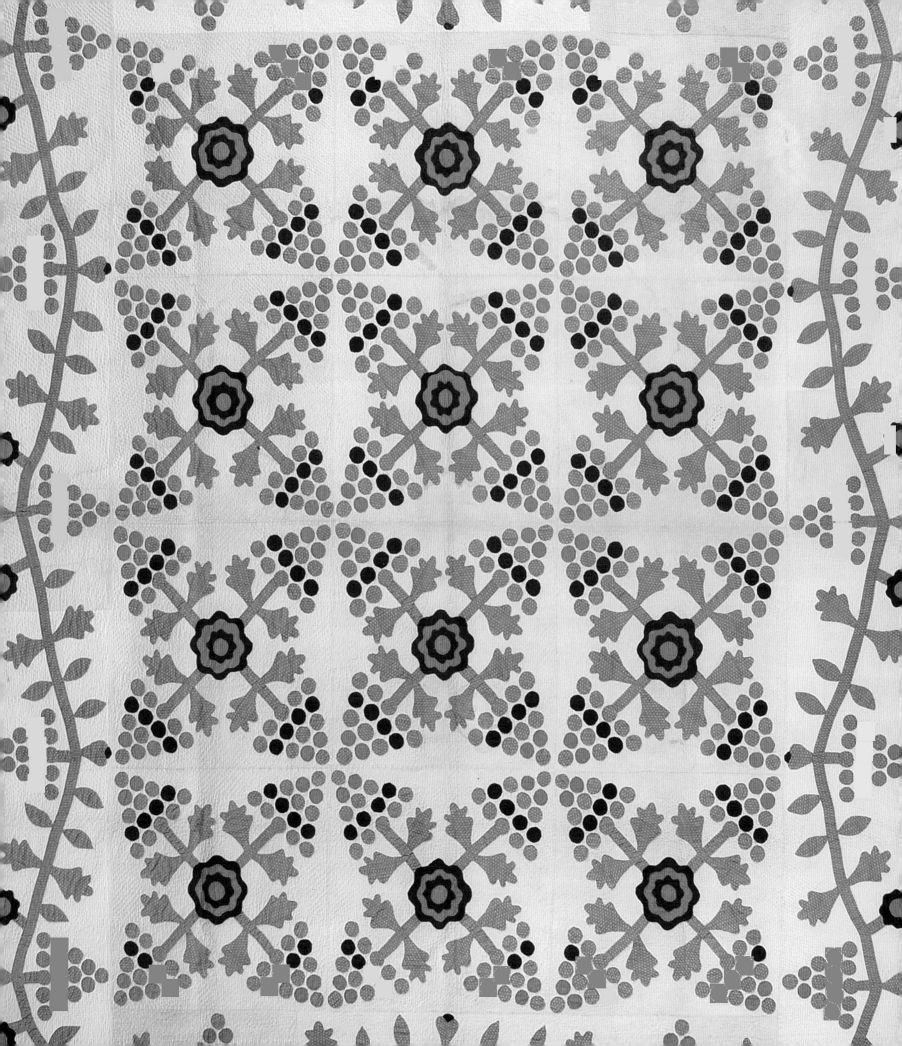

NOTES

Introduction

1. Portions of this description of Miss Ima Hogg appeared previously in a different form in *Miss Ima's Quilts, October 28, 2006–January 7, 2007*, published by the Bob Bullock Texas State History Museum to accompany its exhibition of the same name for which I was guest curator. Miss Hogg's generosity to the people of Texas extended beyond gifting Winedale to the University of Texas. She also donated, in 1957, her Bayou Bend home with its twenty-eight rooms of furnishings and fourteen acres to the Museum of Fine Arts, Houston, and her father's Varner-Hogg Plantation property in Brazoria County to the state in 1958.

2. For additional information about Miss Ima Hogg and Winedale's history, structures, furniture, and decorative arts objects, see the Briscoe Center's website, http://www.cah.utexas.edu/museums/winedale.php.

3. Lonn Taylor to Kate Adams, e-mails, August 20, 2007; October 8, 2012; February 10, 2015, Ima Hogg Quilt Collection Biographical File, Winedale Quilt Collection, hereafter cited as WQC.

4. Taylor to Adams, e-mails, August 20, 2007; October 8, 2012; February 10, 2015, Ima Hogg Quilt Collection Biographical File, WQC. The accession worksheet for Miss Hogg's *Irish Chain* notes, "Has a number of mud daubers on back & front—vacuumed & brushed, also photographed and rolled: 26 Aug 75." *Irish Chain* quilt file, W2h10.67, WQC.

5. The Quilt Index is a joint project of Michigan State University, and the Quilt Alliance to preserve and provide access to images and stories about quiltmakers, quilts, and quilting activities.

6. Kathleen McCrady describes her lifelong love affair with quilts in her book *My Journey with Quilts: Over 70 Years of Quiltmaking, 1932–2003* (Austin: McCrady Enterprises, 2005).

7. "Networking," photocopy of typed notes by Joyce Gross, n.d., Joyce Gross Quilt History Collection Biographical File, WQC.

8. Ruth Rucker Lemming, *The National Hotel* (Burnet, Tex.: Eakin Publications, 1982), 12.

Gallery of Quilts

1. Florence Peto, "Some Early American Crewelwork," *The Magazine Antiques*, May 1951, 387.

2. *Quilted Crewel* is not listed in Appendix A, the list of quilts associated with Florence Peto, in Barbara Schaffer et al., *A Passion for Quilts: The Story of Florence Peto, 1881–1970* (Livingston, N.J.: Heritage Quilt Project of New Jersey, 2011), 144–151.

3. At the author's request, quilt historian and WQC volunteer Kathy Moore conducted a microscopic fiber analysis of this quilt's top, back, binding, and quilting thread. Both of us expected this quilt to be made of linen, but Kathy's analysis showed that only the back contained linen fibers.

4. Florence Peto, *American Quilts and Coverlets* (New York: Chanticleer Press, 1949), 16.

5. L. M. A. Roy, "Old-Time Methods of Dyeing," *The Magazine Antiques*, June 1950, 452–453.

6. Before 1810, sewing thread in the United States was made from linen or silk. Manufactured cotton thread became available by 1810 and was marketed nationally by 1820. See Rachel Maines, "Paradigms of Scarcity and Abundance: The Quilt as an Artifact of the Industrial Revolution," in *In the Heart of Pennsylvania: Symposium Papers*, ed. Jeannette Lasansky (Lewisburg, Pa.: Oral History Traditions Project of the Union County Historical Society, 1986), 84–89.

7. Sources differ over Adam Orgain's status as free or enslaved. See "Adam Orgain: The First Settler of Hutto," Williamson County Historical Commission, n.d., http://www.williamson-county-historical-commission.org/Hutto/Adam_Orgian_THE_FIRST_SETTLER_OF_Hutto_Texas_in_williamson_county.html; Harvey Olander, "A Tombstone Named Orgain," *Hutto Herald*, November 6, 2003.

8. Mary Jaene Edwards, *Samplers and Samplermakers: An American Schoolgirl Art, 1700–1850* (New York: Rizzoli, 1991), 16–22.

9. Barbara Brackman, *America's Printed Fabrics, 1770–1890* (Lafayette, Calif.: C&T Publishing, 2004), 12, 24–25.

10. Florence Montgomery, *Printed Textiles: English and American Cottons and Linens, 1700–1850* (New York: Viking Press, 1970), 120, 126–141.

11. Linda Wyatt to Lonn Taylor, March 1, 1971, photocopy of a letter, *Evening Star* quilt file, W2h12.71, WQC.

12. Carolyn Ducey, *Chintz Appliqué: From Imitation to Icon* (Lincoln, Neb.: International Quilt Study Center, 2008), 10–12; Laurel Horton, "Quiltmaking Traditions in South Carolina," in Laurel Horton and Lynn R. Myers, *Social Fabric: South Carolina's Traditional Quilts* (Columbia: University of South Carolina McKissick Museum, n.d.), 11–14.

13. The two birds and single butterfly in this quilt appear identical to ones in the chintz appliquéd *Tree of Life*, 1790–1810 (IQSC 2007.034.0001), shown in Ducey, *Chintz Appliqué*, Plate 4, p. 19, and on the book cover. The birds in the Briscoe Center's *Chintz Appliqué Medallion* have been cut from their branch perches, which appear in the *Tree of Life* quilt in both the medallion and the borders. The chintz appliquéd flowers in the two quilts are not the same.

14. I am very grateful to quilt historians Merikay Waldvogel and Xenia Cord for untangling the history of the printed panels in *Chintz Appliqué Medallion*. Merikay examined the quilt on

February 20, 2015, at the Briscoe Center. The printed panel in the quilt's inner border corners was one she had not previously seen in her research on printed panels for chintz quilts. See Merikay Waldvogel, "Printed Panels for Chintz Quilts: Their Origins and Use," in *Uncoverings: Research Papers of the American Quilt Study Group*, vol. 24, ed. Lynne Zacek Bassett (Lincoln, Neb.: American Quilt Study Group, 2013), 101–131. With the help of Xenia, Merikay established where and when the panels were printed. See also Cyril G. E. Bunt and Ernest A. Rose, *Two Centuries of English Chintz, 1750–1950: As Exemplified by the Productions of Stead, McAlpin & Co.* (Leigh-on-Sea, U.K.: F. Lewis Publishers, 1957), Plate 44.

15. Helen and William had three children of their own in April 1833, when Helen inscribed this quilt. She also was pregnant with a fourth child, Rebecca Brockinton, who was born April 10, 1833, the day after she inscribed this quilt to Elizabeth.

16. The 1850 Federal Census records William Brockinton's occupation as a farmer and lists fourteen slaves, ages three months to fifty-seven years, as part of his property.

17. Elizabeth B. Hearne to Helen P. Salter, February 20, 1820, typescript of letter housed at the Darlington County Historical Commission, Darlington, S.C., typescript sent by e-mail by Doris G. Gandy to Mary Evelyn Sorrell, January 6, 2009, *Chintz Appliqué Medallion* quilt file, 2009-038, WQC.

18. Ruth Thomas to Mary E. Sorrell, e-mail, October 30, 2008, *Chintz Appliqué Medallion* quilt file, 2009-038, WQC.

19. Ibid.

20. Schaffer et al., *Passion for Quilts*, 72.

21. Ibid., 150; Data sheet, *Baltimore Star* quilt file, W2h001.023.2008, WQC; "Heirloom Quilts: Bright Accents for Today's Living," *The American Home*, November 1960, 27.

22. Schaffer et al., *Passion for Quilts*, 144–151.

23. Ruth E. Finley, *Old Patchwork Quilts and the Women Who Made Them* (Philadelphia: J. B. Lippincott, 1929), Plate 73, p. 133.

24. Mrs. L. V. Wallace to the Memorial Museum, University of Texas, September 23, 1965, photocopy of a handwritten letter, *Rose of Sharon* quilt file, TMM 2012.1, WQC.

25. Schaffer et al., *Passion for Quilts*, 73–74; 144–151; Florence Peto, *Historic Quilts* (New York: American Historical Company, 1939), xiii.

26. Data sheet, *Nine Block Appliqué Sampler* quilt file, W2h001.031.2008, WQC.

27. This date is based on information in a letter Peto wrote on December 30, 1948, to her friend and fellow quiltmaker Emma Andres of Prescott, Arizona. In it, Peto states that the *Album with Dogs and Birds* top "has been in my possession for 14 years! It was the first quilt I ever bought from Abigail." Florence Peto to Emma Andres, December 30, 1948, photocopy, Joyce Gross Quilt History Collection, 2008-013/149.

28. Peto, *Historic Quilts*, Plate 21a, p. 31; Peto, *American Quilts and Coverlets* (New York: Chanticleer Press, 1949), Plate 48, pp. 158–159.

29. Kate Adams to Karey Bresenhan; Bresenhan to Adams, e-mails dated May 7, 2008, in *Album with Dogs and Birds* quilt file, W2h001.024.2008, WQC. The Index of American Design, the New Deal arts project that documented American decorative and utilitarian design through the late nineteenth century, recorded this quilt top through description and artistic rendering. *Album with Dogs and Birds* is located in the microfiche version of the index in the section on Textiles, Costumes, and Jewelry, fiche no. 49C2, *Untitled Quilt Top*, 1850–1900, York, Pa.

30. Peto, *Historic Quilts*, 159; Peto, *American Quilts and Coverlets*, 31.

31. Peto, *Historic Quilts*, 159.

32. Ibid.

33. Ibid., 160.

34. Ibid., 162.

35. See Ducey, *Chintz Appliqué*; and Kay Triplett, Lori Lee Triplett, and Xenia Cord, *Chintz Quilts from the Poos Collection* (La Castillerie, France: Quiltmania, 2013).

36. Information about the Quick family comes from U.S. Census records for 1850–1880; "Guide to the Papers of the Quick-Garretson Family, 1745–1904," 2004, New Jersey Historical Society, Newark; "VanderVeer Genealogy," http://www.veerhuis.org/; "Sarah V. C. Quick," http://www.findagrave.com/; and "Six Mile Run Historic District," in *Somerset County Cultural and Heritage Commission, Historic Sites and Districts in Somerset County, New Jersey*, 2005, http://www.co.somerset.nj.us./pdf/NationalRegisterBookWEB.pdf.

37. The Heritage Quilt Project of New Jersey, *New Jersey Quilts, 1777 to 1950: Contributions to an American Tradition* (Paducah, Ky.: American Quilter's Society, 1992), 18, 68–69, 93–96; Linda Otto Lipsett, *Remember Me: Women and Their Friendship Quilts* (San Francisco: Quilt Digest Press, 1985), 16–30. See also *Pieced and Appliquéd Friendship Quilt Top*, ca. 1843–1844, attributed to an unknown New England quiltmaker, in Jeremy Adamson, *Calico and Chintz: Antique Quilts from the Collection of Patricia S. Smith* (Washington, DC: Renwick Gallery of the National Museum of Art, Smithsonian Institution, 1997), 118.

38. *New Jersey Quilts*, 28–33; Rita Erickson to Louise O. Townsend, April 29, 1993, photocopy of a typed letter, *Oak Leaf and Reel* quilt file, W2h001.053.2008, WQC.

39. "Biographical Sketch of Homer Eachus," in Samuel T. Wiley, *Biographical and Portrait Cyclopedia of Chester County, Pennsylvania* (Philadelphia: Gresham Publishing Company, 1893), 509–510; Jim Jones, "Josiah Hoopes," Friends Burial Society Project, 1995, http://www.purple-martin.org/Hoopes Biography.doc; "Cumberland Burial Ground," Delaware County History, n.d., http://www.delawarecountyhistory.com/middletowntownship.

40. John Bunyan, *The Pilgrim's Progress: From This World to That Which Is to Come*, ed. Roger Foley (London: Penguin Books, 2008), 122.

41. "Appendix A: Antique Quilts," in Schaffer et al., *Passion for Quilts*, 14.

42. Manuscript notes by Mrs. J. N. Kaderli, San Antonio, n.d., *Album Patch* quilt file, W2h114.2007, WQC.

43. Greg J. Hansen et al., "Troup Factory: Archaeological Investigation of a Nineteenth Century Mill Site in LaGrange, Georgia," *Georgia Journal of Science* 68, no. 2 (2010): 1–2; Anita Zaleski Weinraub, ed., *Georgia Quilts: Piecing Together a History* (Athens: University of George Press, 2006), 130–131; Susan W. Greene, *Wearable Prints, 1790–1860: History, Materials, and Mechanics* (Kent, Ohio: Kent State University Press, 2014), 50–51.

44. Greene, *Wearable Prints*, 64.

45. Manuscript statement (torn) by Lena Dancy Ledbetter, n.d., Lena Dancy Ledbetter Papers, 2E353.

46. Ruth E. Finley, *Old Patchwork Quilts and the Women Who Made Them* (Philadelphia: J. B. Lippincott Company, 1929), 31.

47. Ibid., Plate 33, p. 82.

48. Quilt donor Rebecca Phelps prepared "History of the Family 'Slave' Quilt," a review of her family's history, genealogy, and oral tradition relating to *Burgoyne Surrounded*. A copy is in *Burgoyne Surrounded* quilt file, 2010-038, WQC.

49. William Rush Dunton, Jr., *Old Quilts* (Catonsville, Md.: n.p., 1946), 17–177; Dena S. Katzenberg, *Baltimore Album Quilts* (Baltimore: Baltimore Museum of Art, 1981), 60–65; Roderick Kiracofe, *The American Quilt: A History of Cloth and Comfort, 1750–1950* (New York: Clarkson Potter, 1993), 92–93.

50. "Table of Contents," *Quilt World* 6, no. 6 (November–December 1981): 6; John Rice Irwin, *A People and Their Quilts* (Exton, Pa.: Schiffer Publishing, 1983), 51. Sharon Spigel of Timeless Blossoms, Nashville, Tennessee, assisted in this sale and gathered genealogical and historical information relating to the quilt and the persons whose names are inscribed on it. This information is housed in Baltimore Album Quilt Research Project files, Joyce Gross Quilt History Collection, 2008-013/43.

51. Irwin, *A People and Their Quilts*, 51.

52. Francis P. O'Neill to Sharon Spigel, August 11, 1991, and September 7, 1991, typed letters, Baltimore Album Quilt Research Project, Joyce Gross Quilt History Collection, 2008-013/43. Sometime after 1981, Joyce Gross and several colleagues, including quilt historian Cuesta Benberry, undertook a project to identify and catalog every Baltimore Album quilt they could locate. They created an identification system based on the number of blocks in each quilt's grid and whether the quilt contained sashing and border. By 1996 they had created files for 395 BAQs. These files, named the Baltimore Album Quilt Research Project, are part of the Briscoe Center's Joyce Gross Quilt History Collection, 2008-013/29, 2008-013/43, 2008-013/44, and 2008-013/55.

53. Kathryn Ledbetter, "Textiles, Print Culture, and Nation Building in the 1840s," in *Uncoverings: Research Papers of the American Quilt Study Group*, vol. 33, ed. Lynn Zacek Bassett (Lincoln, Neb.: American Quilt Study Group, 2012), 89–113. Dr. Ledbetter's thorough analysis of this historically important comforter includes her comparison of it with a similarly patterned whole-cloth chintz quilt at the Winterthur Museum in Wilming-

ton, Delaware. I am very grateful to Dr. Ledbetter for sharing her research with me and for broadening my understanding of the rare fabrics in this bedcover.

54. Ibid., 94–96.

55. "Annville Historic District," n.d., http://www.living places.com/PA/Lebanon_County/Annville_Township/Annville _Historic_District.html.

56. Several studies investigate the popularity and construction of the traditional Princess Feather pattern. See, for example, Carol Williams Gebel, "The Princess Feather: Exploring a Quilt Design," in *Uncoverings: Research Papers of the American Quilt Study Group*, vol. 28, ed. Joanna E. Evans (Lincoln, Neb.: American Quilt Study Group, 2007), 129–164, in which she reviewed 370 examples of this pattern.

57. Florence Peto to Elizabeth Richardson, October 7, 1948, photocopy of a letter, Joyce Gross Quilt History Collection, 2008-013/149.

58. Margaret A. Nash, *Women's Education in the United States, 1780–1840* (New York: Palgrave Macmillan, 2005), 82–91.

59. For a discussion of the history and construction of the Pot of Flowers pattern and a list of known examples, see Connie J. Nordstrom, "One Pot of Flowers Quilt Pattern: Blossoming through Centuries," in *Uncoverings: The Research Papers of the American Quilt Study Group*, vol. 23, ed. Virginia Gunn (Lincoln, Neb.: American Quilt Study Group, 2002), 31–64.

60. Pamela Weeks, "One Foot Square, Quilted and Bound: A Study of Potholder Quilts," in *Uncoverings: Research Papers of the American Quilt Study Group*, vol. 31, ed. Laura Horton (Lincoln, Neb.: American Quilt Study Group, 2010), 131–157.

61. Ibid., 136.

62. Ibid., 138–140.

63. Photocopy of a typed note "supplied by Brigadier Gen'l Frederick Butler 18–25th Ave 10/74," in *Paisley Hearts* quilt file, W2h001.061.2008, WQC; U.S. Census records for 1870 and 1880 identify a Mary and Francis Patrick Butler who moved to San Francisco after the birth of a daughter in Massachusetts. Both parents were born in Ireland; "Jan 28, 1855: First Train Crosses the Panamanian Isthmus," n.d., http://www.history.com/ this-day-in-history/first-train-crosses-the-panamanian-isthmus.

64. W. P. E. from Columbia, Ohio, inked this inscription, dating it February 9, 1850.

65. The inscriptions quoted were written by the following persons: the "distant friend" is G.M.W., Cincinnati; I.P.A. of New Orleans penned his inscription on July 11, 1850; the inscription referring to the quilt came from "your sincere friend E.C.B."; and the short poem concerning the possibility of Virginia being "taken from our grasp" was from her niece, Jenny, dated March 9, 1851.

66. Another possibility is that Virginia Reiley died young, perhaps shortly after receiving the quilt, and that her mother saved the quilt as a reminder of her daughter. At some point this quilt moved out of the Reiley family. Austin quiltmaker and historian Kathleen McCrady acquired the quilt in Texas in 2000.

67. Governor Treutlen Chapter, Daughters of the American Revolution, *History of Peach County, Georgia* (Atlanta: Cherokee Publishing Company, 1972); "W. G. Vinson Family: South Carolina & Alabama," n.d., http://www.next1000.com/family/EC/vinson.wg.html.

68. "Joanna Troutman," *Online Handbook of Texas*, n.d., http://www.tshaonline.org/handbook/online/articles/ftr13; Henry David Pope, *A Lady and A Lone Star Flag: The Story of Joanna Troutman* (San Antonio: Naylor, 1936), 10–28. Henry Pope, the great grandson of Joanna Troutman, states that Joanna made her flag in the upstairs room of her father's inn with the help of other young women in the area. The flag, says Pope, was made out of "one or more of the voluminous skirts worn by the women of that period" (10–11). See also newspaper clippings in the Briscoe Center's Joanna Troutman Papers, Box 2H81.

69. The famed sculptor Pompeo Luigi Coppini (1870–1957) was born in Italy but immigrated to the United States in 1896, coming to Texas in 1901. His thirty-six public monuments in the United States include sculptures on the grounds of the State Capitol and at the University of Texas at Austin.

70. Nancy O'Bryant Puentes and Karoline Patterson Bresenhan acquired the *Troutman Quilt* from Wyolene P. Bivins, the granddaughter of Ellen Roberta Vinson Hartley and the last Troutman–Vinson–Hartley family member to own the quilt. In her final years, Ellen Hartley lived with her granddaughter's family, hence Wyolene Bivins heard stories about the *Troutman Quilt* much of her life: "I was told by older family members that the quilt was a gift to my grandmother from Joanna and her family." Mrs. Bivins didn't see the quilt until about 2008 but noted, "Upon my grandmother's [Ellen Vinson Hartley] death [in 1951], I understand that the quilt remained in my mother's linen closet until her death in 1979. At that time my brother took it and had it until [about 2005–2008], when he gave it to me." Wyolene Bivins to Julie Maffei, e-mail forwarded to Kate Adams, July 30, 2013; Wyolene Bivins to Kate Adams, e-mail, August 6, 2013, *Troutman Quilt* quilt file, 2013-214, WQC.

71. Lorena Hillyer Fox, "Monument Honors Joanna Troutman as Creator of Texas Flag," in Otis Hartley Ogburn, *The Hartley-Vinson Family History* (Harker Heights, Tex.: O. H. Ogburn, 1992), 97–99. The Troutman Inn was still in use in 1913, but it burned down in 1928. Elmwood remained standing until 1970, when it was disassembled but never rebuilt. See Billy Powell, "The Vanished Town of Hammett," n.d., http://www.thegagenweb.com/gacrawfo/Cities/hammett.htm.

72. "Crawford County, Georgia, Largest Slaveholders from 1860 Slave Census Schedules," n.d., http://freepages.genealogy.rootsweb.ancestry.com/~ajac/gacrawford.htm.

73. Fox, "Monument Honors Joanna Troutman," 98.

74. William Green Vinson was one of nine children of Henry and Sarah Reid Vinson, and the only one not born in Crawford County, Georgia. Descendants of Henry and Sarah were associated with that county at least through 1955. Ellen Vinson's father was John Fletcher Vinson (1827–1863). He died from illness during the Civil War. See "Vinson-L Archives," April 4, 2007, http://archiver.rootsweb.ancestry.com/th/read/VINSON/2007-04/1175699258.

75. Wyolene Bivins to Kate Adams, e-mail, August 6, 2013, *Troutman Quilt* quilt file, 2013-214, WQC. Mrs. Bivins had the netting applied over the initial during her ownership of the quilt, from about 2008 to 2013.

76. Quilt donor Sherrill G. McCullough provided family genealogical information with this quilt. See *Double Irish Chain* quilt file, 2012-254, WQC; and "Harris-Hunter-L Archives," July 21, 1998, http://archiver.rootsweb.ancestry.com/th/read/HARRIS-HUNTERS/1998-07/0901027586.

77. Details about Aunt Patsy's and Mary Ann Ellington's history are contained in records acquired and generated at the time of the quilts' acquisition by the University of Texas in 1990. These include a collection of short questions and answers supplied by donor Mrs. Margaret Alexander Steiner of Gonzales, Texas. See *Carolina Lily* quilt file, TMM 2592-1, WQC.

78. Mrs. Thomas William Steiner to the Texas Memorial Museum, University of Texas, February 14, 1990, photocopy of letter, *Carolina Lily* quilt file, TMM 2592-1, WQC.

79. William C. Griggs, *The Elusive Eden: Frank McMullan's Confederate Colony in Brazil* (Austin: University of Texas Press, 1987) is the definitive study of the McMullan Colony, including the colony's organization, harrowing voyages, and settlement in Brazil.

80. Mrs. Harry Joseph Morris, *Citizens of the Republic of Texas* (Dallas: Texas State Genealogical Society, 1977), 65.

81. "Rusk County," *Online Handbook of Texas*, n.d., http://www.tshaonline.org/handbook/online/articles/hcr12, accessed May 7, 2013; Morris, *Citizens of the Republic of Texas*, 65.

82. Griggs, *Elusive Eden*, 12-17; and "Sarah Bellona Ferguson List, May 29, 1935," in ibid., App. B, p. 153.

83. Ibid., 43–66, 71–72; "Find a Grave Memorial," n.d., http://www.findagrave.com/cgi-bin/fg.cgi?page=gr&GRid=109686277 (Amanda Hammonds Linn) and http://www.findagrave.com/cgi-bin/fg.cgi?page=gr&GRid=109698837 (George Alwin Linn).

84. Griggs, *Elusive Eden*, 76–86.

85. Passenger Lists of Vessels Arriving at New Orleans, Louisiana, 1820–1902, Microfilm publication M259, Roll 52, Record Group 36, National Archives, Washington, D.C.

86. In 1984 or 1985 a professional textile conservator and members of the Austin Area Quilt Guild conserved this quilt, as well as others now in the Winedale Quilt Collection. Treatment of Amanda's worn and fragile *Lone Star* quilt included patching and covering worn and fragile areas with silk netting.

87. "Sarah Bellona Ferguson List, May 29, 1935," in Griggs, *Elusive Eden*, App. B, p. 153.

88. Harry McCarthy's popular sheet music "The Bonnie Blue Flag": (New Orleans: A. E. Blackmar & Bro., circa 1861) is illustrated on its cover with the two flags similarly crossed.

89. Mary Decker to Kate Adams, e-mails, August 28 and October 20, 2014, *Mosaic* quilt file, 2014-063, WQC. Mary C.

Decker and Cheryl Denney, descendants of quiltmaker Mary E. Perry, generously supplied details of Perry's life and continue to research Perry and her family.

90. Virginia Singletary to Kate Adams, e-mail, September 9, 2014, *Mosaic* quilt file, 2014-063, WQC; Edith Stribling to Grady Carlton, January 23, 1991, photocopy of a letter, *Mosaic* quilt file, 2014-063; Mary Decker to Kate Adams, e-mail, April 8, 2014, *Mosaic* quilt file, 2014-063; Deborah Lovett Burkett, *Quilts and Their Stories: Binding Generations Together: Journal of a Small Town Quilt Show* (Jacksonville, Tex.: Creative Graphics of Texas, 2012), 252–254.

91. Deborah Burkett to Kate Adams, e-mail, October 21, 2014, *Mosaic* quilt file, 2014-063, WQC.

92. Bolling note, typed, *Rose with Oak Leaves and Lilies* quilt file, W2h81.06, WQC.

93. *Goodspeed's Biographical and Historical Memoirs of Western Arkansas, 1891, Pope County*, http://freepages.genealogy.rootsweb.ancestry.com/~jblaney/gdspd2.html#D.%20C.%20Brown.

94. "The Brown Sisters' Quilts," typed notes relating to the Brown family history, *Rose with Oak Leaves and Lilies* quilt file, W2h81.06, WQC.

95. *Goodspeed's Biographical and Historical Memoirs*, http://freepages.genealogy.rootsweb.ancestry.com/~jblaney/gdspd2.html#D.%20C.%20Brown.

96. "The Brown Sisters' Quilts," *Rose with Oak Leaves and Lilies* quilt file, W2h81.06, WQC.

97. *Variable Star Crib Quilt* quilt file, 2010-019, WQC. See also the Charles H. Miller Family Papers, 2012-182, and the Charlene Miller and Edna Toland Collection, 2015-080, for additional information documenting Herr-Miller family history and genealogy.

98. E. P. Shaw to Dr. W. S. Barnes, April 3, 1864, photocopy of typed transcript of a letter, *Prairie Rose* quilt file, 2012-093, WQC.

99. Typed text of a written note card in possession of quilt donor Colleen Barnes, as copied by Kate Adams, January 25, 2012, *Prairie Rose* quilt file, 2012-093, WQC.

100. Colleen Barnes to Kate Adams, e-mail, June 27, 2012, *Prairie Rose* quilt file, 2012-093, WQC.

101. Lonn Taylor, "The McGregor-Grimm House at Winedale, Texas," *The Magazine Antiques*, September 1975, 515–521.

102. Biographical information for Mary Ann Pumphrey DeSellem and her family, including dates, is a composite of several sources available online through http://www.ancestry.com/, including U.S. Census records, 1870–1940; California Death Index, Ohio Birth and Christenings Index, 1800–1962; and Glendale, California, City Directory.

103. "Germans," *Online Handbook of Texas*, n.d., http://www.tshaonline.org/handbook/online/articles/png02.

104. Kathleen McCrady kept meticulous records of the quilts and other textiles and objects she acquired for use in her Quilt History Study Hall, her home studio in which she offered free quilt history classes. In her record for *Ocean Waves* Kathleen recorded "Good example of double pinks, chrome yellow, and green. Dark brown border unusual color." Kathleen H. McCrady Quilt History Collection file 2006-074, WQC.

105. Ellen Lockwood to Lynn Bell, e-mail, April 22, 2010, *Snowflake* quilt file, 2010-115, WQC. This e-mail contains Ellen Lockwood's research on the Wheelock family.

106. Lockwood to Bell, e-mail, April 22, 2010; "Wheelock, Texas," *Online Handbook of Texas*, http://www.tshaonline.org/handbook/online/articles.hlw29; Mary Foster Hutchinson, *Texian Odyssey: The Life and Times of a Forgotten Patriot of the Republic of Texas, Colonel Eleazar Louis Ripley Wheelock* (Austin: Eakin Press, 2003), 235–236.

107. Ellen Lockwood to Kate Adams, e-mail, May 6, 2010, *Snowflake* quilt file, 2010-115. The Briscoe Center also houses the Eleazer Louis Ripley Wheelock Papers, 1814–1935, and the Samuel Blackburn Killough Republic of Texas Army Commission, 1844.

108. Patricia Herr, *Quilting Traditions: Pieces from the Past* (Atglen, Pa.: Schiffer Publishing, 2000), 84–91.

109. Lockwood to Bell, e-mail, April 22, 2010.

110. Sarah Mehettable Baker Shannon to Effie Shannon Porter, handwritten postcard, Fort Worth, March 28, 1932, in *Feathered Star* quilt file, 2014-157, WQF.

111. Details of the William Thatcher Baker family's history and genealogy are in Kathryne Baker Witty and Alma Baker Rea, *The William Thatcher Baker Family, 1830–1971, Biography and Genealogical Records* (n.p., 1971).

112. Carol Williams Gobel, "The Princess Feather: Exploring a Quilt Design," in *Uncoverings: Research Papers of the American Quilt Study Group*, vol. 28, ed. Joanna E. Evans (Lincoln, Neb.: American Quilt Study Group, 2007), 129–164.

113. "Miss Lucy Kendall," obituary in the *Eastern Gazette*, Abbott, Maine, December 31, 1931, p. 5, http://www.abbott-library.com/readobit.php?obitid=4100.

114. "Roman Stripe" in "Great Quilts and Quilters I Have Known," draft caption for International Quilt Festival, Houston, 2005, *Roman Stripe* quilt file, W2h001.064.2008, WQC.

115. Other names for the pattern of this quilt are All Hands Around, Captive Beauty, Heavenly Stars, and Stars and Cubes. Barbara Brackman, *Encyclopedia of Pieced Quilts* (Paducah, Ky.: American Quilters Society, 1993), 460–461.

116. Marcia Kaylakie, description and notes on *Yankee Pride*, October 1, 2013, *Yankee Pride* quilt file, 2013-230-1, WQC.

117. Evidence suggests that Dr. William J. Shumatte was related to the quiltmaker. In correspondence documenting the quilt's gift to the University of Texas in 1949, donor Mary Dill Woodson (Louise Murray Dill's daughter) refers to another object, an Indian scabbard, among the items she donated. She notes that the scabbard was "made by a tribe of East Texas Indians near Palestine Texas and given by one of them to my grandfather—Dr. Wm. J. Shumatte in the early 1800s." The author's search of U.S. Census records could not confirm this relationship. The term

NOTES TO PAGES
111–146

"grandfather," as used here by the quiltmaker's daughter, may be one of affection rather than one confirming a blood relationship. However, both the Murray family and Dr. Shumatte moved to Texas from Tennessee. Shumatte may have been related to Alexander Murray's wife, whose name is unknown. Mrs. W. W. Woodson to E. H. Sellards, March 24, 1949, photocopy of letter, in *Crazy Quilt with Ruffle* quilt file, TMM 925.2, WQC.

118. The Palestine Female Institute was chartered in 1858. Despite its name, by the mid-1870s the institute enrolled male and female students, offering them literary, art, and music courses. U.S. Census records for 1870 list Louise and Sarah Murray as "at school." The girls then would have been eighteen and sixteen years old and may have boarded there.

119. Mrs. W. W. Woodson to E. H. Sellards, March 24, 1949, photocopy of letter, *Crazy Quilt with Ruffle* quilt file, TMM 925.2, WQC.

120. Barbara Brackman, "Quilts at Chicago's World's Fairs," in *Uncoverings 1981: Research Papers of the American Quilt Study Group*, ed. Sally Garoutte (Mill Valley, Calif.: American Quilt Study Group, 1982), 63–75.

121. "Farm House Breakfast," handwritten manuscript by Mildred P. Mayhall, Mildred P. Mayhall Papers, Box 3U26.

122. Notes from telephone conversation, Kate Adams and Sharon Voudouris-Ross, October 16, 2013, *Thomason Family Quilt* quilt file, 2010-175, WQC.

123. "William Dowdy Family, 1800–1994, Prepared by Leonard I. Dowdy from Information Provided by Family Members," 1994, *Thomason Family Quilt* quilt file, 2010-175, WQC.

124. "The Thomason Clan 2003 Spring Fling," poster invitation, *Thomason Family Quilt* quilt file, 2010-175, WQC.

125. Cynthia Leach to Kate Adams, e-mail, August 3, 2011, Eva Lea Leach Quilt Collection File, 2010-152, WQC. Mission Valley Textiles, founded in 1921 as Planters & Merchants Mill, at one time employed more than six hundred workers to manufacture yarn-dyed woven fabrics. The mill closed in 2004, a victim of consolidation with another plant and the flood of cheap imports. "Plant with a Mission," *Horizons 2001: Business and Industry*, March 22, 2001; Roger Croteau, "New Braunfels (TX) Textile Mill Lays Off 48 More Workers," *Free Republic*, February 6, 2004, http://www.freerepublic.com/focus/f-chat/1074444/posts.

126. Cheri Wolfe, "Notes from Conversation with Lucy Meserole," November 11, 1985, *Cracker* quilt file, TMM 2515.1, WQC. The author visited the construction site at 500 West 2nd Street in March 2015. Signage there also announced the North Shore, a luxury apartment complex under construction.

127. Sanborn Fire Insurance Company Maps, Austin, 1900, Sheet 42, and Austin, 1935, Sheet 12; Michael Barnes, "Seven Generations of Schneiders Helped Shape Austin," *Austin American Statesman*, February 8, 2015, D1, D4-5; David C. Humphrey, *Austin: An Illustrated History* (Northridge, Calif.: Windsor Publications, 1986), 268–269; "Austin's Guy Town," *History House: An Irreverent History Magazine*, n.d., http://www.historyhouse.com/in_history/guy_town/.

128. Wolfe, "Notes from Conversation with Lucy Meserole."

129. "Lucy Rossi Meserole: Obituary," *Austin American-Statesman*, July 13, 2011, http://www.legacy.com/obituaries/statesman/obituary.aspx?n=lucy-rossi-meserole&pid=152519811. Lucy Rossi Meserole's obituary names her parents as Aplo Vito and Virginia Rossi. Lucy lived in Austin her entire life. She married Joe Meserole in 1928, and the couple had eight children. Both Lucy and Joe Meserole are buried in Austin's Mt. Calvary Cemetery, as are Josephine and Louis Starr and their son Peter.

130. Wolfe, "Notes from Conversation with Lucy Meserole."

131. Ibid.

132. Barnes, "Seven Generations of Schneiders Helped Shape Austin," D4.

133. Deborah Harding, *Red and White: American Redwork Quilts* (New York: Rizzoli International Publications, 2000), 34–35, 38, 108–109, 117.

134. Sally Helvenston, "From Feathers to Fashion," *Michigan History Magazine* 5 (September–October 1996): 31–35.

135. The Winedale Quilt Collection's hand-pieced and hand-quilted 1978 example of the *Double Wedding Ring* made by Virginia McDaniels of Topaz Lake, Nevada, attests to the pattern's ongoing popularity. See *Double Wedding Ring*, Virginia McDaniels Quilt Collection, 2013-226-1. For a review of the probable earlier origins of the pattern, see Robert Bishop, *The Romance of Double Wedding Ring Quilts* (New York: E. P. Dutton in association with the Museum of American Folk Art, 1989), 1–10.

136. *Log Cabin, Straight Furrow*, by Martha Offutt Mayhall, Taylor, Texas, circa 1899–1905, gift of Temple B. Mayhall, TMM 2490.3, WQC.

137. Martha Day Mullins, *A History of the Woman's Club of Fort Worth, 1923–1973* (Fort Worth: Evans Press, 1973), 35–36, 102–104.

138. Kate Adams interview with Martha Ingram McCormick, July 3, 2012, notes in *Woman's Shakespeare Club Friendship Quilt* quilt file, 2012-195, WQC.

139. Kate Adams interview with Dr. Jeanne Lagowski, May 14, 2013, notes in *Boudoir Quilt and Sham* quilt file, 2009-143, WQC; Dr. Lagowski also supplied a copy of the plaque "Mrs. Josephine Emma Wecker Mund, B.A." that graces the Dupo Community High School Library, Dupo, Illinois. Plaque copy in *Boudoir Quilt and Sham* quilt file, 2009-143, WQC.

140. Virginia Gunn, "Quilts for Milady's Boudoir," in *Uncoverings: Research Papers of the American Quilt Study Group*, vol. 10, ed. Laurel Horton (San Francisco: American Quilt Study Group, 1990), 82–90.

141. Minna Hackett, "Bedroom Embroideries, Easy to Do and Extremely Good-Looking," *Needlecraft Magazine*, March 1929, 10–11, 34.

142. Adams interview with Dr. Lagowski, May 14, 2013.

143. I am indebted to Marilyn Goldman of Selma, Indiana, for generously sharing her research on the Wilkinson Quilt Company and for her thoughts concerning the Briscoe Center's

Forget-Me-Not quilt and its relationship to that company. Marilyn Goldman to Kate Adams, letter, December 29, 2010; Goldman to Adams, letter, May 15, 2013; Goldman to Adams, e-mail, May 28, 2013, in *Forget-Me-Not* quilt file, 2010-296-14, WQC; Marilyn Goldman, "The Wilkinson Quilt Company: 'America's Original Makers of Fine Quilts,'" in *Uncoverings*, vol. 23, ed. Gunn, 131–161.

144. Wilkinson Catalog, circa 1920, as quoted in Goldman, "Wilkinson Quilt Company," 142; see also 144–152.

145. "Wilkinson Art Quilts, *Harper's Bazaar*, October 1929, 198.

146. "Mrs. Minnie Rucker Presents Garner with Quilt," *The Franklin Texan*, Franklin, Tex., n.d., photocopy in *Texas Star* quilt file, 2007-151-7, WQC. Until recently, this quilt was housed at the Briscoe Center's Briscoe-Garner Museum, which is dedicated to the remarkable lives of John Nance Garner and Dolph Briscoe, both Uvalde natives and historically important political figures from Texas. In 1982 Ruth Rucker Lemming published *The National Hotel*, her reminiscences about her mother's hotel in Franklin, Texas. In the book she describes her mother making and sending a *Texas Star* quilt to Roosevelt: "She sent a Star of Texas as a gift to F. D. Roosevelt in the White House; Mama treasured the letter of thanks she received signed 'Eleanor.'" Lemming, *National Hotel*, 12. Roosevelt Presidential Library Museum Collections Manager Michelle Frauenberger, however, confirmed that the library does not own a quilt with the *Texas Star* name or any correspondence from Eleanor Roosevelt relating to this quilt's receipt. It seems likely that Minnie Rucker made only one quilt, which she sent to Garner. Her daughter probably misidentified the Garner *Texas Star* quilt gift and the letter of acknowledgment from Ettie Garner for a *Texas Star* quilt made for Roosevelt. Kate Adams to Michelle Frauenberger, e-mail, January 29, 2014, *Texas Star* quilt file, 2007-151-7, WQC.

147. *The Franklin Texan*, Franklin, Texas, n.d., photocopy in *Texas Star* quilt file, 2007-151-7.

148. Lemming, *National Hotel*, 1–17, 129.

149. Ibid., 12.

150. Ibid.

151. For additional information about Emma Andres, including photographs of four of her quilts, see Helen Young Frost and Pam Knight Stevenson, Arizona Quilt Project, *Grand Endeavors: Vintage Arizona Quilts and Their Makers* (Flagstaff, Ariz.: Northland Publishing, 1992). Joyce Gross also wrote about Emma Andres in her *Quilters' Journal* 4, no. 2 (1981): 1–4, 16–18. She based her biography of the Arizona quiltmaker in part on information gathered during her interviews with Andres, plus numerous telephone conversations. The Briscoe Center's Joyce Gross Quilt History Collection contains a number of objects owned by Andres, including two miniature watercolors she painted and her Sears, Roebuck and Company's Century of Progress Quilt Contest Merit Award ribbon, as well as photocopies of correspondence between Andres and Florence Peto.

152. Florence Peto to Emma Andres, January 21, 1948, photocopy of typed letter, Joyce Gross Quilt History Collection, 2008-013/149. Seamstresses sometimes referred to a sewing bird as a "third hand." This example was clamped to a worktable. The bird's beak, designed to open and close, held one part of the fabric, allowing the seamstress to use one hand to hold the fabric taut and the other hand to stitch.

153. The color photograph is housed in Emma Andres biographical file, Joyce Gross Quilt History Collection, 2008-013/151, along with Andres's dressmaker's label and cross-stitch pattern.

154. Joyce Gross, "Emma Andres," *Quilters' Journal* 4, no. 2 (1981): 17.

155. Elizabeth Anthony to Family, April 19, 1933, Mineola, Tex., photocopy of letter, Elizabeth Anthony Papers, 2.325/B12.

156. "Mrs. Anthony's Address," and untitled article, *Tyler Journal*, Tyler, Tex., April 21, 1933, Elizabeth Anthony Papers, 2.325/B12.

157. Joyce Gross purchased some of Bertha Stenge's quilts in 1997 from Stenge's daughter Prudence Fuchsmann, who had inherited her mother's quilts directly from sister Frances Traynor following her death (date unknown). Two Stenge quilts, *Lotus* and *Tiger Lily*, were owned for a time by Mrs. Alta Rademacher, who purchased them when Fuchsmann offered them for sale in 1971. Merikay Waldvogel to Kate Adams, e-mail, March 9, 2009, *Serpentine and Stars* quilt file, W2h001.010.2008, WQC.

158. Quoted from "Dear Editor" column, *Woman's Home Companion*, July 1933, photocopy in Joyce Gross Quilt History Collection, 2008-013/161.

159. "An Artist with a Needle," *Chicago Daily News*, January 15, 1955, photocopy, Joyce Gross Quilt History Collection, 2008-013/161.

160. Quoted from "Bertha Stenge," *Quilters' Journal* 2, no. 2 (1979): 5.

161. As quoted in Roderick Kiracofe, *The American Quilt: A History of Cloth and Comfort, 1750-1950* (New York: Clarkson Potter, 1993), 240.

162. "Quilts as Art," *Newsweek*, August 2, 1943, photocopy, Joyce Gross Quilt History Collection, 2008-0133/161.

163. Hilda Loveman to Bertha Stenge, August 6, 1943, photocopy of letter, Joyce Gross Quilt History Collection, 2008-0133/161.

164. Cuesta Benberry, "The Superb Mrs. Stenge," *Nimble Needle Treasures*, Summer, 1971, 4.

165. "Bertha Stenge Quilts Found," *Quilters' Journal* 26 (1985): 15.

166. Merikay Waldvogel to Kate Adams, e-mail, October 10, 2012, *Stars with Wavy Sashing* quilt file, W2h001.011.2008, WQC.

167. Merikay Waldvogel and Jan Wass, "A Cut and Stitch Above: *Quilts by Bertha Stenge*," Illinois State Museum, December 30, 1998, http://www.museum.state.il.us/ismdepts/art/collections/daisy/biography.html.

168. Florence Peto to Elizabeth Richardson, March 2, 1952, photocopy of letter, Joyce Gross Quilt History Collection, 2008-013/149; Peto to Richardson, May 11, 1952, photocopy of letter, Joyce Gross Quilt History Collection, 2008-013/153.

169. "Art of Quilt-Making Honors North West Sider," *North Side News*, Chicago, November 13, 1953, photocopy in *Mexican Dancers* quilt file, W2h001.009.2008, WQC.

170. "Callie Elizabeth Jeffress Fanning 'Smith,'" photocopy of a typed biography by Jo Ann Fanning Durham, n.d., *Callie Elizabeth Jeffress Fanning Quilt Collection* quilt file, 2010-303, WQC. Fanning's granddaughter and quilt donor Jo Ann Durham requested that her grandmother be identified as Callie Elizabeth Jeffress Fanning, that is, without Fanning's married name, Smith. The Briscoe Center also owns these other quilts by Fanning: *Ladies and Hats* (2010-303-1) and *Fashionable Ladies* (2012-314).

171. Fanning's *Leading Ladies* is part of the collection of the Morris Museum, Morristown, N.J. Her *Eleanor Roosevelt Picture Album* hangs in the Franklin D. Roosevelt Library in Hyde Park, N.Y.

172. Barbara Brackman, *Making History: Quilts and Fabric from 1890–1970* (Lafayette, Calif.: C&T Publishing, 2008), 83–86.

173. *Grandmother Clark's Patchwork Quilt Designs from Books 20-21-23* (St. Louis: W. L. M. Clark Inc., 1932).

174. Dr. Claud A. Bramblett, professor emeritus, Department of Anthropology, University of Texas at Austin, provided the author with many details about his mother, Alta Butcher Bramblett. E-mails and notes from Kate Adams interview with Dr. Bramblett, August 30, 2012, *Album Patch* quilt file, 2011-336, and *Fan Quilt* quilt file, 2012-247, WQC.

175. Joyce Gross, "Pine Hawkes Eisfeller," *Quilters' Journal* 3, no. 4 (1981): 1.

176. Pine Eisfeller married Robert Eisfeller in 1929. She had been married twice before, to Lowell Crawford, with whom she had a daughter, Dorothy, and to Jack McDonald, with whom she had two sons before she and McDonald divorced.

177. Eisfeller, "Heirlooms for Tomorrow," *The American Home*, March 1945, 53, 55. Joyce Gross wrote extensively about Pine Eisfeller and her quilts. See her separately published biography of Eisfeller in Joyce Gross, "Pine Hawkes Eisfeller," *Quilters' Journal*, November 1981, portions of which appear in "Pine Hawkes Eisfeller," *Quilters' Journal* 3, no. 4 (1981): 1–3, 15.

178. Eisfeller, "Heirlooms for Tomorrow," 56.

179. Ibid.

180. Dorothy Patterson to Joyce Gross, May 18, 1993, Joyce Gross Quilt History Collection, 2008-013/147.

181. Joyce Gross interview with Pine Eisfeller, May 17, 1975, typed notes, Eisfeller biographical file, Joyce Gross Quilt History Collection, 2008-013/147.

182. Pine Eisfeller Scrapbook, Joyce Gross Quilt History Collection, 2008-013/38.

183. "Prize-Winning Quilting," *Woman's Day*, May 1943, 40; Gross, "Pine Hawkes Eisfeller," *Quilters' Journal* 3, no. 4 (1981): 15.

184. Ruth E. Finley, *Old Patchwork Quilts and the Women Who Made Them* (Philadelphia: J. B. Lippincott, 1929), Plate 57, p. 121.

185. Ibid., 121.

186. Joyce Gross, draft caption for Pine Eisfeller's *The Garden*, for exhibit in "America Collects Quilts: The Joyce Gross Collection," International Quilt Festival, Houston, 2005, Joyce Gross Quilt History Collection, 2008-013/147.

187. Eisfeller, "Heirlooms for Tomorrow," 60.

188. Gross, "Pine Hawkes Eisfeller," *Quilters' Journal* 3, no. 4 (1981): 6.

189. Marie D. Webster, *Quilts: Their Story and How to Make Them* (New York: Doubleday, 1915), Fig. 7.

190. Alan S. Cole, "Old Embroideries: Part III," *Home Needlework Magazine* 3, no. 1 (1901): F. 7, pp. 9–11. For a full description of the original Persian bath carpet, see Cole's article and Rosalind Webster Perry, *Quilts: Their Story and How to Make Them, New Edition of America's First Quilt Book* (Santa Barbara, Calif.: Practical Patchwork, 1990), 198.

191. Invoice, Textile Conservation Workshop to Joyce Gross, September 1, 1981, photocopy, Joyce Gross Quilt History Collection, Pine Eisfeller biographical file, 2008-013/147.

192. "Prize-Winning Quilting," 40.

193. Ibid.

194. Gross, "Pine Hawkes Eisfeller," *Quilters' Journal* 3, no. 4 (1981): 3.

195. Pine Eisfeller Scrapbook, Joyce Gross Quilt History Collection, 2008-013/38; Eisfeller Biographical File, Joyce Gross Quilt History Collection, 2008-013/147; Eisfeller, "Heirlooms for Tomorrow," 53.

196. Typed note by Joyce Gross, January 16, 1999, and photocopy of *Victoria Bier*, Pine Eisfeller biographical file, Joyce Gross Quilt History Collection, 2008-013/147.

197. Gross, draft caption for *White Magic*, "America Collects Quilts," International Quilt Festival, Houston, 2005, Joyce Gross Quilt History Collection, 2008-013/147.

198. Press release, Office of the Secretary of State, Sacramento, Calif., July 25, 1968, Eisfeller biographical file, Joyce Gross Quilt History Collection, 2008-013/147.

199. Joyce Gross gave details of Eisfeller's quilt exhibit on the back page of *Quilters' Journal* 4, no. 4 (Spring 1982); Joyce Gross typed draft label for "America Collects Quilts: The Joyce Gross Collection," International Quilt Festival, Houston, 2005, Eisfeller biographical file, Joyce Gross Quilt History Collection, 2008-013/147.

200. Effie Roe's sparse family history comes from information transmitted to Kathleen McCrady when she acquired the quilt in 2003 and from U.S. Census records. Roe, one of three daughters and three sons of William L. and Della E. Roe, was born in February 1887. U.S. Census records for 1900 and 1910 list her as living in Bastrop, Bastrop County, Texas. William Roe's occupation is listed as "farmer." It is possible that Effie married sometime after 1910; however, a niece who once owned this quilt referred

to her aunt as Effie Roe, suggesting that Roe never married. One of Effie's nieces is the source of the information locating Effie in Kerrville at the time she made this quilt. Kathleen McCrady to Kate Adams, e-mail, August 19, 2013, *Tobacco Sack Puff* quilt file, Kathleen McCrady Quilt History Collection, W2h89.06, WQC.

201. "Golden Belt Manufacturing Co. History," n.d., http://www.fundinguniverse.com/company-histories/golden-belt-manufacturing-co-history/; OpenDurham, "Golden Belt Manufacturing Co.," n.d., http://www.opendurham.org/buildings/golden-belt-manufacturing-co.

202. Notes from Kate Adams interview with Donna and Joe David Miller, June 13, 2011; Kate Adams and Donna Miller, e-mail correspondence, July 8 and July 16, 2014, in *WPA Quilt* quilt file, 2011-178, WQC.

203. Merikay Waldvogel, "Quilts in the WPA Milwaukee Handicraft Project, 1935–1943," in *Uncoverings: Research Papers of the American Quilt Study Group*, vol. 5, ed. Sally Garoutte (Mill Valley, Calif.: American Quilt Study Group, 1985), 153–167; "'We Patch Anything': WPA Sewing Rooms in Fort Worth, Texas," *The Living New Deal: Still Working for America*, May 27, 2013, http://livingnewdeal.berkeley.edu/tag/wpa-women/; "Women and the WPA: Sewing," *New Deal of the Day*, January 13, 2014, http://nddaily.blogspot.com/2014/01/women-and-wpa-part-4-of-10-sewing.html.

204. Draft label for *Snowflake*, in "Great Quilts and Quilters I Have Known," for exhibit in "America Collects Quilts: Joyce Gross Quilt Collection," International Quilt Festival, Houston, 2005, *Snowflake* quilt file, W2h001.066.2008, WQC.

205. Photocopy of Paragon Quilt No. 01090 Dogwood Design, *Dogwood* quilt file, W2h001.068.2008, WQC; draft label for *Snowflake*, *Snowflake* quilt file, W2h001.066.2008, WQC.

206. Draft label for *Shades of Orange*, in "Great Quilts and Quilters I Have Known," for exhibit in "America Collects Quilts: Joyce Gross Quilt Collection," International Quilt Festival, Houston, 2005, *Shades of Orange* quilt file, W2h001.067.2008, WQC.

207. Photocopy of portion of Bucilla Morning Glory Design no. 2005, *Shades of Orange* quilt file, W2h001.067.2008, WQC.

208. Cuesta Benberry, "White Perceptions of Blacks in Quilts and Related Media," in *Uncoverings: Research Papers of the American Quilt Study Group*, vol. 4., ed. Sally Garoutte (Lincoln, Neb.: American Quilt Study Group, 1983), 59. Benberry collected one *Little Brown Koko* quilt, made in Minnesota in 1943. It is part of the Cuesta Benberry Quilt and Ephemera Collection at Michigan State University Museum in East Lansing.

209. Robert E. Sutherland, "Hidden Persuaders: Political Ideologies in Literature for Children," *Children's Literature in Education* 16, no. 3 (1985): 143–157.

210. Sherry Springer, "Blanche (Seale) Hunt," *Oklahoma Cemeteries*, February 18, 2015, http://www.okcemeteries.net/lincoln/carney/huntbsbio.html.

211. Blanche Seale Hunt, *Stories of Little Brown Koko* (Chicago: American Colortype Company, 1953), 5.

212. "An Ideal Gift for Kiddies," advertisement in *Household Magazine*, ca. 1940, n.p.

213. Ibid.; *Celebrity Doll Journal* 22, no. 1 (1987): 2–8.

214. Photocopy of Numo Hot Iron Transfers no. C9040, Capper's Reader Service, Topeka, Kans. These iron-on transfers were one-use only and typically were available from Capper's Reader Service in the late 1930s through the early 1940s. *Little Brown Koko* quilt file, 2011-038, WQC.

215. Mary Anne Pickens typed note, February 13, 2011, *Little Brown Koko* quilt file, 2011-038, WQC.

216. Marie Webster, *Quilts: Their Story and How to Make Them* (New York: Tudor Publishing, 1915), 116–117.

217. Joyce Gross, "Dr. Jeannette Dean Throckmorton," *Quilters' Journal* 2, no. 1 (1979): 1–3.

218. Maxine Teele, "Dr. Jeanette: A Fine Needlewoman," *Nimble Needle Treasures* 7, no. 2 (1975), as quoted in ibid., 3.

219. Joyce Gross, exhibit label for *Modernistic Star*, in "The Legendary Quilts from the Joyce Gross Collection," Quilter's Hall of Fame, Marion, Indiana, July 19–21, 1996, *Modernistic Star* quilt file, W2h001.014.2008, WQC.

220. Cuesta Benberry to Joyce Gross, February 13, 1984, Joyce Gross Quilt History Collection, 2008-013/151.

221. *Prize Winning Designs* (Rock Island, Ill.: The Modern Woodman, ca. 1931), 9. A copy of this booklet is in the Joyce Gross Quilt History Collection, 2008-013/164.

222. Dr. Throckmorton's sets of paper templates are housed in the Joyce Gross Quilt History Collection, 2008-013/164.

223. *Prize Winning Designs*, 9, Joyce Gross Quilt History Collection, 2008-013/164.

224. Exhibit label for *Nine Patch Doll Quilt*, "America Collects Quilts: The Joyce Gross Collection," International Quilt Festival, Houston, October 2005, *Modernistic Star* quilt file, W2h001.014.2008, WQC.

225. Martha Jackson to Edna [last name unknown], July 14, 2013, *Nine Patch Doll Quilt* quilt file, Joyce Gross Quilt History Collection, w2h001.015.2008, WQC. Ms. Jackson's correspondent may have been Edna Ford, whom Cuesta Benberry identifies as having "conducted a *massive* study of Aunt Martha Studios. (I helped *some*, but the major portion of the work was *hers*.) She dated 'Prize Winning Quilts' booklet as *1931*." See Cuesta Benberry to Joyce Gross, February 13, 1984, Joyce Gross Quilt History Collection, 2008-013/151.

226. "World War II, Texans In," *Online Handbook of Texas*, n.d., http://www.tshaonline.org/handbook/online/articles/qdw02.

227. Photocopy of *American Veterans Council World War II, Council No. 1, Austin, Texas: Charter Members* (Austin, ca. 1945), *American Veterans Council World War II Memorial Quilt* quilt file, 799.1, WQC.

228. Fields of Honor Database, http://www.fieldsofhonor-database.com/index.php/american-war-cemetery-margarten-h/58124-hornberger_homer_t.

229. Maxine Teele to Joyce Gross, letter, October 8, 1975, Joyce Gross Quilt History Collection, 2008-013/183.

230. Correspondence (some handwritten, some photocopied) between Maxine Teele and Florence Peto is in the Joyce Gross Quilt History Collection's Who's Who files for both Teele and Peto.

231. Maxine Teele, "In Partial Payment," *Nimble Needle Treasures*, Winter 1973, 9.

232. Florence Peto to Maxine Teele, photocopy of letter, August 30, 1965, and Peto to Teele, photocopy of letter, May 11, 1967, Joyce Gross Quilt History Collection, 2008-013/183; Teele, "In Partial Payment," 9. Teele used the 1876 commemorative fabrics acquired from Peto in her *And Bright Stars* quilt, which she completed in 1975.

233. Mary Jo Teele Reed, *Material Pleasures: A Biography of Maxine Teele, Iowa Quilter* (n.p., 2006), 84.

234. Maxine Teele, "California Quilt Doings," quoted from an article in *Needle's Eye*, Council Bluffs, Iowa, September 1976, in unknown correspondent to Joyce Gross, letter, April 25, 1977, Joyce Gross Quilt History Collection, 2008-013/183.

235. *Patchwork Patter*, July 1977, 11, Joyce Gross Quilt History Collection, 2008-013/199.

236. Vicki Chase to Kate Adams, e-mail, March 20, 2013, *Frog Pillow Cover* quilt file, W2h001.182.2008, WQC.

237. Jean Ray Laury to Joyce Gross, typed letter, undated (received by Gross in June 1976), Joyce Gross Quilt History Collection, 2009-013/160.

238. "*Barefoot and Pregnant*," in *The Twentieth Century's Best American Quilts*, ed. Mary Leman Austin (Golden, Colo.: Primedia Special Interest Publications, 1999), 18.

239. Jean Ray Laury, *The Creative Woman's Getting-It-All-Together at Home Handbook* (New York: Van Nostrand Reinhold, 1977). Laury's questionnaire included questions such as "What if your husband doesn't like all the mess and activity?" and "How do you keep children out of your work? Do you?" Jean Ray Laury questionnaire, n.d., Joyce Gross Quilt History Collection, 2009-013/160.

240. "Housewife's Fantasy Panel," *Needle and Thread*, March/April 1981, 13; Jean Ray Laury to Joyce Gross, undated, Joyce Gross Quilt History Collection, 2009-013/160. This same issue of *Needle and Thread* sold a full-sized pattern and instructions for making *The Housewife's Fantasy, Sew Far, Sew Good*, and a set of eight postcards depicting Laury's fantasy panels. The postcard version of *The Housewife's Fantasy No. 5* (the "Things Are Cooking" panel) was subtitled "Riding the Kitchen Range: Performance Piece of Culinary Talents."

241. "Housewife's Fantasy Panel," 13.

242. Anita Murphy, "Great American Quilt Contest and Festival Scrapbook," Anita Murphy Quilt Collection, 4M699zq.

243. Great American Quilt Contest questionnaire and answers, p. 2, *Freedom to Dream* quilt file, Anita Murphy Quilt Collection, 2009-296-17, WQC; Karoline Patterson Bresenhan and Nancy O'Bryant Puentes, *Lone Stars: A Legacy of Texas Quilts*, vol. 2: *1936-1986* (Austin: University of Texas Press, 1990), 170-

171; Murphy, "Great American Quilt Contest and Festival Scrapbook," Anita Murphy Quilt Collection, 4M699zq. For an interesting article about the Great American Quilt Contest, see Jane Przybysz, "Competing Cultural Values at the Great American Quilt Festival," in *Uncoverings: Research Papers of the American Quilt Study Group*, vol. 8, ed. Laurel Horton and Sally Garoutte (San Francisco: American Quilt Study Group, 1989), 107-127.

244. Karoline Patterson Bresenhan and Nancy O'Bryant Puentes, *Lone Stars: A Legacy of Texas Quilts*, vol. 1: *1836-1936* (Austin: University of Texas Press, 1986); Texas Heritage Quilt Society, *Texas Quilts, Texas Treasures* (Paducah, Ky.: American Quilter's Society, 1986); *Texas: Official 1986 Sesquicentennial Guidebook* (Austin: Texas Sesquicentennial Commission, 1986).

245. A. J. Sowell, compiler, "Capt. John F. Tom: A Biography," carbon copy of a typescript, n.p., ca. 1906, Texas Collection Library.

246. Ibid.

247. Ibid.; Shirley Stevenson to Karey Bresenhan, photocopy of an e-mail, October 18, 2010, and "Captain Tom, a Tall Texan, a Texas Album Quilt," typescript by Shirley Fowlkes Stevenson, n.d., *Captain Tom, a Tall Texan* quilt file, Shirley Godbold Fowlkes Stevenson Quilt Collection, 2014-174-4, WQC.

248. Karey Bresenhan to Shirley Stevenson, photocopy of an e-mail, October 18, 2010, *Captain Tom, a Tall Texan* quilt file, Shirley Godbold Fowlkes Stevenson Quilt Collection, 2014-174-4, WQC.

249. Shirley Stevenson to Kate Adams, e-mail, September 10, 2014, *Captain Tom, a Tall Texan* quilt file, Shirley Godbold Fowlkes Stevenson Quilt Collection, 2014-174-4, WQC.

250. Ibid.

251. Beth Thomas Kennedy to Kate Adams, interview notes, Austin, September 21, 2014, *Our Texas Heritage* quilt file, TMM 2511.1, WQC, *Our Texas Heritage* quilt file, TMM 2511.1, WQC.

252. Ibid.

253. "Musings," e-mail from Beth Thomas Kennedy to Kate Adams, September 25, 2014, *Our Texas Heritage* quilt file, TMM 2511.1, WQC.

254. "Musings," e-mail from Kennedy to Adams, September 25, 2014; Kennedy to Adams, interview notes, September 21, 2014.

255. Beth Thomas Kennedy to Kate Adams, e-mail, September 25, 2014.

256. Kennedy to Adams, interview notes, September 21, 2014.

257. Texas Memorial Museum, University of Texas at Austin website, n.d., http://www.utexas.edu/tmm/tnsc-history/.

258. "Musings," e-mail from Kennedy to Adams, September 25, 2014; Kennedy to Adams, interview notes, September 21, 2014.

259. Beth Thomas Kennedy to Kate Adams, interview notes, October 6, 2014, Beth Thomas Kennedy Quilt Collection file, 2014-212, WQC; *The New Quilt 1: Dairy Barn National* (Newtown, Conn.: Taunton Press, 1991), 35.

260. "Musings," e-mail from Kennedy to Adams, September 25, 2014; Kennedy to Adams, interview notes, September 21, 2014; Kennedy to Adams, interview notes, October 6, 2014.

261. "Musings," e-mail from Kennedy to Adams, September 25, 2014.

262. Ibid.

263. Kennedy to Adams, interview notes, October 6, 2014.

264. Kennedy to Adams, interview notes, September 21, 2014; Kennedy to Adams, interview notes, October 6, 2014.

265. Kate Adams interview notes with Helen Wade, November 7, 2001, *Snowball* quilt file, 2009-144, WQC. For additional information about Helen Wade and for photographs of eighty-one of her quilts, see Linda Johnson and Michelle Johnson, *Helen Wade: A Legacy of Quilts* (Georgetown, Tex.: n.p., 2011).

266. Vernice Thorne, "The Saga of a Quilt," photocopied typescript in *Fairyland Revisited* quilt file, W2h001.065.2008, WQC.

267. Ibid., 17–19.

268. "Sebastopol Woman's Best of Show Quilt Almost a No-Show." *Sebastopol Times and News*, August 13, 1987, 6-B.

269. Draft exhibit label for *Fairyland Revisited*, for "America Collects Quilts: The Joyce Gross Collection," International Quilt Festival, Houston, October 27–30, 2005, in *Fairyland Revisited* quilt file, W2h001.065.2008, WQC.

270. Exhibit label from "Legendary Quilts from the Joyce Gross Collection," Quilters' Hall of Fame, Marion, Indiana, July 19–21, 1996, *Point Bonita Friendship Album* quilt file, W2h001.038.2008, WQC.

271. Joyce Gross to Friends, March 6, 2001, photocopy of a letter, Joyce Gross Quilt History Collection, *Farewell to Pt. Bonita* file, 2008-013/199; Bobbi Finley to Kate Adams, e-mail, May 14, 2013, *Point Bonita Friendship Album* quilt file, W2h001.038.2008, WQC.

272. Bettina Havig to Kate Adams, e-mail, May 14, 2013.

273. Bobbi Finley to Kate Adams, e-mail, May 10, 2013, *Point Bonita Friendship Album* quilt file, W2h001.038.2008, WQC.

274. Bobbi Finley to Kate Adams, e-mail, May 10, 2013.

275. Ibid.

276. Ibid.

277. Joyce Gross to Friends, March 6, 2001, photocopy of a letter, Joyce Gross Quilt History Collection, *Farewell to Pt. Bonita* file, 2008-013/199.

278. Reflections on 9/11 Quilt Collection, *Framework for Peace*, guidelines and questionnaire, p. 2, *Reflections on 9/11 Quilt Collection* quilt file, 2009-159-3, WQC. Project records for the Reflections on 9/11 Quilt Collection are housed in Box 3D254B.

279. Sherry Cook to Kate Adams, e-mails, November 5, 2011, and October 13, 2014, *Log Cabin, Pineapple Variation* quilt file, 2010-264, WQC. Sherry Cook has generously donated more than fifty quilts, tops, redwork, study textiles, printed items, and sewing notions to the WQC since 2008. They are all part of the Sherry Cook Quilt Collection.

280. Kathleen McCrady quilt documentation for *Folk Art Lilies*, 2009, *Folk Art Lilies* quilt file, Katherine J. Adams Quilt Collection, 2013-120-2, WQC.

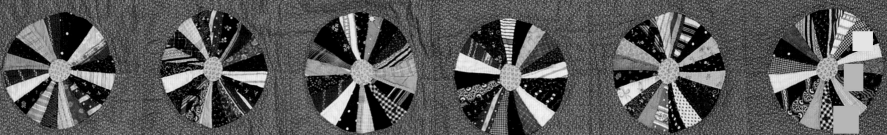
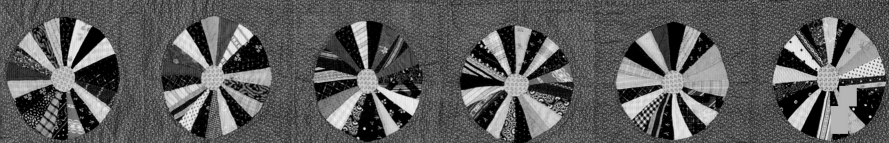
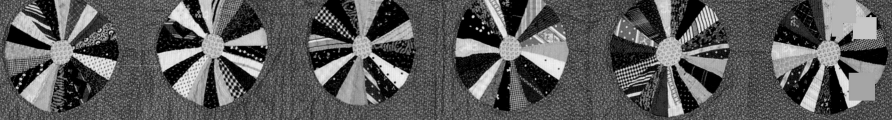
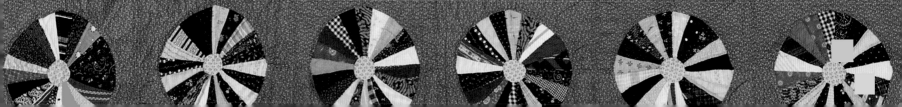

GLOSSARY

appliqué, or conventional appliqué: The technique of cutting fabric pieces and then stitching them, often in layers, onto a background fabric to form various designs. *See also* cutout chintz appliqué, reverse appliqué

block printing: A labor-intensive surface printing technique whereby a design was pressed directly onto a fabric using a wooden block whose raised surface contained a colorant or mordant. The process was repeated to achieve the desired yardage and/or more than one color. The process was used in America through the 1830s.

blotch ground: Fabric printed so that the roller produces the background color and leaves the design, such as polka dots, the color of the original fabric.

broderie perse: *See* cutout chintz appliqué

cadet blue: A medium gray-blue, popular from 1890 to about 1925.

cambric: A fine, closely woven, opaque cloth.

cheater cloth: *See* printed patchwork

chintz: Originally a general term meaning a painted or printed cloth of India, but often understood to be a cotton print fabric with a glaze, often featuring a large-scale printed design, usually floral. Chintz fabrics often were used as furnishing fabrics, especially for furniture, bed hangings and draperies.

chrome orange: An intense orange resembling the color of cheddar cheese (today often called "cheddar orange"), popular in quilts after 1840 and through most of the twentieth century. Chrome orange accents often appeared in nineteenth-century red and green appliqué quilts.

colorfast: *See* fast

colorways: Different color combinations of a textile printed with the same design.

conversation prints: *See* object prints

cording: A technique that achieves a dimensional effect in a quilting pattern. A design is outlined onto two layers of fabric using parallel rows of stitches. These stiches form channels into which soft cotton cord is threaded.

cornerstone: A separate square patch sewn at the junction of the horizontal and vertical sashing on a quilt top. For a decorative effect, cornerstones are often made using a fabric whose color or pattern contrasts with the sashing.

cretonne: Fabric with a large-scale print used for furnishings such as bed covers, draperies, and upholstery, and typically featuring floral designs.

crewel embroidery: Embroidery using wool yarn, also known as crewel yarn, that was stitched across the surface of the fabric rather than following the weave of the cloth. Often referred to as Jacobean embroidery.

cross stitch: A stitch pattern that forms an X. Cross-stitch letters were popular in samplers and often were used to create signatures in pre–Civil War quilts.

cutout chintz appliqué: The technique of cutting designs from chintz fabric, rearranging them, and then stitching them onto a background fabric, often one in a neutral color. The technique is often referred to as *broderie perse*, French for "Persian embroidery."

diagonal-line quilting: A quilting pattern that positions stitch lines parallel to one another on the diagonal.

double pinks: Printed fabrics featuring two or more shades of pink and often one of white, typically in small geometric or floral-like designs. Double pinks were popular throughout the nineteenth century.

echo quilting: A quilting pattern that follows the contour of the appliquéd design, thereby creating a series of curving lines much like ripples radiating from a pebble dropped in water.

English paper piecing: The technique by which fabric pieces are basted over stiff paper templates, often a hexagonal shape, and then whipstitched together to create an all-over set. Typically the paper is removed before the quilt is completed. In the nineteenth century, templates often were made from used ledger paper or newspapers whose writing can help date a quilt.

fast: Dyed or printed color that resists degradation from various sources, including light or abrasion.

fugitive: Dyed or printed color that is subject to degradation from various sources, including light or abrasion.

ground: The background of a printed fabric.

homespun: Fiber spun and woven into cloth in the home, as opposed to mill-spun yarn that is then woven at home or factory-produced cloth.

in-the-ditch quilting: Stitching within the channel made by piecing, or close to the edge of appliqué.

indigo: A plant whose dyeing properties produce a range of colorfast blue shades, typically dark or navy blue.

madder: An herb whose root works as the coloring agent in a natural dye. With different mordants the madder root can produce Turkey red, coppery browns, pink, purple, or orange.

medallion: The center design focus of a quilt, typically framed by pieced and/or appliquéd borders. Medallion-style quilts were especially popular until about the 1830s.

mordant: A dye-setting agent that, when mixed with a coloring agent, produces a fast color.

mosaic: In quilts, the term refers to a continuous patchwork of hexagons, often in rosettes or diamond shapes.

mourning prints: Black or dark prints associated with mourning and the clothing worn during the first year following the death of family member; typically seen from 1880 to 1910.

Nile green: A bluish-gray green especially popular in quilts during the period from about 1925 to 1950.

object prints: Fabrics with white or solid-colored backgrounds printed with tiny realistic illustrations of non-floral objects such as bugs, horseshoes, tennis rackets, or anchors.

ombré print: A fabric printed to achieve a rainbow of colors or different shades of a single color. Often referred to as "fondue print" and "rainbow print."

on point: A fabric square set into the quilt with its point at the top, thereby creating a diamond shape.

overdyeing: The process of vat dyeing fabric in two different baths to achieve a third color.

paper piecing: *See* English paper piecing

paper-cut designs: *See scherensnitte*

penny squares: Small sheets of muslin with stamped patterns, typically of nursery rhymes, historical figures, household items, animals, and flowers. Available by mail order, at dry goods stores, or as souvenirs, often for pennies apiece.

picotage: Designs made of small, closely spaced dots that appear in the background of printed fabric. Originally the dots were created using wood blocks carved with tiny dots; later, the dots were created using blocks fitted with nails or metal pins or by raised points on metal plates or rollers.

plate printing: The technique of surface printing whereby a dye or mordant introduced into the grooves of a design etched or cut into a metal plate are picked up when the plate is pressed into the fabric. The technique, invented around the mid 1700s, permitted finer detail than that achieved by block printing.

printed patchwork: A fabric printed with a design to look like a pieced pattern. Often referred to as "cheater cloth."

Prussian blue: A rich, medium shade of blue achieved from one of the earliest known chemical dyes; popular in textiles by the 1830s.

rainbow print: A fabric printed in stripes of various colors, each blurred at the edges, to achieve a rainbow effect. *See also* ombré print

redwork: Embroidery using red thread rather than black thread.

reverse appliqué: The technique of cutting away the top layer of two or more layers to reveal the layer underneath. Typically, the top layer's raw edge is turned under and stitched down. Sometimes referred to as "inlaid appliqué."

roller printing: Printing that uses a plate curved around a roller, thereby enabling printers to decorate a continuous roll of fabric. The technique was used beginning in the late eighteenth century.

ruching: A technique by which fabric or ribbon is gathered or folded to form repeated ruffles or pleats that decorate clothing and quilts; the resulting decoration is often flowerlike.

sashing: Strips of fabric sewn between quilt blocks to join the blocks.

set: The organizational design of a quilt top.

scherensnitte: The German term for the traditional craft of paper cutting design. Swiss and German immigrants, often those settling in Pennsylvania, introduced paper-cut designs to America in the eighteenth century.

shirtings or shirting prints: Fabrics containing an off-white or white ground and small motifs that are usually geometrical or object prints, such as anchors, dogs, or horseshoes.

stuffed work: Raised design elements in a quilting pattern created by inserting cotton padding from the back of the quilt.

summer spread: A lightweight bedcover typically made of a single fabric thickness; that is, a bedcover with no backing fabric or batting and no quilting.

transfer pattern: A printed design on paper that can be transferred onto fabric using heat, such as a hot iron. The design typically was used for embroidery and needlepoint.

Turkey red: A vibrant red that resulted from a multi-step process requiring the use of the dyestuff known as madder root. Turkey red was prized for being colorfast. The process was unknown to Europeans until the mid-eighteenth century.

vermiculate: Designs made of fine lines, often twisted, squiggly, or wormlike, that appear in the background of printed fabric.

whole-cloth quilt: A quilt whose top is made from one fabric, though typically composed of several seamed lengths.

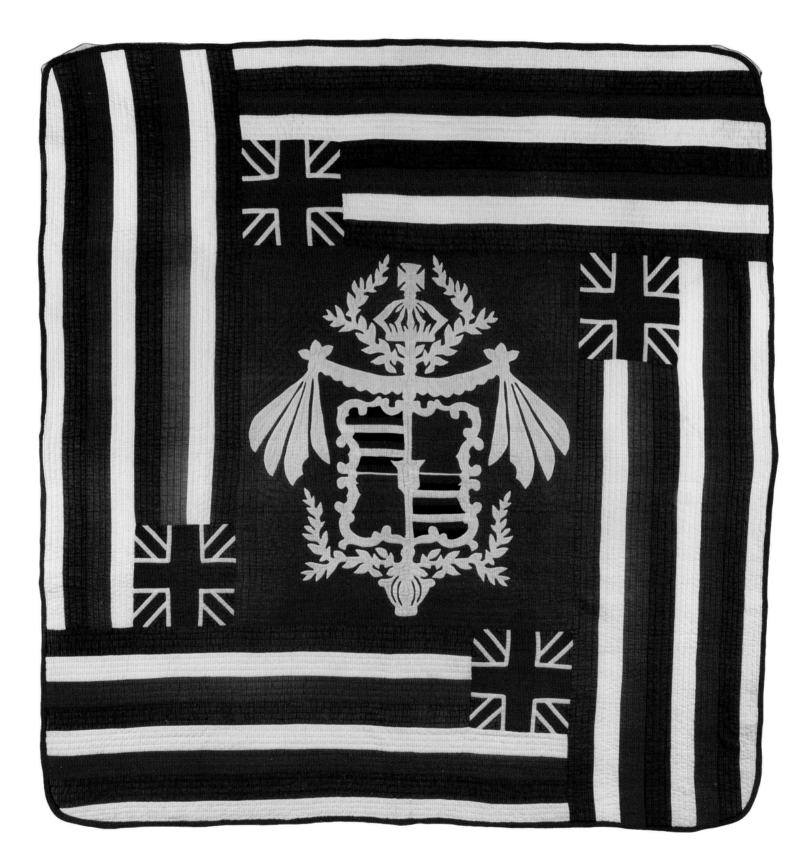

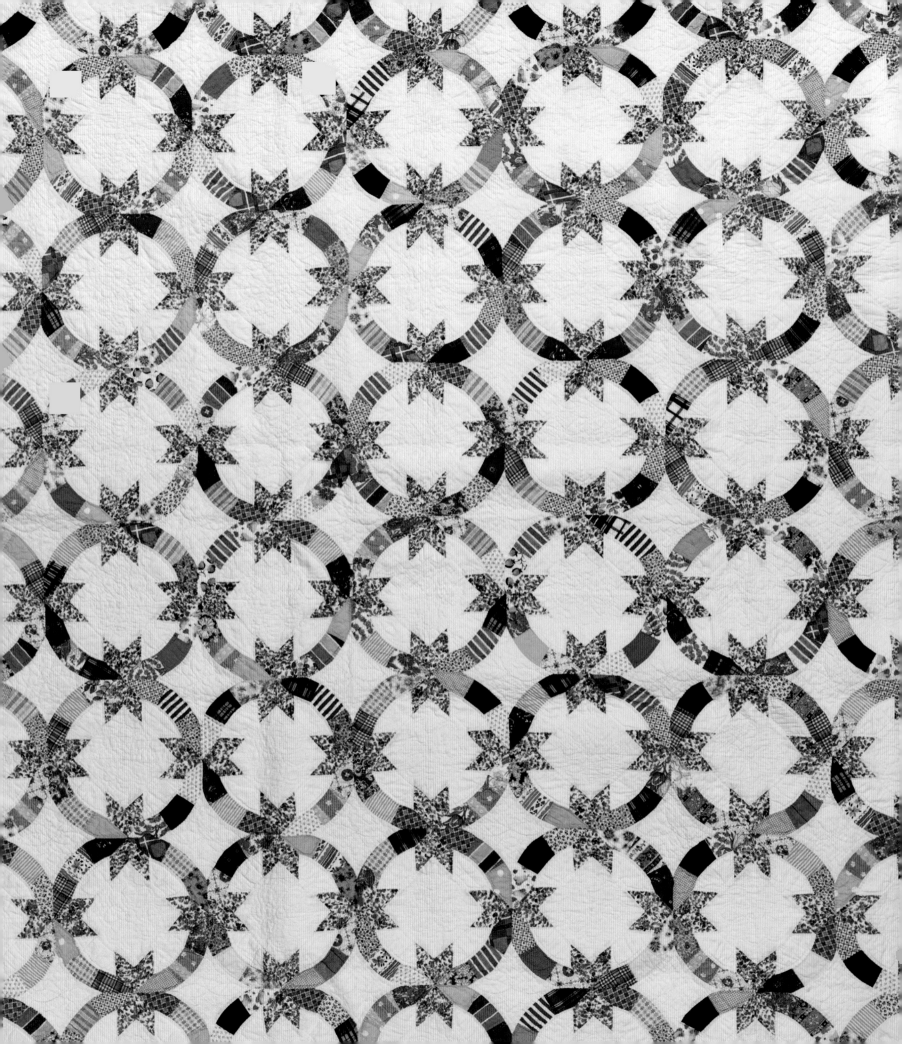

ACKNOWLEDGMENTS

It is a great pleasure to acknowledge in print the many colleagues and friends who helped make *Comfort and Glory* possible. I am grateful to Briscoe Center Executive Director Dr. Don Carleton for naming this book a center project, thereby making available to me the support of my center colleagues on so many aspects of this book. I especially thank Director of External Relations Erin Purdy and Head of Publications Dr. Holly Taylor, for shepherding this book through to publication. I am very grateful, too, to the University of Texas Press, especially Director David Hamrick, Design and Production Manager Ellen McKie, and Editor-in-Chief Robert Devens.

Because photographs are a core part of *Comfort and Glory*, I owe an enormous debt to the talented Hal Richardson, the center's digital projects coordinator, and Aryn Glazier, photography services coordinator. Both of them photographed nearly every quilt and object in this book. I am also grateful for the expertise and the hard work of colleagues Katie Ashton, Catherine Best, Sarah Cleary, Jessi Fishman, Christelle Le Faucheur, Roy Hinojosa, Carol Mead, Anna Prather, and Margaret Schlankey. Together we staged, photographed, and rehoused 107 quilts for this book during our weeklong photo shoot in January, 2015. Earlier photographs taken by Billie Moore were also used in the book. Many thanks, too, to David Zepeda, who created the book's two important quilt grids, and to Paul Wentzell, who took several special and much-needed photographs.

I also have been blessed to have many friends and colleagues who encouraged me throughout this book project. I especially thank my two stellar volunteers, Barbara Woodman and Kathy Moore. In addition to helping manage the Winedale Quilt Collection while I wrote, their expertise on all manner of quilt history and quilt construction topics and their friendship and support have sustained me. I am especially grateful, too, to longtime colleagues Brenda Gunn, director of research and collections; Lynn Bell, assistant director for exhibitions and material culture; Catherine Best, the center's librarian; and Barbara White, site manager at our Winedale Historical Complex, all of whom love quilts and have helped me on so many occasions. I am enormously grateful to the many friends who have been so encouraging throughout this project, especially Karey Bresenhan, Carmel Fenves, Beth Kennedy, Suzanne Labry, Kathleen McCrady, Donna Morrow, Nancy O'Bryant Puentes, Deborah Thiras and, of course, the Mah Jong Ladies. I give a special thank you, too, to Vicki Chase and Ellie O'Connor for their many kindnesses and support.

Finally, loving thanks to my sisters Suzanne and Ann, my daughter Sarah, my son-in-law Aaron, and my husband David, the love of my life. Their encouragement and support throughout this book project has meant so much to me.

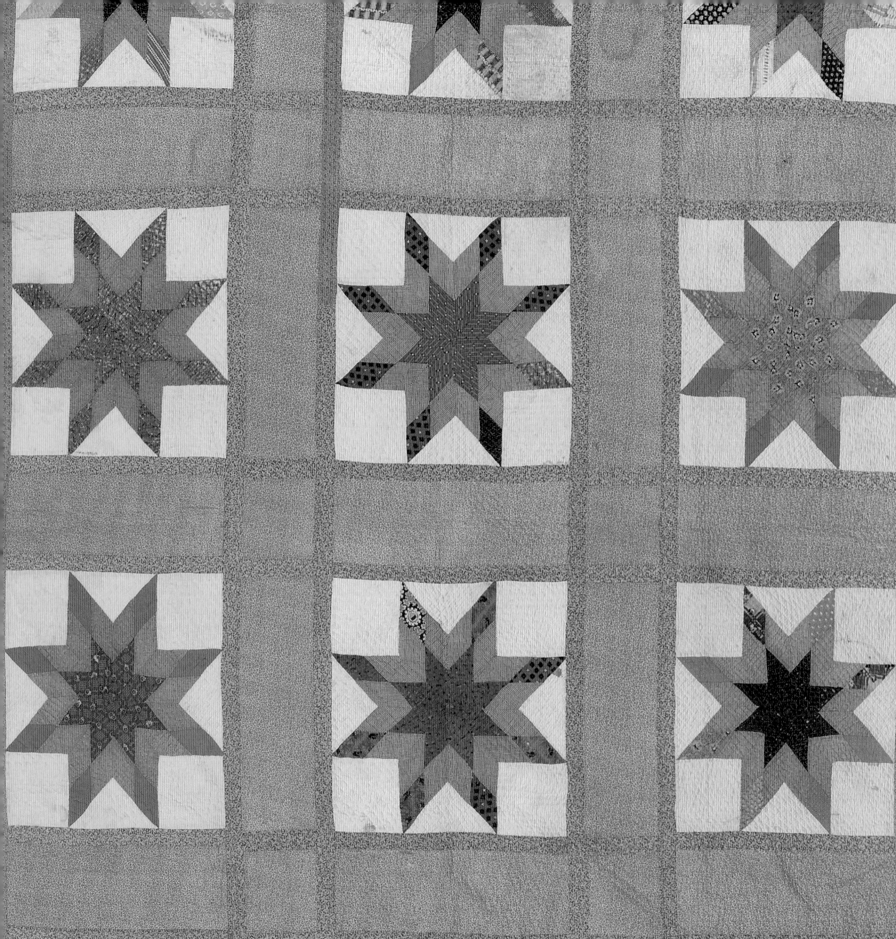

INDEX

Non-quilt images are indicated by *f* following the page number.